Critical Terms
for
Art History

Critical Terms

for

Art History

Edited by

Robert S. Nelson and Richard Shiff

The University of Chicago Press

Chicago & London

The University of Chicago Press, Chicago 60637
The University of Chicago Press, Ltd., London

©1996 by The University of Chicago
All rights reserved. Published 1996
Printed in the United States of America

05 04 03 02 01 00 99 98 3 4 5

ISBN: 0-226-57164-5 (cloth)
0-226-57165-3 (paper)

Approximately one-third of chapter 22 appeared as "Double Visions" in *Artforum,* January 1992, © 1992 Artforum. Reprinted with permission.

Library of Congress Cataloging-in-Publication Data

Critical terms for art history / edited by Robert S. Nelson and Richard Shiff.
 p. cm.
 Includes bibliographical references and index.
 1. Art—Historiography—Terminology. 2. English language—Terms and phrases. I. Nelson, Robert S., 1947– . II. Shiff, Richard.
N34.C75 1996
701′.4—dc20 95-49975
 CIP

Contents

SOCIAL RELATIONS

SOCIETIES

Illustrations

At the Place of a Foreword:
Someone Looking, Reading, and Writing
Robert S. Nelson

I placed a jar in Tennessee,
And round it was, upon a hill.
It made the slovenly wilderness
Surround that hill.

The wilderness rose up to it,
And sprawled around, no longer wild.
The jar was round upon the ground
And tall and of a port in air.

It took dominion everywhere.
The jar was gray and bare.
It did not give of bird or bush,
Like nothing else in Tennessee.

Wallace Stevens, "Anecdote of the Jar," 1919

To introduce this volume of essays about art history in the late twentieth century, I place at the beginning a poem by the American author Wallace Stevens (1879–1955), someone concerned with vision throughout his oeuvre. In this position, the poem might be read as epigraph. But, though short, it is still longer than the standard epigraph, those textual fragments that in books of history or art history are usually passed over silently, thus becoming unacknowledged metaphors for a chapter that follows. But this is a book of words about images and the artistic practices that are thereby defined. In such a context, words themselves matter and so too do epigraphs, metaphors, and verbal frames of all sorts. Like my colleagues elsewhere in the volume, I choose to ground this foreword in the explication of a single object, only mine is a work of verbal, not visual, art.

Stevens's poem introduces ways of engaging art and its history that are suggested in the gerunds of my subtitle and enacted in the articles of this volume. I direct the reader's gaze to verses that themselves look at an object. This act, so fundamental to art history, here takes place in another sphere, where the operations of vision and textuality may be more apparent, precisely because the poem is not art history. It is historical, however. While it derives from the period of art history's greatest growth and development, both demographically (Dilly 1988) and theoretically (Clark 1974; Damisch 1975), the poem nonetheless does not quite belong to our world. It serves to establish what are, minimally, two distinct historical periods in the twentieth century, that of its earlier decades and the poet's modernism and our postmodernism.

The latter is the critical space that all our essays inhabit at century's end, even Charles Harrison's article on *modernism*. Thus the poem is employed to frame what is here with what is not here, define the present by the past, and foreground contemporary art history against its recent disciplinary background. Such a foreword is just that: words written before, words written about prior words, words that are temporally and spatially separate, and, perhaps for this reason, forewords that are both historical and theoretical.

Literary critics have understood Stevens's famous jar, "gray and bare," as a plain, somber American response to European high culture, as exemplified by another poem about a ceramic vessel, Keats's "Ode on a Grecian Urn," which I must also introduce to the discussion. The poets of jar and urn engage their objects rather differently. Keats addresses his vase as a person, giving it a gendered identity redolent of sexual violence ("Thou still unravish'd bride of quietness"). Next he begins his ekphrasis, his personal reaction to the imagery on the sides of the Greek vase, its painted and thus silent musicians playing their ancient pipes ("Heard melodies are sweet, but those unheard / Are sweeter; therefore, ye soft pipes, play on"). Stevens's jar, like the "I" that places it, is also gendered, an object round and tall, thus male and phallic. Hardly quiet or passive and certainly not an object of refined contemplation like Keats's vase, the plain bare jar, devoid of decoration, takes control of a hill in the Tennessee wilderness. By sheer aesthetic power, it transforms an environment so slovenly as to disrupt the poem's meter in the third line ("It made the slovenly wilderness"). The regular rhythm of the next short line, the last of the stanza ("Surround that hill"), restores discipline. The resonance of its "surround" then echoes in the next stanza's "around," "round," and "ground."

In the art and art history of today, the rhetorical and visual strategies evinced by Stevens's modernism or Keats's romanticism would be questioned. All is now contingent: the social, aesthetic, even political status of the jar or urn (Should the vase be returned to Greece?); its site or condition of exhibition (Would an environmental impact statement be needed to set up a jar in a wilderness area?); the poets' gendered projection (as above); the standing of the object within an artistic canon (*Kleinkunst*, fine art, American folk art?); the potential or even the possibility of the work of art to transform its environment; and, lastly, the "I" that set the jar on that hill, the eye that saw it, and the "I" that is presently writing about all of the above. No longer does aesthetic vision seem so simple and unproblematic, as Stevens later expressed in his poem "Credences of Summer" (1947):

> Let's see the very thing and nothing else.
> Let's see it with the hottest fire of sight.
> Burn everything not part of it to ash.

What Stevens and other poets of twentieth-century formalism want to deny, contemporary art historians, working in the aftermath of their own versions of

formalism, want to understand. Indeed, the terms discussed in this volume help us interpret both the objects of the poets' attention and their act of attending, and, more to the point, the art object in the gaze and discourse of the art historian.

Our article on *word and image,* for example, explores that old problem, still relevant today, of the relation of poetry and painting, which motivated Keats's reflections. Several essays consider the art object as *commodity, fetish, primitive* artifact, or *simulacrum.* Others explore *context;* the writing of the object into *art history;* the significance of *avant-garde* viewers and audiences; the status of *narrative, representation,* and *sign;* and the fundamental act of expounding on *meaning* or *interpretation.* The *value* of the object, its *appropriation* or relation to its owner and maker, the act of *collecting,* and the function of the *museum* are found in other essays. *Gaze* and *gender,* topics central to the two poets, appear here, as well as considerations of the *originality* or lack thereof of the art object, its *modes of production,* and the *ritual* of its social negotiation.

When "Anecdote of the Jar" was published in 1923 in Stevens's first volume of poetry, a reviewer likened the poem to an abstract painting, and a recent critic has argued that Stevens was then thinking of Duchamp's readymades (MacLeod 1993). From the vantage point of the late twentieth century, however, the architectonic nature of the object described suggests either a self-contained work of modern sculpture, or, more to the point, an apartment tower placed in what civic planners considered the "slovenly wilderness" of certain parts of the urban environment. If Stevens's elegant poem appears to belong to a distant but related world, its architectural analogy seems more alien at the end of the twentieth century. Few housing projects fulfilled their utopian promise, and their demise has been equated with the decline of modernism. Indeed, Charles Jencks brashly proposed that modernism, at least in architecture, ended at 3:32 P.M. on 15 July 1972, when prize-winning modernist towers, the Pruitt-Igoe housing development in Saint Louis, were demolished because they were unlivable. The notion that postmodernism began a minute or so later, rising Phoenix-like out of a cloud of dust from the explosion, contravenes, of course, not only common sense, but also the poststructuralist critiques of origins in general.

Yet something in art and the humanities was definitely happening in the 1970s, even if its definition then or later is not always clear. Art history was not immune to what some regarded as the contagion of critical theory. The appended select bibliography, arranged in chronological order, provides one narrative of the theoretical expansion of art history during the past two decades. From certain inchoate tendencies and proclivities and motivated by a generational and gender transformation of the profession, new problems and approaches gradually emerged. Some years later these were christened "the new art history." According to the English book of that title, "the shape of things to come" was foretold on 24 May 1974 (no hour specified). On that day,

T. J. Clark declared in *The Times Literary Supplement* that art history was not actually in crisis, only "out of breath, in a state of genteel dissolution." But once, he noted, art history had been in the forefront of scholarly disciplines (at least in Germany, not England or America). The names of art history's leaders from those days—e.g., Riegl, Wölfflin, Dvořák, Saxl, Warburg—if not necessarily their writings, remain well known today. Wolfgang Kemp independently makes a similar point in his essay on *narrative,* and it is well taken. Once art history was part of a vital tradition of intellectual and philosophical inquiry, incorporating history, religion, psychology, ethnography, literary criticism, and philosophy. More recently art history's professionalization, manifested in its journals, scholarly associations, academic departments—each hallmarks of a discipline—suggests a narrowing of its former conceptual parameters. In 1975, Hubert Damisch was more sharply critical of art history's decline from its "great period," pronouncing the field "to be totally incapable of renovating its method" by reference to theoretical developments in other fields.

On this side of the Atlantic, critical reflections on art, its history, and its (re)presentation also appeared in the early 1970s, but significantly only at the margins of art-historical discourse. Particularly noteworthy is a special issue of *New Literary History* (spring 1972) with essays by Svetlana and Paul Alpers, Kurt Forster, and others. Other articles, some still theoretically pertinent today, followed in subsequent issues. The now widely read journal *Critical Inquiry* began publishing in 1974 and from its first issues included essays about art and art history. By the end of the decade, *Art History,* the new journal of the [British] Association of Art Historians, welcomed the introduction of innovative theories and discussions of nontraditional arts; it thereby began the integration of critical theory into the discourse of art history proper.

Thus during the 1970s, critically innovative forays or sondages into art's history were essayed, and new venues were created to report their results. Nevertheless or consequently, discursive angst prevailed during the 1980s. The winter 1982 issue of *Art Journal* discussed "the crisis in the discipline" about a decade after the first theoretical calls to arms. In 1985 yet another new journal, *Representations,* published a group of essays whose general title asked "Art and Society: Must We Choose?" For the first time, taking stock came to the disciplinary center of the profession, at least in its most traditional aspect, when in 1986 Richard Spear, the editor of the *Art Bulletin,* began an extended State of Research Series on different "fields" of Western art history. By no means, however, was critical theory foregrounded in all articles, nor was there any self-consciousness displayed about the classificatory system laid over the discipline. In 1988, Norman Bryson reported on the pulse of the discipline in his introduction to a volume of reprinted essays from France. He began, "There can be little doubt: the discipline of art history, having for so long lagged behind, having been among the humanities perhaps the slowest to develop and the last to hear of changes as these took place among even its

closest neighbours, is now unmistakably beginning to alter." Bryson repeats the claim in 1994.

In certain quarters, however, art history has not been as backward as Bryson claims, but what many regarded as its center did indeed resist critical theory (and may still). The nature of that resistance needs to be more carefully examined than is possible here and in any case should not be summarily dismissed, for within it there may be more than inertia. As artifact or object, the art work, unlike the literary text in the age of mechanical reproduction, retains an aura and a decided cultural, symbolic, and especially economic value, and that value is interwoven with its history and its historians. As building or painting, object or sign, art may well require something more than the application of literary and cultural approaches crafted for and from texts. What the philosopher Richard Rorty termed the general "linguistic turn" in humanities during recent decades may be yielding to the power of the image, whether still or moving, to what W. J. T. Mitchell (1994) calls "the pictorial turn."

More than two decades have passed since the first cries of crisis. Pioneers from within and without the discipline of art history have opened up new spaces of inquiry. Journals and now monographs series have been created, e.g., *Cambridge New Art History and Criticism,* edited by Norman Bryson. Books of a theoretical nature are more common (Bätschmann 1984, Belting 1987, Preziosi 1989, Bryson, Holly, and Moxey 1991, Mitchell 1994, Moxey 1994). That bastion of tradition, *The Art Bulletin,* has become a lively forum for critical reflection under its new editor, Nancy Troy. And the discipline has begun to pay serious attention to its own history, in the form not of accolades for the founding "fathers," but of sustained analysis of philosophical issues and historical contexts (e.g., Podro 1982, Dilly 1979, 1988, Carrier 1991, Olin 1992, Iversen 1993, Potts 1994). All the same, compared to literature, cultural studies, or history, the sheer number and range of publishing venues devoted to theoretical reflections about art history is still limited. And because the margins remain the spaces for some of the most innovative work, access to that thought is not easy even for those within the profession.

The essays that follow, including Richard Shiff's afterword about the concept of *figuration,* elucidate and comment on twenty-three terms used in contemporary art history. They debate the issues raised by the terms, evaluate their general utility, and, for the most part, apply them to the interpretation of some work of art. In so doing, they may enhance the significance of the terms studied, but the first objective is to foster and extend a discourse about theory within art history and to make that discourse accessible to those seeking to enter it. What was needed, we all felt, were as many bridges as possible between critical theory as practiced in other fields and the artwork, art history, and art's practitioners and initiates.

Ergo our book and the dialogues it seeks to open. On its pages the reader will not find every relevant term for the recent, vital art history that I have

described. Our sins as editors and authors are of omission and commission. Doubtless we have overlooked pertinent concepts, and we are certainly aware of our failures to persuade this or that scholar to participate. What our book does offer are essays about theory that are also theoretical themselves and writing that not only explains and describes, but also argues and provokes. In this respect, we followed the preceding volume in what becomes a series with the publication of our book. I refer to *Critical Terms for Literary Studies,* edited by Frank Lentricchia and Thomas McLaughlin. Like them, we asked authors to "do" theory, not just write about it. We too sought explorations that were more conceptual and not mere accountings of critical schools or approaches, and we asked authors to ground their theorizing in the interpretation of some work of art.

But we also went further and encouraged experimentation with styles and formats of presentation, for one of art history's current theoretical concerns is the genre itself and the rhetorical strategies employed in it (cf. *Art Bulletin,* December 1994). Our entries enact diverse modes of explanation and argumentation. Some resemble the encyclopedia; others are more personal, like the narratives of autobiography or lightly veiled fiction; and others still are composed according to genres that we cannot name. As a result, our book is not a dictionary or accounting of *Keywords,* like Raymond Williams's seminal work with that title, but an anthology, a collection of essays, and even a book of short stories.

While we have followed in several respects the preceding volume for literary studies, the two books are hardly the same, even though one of us, W. J. T. Mitchell, appears in each. Some terms are found in both—*representation, narrative, gender, value.* The article by David Carrier on *art history* is the analog of that on *literary history* in the earlier book, while my essay on *appropriation* is a deliberate repositioning and thus a critique of the previous essay on *influence.* In these cases, disciplinary difference is easily assessed. But many essays do not and should not have precise parallels, for the objects of analysis, modes of inquiry, and spaces of discourse in art and literature differ.

Here I return to Stevens's jar. Actually what he wrote was something called "Anecdote of the Jar," that is, a poem and a story about a jar. That text as literature was interpreted by Frank Lentricchia in his afterword to *Critical Terms for Literary Study.* There with rhetorical panache and a flourish of critical strategies, Lentricchia takes the reader through the poem, using it to argue against literary formalisms that have prevailed until recently. I used Stevens's verses for related but different purposes. I looked past Stevens's poesy, his etymologies, his evocation of the pastoral genre, all topics covered by Lentricchia, to the jar beyond, as if words were transparent signifiers, which they are not, and as if there were a gray jar on a hill somewhere in Tennessee. My reaction was prompted by a historical and art-historical regard for *mentalités,* cultural attitudes toward things and the process of seeing, selecting, interpreting, and thus

constituting them. Jars and environment, art and context, sculpture and setting, architecture and space and the acts of attending to them are what art history studies. To state the obvious, words and literature are the stuff of literary criticism, but both disciplines ply their crafts with and through words, sharing their pleasures and their frustrations.

And at the end of the twentieth century, both literature and art confront the many guises of formalism and modernism. At times, modernism seems slowly to fade away; at other times, aspects of this complex and variegated phenomenon reappear in contemporary critical discourses, especially a certain hermeticism and ahistoricity. Once more "The Anecdote of the Jar" is a useful exemplum for art history. As a major work of formalism, both textual or visual, it not so much resists ending and closure as it frustrates beginning and entry, because this discursive system "took dominion everywhere." "Like nothing else in Tennessee" or anywhere else, the poem creates for itself an autonomous, self-contained space, a world constituted by the object and its maker, a stage devoid of other actors or even an audience. Art, art history, and their formalisms did the same, but art history at the end of the twentieth century struggles to open up those discursive spaces and to look at artists, artworks, and their histories, contexts, and audiences from as many perspectives as possible. Our book therefore is also offered to readers who live outside Tennessee.

Our acknowledgments, like everyone's, are local. Karen Wilson, senior editor at the University of Chicago Press, first suggested this project some years ago, and on most days since, Richard and I have been grateful to her for the idea. Our research assistants, Katy Siegel, Megan Granda, and Lisa Deem, have worked faithfully to compile and catalog and to goad editors and authors. Finally, we thank our excellent collaborators, whose contributions, of course, have been critical.

SUGGESTED READINGS

Historiography and Methodology of Art History
(in Chronological Order, 1972–1994)

1970s

Alpers, Svetlana, and Paul Alpers. 1972. "Ut Pictura Noesis? Criticism in Literary Studies and Art History."
Forster, Kurt A. 1972. "Critical History of Art, or Transfiguration of Values."
Clark, T. J. 1974. "The Conditions of Artistic Creation."
Lebensztejn, Jean-Claude. 1974. "Esquisse d'une typologie."
Damisch, Hubert. 1975. "Semiotics and Iconography."
Kubler, George. 1975. "History—or Anthropology—of Art?"
Baxandall, Michael. 1979. "The Language of Art History."

Dilly, Heinrich. 1979. *Kunstgeschichte als Institution: Studien zur Geschichte einer Disziplin.*

1980s

Marin, Louis. 1980. "Towards a Theory of Reading in the Visual Arts: Poussin's *The Arcadian Shepherds.*"

Bryson, Norman. 1981. *Word and Image: French Painting of the Ancien Regime.*

Summers, David. 1981. "Conventions in the History of Art."

Zerner, Henri, ed. 1982. "The Crisis in the Discipline."

Podro, Michael. 1982. *The Critical Historians of Art.*

Bryson, Norman. 1983. *Vision and Painting: The Logic of the Gaze.*

Kemp, Wolfgang. 1983. *Der Anteil des Betrachters: Rezeptionsästhetische Studien zur Malerei des 19. Jahrhunderts.*

Holly, Michael Ann. 1984. *Panofsky and the Foundations of Art History.*

Bätschmann, Oskar. 1984. *Einführung in der kunstgeschichtliche Hermeneutik.*

Rees, A. L., and R. Borzello. 1986. *The New Art History.*

Summers, David. 1986. "Intentions in the History of Art."

Belting, Hans, et al. 1986. *Kunstgeschichte: Eine Einführung.*

Belting, Hans. 1987. *The End of the History of Art?*

Bryson, Norman, ed. 1988. *Calligram: Essays in the New Art History from France.*

Foster, Hal, ed. 1988. *Vision and Visuality.*

Dilly, Heinrich. 1988. *Deutsche Kunsthistoriker 1933–1945.*

Bann, Stephen. 1989. *The True Vine: On Visual Representation and the Western Tradition.*

Freedberg, David. 1989. *The Power of Images: Studies in the History and Theory of Response.*

Preziosi, Donald. 1989. *Rethinking Art History: Meditations on a Coy Science.*

Shiff, Richard. 1989. "On Criticism Handling History."

1990–1994

Bal, Mieke, and Norman Bryson. 1991. "Semiotics and Art History."

Bryson, Norman, Michael Ann Holly, and Keith Moxey, eds. 1991. *Visual Theory: Painting and Interpretation.*

Kemal, Salim, and Ivan Gaskell, eds. 1991. *The Language of Art History.*

Carrier, David. 1991. *Principles of Art History Writing.*

Olin, Margaret. 1992. *Forms of Representation in Alois Riegl's Theory of Art.*

Iversen, Margaret. 1993. *Alois Riegl: Art History and Theory.*

Moxey, Keith. 1994. *The Practice of Theory: Poststructuralism, Cultural Politics, and Art History.*

Bryson, Norman, Michael Ann Holly, and Keith Moxey, eds. 1994. *Visual Culture: Images and Interpretations.*

Potts, Alex. 1994. *Flesh and the Ideal: Winckelmann and the Origins of Art History.*

Mitchell, W. J. T. 1994. *Picture Theory: Essays on Verbal and Visual Representation.*

Troy, Nancy J., ed. 1994. "A Range of Critical Perspectives: The Object of Art History"; "The Subject of Art History."

OPERATIONS

"ideas" and their relations. In these terms, sight (and memory) provided the images completed by the data of the other senses in the mind's painter's representation of the world to itself. (Words, by the same argument, might be said to suggest even the shapes and forms of things, and thus to prompt pure imagination, and poetry, language in the absence of an actual ostensible referent, might be defined as language that was allowed to do that.)

Plato's comparison of the first activity of the soul to painting should not be regarded as positive, or even as neutral. The painter formed opinions, not truth. For Plato, imitations—and therefore images—were dissimulations, inherently culpable because they represent themselves as something they are not. At the same time, they have the power to make us other than we are; we in our turn may be swayed by an apparent reality, the mask and not the actor, neither of whom is subject to reason. This unease about images, this sense of their inevitable duplicity, has persisted in critical language at all levels to modern times.

In Plato's *Cratylus* (432 A–D), the first consideration in Western literature of the origin of language, Socrates rejects the argument that words are imitations of things; in order to be images at all, images must not reproduce most of the qualities of what they show, and this must be even truer of words. To illustrate his argument, Socrates considers the example of an image of Cratylus himself made by some god, which not only shows his outward form and color, as painters do, but also re-creates his physical and mental inwardness. Cratylus is forced to admit that there would not then be himself and an image, but rather two of himself, an absurdity. Precisely because they are images, then, mental images are also not substitutes or doubles.

In his treatise on the soul, also the first in Western literature, Aristotle (*De anima* 424a) extended and adapted such arguments by defining sensation as a sign (*semeion*) of an affection of sense, like the impression left by a seal ring in wax. Again the analogy is to sight, since shape is involved, but also to touch, to real contact. This sign implies a cause (like all signs; Aristotle understood *semeion* to mean what we would call an *index* [*Posterior Analytics* 70a]). As the visual sign became more clearly indexical (rather than iconic) *phantasia* was more explicitly identified with the postsensationary faculties of imagination and memory. In *De memoria* (450a) Aristotle called immediate sensation a "trace" or "mark"—*typos* or *graphe*—and called its likeness in the mind a "picture" (*zoographema*, a drawing from life). The difference between sensation and mental image is developed to make the important point that when we remember we do not remember our first sensation but rather its image *as* an image; otherwise we would not be able to distinguish between reality and memory. It is through *phantasia* or imagination that we have the capacity to recollect or imagine what is not present. *Phantasia* is now more than the capacity to "form opinion"; it is the capacity to represent absent or even impossible things to ourselves in the soul's own light, to remember, imagine, and dream.

Aristotle literalized his metaphor and gave it another dimension in the *Politics* (1340a 30 ff.), arguing that painted figures are not likenesses of character but rather *signs* of it. The painted figure is a resemblant sign, like that given to the sense of sight, as if it were contiguous with the cause of its appearance, which implies completion by the otherwise experienceable qualities of real things; but this same sign also indicates the inwardness defining and animating what can be directly sensed. We might suppose that the birds fooled by the painted grapes of Zeuxis flew down to them because, seeing their shapes and modeled colors, they could anticipate their cool, moist sweetness; and that Zeuxis worried that the birds had not been frightened by the painted boy who carried the grapes because it meant he had failed to make the birds believe what they could not see—the character of the boy—in what they could see.

The definition of visual images—both those actually painted and those "painted" in the soul—as resemblant signs, and as the occasions for sensory and imaginative completion, leads us around to the origin of the word "representation" itself, which to this point I have been using generally and ahistorically, as we are in the habit of doing. *Repraesentatio* is a construction around the verb "to be." *Praesens* is a participial form of *praeesse*, "to be before," which it means in two senses: the first is simple spatial, prepositional location; the second involves precedence or command, being higher in rank, more important than. Perhaps then "presence" implies that which is not simply before us but which "stands out" and concerns us, that to which we are in a sense subject. Then by extension the temporal "present" might also be what is at hand, what can and usually does actually occupy our attention, as opposed to the past and the future, which are "out of reach."

Repraesentatio had meanings very significant for our purposes. In ancient rhetoric, which developed alongside philosophy, the orator is a painter in the soul who uses the "figures," "turns" (tropes), and "colors" of eloquence to shape assent by persuasion (that is, through sweetness), by the artful joining of words in such ways as to unite imagination and feeling, thus to instigate decision and action. It is not enough, Quintilian wrote (*Institutio oratoria*, IV, ii, 63; VIII, iii, 62–63) to please the ears or merely to give an account of the facts (*narratio*) to the judge. Rather things must be set forth and shown to "the eyes of the mind." The artifice of language should afford *evidentia*, going beyond the perspicuous and probable, making the matter "brighter" and "cultivated." The whole problem of the power of eloquence to make the true more than true, or even to make the untrue seem true, is concentrated in this lawyerly advice. *Evidentia*—from the verb "to see"—is what the Greeks called *enargeia*, brilliance; what, Quintilian wrote, some call *repraesentatio*. This is a variation of the pattern just discussed; the induced, inward visual sign provokes the apparent experience of other qualities. The sweetness of sounds—the taste and sight of the audible—leads the imagination to a sense of actual presence.

Repraesentatio could also mean a payment in cash. The implicit third term

that unites the disparate uses of *repraesentatio* might be said to be "fullest equivalent"; a *repraesentatio* is something of equal present force or value. In these terms to make an image means not to make an impossible double, but to fashion a fullest equivalent presence. Words cannot re-create, but they may be fused to memory and feeling and may have an equivalent force in the imagination, much as cash is most immediately equivalent to goods exchanged. ("Representation" is thus at least in part descended from commercial analogy, like the word "interpretation" itself, which is related to "price." To interpret is to negotiate, to have no leisure, to do business, to trade, bargain, haggle, but also to find an equivalent in other terms.) *Equivalence* has definitively replaced substitution or resemblance in our argument.

To move ahead quickly, the medieval Scholastics defined a sign as "that which *represents* other than itself to the operations of the mind," joining representation still more closely to signification and separating it more clearly both from substitution and resemblance. Responding to the generally Platonic argument that the cult of God should be "honest," and that poetry and theater, which *represent* something they are not, are therefore inappropriate to Christian ritual, Thomas Aquinas replied that in the state of our present life we cannot directly intuit divine truth and that it is necessary for ritual to be accommodated to our way of knowing, which is through sense. "It is clearly more useful that the divine mysteries be conveyed to the unlettered people under the cover of certain figures." Poetry and theater cannot be grasped by human reason because they are in themselves prerational, like sense itself; and the mysteries of the faith cannot be grasped because they surpass the powers of reason. Both therefore appropriately make use of figures; that is, they *represent*. They are the means by which we may at least "implicitly" grasp the truths of the faith. The "lower" visible forms cannot in principle be like the "higher" meanings they manifest; at the same time, however, the need to make the "higher" manifest in sense justifies these lower forms. Always close to such arguments was the theological reply to the iconoclasts—that the sacred image is like its prototype in having a form and in being able to be called by the same name, but not in its matter or substance. The higher could be addressed through the lower, to which it was, however, not equivalent. Behind this lay the theology of the Incarnation and the Trinity.

There is an important difference between this example and the others we have considered. Representation now has a vertical dimension. The fruit in a Roman still life stands before us on its stage and might be seen to suggest the sensory qualities of some real fruit in real light; on the other hand, the orange in the window of Jan van Eyck's *Arnolfini Wedding* invites us precisely through its apparent brilliance to other meanings entirely, to considerations not just of the prosperity of patrons, but beyond that to prosperity itself, to fecundity, perhaps to the fall and the mystery of the beginning of human generations. Of course Platonism had always had a vertical dimension, but there is again an

important difference. Plato's "ideas" and "forms," despite their being "higher," were still, if invisible, metaphorically visual, still in an image relation to actual things comparable to the relation of sight and its objects. Aquinas aligned representation on a vertical armature, but the relation between higher and lower is no longer one of similitude. The sign is now truly an allegory, representing *to the mind in other terms something it does not resemble*. The resemblant sign— what we recognize as something, an orange, for example—is not, *insofar as it is a representation,* defined by resemblance. Such disrelation has a clear counterpart in the allegory and personification so pervasive in medieval and Renaissance art and literature. On a thoroughly practical level, but still within the same broad tradition of visual meaning, Cosimo I de' Medici could tell Giorgio Vasari not to show him surrounded by counselors as he decided to wage war against Siena. Instead there should be a figure of Silence and some other Virtue. "That," he said, "would *represent* the same thing as the counselors."

These arguments have important general consequences. Representation has now become *symbolic;* the resemblant sign does not merely convey that which it resembles to the mind, as in our earlier examples; rather it is that through which a meaning not defined by image relation may be apprehended. In that sense, the resemblant sign itself has become wordlike. It is not merely "arbitrary," however; rather the thing itself is now a sign, written in the late medieval "Book of Nature," and the specificity of the image, the sign of the sign, is guaranteed by a higher order of meaning, to which access may be had through that specificity.

The Book of Nature was written by God, which did not, however, put an end to the matter. Galileo, laying down the foundations of modern science, returned to the Pythagorean and Platonic roots of the Western philosophical tradition to argue that the Book of Nature could not be understood except mathematically. Aristotle's common sensibles (which Galileo called primary qualities) could be described quantitatively and provided the basis for the general description of the physical world *as quantitative*. This mathematical world, appropriate in its economy and clarity to divine writing, was metaoptical, the framework against which the actual data of sense were merely "subjective" affections of an individual. Representation is now not so much of things as of *relations,* and in these broad terms an equation or the height of mercury in a thermometer may be regarded as representations. Physical forms themselves might be described in terms of the spatial relations they bound, and relations *among* forms might be defined in the same terms. Perspective began the representation of relations "in" virtual spaces in specifically quantitative terms at the same time that it explicitly unified virtual space *for a subject*. (Subjectivity would prove to be the deeper principle; the quantitative was simply the means by which the unity of representation was first articulated, and "perspective" would enter the language of modernity as a metaphor not so much for "objective" spatial order as for "subjective" point of view.)

At the beginning of the tradition of modern empiricism, Francis Bacon distinguished between the *interpretation of nature* (the inference from "facts," that is, from what nature "has done") and the *anticipations of nature,* which are subjective, and, like a false rhetoric, "straightaway touch the understanding and fill the imagination," leading us into error. These "anticipations" Bacon rejected with iconoclastic zeal as "idols." Bacon's iconoclasm extended beyond the illusory forms of prejudicial error to the metaphorical mental "forms," the final causes, that were the cornerstone of Aristotelian science, the highest consonance between reason and the system of the world. At all levels, the human mind creates fictions; it is, Bacon wrote, "like a false mirror, which, receiving rays irregularly, distorts and discolors the nature of things by mingling its own nature with it." In crowning iconoclastic terms, Bacon wrote of philosophical and religious systems as "Idols of the Theater; because in my judgement all the received systems are but so many stage plays, representing worlds of their own creation after an unreal and scenic fashion."

This characterization of representation is truly and simply revolutionary and it is deeply and prophetically modern. At the same time that "nature" may be understood, everything not arising from this understanding becomes a *misrepresentation* in the distorting mirror of the mind. The scientific understanding of the world thus implies another science, a new anthropology: it needs to be explained why we have represented the world to ourselves in ways that have no warrant in external nature. This can partly be explained by the prevalence of the "empty dogma" of religion and philosophy, but beyond that human understanding itself "receives an infusion from the will and the affections"; it is "unquiet; it cannot stop or rest"; it is of its own nature prone to suppose the existence of more order and regularity in the world than it finds. We are by constitution inclined to see the world as if it were a work of our own art, to see it "as one would."

For Bacon, the reformation of the human mind, necessary at once for the empirical exploration of the world and for the creation of a new human world, implied a critique of all previous human institutions and their justifications, all of which must be regarded as without substance until they "stand to reason." His arguments provided the foundation for the Enlightenment project of *ideology,* an at least implicitly iconoclastic "science of ideas" that in turn provided the basis for the Marxist notion of ideology.

As the centuries passed, the conception of the human mind individually and collectively spinning baseless fictions from its own resources would shape the new human sciences and come to involve the reduction of the human mind to a single motive and explanatory principle, on analogy to the physical principles of inertia and gravity. The "restlessness" of the mind might be reduced to association, then to the operations of the unconscious, driven by sex or will. On the new model, human institutions might be reduced to collective psychologies, to economic "forces," or to the "force" of history itself; or these factors

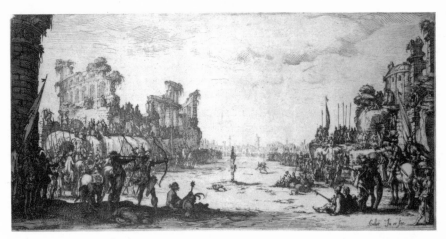

1.1 Jacques Callot, *The Ordeal by Arrows*, ca. 1632–33. National Gallery of Art, Washington, D.C., Baumfield Collection.

might combine in still more embracing reductions, in which, for example, the will that drives human action is concentric with the "will" of the natural world as a whole.

The new scientific world progressively demarcated the old, which came to be grouped with the "aesthetic" and imaginative worlds of art, ranged on the side of subjectivity, whether individual, collective, or transcendental. It would become possible to view art as the expression of the world "as one would," in Nietzsche's phrase, as the world that makes life possible, or as a neurotic projection. Representation is now the imagination of some order, some "world," arising from needs of our own for order. Both representation and imagination have assumed new, modern proportions.

To better understand these changes, we must return to another of the founders of modern science and philosophy. At the beginning of his *Meditations*, Descartes defined "ideas" as thoughts that "are like images of things." The "image" relation he meant was more that of generation than of resemblance. Descartes, like all the originators of modern natural science, was keenly interested in optics, a mature tradition at the time he wrote, based upon Alhazen's *Book of Optics*, translated from Arabic to Latin in the early thirteenth century. Alhazen's optics made it possible to describe how surfaces in light are transferred point for point to facing surfaces. At first this might seem simply to certify the data of sight, but Descartes saw very different implications, implications that were again revolutionary. Earlier nominalists had been quick to see that if the surfaces of things are translated to the eye, then it is unnecessary to suppose that "forms" or *species* are also somehow transferred. In his own *Optics* Descartes ridiculed the Scholastic philosophers' "intentional [or thinkable] spe-

cies," "all those small images floating through the air," and considered sight instead as the response of the eye to physical pressures exerted by objects through the medium of space by light. When we see, we are, he argued, like a blind man who feels his way with sticks. Just as the objects he encounters are *"nothing like the ideas he forms of them,"* so in general it is not necessary to suppose—and not legitimate to assume—"that there is anything in objects which is similar to the *ideas* of sensations that we have of them."

Having separated the representation of things in the mind from form, Descartes used the economy of light and the physiology of the eye to show how protean vision really is. His paradigm for vision is not some "Cartesian" grid but rather *anamorphosis,* the infinitely possible manipulation of the grid. To be sure, the surfaces of facing objects are registered on the back of the eye, but they vary with light, distance, and the shape of the eye itself. The image in the eye is inverted and reversed; focus is partial, straight lines are curved, forms are foreshortened. The sense of sight is a "bad painter," not a painter without skill but rather a too sophisticated and deceitful one, whose illusions must be clarified by the "sight" of higher judgment.

Descartes insisted that it is the mind that sees, not the eye, and from the "defects" of vision shown by optics and anatomy he drew the conclusion that there are other things than "little pictures" of the objects that "touch our senses," and that may also stimulate our thought, "such as signs and words, which do not in any way resemble what they signify." When we see engravings, no more than a little ink here and there on pieces of paper, they *represent* to us a great world of forests, towns, men, even battles and storms. They make us conceive an infinity of qualities in objects that resemble only through shape. Even this resemblance is slight; "in order to be more perfect as images and better to *represent* an object," Descartes concludes, "they ought not to resemble it." We may react only as subjects to the myriad representations in sensation of active physical force. The "signs," the representations of the world in sense, although based on contact, are cut off from necessary relation to visual form.

It is important to note that Descartes formulated the horizontal asymmetry of cause and form in the mind (as opposed to the vertical asymmetry of medieval allegory) explicitly in terms of the sense of sight. This asymmetry, firmly rooted in the first principles of modern science, was to be fundamental for Nietszche and for Freud, who defined memory as the differential capacity for the retention of stimuli. Such arguments are continued in Derrida's poststructuralist version of the principle of the arbitrariness of the sign. The representation cannot represent, and the illusion that it does, or should, can only be explained endogenously.

The simply and truly revolutionary importance of the modern separation of cause and image in the mind cannot be exaggerated, and, as the last examples suggest, we are still drawing its implications not only for the problem of representation but for our understanding of human culture taken altogether. The

systematic implications of arguments like those of Descartes were drawn by Immanuel Kant. In his *Inaugural Dissertation,* Kant wrote that "objects do not act upon the senses through their form or species, and in order that the various objects affecting our senses might coalesce in some whole representation, some work of an internal principle of the mind is necessary, by which those various things are clothed with a certain species according to stable and innate laws." In the preface to the second edition of his *Critique of Pure Reason,* Kant generalized this principle to say that "our representation of things, as they are given to us, does not conform to these things as they are in themselves . . . these objects as appearances conform to our mode of representation."

It would take much more than this space to review the idealist notion of representation, which must, however, be characterized in general for the sake of the rest of this discussion.

Idealist representation, rather than defining individual forms, like Plato's painter in the soul, extends the powers of imagination to the unified projection of a whole field, like Descartes's landscape. There is no reason to suppose that Kant imagined actual representation as Plato had, and imagination is now "pictorial" in the deep but specific sense of post-Renaissance painting. The imagination—the *Einbildung*—that constitutes the world for a subject shows a spatiotemporal horizon, unified as it is not so much because of the unity of the world as because of the unity of the subject. Within this unity, representation is *schematic,* defined by potential relations prior to any experience. Imagination makes a distinctly human reality, through a subject, and does not replicate a world "outside."

In Kant's idealism, consciousness represents the same Newtonian spatiotemporal world, and Kant was therefore not concerned with the problems of a *history* of representation. For Hegel, however, the initial representation of the spatiotemporal world is only the beginning; in representing the natural world we also become aware that this world is not like ourselves. Progressively, Hegel believed, the world *is* made like ourselves, and this is the realization of the human spirit in history. This progress of the spirit is evident in the manifold human transformations of the world, in culture. The recasting of the world in the forms of culture implied a *higher* representation. (The forms of culture, as expressions of spirit, are like us and unlike us, themselves objects of continual transformation; they demand interpretation, which itself became involved in the problem of its own status as representation, hence the rise to prominence of hermeneutics in its modern form. In such circumstances the study of history and culture had a new urgency. Not incidentally, the history of art in all the variants of its modern "critical" form has largely been a history of "representations" in this higher sense, from embracing historicist theories of formal period style to E. H. Gombrich's antihistoricist rejection of the "innocent eye" in favor of already existing cultural formulae.)

As we have seen, idealist representation is *pictorial,* with the unity for a

veiwer of a cogent virtual space. According to the first principles of idealism, the world is represented by us at the same time that it is manifest to us, and weltanschauung is perhaps best translated as "world intuition." ("Intuition" is at base another visual metaphor, as in the more popular "worldview.") Both idealist weltanschauung and its materialist counterpart, *ideology*, for all the differences between them, retained this pictorial character. (The word "ideology," it should be noted, like "idealism," is still from the Greek word meaning "to see.")

Idealist representation was inextricably linked to the newly emerged realm of the *aesthetic*, which was described at the level of intuition. Kant defined aesthetic judgment as integral with primary imaginative representation, and the aesthetic also became in important respects historical and cultural. We may speak, to take a familiar example, of the "aesthetics" of a period much as we speak of its "worldview."

Both weltanschauung and ideology presuppose synthesizing imaginations, and both demand interpretation of syntheses and schemata in themselves. From either standpoint, representations are primarily significant not only in terms of *what* is represented, but also in terms of *how* it is represented. The *what* of representation—subject matter—is most significant for what it reveals in having been chosen, and the *how*, the manner of treatment, reveals the syntheses and schemata. What is presumed to express the structure of a more or less historical subjectivity becomes the primary object of study. But subjectivity occurs in individuals, and, in order to account for the uniformity and continuity of cultures, it was expanded to become more or less embracing *collective* subjectivity. On this view (which is at least implicit in much art-historical practice) a work of art "expresses" both personal and collective "points of view."

As a principle of historical explanation, weltanschauung, like "culture," recognized the local commonality of the forms of human imagination, explaining evident differences among groups in terms of the "spirits" of peoples, places, and times, which might arise separately, "influence" one another, or undergo internal "development." "Worldviews" might be postulated to account for any number of differences, and made to accommodate any individual or collective "perspective." As I have already suggested, the art-historical idea of style embraced many of the features of weltanschauung.

If idealist weltanschauung implied unity and internal transformation, materialist ideology implied antagonism and conflict. Marx's notion of ideology, as I have remarked, descends from the "idols" of Francis Bacon. Like Bacon, Marx argued for an empirical reality, subject not only to physical laws, but, in its deepest historical dimension, to economic laws. It was the aim of his *Capital*, he wrote in the preface, to "lay bare the economic law of motion of modern society." To read the book of history, as Galileo might have said, we must know economics (and Hegelian dialectics, suitably modified). As natural phenomena may be reduced to physical principles, so cultural-historical "phenom-

13

ena" may be reduced to economic-historical principles. Continuing the analogy, it is the real economic and historical world that is represented—or misrepresented—by ideology, which is a Baconian "distorting mirror," or, as Marx called it, a *camera obscura,* in which the world is focused upside down. Ideology has no independent history, and it is always necessary to interpret any history as secondary and derivative (if not nugatory). Furthermore, all representation, as ideology, cannot be taken at face value, but must be regarded and interpreted with systematic "suspicion."

Although ideology in itself is void of real content in comparison with economic history, it is not unrelated to the dialectic of history. If for Marx ideology was "false consciousness" arising from the "distorted mirror" of the human mind, it also constituted major and pervasive modes of oppression, to be countered by awareness of the real history concealed by ideology. Cultures thus do not simply express the "spirit of the age"; rather "culture" itself is in question. There is not one representation, and, if one ideology may be dominant, there are also contending positions.

Whatever the distinctions and alternatives originally intended among them, the categories branching from the great stalk of idealist representation readily collapse into one another. Styles, cultures, ideologies, worldviews, symbolic forms, paradigms, and epistemes tend to be highly interchangeable in critical use. The unity of a metaphorical *psyche,* upon which the whole system I have described is ultimately based, magnified by the reduction of the physical and historical worlds to a single principle, underlies these overlappings and transformations, which have become very familiar. So, for example, the general coincidence of the rise of the middle class and the appearance in painting of one-point perspective might result in perspective's being regarded as essential to middle class representation, to the "bourgeois worldview" or "bourgeois ideology"; and, if we follow Freud in linking Leonardo da Vinci's Faustian thirst for knowledge to the scopic drive of male infant sexual research, we might diagnose and evaluate modern bourgeois culture in similar psychoanalytic terms without having to give much attention to questions of how and why either the middle class had arisen or perspective been formulated.

What would be left if the representationalist component—which has been a constant thread through the ancient and modern traditions I have traced—were removed from the current ideas of representation descending from idealism? The answer is: nothing. But what if the assumption of representationalism itself is questioned? What if it were assumed instead that people always found themselves *in* a world with other people and things, a world the practical existence of which did not have to be demonstrated, but which, precisely because of locally different practices, was locally specific. Cultural differences would then exist not because the world was differently "represented" and these representations in some way imposed upon it, but because accommodation simply had been made to the world at hand in the first instance in any number of ways and for any number of purposes.

To put this in another way, if the assumption of the necessity and priority of the second idealist level of representation is called into question, then it may further be asked if the history of art, both in its idealist and materialist versions, must be considered first of all as the history of representation it has been considered to be. An alternative may be offered by pushing idealist (and materialist) representation beyond imaginative formation to the *construction* of the actually formed and shaped implicit in the idea of formation. The world is not simply projected from the mind, it is made, and even the simplest artifacts involve techniques of gathering and working as well as the teaching and transmission of these techniques. They are thus irreducibly integral with human action and purpose, both individual and social. To return to the subject of this essay, I would argue that actual representation—something's being put under one set of conditions or another in place of something else—is primarily *communication,* not the *expression* of private images or meanings (which we especially associate with art) but rather that which is effected *through the common.* In these terms the history of art embraces any number of artifactual histories in which the world at hand has been treated as if real for any number of local purposes. The commonalities cutting across these histories point to the common orientations and exigencies of human physical existence in the world of social spaces in which we all find ourselves.

Plato already understood at the beginning of the long discussion I have been outlining that in order to serve their purposes images cannot be doubles. Images are also *substitutes,* which means that they are always placed and located in spaces of human use. Substitution, moreover, is specific, putting *these* materials to *these* uses, and substitution therefore always has many additional real connections as well as meanings and values. Meanings and values are thus evident in the nonmimetic conditions of images, which must consequently be regarded as positive and even primary. Our inclination has been to regard the nonmimetic conditions of images as neutral or negative, certainly partly because the ancient metaphor of mental images still leads us to believe that mental images are somehow prior and most real. It is not necessary to deny the existence of mental images, of dreams and daydreams, to ask whether it might not be better to say that knowing how to make an image—even an image of a dream or daydream—means knowing how to perform a number of culturally specific actions in and for equally specific spaces and purposes before it means always having a prior image in one's mind that is then executed in some material. If so, then the historical understanding of images involves the reconstruction of these conditions, of the specific real spatial contexts of their making and use, not just the analytic isolation and interpretation of the "world" "represented."

If we remove the mental image, what I spoke of at the beginning as the third term, from our consideration of representation, then the necessity vanishes to further consider the deeply and complexly value-laden question of the relative status of kinds, levels, and hierarchies of mental representation (impressions, fantasies, concepts, ideal forms, etc.) which should be regarded as formulations

15

peculiar to the tradition to which they belong. In these terms, too, the question of simple representation—whether something may resemble something else—may be simply answered in the affirmative without raising the further, more anxious question of whether an image corresponds to the adequate representation of the same thing to the mind or to the mind's eye.

I have raised the question concerning the priority of mental images historically, which suggests that these ideas and attitudes are culturally specific. If that is so, then the history of art, everywhere interlaced as it is with the problems of representationalism, is in large part a commentary of the Western tradition upon itself, even if examples may be chosen from beyond its borders. Representationalism and its attendant problems are integral to the history of Western art, but not to the history of all art. In fact, it should be assumed on principle that other assumptions are at work unless there are historical grounds to think otherwise. That very general clarification having been made, we may begin to inquire why and how some resemblance or another was part of the whole representation of an image and how the conditions of that presentation related to the specific cultural world of which the image was part. The focus of such art-historical interpretation shifts away from "realism" and "worldview" and "ideology" to constructions of common human corporeality and of personal, social, and political spaces, both our own and those alternative to our own.

SUGGESTED READINGS

Alpers, Svetlana. 1983. *The Art of Describing: Dutch Art in the Seventeenth Century.*
Bryson, Norman. 1983. *Vision and Painting: The Logic of the Gaze.*
Gombrich, E. H. 1963b. *Meditations on a Hobby Horse and Other Essays on the Theory of Art.*
———. 1969. *Art and Illusion: A Study in the Psychology of Pictorial Representation.*
Goodman, Nelson. 1976. *Languages of Art: An Approach to a Theory of Symbols.*
Mitchell, W. J. T. 1986. *Iconology: Image, Text, Ideology.*
Todorov, Tzvetan. 1982. *Theories of the Symbol.*

TWO

Sign

Alex Potts

While in everyday language we often talk as if the significance of a work of art is inherent in its identity as object, this is somewhat at odds with our theoretical understanding of how objects convey meaning. We all know that we do not literally see meaning in a work of art. Rather something compels us to view it as having significance which is not simply to be found there in it as thing, and this compulsion clearly has a lot to do with the habits of our culture. The meaning we attribute to a work is not only mediated but in large part activated by cultural convention. Another way of putting this would be to say that a work of art operates like a sign. It points to or evokes a significance quite other than what it literally is as object through conventions of which we may or may not be consciously aware. The viewer who assigns significance to a work of visual art is like the user of a language who envisages a word or a text as having meaning because she or he has internalized the rules of the language concerned. But while we know that meanings do not arise spontaneously out of physical objects, that they only seem to do so because of codes to which we are so attuned that we do not notice their operations, the compulsion to talk as if this were the case never goes away.

Here we shall be trying to make sense of this apparent paradox, not in order to suggest that works of visual art can at some level bypass the mediations inherent in their quality as signs, but rather to problematize the way in which we understand these mediations. To this end we shall be turning to the realist understanding of how signs operate developed by the American philosopher Charles Sanders Peirce, rather than the familiar structuralist theories deriving from the French linguist Ferdinand de Saussure. Of the two founding models of the modern theory of signs, Peirce's is particularly illuminating about the discrepancies in our present-day understandings of how works of visual art come to mean something, largely because it goes against the grain of the often easy conventionalism and antirealism that pervade much modern understanding of the sign. Peirce's analysis is designed to focus attention on the reference a sign makes to an object other than itself, whether this be a material thing or substantive concept—something assumed in everyday usage, but often strategically bracketed out in modern theories that focus on the internal operations of sign systems.

Why has semiotic theory—the theory of how signs operate—had such a major impact on the study of visual images over recent years? A cynic might argue that it has been appropriated to expand the repertoire of art-historical

interpretation and to give a new appearance of rigor to art historians' long-standing obsession with uncovering the "hidden" meanings of visual images. Images now signify rather than represent, vaguely intuited stylistic conventions become semiotic structures, and a hunch about the kinds of meaning people in the past might have attributed to a motif becomes an exercise in the recovery of a cultural code. But the value of semiotic theory lies in the way it makes us rethink the how of meaning, not in providing us with newfangled iconographical aids to determining what images mean. It has perhaps been most effective in giving a new twist to the formal analysis of visual style that has traditionally been such a central preoccupation of art history as a discipline. If we envisage a work of art as a sign or a combination of signs, our understanding of its form no longer operates at a purely visual level, but also concerns the articulation of meaning.

A theory of the sign, as distinct from a theory of the image or a theory of representation, gives a distinctive cast to the analysis of a work of art by focusing on its function as a vehicle to convey meaning. Reduced to bare essentials, a sign is any entity that "on the grounds of previously established social convention, can be taken as something standing for something else" (Eco 1976, 16). We call the social convention correlating a set of signs (which might for example be a language) with the meanings they stand for a code. What a theory of the sign establishes first and foremost is that a sign points to a meaning outside itself and that this meaning is inferred by the viewer or reader on the basis of her or his previous experience of decoding signs.

At a very basic level, a work of art functions as a sign simply by virtue of its being recognized as art. A more precise elaboration of its meaning depends upon the viewer's drawing upon further codings or conventions to interpret its significant features. Much art history is concerned with trying to offer an ever more precise understanding of the conventions operating within past cultures which enabled works to be decoded by their audiences but which are not immediately accessible to a modern viewer.

In addition to making us attentive to the conventions mediating between viewer and artwork, the sign model also highlights how a work has no meaning without an audience willing to interpret what this meaning might be. A sign becomes a sign only through an act of interpretation envisaging it as referring to some entity other than itself. Hence the logic of the tripartite definition of the sign proposed by Charles Sanders Peirce, in which the *sign* as material entity points to its *object* by virtue of an *interpretant,* an interpretative response which picks up on the reference to its object made by the sign (Peirce 1991, 141–43, 239–40, 253–59). This is usually summarized in a simple triangular diagram:

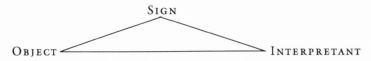

SIGN

OBJECT — INTERPRETANT

Peirce's model is designed to ensure that the signifying process cannot be reduced to a binary operation in which a sign simply generates its message. His point is that we are unable to envisage a sign's evoking something, namely its interpretant, without thinking of it as referring to an object outside itself; nor can we conceive of a sign as referring to an object unless it prompts an appropriate interpretative response. His tripartite schema is very different from the more widely known structuralist model of the sign associated with the other founder of modern semiotic theory, Ferdinand de Saussure. With Saussure, the sign is defined in terms of a physical entity, or signifier, and a nonmaterial meaning, or signified, while reference to anything outside the system of signs is deliberately left out of account. A correlation between signifier and signified is established by the complex mediation of the rules or code constituting the "language" to which the sign belongs. But Saussure is not concerned with analyzing the signifying process as such, and within his schema the latter effectively becomes a simple operation in which a signifier evokes a signified. With later poststructuralist theory, the notion of a fixed signified correlated on a one-to-one basis with a signifier is abandoned and meaning becomes instead the unstable effect of a never-ending process of signification. This open-ended play of signs, however, is still based on a binary process in which one sign generates another in a continuous sequence.

There is in Peirce's scheme something of this wanton chase from sign to sign, what we might call an "unlimited semiosis." Going back to Peirce's diagram for a moment: as the interpretant picks up on the reference to an object made by the sign, it in turn makes its own reference to the object evoked by the original sign. This means that it becomes another sign, setting up a further triangular relationship between itself as sign, and an object and an interpretant, the nature of the object in this case being inferred from the reference to it made by the original sign. Signs, as soon as they are interpreted as signs, generate other signs, and there are no inherent limits as to how long this process can go on.

Peirce differs from the poststructuralists in his insistence that the process of endless semiosis is anchored in and hence limited by the reference continually being made to an object. As Peirce conceives it, the definition of the object may metamorphose from signification to signification. What is represented in a series of signs referring to the same object is not a static entity but what he calls a dynamic object, an ever-developing cumulative definition of it, to be distinguished from the immediate object conjured up in any individual signification. But in this process of generating an ever-expanding sequence of signs, reference to the object is reconstituted at each stage and is not just the product of the suggestive power of the previous series of signs.

This conception of endless semiosis provides an illuminating basis for conceptualizing the interpretation of works of art, highlighting both the logic of inference involved, in which defining what the work means moves onward from interpretation to interpretation in ever more elaborate specifications and the

alluring or disheartening prospect, depending upon your point of view, of a potentially endless multiplication of meaning. Let us take Leonardo's *Mona Lisa* as an example. By envisaging it as a painting of something and not just paint on canvas, we are already interpreting it as a sign. If we combine this basic recognition with a general knowledge of how images function, we could be more specific. We should recognize the painting as a particular type of visual image designed to evoke an object in the real world, and see it as a figure set in a landscape, rather than an abstract form. Even with this very basic definition of the object pointed to by the work, we should already be drawing on a complex web of linguistic signification surrounding paintings and other forms of visual image in our culture.

If we proceeded for a moment with a laboriously explicit progress from sign to verbal sign, elaborating ever more specific meanings, we could go on to define the figure more closely by interpreting it as a portrait as distinct from a religious or symbolic image. This apparently simple designation opens up a number of divergent chains of interpretation, depending on the meaning we assign to the idea of a portrait. Portrait could be taken in its everyday significance as a likeness of the sitter that is in part determined by the painter's response to her or him. In this case our decoding would depend upon trying to infer what kind of a person Mona Lisa might have been and what particular importance she might have had for Leonardo. On the other hand, we might envisage the portrait in broader cultural terms as an icon of womanhood whose meaning needed to be elaborated in relation to archetypical images of femininity in the period. This is how most well-behaved art historians nowadays would go about decoding the work.

In any reasonably coherent interpretation, the internal logic of a pursuit of meaning from sign to sign, with each successive sign redefining and adding to the previous sign's evocation of the object, determines to a large extent the choice of features of the painting singled out as significant, as well as the meaning attributed to these. Thus modern interpretations that seek to decode the work as a likeness recording the painter's response to the sitter have attributed a lot of meaning to the form of the mouth, construing it as an enigmatic smile. Such interpretation often finds itself carried away by a logic impelling it to uncover ever more signs of the figure's enigmatic presence, so the distinctive modeling of the face will come to evoke a mysterious veiling, and the distant landscape a sense of strange hidden depths. As in theory there are no limits to this process of endless semiosis, we might incline to the view that worthwhile interpretation has as much to do with blocking the chains of signification as with stimulating them to ever more abundant productivity. Indeed, in a moment of revulsion against the efflorescence of meaning generated around widely touted masterpieces such as this, we might be impelled to take extreme countermeasures, such as inserting a countersign in the form of a mustache to wipe the smile off the face, or dismissing all these baroque outgrowths as mere

products of the work's status in our museum culture as a clichéd exemplar of great art and artistic genius—in which case the so-called smile would pale into insignificance by comparison with other more telling attributes such as the bulletproof glass shielding the painting in the Louvre.

It is not just the idea that works of art operate as signs or systems of signs that has been particularly influential over the past few decades. The tendency has brought with it a decided linguistic bias. The pressure to ground the study of visual images in models derived from the study of language runs pretty deep. First, as speaking and writing are our dominant media of communication, our understanding of any system of signification is going to be based on our understanding of language. But there is a further point. Any interpretation we offer of a visual image is inescapably elaborated in words. Interpretation of an art object involves us in constituting it and significant aspects of it as verbal signs and then in elaborating and reflecting on the meaning of these signs (or, as Michael Baxandall [1985a, 5] puts it, "what one offers in a description [of a picture] is a representation of thinking about a picture more than a representation of a picture").

A favoring of linguistic models in recent analysis of art also arises out of a reaction against those conceptions of symbolization traditionally associated with visual art. Visual images have often been seen as less culturally mediated, more primary in their operations, than verbal texts. There is a long tradition of cultural common sense that considers the visual image to be somehow more natural, offering up a replica of reality rather than a conventionally coded representation of it as in language. Reinforcing this tendency is another pervasive common sense of modern Western culture whereby visual representations are seen to be more rudimentary and intuitive than linguistic ones. Freud, for example, makes a distinction between an essentially visual thing presentation that operates in the unconscious and a more developed verbal presentation of a phenomenon that allows conscious thought (Laplanche and Pontalis 1988, 447–49). Images thus often tend to be seen as more childlike and "primitive" than words or texts—as natural signs that more easily transcend the particularities of their cultural formation. Thus it makes a lot of sense to designate visual images as textlike if one wishes to do justice to the complex of cultural conventions they deploy.

If present-day models of cultural analysis push us in the direction of linguistic analogies, and if we are in any case obliged to immerse ourselves in language the moment we even try to describe a work of art, are we to assume that works of art are best thought of as signs or combinations of signs that operate like words or texts? There are limits to the analogy, not just because images lack what is called the double articulation of language—that is, a first articulation of the material fabric of the sign into subunits having no semantic significance in themselves (such as the phonemes of a language) that are combined according to established rules to form a sign (a word, for example)—as well as a second

articulation relating a whole sign fashioned in this way to a unit of meaning. There is a more serious limit to the linguistic analogy in that a visual image is always to some extent continuous and never entirely divisible into a series of distinct units like the words or phrases of a text. Moreover, there is no equivalent in known systems of visual representation to the closely coded correlations between signs and meanings elaborated in a dictionary. The only exceptions are cases where a type of writing has developed, such as ancient Egyptian hieroglyphics, in which linguistic forms are linked by way of an explicit code with conventionalized pictograms. In this case, however, the determining logic of the system lies in the structure of the language, not in the visual forms used.

In traditional Western European art theory, it would sometimes be claimed that picturing utilized a natural language of representation. But the notion of language being invoked is a very vague one. The demands of naturalistic accuracy may have set up fairly stringent expectations as to whether a picture looked properly lifelike or not. However, there was never any body of rules governing the definition of pictorial forms and their combination comparable to a dictionary or a grammar. People used to say that the dictionary of picture making was the dictionary of nature, but such a dictionary could not be more than a figure of speech unless it was believed to be revealed in the mind of God.

In traditional religious and secular art, there exist quite elaborate visual allegories using coded representations of abstract qualities, such as virtues and vices, and religious and mythological personalities, such as saints and Greek gods and heroes. But the coding involved does not constitute an autonomous, distinctively visual language. The associations between particular motifs and their meaning was based on a cultural knowledge that could also be elaborated in words and serve as the basis for similarly conceived allegories in verse or prose. To explain the rationale which made the image of a female figure accompanied by an anchor the symbol of hope did not require recourse to anything exclusively visual. It was not thought that the distinctive form of the anchor somehow conjured up the idea of hope in the mind of the viewer. Rather the anchor was recognized as an object which had something to do with hope. The connection was a cultural or ideological one which could be explained to the uninitiated in words.

This is not to say that a visual allegory or symbol was seen simply as the equivalent of or substitute for something that could be more fully or clearly elaborated verbally. On the contrary, and particularly prior to that modern scepticism regarding images associated with the Reformation, visual representations were often seen as conveying their meaning to the mind more vividly and immediately than any verbal equivalent. For example, an image of the Virgin as mother of Christ, showing a conventional feminine stereotype of youthful beauty and modesty, dressed in a blue robe, and seated on a gilded throne, holding an infant in her arms, would evoke for a viewer who recognized the relevant attributes the personality and divine qualities of the real figure of the

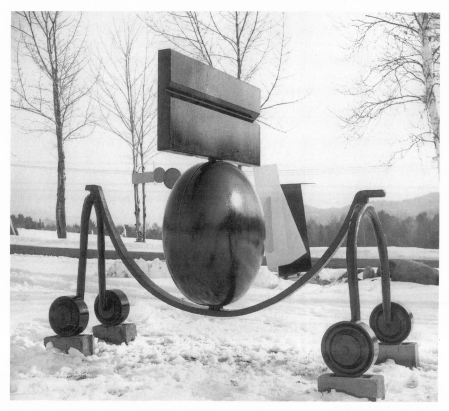

2.1 David Smith, *Wagon I,* 1963–64. Photograph: David Smith, National Gallery of Art, Ottawa. © 1996 Estate of David Smith/Licensed by VAGA, New York, NY.

from lumps of steel. Who would construct a wagon with axles that bowed upwards at the center as these do, so the central supporting element threatened to topple them over, and the whole thing only held together because the connections were rigidly welded? Given the automatic allowances we make for a work such as this to evoke a motif schematically, we readily interpret the bowed metal rod forming the central axis as the wagon's platform. But we cannot help but think that it is quite disproportionately slender: anything unattached would fall off it, and it really sags in the middle under the weight of the lumpish burden welded above it. What makes us conceive of the work as significantly disarticulated comes in large part from our thinking about it as a "real" wagon which actually has to balance itself and hold together under the most intolerable physical stresses put on it by its awkward construction.

Smith, one of the better interpreters of his own work, put this rather well when he said: "It's a kind of iron chariot, on four wheels, with open linear

elements. Each section of drawing is totally unrelated, and they don't fall to-gether, they just sit there broken" (1973, 184). This compulsion to see the work as a ruptured totality comes both from a formal model grounded in logic and language and from a different, more literal understanding we have of the work as a dysfunctional and precariously poised object.

There is another significant aspect to the effect the work has as a sign. If we imagine ourselves facing it, and being in the environment represented by the photograph, rather than just seeing the photograph as a representation of the work's form—and to this end we have to make allowance for the unusually low viewpoint that increases the graphic impact of the image and compensates for the inevitable loss of sense of scale produced by the miniaturizing perspec-tive of photography—a kind of drama suggests itself. We endow the work with significance because it stands out, or, to use a habitual personification that recurs whenever we describe a psychically charged interaction with an object, because it has a certain presence. The sculpture seems to oblige us to take cognizance of it, but in doing so its confronting us as sign is quite literally dramatized—more so than might be the case with a picture where the presence attributed to the image would be visibly mediated by a frame. The sculpture is in fact inscribed with a salutation to Smith's two daughters: "Hi Becca, Dida." Our imagined interaction with it thus stages it as a sign confronting us and compelling us to take note of what it might be saying or pointing to.

Peirce evoked this kind of dramatic effect when he was explaining how "a sign, in order to fulfill its office, must actualize its potency, must be compelled by its object":

> Here is a view of the writer's house: what makes that house to be the object of the view? Surely not the similarity of appearance.
> . . . No, but the photographer set up the film in such a way that according to its laws of optics, the film was forced to receive an image of this house. What the sign virtually has to do in order to indicate its object—and make it its—all it has to do is to seize its interpreter's eyes and forcibly turn them upon the object meant: it is what a knock at the door does, or an alarum or other bell, or a whistle, a cannon shot, etc. It is pure psychological compulsion, nothing else. (Peirce 1991, 254–55)

When Smith's sculpture confronts us as palpable object, it's as if there is a knock on the door, a ring of a bell, that forces us to pay attention. But what does the sculpture announce? Not something outside itself, but only itself. This short-circuiting of the semiotic process is characteristic of the autonomous mod-ernist work, an object that points back to itself as the source of its own signifi-cance. It is as if the knock on the door, the ringing of the bell, were momentarily to demand attention as significant in their own right. If we were literally to linger over the work's simply commanding us to attend to it in this way, the

effect could be a catatonic breakdown of the signifying process and ultimately of any interest that the work might have for us—as if the bell just kept ringing and ringing and nothing happened. Insofar as this breakdown does not occur, it is because in the very act of taking note of the work we begin to attribute something to it that is not literally there—it becomes a sign of something else, and we are, perhaps involuntarily, again drawn into a potentially endless play of signification.

The moment of potential breakdown, when the work faces us as a mute ponderous object, a presence that commands our attention but makes no definite sense, is important, not just as the point of entry into the play of signification. It also gives substance to the work's significance by momentarily stalling the process of semiotic creativity, disrupting the flow of interpretative associations, and creating the possibility for more unmanageable responses that really do compel us to take note of the work. When it does not quite yet mean anything, the sculpture might confront us as a "monster," to use Smith's word (1973, 155)—a man monster, a woman monster, a toy monster, a threatening monster, a monster of vulgarity subverting "bourgeois" respectability, or a monstrosity of nonsensicalness designed to give a semiotician nightmares. Here again we are off on one of those wanton chases from sign to sign, wrapping the work with meaning just as we imagine we are face to face with its unmediated presence.

An artwork is a distinctive kind of sign in that it draws more attention to itself and the means whereby we attribute significance to it than happens in our day-to-day exchange of signs for practical communication. But the effect is not always to produce a greater critical awareness of the mediations inherent in the signifying process. On occasion, there can also be an intensified illusion of having unmediated access to meaning. Nowhere more vividly than in responses to works of art do we find those moments when meaning somehow seems to be given by a sign without the intervention of a code or an act of interpretation. In a realist aesthetic, the literal fabric of the image will seem to offer a transparent window onto the objects it represents; in a symbolist one, the work as physical object will appear to be of the very same substance as its meaning, as if form and content were somehow mysteriously fused together. Thinking about the way works of art come to signify in modern culture thus involves negotiating between the complex mediations governing any signifying process and reversions to a mythic immediacy in which the work of art momentarily seems to confront the viewing subject as an autonomous presence embodying its own meaning.

This is nowhere more eloquently articulated than in Roland Barthes's now-classic semiotic analysis of the photograph ("The Photographic Message" and "The Rhetoric of the Image" in Barthes 1977). Barthes was centrally concerned to establish that the meaning with which we endow a photograph is not a natural effect of the image we recognize but saturated through and through

with cultural convention. In the first place, without a verbal label or caption specifying what the image is, we should find it difficult to assign a definite meaning to most photographs. In the second place, the meanings that we conjure up from looking at a photograph are produced by coded cultural associations we make with the visual motifs we see. But our interpretation is still in some way connected with an apprehension of the image that is not entirely formed by cultural codes. Barthes called the immediate visual recognition of the image its denoted meaning and the cultural content projected onto it by way of this recognition its connoted meaning. Even though a photograph is different from most other visual artifacts in that the forms defining the objects it represents can literally get there mechanically without being culturally inflected, there is something of this effect in almost any visual work of art, abstract or representational. In most cases, we are invited to interpret visual forms as significant even if the person making them did not have a coded significance in mind.

To turn to David Smith's sculpture again, some of the forms are not consciously fabricated at all but simply given by the objects from which he assembled his construction; and much of the shaping and connecting of the elements turned out as they did, not through his attending to fine-tuned formal modulations of meaning, but simply as a result of the techniques he used to fit these elements together. What the work means rests to a considerable extent on our response to particularities of form that were generated in processes that were as blind to the definition of meaning as the automatic recording of an image in a photograph. If we think for a moment of the three-dimensional configuration presented by the sculpture as analogous to a photographic image, then our response to it fits quite well with Barthes's schema—the unnameable recognition of it as thing would become its denoted meaning, while any definable significance we attribute to it would be its connoted meaning.

Panofsky, in his celebrated analysis of how we interpret the meaning of works of art (Panofsky 1972), identifies a first-order level of interpretation involving a simple recognition of visual motifs without any reference to cultural convention. But he makes this immediately denoted meaning into a specifiable entity, namely a verbal description of the objects represented in the image. Even the barest description of a painting as representing, say, figures in a landscape, however, already involves a cultural coding, let alone descriptions of the more evidently loaded motifs that interest Panofsky, such as a figure's gesture of salutation. Simply to isolate and name a motif is to utilize a coding that identifies it as a whole entity with a certain significance. We are already, as Barthes would say, in the field of cultural connotation. If we wish to preserve the notion of a baseline of immediate visual recognition, we have in the end no alternative but to see this as without definable significance. It is as if we were stalling the signifying process at the point where a mere object begins to come into being as a sign but is not yet quite defined as a sign properly speaking.

28

Is it only "naively" realist and symbolist interpretations of the sign that effect a reductive model of the semiotic process? What happens when, as in much modern semiotic analysis, the idea of a sign being "compelled by its object" as Peirce would say is dismissed as illusory and the effects of the sign are reduced to that of pointing to another sign? Taken to its extreme, this understanding fetishizes the code as blocking any reference a sign might seem to make to things existing outside the network of relations between signs. Everything becomes code and structure and any suggestion of what in common parlance is understood as material reality is bracketed out—whether this be the material substance of the sign as object or the physical identity of the object to which the sign is understood to refer (Baudrillard 1981). The illusions of immediacy that traditionally have haunted discussions of visual art are systematically dispelled, but the space is filled by another equally seductive illusion—that meaning is generated by the self-contained operations of a system of signs. We should remind ourselves that even the most antirealist analysis of signs by the more provocative French structuralist and poststructuralist thinkers betrays a fascination with those opaque and unmanageable moments when the symbolic order of language seems to confront a nonsymbolizable material reality (see, for example, Barthes 1981 and Kristeva 1992).

The antimaterialist bias of recent understandings of the sign has an ideological thrust that is particularly important to signal in the present context. If we talk of the compulsion to signify in materialist terms, we are almost inevitably driven towards models of how a subject interacts with its objects which involves a power politics of confrontation, domination, and resistance. The sign envisaged as brute fact makes itself known by compelling the subject to take note of it, by intruding into its internal world, or by opposing or resisting its illusions of self-determination. Such rhetoric is much in evidence in the passage from Peirce quoted above. At one level, then, the structuralist and formalist bracketing out of a materially substantial subject and object represents an understandable desire to get away from such confrontational groundings of the self's interactions with the world, a desire to abandon once and for all the ideological baggage of late nineteenth-century materialism and its macho models of a subject asserting itself against the givenness of the outer world. But bracketing out this baggage hardly rids us of the grip it has on our way of thinking. Materialist understandings of the compulsion to signify might be repressed but not abolished. They constitute a crude "truth" about visual signification that inflects even the most self-conscious discussion about how an artwork's significance is apprehended by a viewing subject.

SUGGESTED READINGS

The best general book on the theory of signs to address visual images and other nonverbal systems of signs is the classic textbook by Umberto Eco (1976), *A Theory of Semiotics*.

Bal, Mieke, and Norman Bryson. 1991. "Semiotics and Art History."
Barthes, Roland. 1961. "The Photographic Message."
———. 1964. "The Rhetoric of the Image."
Baxandall, Michael. 1985a. "Language and Explanation."
Gombrich, E. H. 1948. "Icones Symbolicae: The Visual Image in Neo-Platonic Thought."
Krauss, Rosalind E. 1985. *The Originality of the Avant-Garde and Other Modernist Myths.*
Panofsky, Erwin. 1972. "Studies in Iconology, I. Introductory."
Peirce, Charles Sanders. 1991. *Peirce on Signs.*

Simulacrum

Michael Camille

At least since Plato the theory and practice of the visual arts have been founded, almost exclusively, upon the relationship between the real and its copy. This duality has shaped the writing of art history as a story of the "conquest of the real" from Vasari's *Lives of the Artists* to E. H. Gombrich's *Art and Illusion* and has helped define modern art movements, like abstraction, that consciously rejected iconic resemblance. The simulacrum has been repressed in this history of representation because it threatens the very notion of representation itself. This is because it subverts the cherished dichotomy of model and copy, original and reproduction, image and likeness. For while the mimetic image has been celebrated as an affirmation of the real, the simulacrum has been denigrated as its negation. An image without a model, lacking that crucial dependence upon resemblance or similitude, the simulacrum is a false claimant to being which calls into question the ability to distinguish between what is real and what is represented. The simulacrum also disturbs the order of priority: that the image must be secondary to, or come after, its model. For these reasons, in ancient and medieval discourse on the visual arts, the term was almost always used negatively, to define things that were deemed false or untrue, the idols of the "other" as against the proper icons and images of "our" churches and institutions. Then for half a millennium the term went underground, hidden under the surfaces of "lifelike" statues and "naturalistic" paintings produced by a Platonically driven "high art" culture that prioritized the "idea" over its object and focused upon the role of the artist as secondary copier of nature rather than the status of the copy itself. Only since the 1960s—in response to a breakdown in the solidity of the "real," its massive mediation by new technologies of the visible, the increasing numbers of images permeating everyday life and concomitant transformations in what is considered "art"—have philosophers, critics, and, most crucially, artists themselves returned to the repressed term "simulacrum" and revived it as a crucial concept for interrogating postmodern artistic practices and theories of representation.

The Latin term "simulacrum" has its crucial beginnings in Plato's Greek dialogues, where it appears as the term we would translate as "phantasm" or "semblance." Plato sought to distinguish essence from appearance, intelligible from sensible, and idea from image. His famous banishment of painters from his republic was founded upon the embodiment of truth in the *Eidos* or Idea and his deep mistrust of "the imitator," who, "being the creator of the phantom, knows nothing of reality" (*Republic* X, 601 c). The simulacrum is more than

just a useless image, it is a deviation and perversion of imitation itself—a false likeness. Plato describes this in a famous passage of the *Sophist* (236 a–d) where Theaetetus and the Stranger discuss image making and a distinction is made between the making of likenesses ("eikons") and the making of semblances ("phantasms"). Likeness making involves creating a copy that conforms to the proportions of the original in all three dimensions, "whereas sculptors and painters who make works of colossal size" often alter the proportions to accommodate the perspective of the viewer. So that the upper parts do not look too small and the lower parts too large "they put into the images they make, not the real proportions, but those that will *appear beautiful*." Whereas the icon is "other but like," the phantasm only appears to look like the thing it copies because of the "place" from which we view it. Plato's dialogue goes on to call into question the status of this image of an original, for if it is not the original we see, it must be something else—a simulacrum, a false claimant to being. The Platonic task is therefore to distinguish, in Gilles Deleuze's terms, "between good and bad copies, or rather copies (always well founded) and simulacra (always engulfed in dissimilarity)." The complex associations of language making (sophistry) and image making (mimesis) in Platonic philosophy (Rosen 1983) go beyond the subject under discussion here, but it is crucial to understand that what disturbs Plato is not just that the plastic realm of "fiction" is something dead that only seems to be alive but what we would call today the "subject position" of the beholder. It is the particular perspective of human subjectivity that allows the statue that is "unlike" and misproportioned in reality to *seem* "like" and, moreover, beautifully proportioned from a certain vantage point. From the beginning, then, the simulacrum involved not just image makers but also their viewers.

The Mosaic prohibition against idols in the Old Testament restated the Platonic position far more crudely. In Christianity, however, there was an ambiguity surrounding the image. At the same time that it was a Platonic "false claimant" it was also the means by which God created man "in his own image" and Christ was incarnated. The Latin term *simulacrum,* used as a negative term throughout the early Middle Ages, has a second period of discursive intensity during the thirteenth century when it appears in theological discussion and in the writings of writers on optics like Roger Bacon and John Pecham. In this period, during which vision and observation took priority in the human sensorium and Platonism was eclipsed by a more materialistic Aristotelian view of the world, the emanations of visual *species* in the anatomy of the eye and fascination with optical devices like mirrors encouraged artists and poets to think about images not as simple copies of the world but as phantasmic alternatives to it.

In an essay first published in 1967, "The Simulacrum and Ancient Philosopy," the French philosopher Gilles Deleuze attempted to "reverse Platonism" and in so doing refounded the simulacrum as a crucial critical and art-historical

term for our own times (Deleuze 1990). The term was already renascent in French postwar writings and had been used by the surrealists, especially in essays by Georges Bataille and the painter Pierre Klossowski (1963, 195–96) in their attempts to describe the noncommunicable dimensions of the pictorial sign. Deleuze's more distinctive manipulation of the idea was far more powerful and influential in that it replaced the Platonic priority of model over copy with an inverted system in which the simulacrum does not have the claim of the copy. "The copy is an image endowed with resemblance, the simulacrum is an image without resemblance. The catechism, so much inspired by Platonism, has familiarized us with this notion. God made man in his image and resemblance. Through sin, however, man lost his resemblance while maintaining the image. We have become simulacra. We have forsaken moral existence in order to enter into aesthetic existence" (Deleuze 1990, 257).

Deleuze goes on to claim that "to reverse Platonism" means to make the simulacra rise and to affirm their rights among icons and copies. The problem no longer has to do with the distinction between essence and appearance or model and copy but rather with erasing these distinctions entirely.

> The simulacrum is not a degraded copy. It harbors a positive power which denies *the original and the copy, the model and the reproduction.* At least two divergent series are internalized in the simulacrum— neither can be assigned as the original, neither as the copy. . . . There is no longer any privileged point of view except that of the object common to all points of view. There is no possible hierarchy, no second, no third. . . . The same and the similar no longer have an essence except as *simulated,* that is as expressing the functioning of the simulacrum. (262)

The "point of view," which was at the very fulcrum of Plato's construction of the phantasmic simulacra—the colossal statue as viewed from the ground—is here displaced. Precisely because there is no point of view the difference between icons and simulacra disappears. It is difficult to assess the impact of these pronouncements upon artists of the sixties and seventies, but Deleuze was certainly conscious of their critical relevance, arguing that

> modernity is defined by the power of the simulacrum. . . . The artificial and the simulacrum are not the same thing. They are even opposed to each other. The artificial is always a copy of a copy, which should be pushed *to the point where it changes its nature and is reversed into the simulacrum* (the moment of Pop Art). (265)

Rather than locate simulacral strategies in contemporary art, as Deleuze did with individual artists like Andy Warhol and Francis Bacon, Michel Foucault looked earlier to surrealism for the simulacrum in modernity. In his famous essay on the work of the Belgian surrealist artist Magritte, Foucault provides a searching analysis of the problem of the real, focusing on the paintings which

call into question the ontology of the object itself—"Ceci n'est pas une pipe." Foucault also unpacks an alternative story of modernism, which incorporates the notion of the simulacrum to define what Magritte is trying to do. Foucault was one of the earliest to see the radical aspect of Deleuze's reversal of Platonism; in his essay "Theatrum Philosophicum," Foucault showed how the "philosophy of representation—of the original, the first time, resemblance, imitation, faithfulness—is dissolving; and the arrow of the simulacrum released by the Epicurians is headed in our direction" (Foucault 1977, 172). The threat posed to traditional art-historical methods by the simulacrum is here made explicit. What art-history monograph does not place heavy emphasis upon the "original" works that are ascribed to an artist, the "first time" in the sense of origins and sources for styles, and "faithfulness" in terms of the social world that whatever painter is recording in paint? Significantly, this interest in the simulacrum arose in the French philosophical context of the sixties (Deleuze, Foucault, and Klossowski) and not in art production and criticism itself, although pop art and other movements in Britain and the United States seem to have discovered the lure of the "false" in painting and sculpture at exactly the same moment. France's long philosophical anxiety around the visual recently explored by Martin Jay (1993) and its Catholic fascination with idolatry and iconoclasm still present in the writings of the phenomenologists and Sartre had fascinating repercussions in French discourse, but not in images. This was the period when art criticism in the United States was at its most "high modernist" and antitheatrical, obsessed with the quest for authenticity and feeling, the Platonic "Idea" displayed in the romantic "last gasp" of minimalism. If postwar France had lost the lead in twentieth-century art making and New York "stolen the idea of Modern Art," the French made up for it in the simulacrum of the word. Their writings, not about art, but about theories of language and poststructuralist philosophy, could then be exported to New York and applied to the art object. By the eighties journals of contemporary art like *Artforum* and *October* presented Baudrillard, Derrida, and Deleuze as constituting a radically new international discourse of art, far more influential, in fact, than anything merely made or painted.

Another crucial medium of twentieth-century image making which would ultimately help undermine modernist paradigms and for which the simulacrum came as a useful, though complicated, term of reference was photography. This played upon the identity of the image as simulacrum in a special way for a number of artists working in the seventies, who emphasized photography's nature as a multiple, reproducible challenge to "auratic" art and to the related humanist assumptions of authorship, subjectivity, originality, and uniqueness. The impact of photography in culture is only just beginning to be understood, influenced by what is, perhaps, the single most discussed and influential cultural essay of the century, Walter Benjamin's "The Work of Art in the Age of Mechanical Reproduction," first published in 1936 but endlessly reprinted and

[handwritten annotation: post war — mid to late 20th century = derivation from]

quoted over the past two decades. If the simulacrum is not a key term in Benjamin's analysis, his celebration of photography and cinema and discussion of the decline of the aura are part of a similar renegotiation of modernity in terms of image production that does not prioritize the relations between the copy and its model (Benjamin 1968c).

A 1984 photograph by *New York Times* photographer Paul Hosefros in which President Ronald Reagan addresses the Republican National Convention via closed-circuit TV while Nancy waves from the podium to the TV screen was well chosen to illustrate the reprinting of an essay by Jean Baudrillard, "The Precession of Simulacra," when it was reprinted in an anthology of post-modern art criticism (Wallis 1984, 260). This image shows the simulacral president par excellence blown up to gargantuan size as a ghostly idol adored by his worshippers, as nothing more than an image (Plate 3.1). But an earlier, subtler instance of presidential representation which reveals the same problems of distinguishing between image and purported reality, and one contemporary with the sixties' resurrection of the simulacrum in Deleuze and not its later Baudrillardian precession, is an "art" photograph by Gary Winogrand, taken at the Democratic National Convention in 1960 (Plate 3.2). As an image of speech making it takes us all the way back to the relation between artifice and rhetoric in Plato's *Sophist*. Here speech and sophistical persuasion are mediated by purely specular simulation. The speaker's words are being delivered over to the spectacle, to a host of cameramen and lights. The great icon of John F. Kennedy reversed by representation, his face and gesturing arm appear to us captured in the small TV monitor behind him, his eloquent body viewed only from behind but shining with splendor like a saint with a halo. The "aura" that his body radiates is not there, however, but is visible only on the phantasmic screen below. It is this blurred image on the TV that presents itself to us as the "real" body of the future president. The camera itself is implicated in this cross-wired gaze of publicity, available to us as voyeurs standing behind the spectacle. Winogrand and photographers all over the world in this period were highly attuned to issues of authority and authenticity and made numerous representations like this, which resonate with anxieties about the relation between real and camera reportage, especially in the killing fields of war, exploring the duplicitous rather than divine nature inherent in all image making. A quarter of a century later, however, the philosophical photograph, telling of the real and the image, has been replaced by the swelling smile of the simulacrum alone (Plate 3.1).

Whereas the simulacrum had given Deleuze the opportunity to invert the Platonic hierarchies and provide a new model for artistic production that did not privilege the unique, the ideal, and the numinous, it still did so within the realm of aesthetics. The writings of Jean Baudrillard, most notably his famous/infamous work of 1981, *Simulacres et simulation,* by contrast, placed the issue at the center not of philosophical but of social debate. The apocalyptic tones

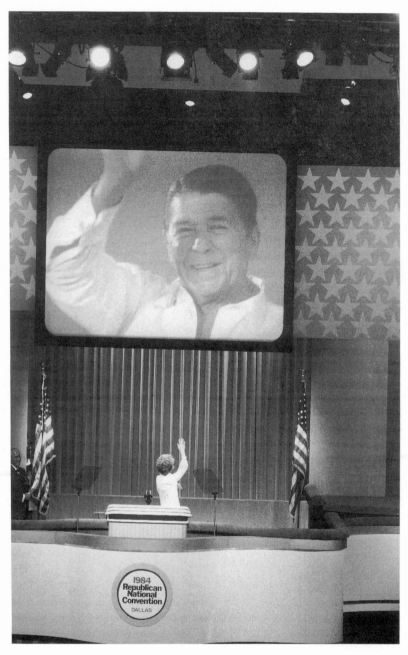

3.1 Paul Hosefros, photograph from the *New York Times* of President Ronald Reagan addressing the Republican National Convention, 22 August 1984, via closed-circuit television.

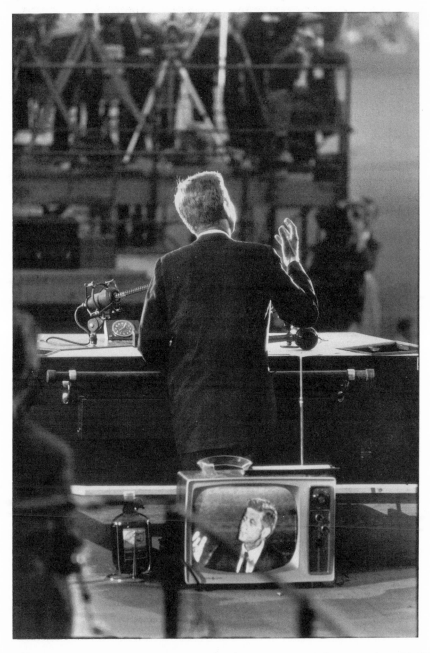

3.2 Gary Winogrand, photograph of the Democratic National Convention, 1960.
Courtesy Fraenkel Gallery, San Francisco. © Estate of Gary Winogrand.

and millennial ferver of Baudrillard's theories of simulation derive from wider philosophical and political currents that were affecting art criticism in these years as never before. These are his readings of Marxism (the economy of images), Maussian anthropology (the symbolic exchange of images), and the writings of American cultural critic Marshall McLuhan (the medium and message of images). "The Precession of Simulacra," the first essay in the book and the one translated and reprinted many times in art journals and anthologies, has had a far-reaching effect upon contemporary artists and critics and its most shocking statements return to the Platonic dichotomy, only to reverse it. "It is no longer a question of imitation, nor even of parody. It is rather a question of substituting signs of the real for the real itself. . . . Illusion is no longer possible because the real is no longer possible" (Baudrillard 1994, 19).

Baudrillard's examples are neither philosophical texts nor works of art but the strange spaces of postmodernity like Disneyland ("the perfect model of all the entangled orders of simulation" in which America comes to revel in its own cozy gadget-ridden infantilism) and strange events like the Watergate affair. In Baudrillard's work America is the land of simulation, and in a kind of reversed "orientalism" it becomes the mysterious site of the West's projected fantasy and desire. If imitation is rooted in the Old World, simulation is Uncle Sam's new one. Images take on a terrifying aspect of danger, which again reminds one of Platonic and Biblical prohibitions:

> Thus perhaps at stake has always been the murderous capacity of images: murderers of the real; murderers of their own model as the Byzantine icons could murder the divine identity. To this murderous capacity is opposed the dialectical capacity of representations as a visible and intelligible mediation of the real. All of Western Faith and good faith was engaged in this wager on representation: that a sign could refer to the depth of meaning, that a sign could *exchange* for meaning and that something could guarantee this exchange— God, of course. But what if God himself can be simulated, that is to say, reduced to the signs which attest his existence? Then the whole system becomes weightless; it is no longer anything but a gigantic simulacrum: not unreal, but a simulacrum, never again exchanging for what is real, but exchanging in itself, in an uninterrupted circuit without reference or circumference. (5–6)

Baudrillard's pessimistic visions arrived at the moment of highest anxiety and nostalgia, stimulated not only by the shock of events like Watergate but also by new technologies that had totally transformed traditional ways of communication, not least in the field of vision. Artists like Sherrie Levine, who rephotograph classic images by Edward Weston and sign them as their own, play exactly Baudrillard's game. The impact of popular media upon art in the past decade, blurring all distinctions between the art museum and its spaces and the shopping mall, similarly both respond to and stimulate the strategies for undermining the real that Baudrillard chronicles (see Institute of Contempo-

rary Arts 1986). TV and video images served a simulacral function from their inception, taking the uncanny associations between photography and death to their fetishistic limits. It is a crucial fact for art history of the second half of the twentieth century that the majority of people spend much of their spare time staring entranced by myriads of multiple registers of representations that flicker before them on small screens in their homes and which increasingly blur the distinctions between what is real and what is staged, what takes place and what is only simulated.

Baudrillard's argument, that mass media have neutralized reality in stages, at first reflecting, then masking and finally substituting themselves for reality, is in many ways a reactionary lament, truth and reference remaining unproblematized by these claims as things lost. Unlike Deleuze, who sought to provide an alternative to Platonism, Baudrillard seems still to work within it. His nightmarish vision of art offers no constructive alternatives to our image culture, and many have criticized the French theorist for not taking into account the positive effects of new mass-media images and their ability to provide alternative viewpoints and teach difference, not just unitary "Big Brother" ideology. While Baudrillard has pointed out some important ways in which strategies of simulation now control our everyday lives, he overlooks how many artists of the past decade have sought to dissect or criticize the media and ironically displace it in their work. Without claiming the total nihilism of Baudrillard's use of the term "simulacrum," how can it be fruitfully used to negotiate the contested realms of image making both in a future artistic practice and in art history?

Fredric Jameson's more focused, Marxist-inspired political analysis of postmodernism, just to describe one alternative model to Baudrillard's, depends upon a different trajectory through the simulacral, which he traces from the *situationistes,* another important French postwar group. Guy Debord's *Society of the Spectacle,* first published in 1967, is the key text in this history of a world transformed into "pseudo-events" and "spectacles." "It is for such objects" Jameson claims, "that we may reserve Plato's conception of the 'simulacrum,' the identical copy for which no original has ever existed. Appropriately enough the culture of the simulacrum comes to life in a society where exchange value has been generalized to the point at which the very memory of use value is effaced, a society of which Guy Debord has observed, in an extraordinary phrase, that in it 'the image has become the final form of commodity reification' " (Jameson 1991, 18). Jameson goes on to argue that the "new spatial logic of the simulacrum" will have its greatest effect on "what used to be historical time," undermining the capacity of images to interface with history at any point. His examples are recent films in which the past is presented as a nostalgic referent rather than a focus of action, an arena in which history itself is forever only simulated rather than engaged with. This "crisis of historicity" (25) is having a profound effect, not only upon the production of art but upon the writing of art history.

How then might one write a history, not of art but of simulacra, an *Art and*

Delusion instead of an *Art and Illusion*? Based upon the premise that images do not so much replicate the real or substitute for it but rather are encounters with another order of reality entirely, it would be a history of art that could not claim to be about objects at all but about strategies of their simulation. It would take seriously Deleuze and Guattari's startling statement that "no art and no sensation have ever been representational" (1994, 193). Fakes and copies would, in this system, be as important and crucial to the understanding of past art as the authenticated "old masters" themselves. But more problematically, where would this history of art begin and what would happen to the painted animals of Lascaux, those ur-images which we always interpret as the first instinctual instances of attempting to copy and thus control the external world through its representation? Since there can be no "first image" or founding moment of representation in the real, can the cave paintings be said to be already representations of representations? To a certain extent yes, since many of them are layered upon earlier images and experts have had enormous difficulties in describing the priority of one animal form over another. Did the cave artist consider the image on the wall a representation at all, as a sign that was based upon the living things that roamed outside or rather something that came before and pointed toward them?

If a simulacral history of art has to begin from a different place, it would look throughout very different from our traditional textbook story. It would lack the great progressive "moments" in the history of representation, most of which are based on the notion of the factor of technical mastery in mimesis. The "Greek revolution," by which the human body during the fifth century B.C. was assimilated to the carved form of life-size sculptures, would become a more complex game of idol making in which fetish, ritual, and magic played a more important role than imitation and Deleuze's analysis of Platonic and Lucretian theories of the "phantasm" and surfaces, epiderms, and atoms would be more useful than our modern measures of "lifelikeness." The Renaissance "discovery" of linear perspective, rather than allowing the artist to deposit the real directly upon the panel complete with a supposedly "unique" point of view, would become instead a tyrannous moment when simulacra take over in the sphere of the imaginary, trapping subjectivities in the thrall of corridors and cityscapes and holding them in place and making it even more difficult to distinguish between the model and its copy. From a Platonic viewpoint, the simulacra take over at the moment of perspectival accommodation, as in Plato's example of the colossal statue that is altered to fit the standpoint of the observer. Baroque art, which does so much to implicate the observer within the image, becomes a marvelous theater of sensations. Likewise, the impressionists' ocular desire to approximate light in paint might be measured not in terms of their efforts to close the gap between the world and the picture but by their fear of the disappearance of reality under the microscope and telescope of modern science. What they produce are evanescent simulacral emanations of matter,

[handwritten margin note: Simulacral history = freedom from the real.]

light, and atmospheric effects, their fetishized focus free of industrial smoke. Instead of a conquest of the real, a simulacral history of art would be the story of escape from the real in the realms of imagination and fantasy, a story of introjection as well as projection, of desire as well as fear, liberating the object from any dependence upon the regimes of the eye or text. Whether or not it would still be a history constructed out of a string of "great masters" is a more difficult question. Deleuze's writings on painters such as Cézanne and Francis Bacon show his adherence to a romantic model of the artist as the maker of new perceptions and destroyer of clichés. A properly simulacral history would, by contrast, surely have to renegotiate any claims to an individual authorship of a work of art. *[handwritten margin note: no. individual authorship]*

It is the history of modern art that stands to change most from this rewriting not in terms of resemblance but dissemblance encouraged by the displacements of the simulacrum. As Hal Foster has observed, a simulacral reading of abstract painting, such as that practiced by Kandinsky, would see it not as a freeing of the pictorial to go beyond resemblance to the realm of the spiritual and Platonic but as yet another way of underlining the thrall of the real. Precisely because it rejects resemblance, abstract painting is "far less subversive to both traditional mimesis and transcendental asthetics than is usually thought" (Foster 1993, 96). In this narrative it is surrealism, rather than abstraction or constructivism, that emerges as the most radical and innovative movement of Western art in our century, maintaining resemblance, as in the uncanny cityscapes of de Chirico or the composite collage fantasies of Max Ernst, but at the same time undermining its hold over the real. Our aesthetic tradition imprisoned simulation in the realm of fantasy, which has always had an equivocal, if not negative, resonance in the visual arts. But after Freud and the surrealists and more recently Lacan's repositioning or rather dethronement of the "Real" and emphasis rather upon the "Imaginary" as a powerful, preverbal, and essentially visual register, fantasy has returned to haunt our fin de siècle and become a key issue in psychoanalytically driven art criticism.

Contemporary artists, with their increasingly visible debt to the surrealist marvelous and to the tradition of the fantasmagoric uncanny in photography, are constantly revealing that the concept of the simulacrum is capable of reacting to and shaping ideas and not just repeating them in a self-indulgent play of Baudrillardian mirrors. Gary Winogrand's photographs (e.g., Plate 3.2), like those used by the contemporary artist Hans Haacke in his installations, are pictorial plots, using simulation to emphasize the relations between viewers and objects. The ubiquity of installations rather than paintings, environments rather than sculptures, and performances rather than pictures in artistic productions of the past decade is related to this turn away from external representation towards the realm of felt experience, simulating not an illusion of the real but affirming the whole realm of "sensation," to use another crucial term of Deleuze's. The impact of this reformulation of reference also has larger repercus-

sions. The phantasmic criticism of art, viewing images as incarnations rather than representations, affects and materialities rather than reflections and copies, involves rewriting the history not only of art but also of science and philosophy (Deleuze and Guattari 1994).

Rather than end this brief fantasy fragment on the simulacrum with reference to an image like Winogrand's photograph, as though it somehow secured my argument by anchoring it to the real, to some "thing" that is a photograph, or is depicted in that chemical deposit, I want to close with a narrative that returns us to the problematic status of the object via the greatest and most popular of all simulacral discourses being produced today—science fiction. "Pay for the Printer," a short story by Phillip K. Dick (who published a science-fiction novel in 1964 called *The Simulacra*), describes a future post–nuclear holocaust earth in which the survivors have become totally dependent for their continued existence and all their luxuries and commodities from garages to newspapers not upon things but upon copies of things. These are made for them by a powerful and benign alien being, a vast amorphous blob called a Biltong, who produces for all those who wait in line perfect "prints" from the models of things brought to it. The horror in the story is that these objects—toasters, cars, and clothes—are of course not the "real thing" but simulacra. They gradually begin to fragment and distort in shape and crumble into nothing. The world literally starts to fall apart. This is because it is a world that has been increasingly removed from the model and made from copies of copies, or "defective duplicates" as Dick calls them. Things start to lose their "reality," newspapers are filled with squiggles that look like print but which are unreadable, cars lack engines, the surface has no depth at all, as the Biltong's "prints" melt and collapse before people's eyes and the creature itself begins to die. Even though "originals" of cigarette lighters and crystal cups from the wreckage of the old original world are placed before it, nothing can be printed any longer and at the end of the story the survivors have to resort once again to making things for themselves from scratch, the first item being a small wooden cup. "It's simple and it's crude," proclaims the hero as he shows this splendid object to others, "but it's the real thing!" This brilliant story, written during the decade when the simulacrum was returning to French philosophical thought stimulated by the very same world of American mass consumption that inspired Dick's fantasy, also takes us back to the very beginnings of the Platonic anxiety about things as real and as mere representations.

Is it a reactionary nostalgia for the "real" that makes Dick, Deleuze, and Baudrillard, in their very different ways, all fearful of a future society based upon the simulacrum? Certainly for Donna J. Haraway, a contemporary feminist commentator coming at these issues from the viewpoint of "science" rather than "art," what she calls the "scary new networks" that replace "Representation" with "Simulation" and the body with the cyborg are, by contrast, to be celebrated as liberating coalitions of technological forces rather than lamented as the loss of some essential ideal of nature (Haraway 1991, 161). Referring

42

to communications systems that are based not upon notions of authenticity but upon the parameters of positioning vision itself (who is looking and from where, rather than what are they looking at, and is it real or imaginary?), she suggests "a way out of the maze of dualisms" like the real and its copy, and provides instead rich possibilities for remapping relations of power, especially of gender, which had previously (for two and a half millennia) placed woman in the realm of simulation. Arguing that "micro-electronics is the technical basis of simulacra, that is, of copies without originals" and also influenced by the discourse of science fiction, Haraway takes the debate beyond ontological categories and onto a political level that is far more challenging and potent than Baudrillard's gloomy gloatings over the loss of reference. What we have is a new real in which the artist's traditional role has to be vastly different, indeed some might say erased altogether. Artists will surely continue to grapple with things as well as ideas, materials and not only recycled images. However, what computer and other imaging technologies will create in the visual matrix of the future will no doubt make Baudrillard's "precession of simulacra" seem as solid and eternal as the Parthenon frieze. Science is already the "real" site of simulacra. The popularity of organic, vegetable, and even animal media and somatic performance art in current visual practice might be taken as a fear of science, a nostalgia for nature and the body as against the machine and the cyborg on the part of image makers. In a strange romantic reversal, it is in fact the artist, the figure originally banished from Plato's republic—the maker of the crude wooden cup—who, in this reactionary scenario, alone has access to the real. As the last, sad remnant of production in a culture of consumption, will the artist of the future be the sole creator, the auratic and archaic witch or wizard of "things" stranded but godlike in a sea of "no-things"? If rewriting the history of art in simulacral terms seems dangerous, envisioning its future is even more problematic and perhaps best left for writers of science fiction to make into reality.

SUGGESTED READINGS

Baudrillard, Jean. 1984. "The Precession of Simulacra."

Benjamin, Walter. 1968c. "The Work of Art in the Age of Mechanical Reproduction."

Debord, Guy. 1983. *The Society of the Spectacle.*

Deleuze, Gilles. 1990. "Plato and the Simulacrum."

Deleuze, Gilles, and Félix Guattari. 1994. *What Is Philosophy?*

Dick, Phillip K. 1987. "Pay for the Printer."

Durham, Scott. 1993. "The Simulacrum: Between Painting and Narrative."

Foster, Hall. 1993. *Compulsive Beauty.*

Foucault, Michel. 1977. "Theatrum Philosophicum."

———. 1982. *This Is Not a Pipe.*

Gombrich, E. H. 1969. *Art and Illusion: A Study in the Psychology of Pictorial Representation.*

Haraway, Donna J. 1991. "A Cyborg Manifesto."

Institute of Contemporary Arts. 1986. *Endgame: Reference and Simulation in Recent Painting and Sculpture.*

Jameson, Fredric. 1991. *Postmodernism, or the Cultural Logic of Late Capitalism.*

Jay, Martin. 1993. *Downcast Eyes: The Denigration of Vision in Twentieth-Century French Thought.*

Klossowski, Pierre. 1963. "A propos du simulacre dans la communication de Georges Bataille."

Patton, Paul. 1992. "Anti-Platonism and Art."

Rosen, Stanley. 1983. *Plato's Sophist: The Drama of Original and Image.*

Wallis, Brian, ed. 1984. *Art after Modernism: Essays on Rethinking Representation.*

COMMUNICATIONS

Word and Image = relationship to of visual language

W. J. T. Mitchell

If the central task of art history is the study of visual images, the issue of "word and image" focuses attention on the relation of visual representation to language. More broadly, "word and image" designates the relation of art history to literary history, textual studies, linguistics, and other disciplines that deal primarily with verbal expression. Even more generally, "word and image" is a kind of shorthand name for a basic division in the human experience of representations, presentations, and symbols. We might call this division the relation between the seeable and the sayable, display and discourse, showing and telling (Foucault 1982; Deleuze 1988; Mitchell 1994).

Consider, for instance, the words you are reading at this moment. They are (one hopes) intelligible verbal signs. You can read them aloud, translate them into other languages, interpret or paraphrase them. They are also visible marks on the page, or (if read aloud) audible sounds in the air. You can see them as black marks on a white background, with specific shapes, sizes, and locations; you can hear them as sounds against a background of relative silence. In short, they present a double face to both the eye and the ear: one face is that of the articulate sign in a language; the other is that of a formal visual or aural gestalt, an optical or acoustical image. Normally we look only at one face and ignore the other: we don't pay much attention to the typography or graphic look of a text; we don't listen to the sounds of words, preferring to concentrate on the meaning they convey. But it is always possible to shift our attention, to let those

black marks on a white background

become objects of visual or aural attention, as in this self-referential example. We are encouraged to do this by poetic or rhetorical uses of language that foreground the sounds of words, or artistic, ornamental uses of writing (e.g., illuminated manuscripts, calligraphy) that foreground the visual appearance of letters. But the potential for the shift "from word to image" is always there, even in the most spare, unadorned forms of writing and speech.

A similar potential resides in visual images. In the act of interpreting or describing pictures, even in the fundamental process of recognizing what they represent, language enters into the visual field. Indeed, so-called "natural" visual experience of the world, quite apart from the viewing of images, may be much like a language. The philosopher George Berkeley (1709) argued that eyesight is a "visual language," a complex, learned technique that involves the coordina-

tion of visual and tactile sensations. Modern neuropsychologists like Oliver
Sacks (1993) have confirmed Berkeley's theory, showing that people who have
been blinded for an extended period of time have to relearn the cognitive
techniques of seeing, even when the physical structure of the eye has been fully
repaired. As a practical matter, the recognition of what visual images represent,
even the recognition that something *is* an image, seems possible only for lan-
guage-using animals. The famous image game of the duck-rabbit illustrates the
intimate and intricate interplay of words and images in the perception of a
visual image. Being able to see both the duck and the rabbit, to see them shift
back and forth, is possible only for a creature that is able to coordinate pictures
and words, visual experience and language (Wittgenstein 1953).

"Word and image" has become something of a hot topic in contemporary
art history, largely because of what are often seen as invasions of the visual arts
by literary theory. Scholars like Norman Bryson, Mieke Bal, Michael Fried,
Wendy Steiner, and many others (myself included) have been spotted crossing
the borders from departments of literature into art history. These scholars bring
along methods and terms developed initially in the study of texts: semiotics,
structural linguistics, grammatology, discourse analysis, speech-act theory, rhet-
oric, and narrative theory (to name only a few examples).

Not surprisingly, the border police are on the alert to protect the territory
of art history from colonization by literary imperialism. Even an adventurous,
wide-ranging art historian like Thomas Crow gives in to a defensive "art histo-
rian's reflex" when he sees scholars from "text-based academic disciplines" mov-
ing into the study of visual art (Crow 1994, 83). This sort of defensiveness
might seem strange, given the intimate relations between word and image we
have just observed in a pair of textual and pictorial examples. It seems even
stranger when we reflect on the intense interest of great art historians like Erwin
Panofsky in philology and literature. The very name of Panofsky's science of
image analysis, "iconology," contains a suturing of the image (icon) with the
word (logos). What is art history, after all, if not an attempt to find the right
words to interpret, explain, describe, and evaluate visual images?

Insofar as art history aims to become a critical discipline, one that reflects
on its own premises and practices, it cannot treat the words that are so necessary
to its work as mere instrumentalities in the service of visual images or treat
images as mere grist for the mill of textual decoding. It must reflect on the

relation of language to visual representation and make the problem of "word and image" a central feature of its self-understanding. Insofar as this problem involves borders between "textual" and "visual" disciplines, it ought to be a subject of investigation and analysis, collaboration and dialogue, not defensive reflexes.

There is one dimension of art-historical defensiveness that makes good sense, then, and that is the resistance to the notion that vision and visual images are completely reducible to language. One of the more depressing sights in contemporary art history is the rush to fix on some master term (discourse, textuality, semiosis, and culture come to mind) that will solve the mystery of visual experience and representation and dissolve the difference between word and image. The maintenance or even policing of this border is a useful task when it is conducted in a spirit of respect for difference. G. E. Lessing's words bear repeating here:

> Painting and poetry should be like two just and friendly neighbors, neither of whom indeed is allowed to take unseemly liberties in the heart of the other's domain, but who exercise mutual forbearance on the borders, and effect a peaceful settlement for all the petty encroachments which circumstance may compel either to make in haste on the rights of the other. (Lessing 1776, 116)

The domains of word and image are like two countries that speak different languages but that have a long history of mutual migration, cultural exchange, and other forms of intercourse. The word/image relation is not a master method for dissolving these borders or for maintaining them as eternally fixed boundaries; it is the name of a problem and a problematic—a description of the irregular, heterogeneous, and often improvised boundaries between "institutions of the visible" (visual arts, visual media, practices of display and spectation) and "institutions of the verbal" (literature, language, discourse, practices of speech and writing, audition and reading).

The relation between words and images is an extraordinarily ancient problem in the study of the arts and in theories of rhetoric, communication, and human subjectivity. In the arts, the comparison of poetry and painting, literature and visual art has been a consistent theme since antiquity in both Eastern and Western aesthetics. The casual remark of the Roman poet Horace "*ut pictura poesis*" (as is painting, so is poetry) became the foundation for one of the most enduring traditions in Western painting and has served as a touchstone for comparisons of the "sister arts" of word and image ever since. Aristotle's theory of drama includes a careful gauging of the relative importance of *lexis* (speech) and *opsis* (spectacle) in tragedy. Theories of rhetoric routinely appeal to the model of word/image conjunctions to define the relation between argument and evidence, precept and example, *verbum* (word) and *res* (thing, substance). Effective rhetoric is characteristically defined as a two-pronged strategy of verbal/visual persuasion, showing while it tells, illustrating its claims with powerful

49

examples, making the listener *see* and not merely *hear* the orator's point. Ancient theories of memory regularly describe it as a technique of coordinating a sequence of words with a structure of visible places and images, as if the mind were a wax tablet inscribed with images and words, or a temple or museum filled with statues, paintings, and inscriptions (Yates 1966).

Contemporary culture has made the interplay of word and image even more volatile, intricate, and pervasive. Whatever else movies may be, they are clearly complex suturings of visual images and speech, sight and sound, and (especially in the silent era) image and writing. The transformation of visual and verbal identity we saw in the example of the duck-rabbit is multiplied many times in the digital manipulation of electronic images, the "morphing" which shifts rapidly through a series of racial and gender types in the videos of Michael Jackson or a Gillette shaving cream commercial. Any child nurtured on the alphanumeric soup of *Sesame Street* knows that letters are visible signs and words may turn into images and back again at the flash of a "silent E." If ancient memory systems had their illustrated wax tablets and art-filled temples, modern memory technologies coordinate streams of digital and analog information within a virtual electronic architecture, converting images to texts and vice versa. Although one of the central impulses of artistic modernism in the twentieth century has been, as Clement Greenberg argued, to explore the distinctness and difference of verbal and visual media, seeking a purely optical painting and a purely verbal poetry, the larger culture has been dominated by the aesthetics of kitsch, which freely mixes and adulterates the media.

What is it about the construction of the human mind that makes the interplay of words and images seem, despite innumerable historical and regional variations, to be something like a cultural universal? One might appeal to the hemispheric structure of the brain, with its divisions between visual, spatial, intuitive functions and verbal, sequential processes of reasoning. One might adopt a psychoanalytic account of the formation of subjectivity as a progression from an imagistic "mirror stage" in infancy to a symbolic, verbally constructed self in maturity. Or one might prefer a theological explanation that looks to the recurrent accounts of the creation of the human species as both image and word of the creator, the sculpting of Adam and Eve as clay vessels from the earth, and the breathing of spirit into them, making them not only "images" of their creator, but living, speaking emanations of the Word. In my view, these are not so much "explanations" of the word/image phenomenon, as highly general, mythic instantiations of it. They are foundational cultural narratives that turn the categories of word and image into something like characters in a drama that is subject to infinite variation, historical transformation, and geographical dislocation. It is stories like these that make the relations of word and image something more than a merely technical matter of distinguishing different kinds of signs and associate them with deeply felt values, interests, and systems of power. Before we go further with these broader issues, however, it might be

useful to examine a bit more closely just what the relation of words and images is, how it is usually defined, and why it plays such a pervasive and volatile role in discussions of art, media, and consciousness.

Much of the power and interest of the word/image relation comes from its deceptive simplicity. What could be more straightforward than the distinction between a picture of a tree and the word "tree"?

TREE

As a practical matter, we have no trouble in saying which is the word, which is the image. The problem comes when we try to explain the difference, to define the precise features that make one sign a word, the other an image. One common explanation would base the difference in the sensory "channel" appropriate to each kind of sign. The word is a phonetic sign: it is meant to be read aloud or subvocalized and "heard" as an acoustical event. The image is a visual sign: it represents the visual appearance of an object. The difference between word and image is simply the difference between hearing and seeing, speaking and depicting.

The clarity of this distinction is less secure than it might seem at first glance. We do, after all, see the written word "tree," and the word refers us to a class of visible objects, the same class that the image designates. And it's not entirely clear that we simply "see" the tree represented by the image. We could easily see these marks as something else—as an arrowhead or a pointer indicating a direction. To see this as an image of a tree means assigning that label to it, giving it that name. If we were seeing this image in the context of a pictographic or hieroglyphic inscription, we might discover a whole range of symbolic connotations: the image seen as a tree could refer to a whole forest, or to associated concepts like growth and fertility; seen as an arrowhead it could be a sign for war or hunting, or for the warrior or hunter. The image might even lose all connections with the visual appearance of a tree, and become a phonetic sign, indicating the syllabic unit "tree," so that it would be usable in a rebus like the following:

POE

At this point the image is well on its way into the domain of language, becoming part of a phonetic writing system. This doesn't mean there is no difference

between words and images, only that the difference is not *simply* traceable to the difference between seeing and hearing. We can see words and hear images; we can read pictures and scan the visual appearance of texts. The difference between word and image cuts across the difference between visual and aural experience.

It might seem, then, that the difference between words and images is not built into our sensory apparatus or inherent in different kinds of symbolic forms, but has to do with different ways of coordinating signs with what they stand for. Images, we might say, signify by virtue of resemblance or imitation: the image of the tree looks like a tree. Words, by contrast, are arbitrary signs that signify by virtue of custom or convention. This is one of the most enduring accounts of the word/image difference, cropping up as early as Plato's *Cratylus* and recurring throughout the history of theories of representation. It has the added virtue of explaining why images are not necessarily visual, why there can be things like sound images. Resemblance is an extraordinarily general relation, one that can function in any sensory channel and connect any number of perceptual experiences.

The problem, in fact, is that resemblance applies far too generally to be of much use in picking out what is special about visual images. One tree may resemble another tree, but that doesn't mean that one tree is the image of the other. Many things resemble each other without being images of one another. It may be that resemblance is a necessary condition for something to be an image, but it certainly is not sufficient. Something else is required: the image has to denote or represent what it stands for; merely looking like it isn't enough. There is also the problem that many images don't look much like anything in particular except themselves. Many things we would want to call visual images (the formal patterns in ornament, the array of shapes and colors in abstract paintings) don't resemble things in the visual world nearly as closely as they resemble each other.

The theory, then, that images are copies of things, that they signify by resemblance fails on two counts: on the one hand, it cannot explain the existence of images that do not resemble or represent anything; on the other hand, it identifies only a necessary, not a sufficient condition for images that do both resemble and represent something. It seems that once again for images to do their work, they have to intersect with the domain of language, this time by appealing to the role of custom and convention. The image of the tree signifies a tree, not *just* because it resembles it, but because a social agreement or convention has been established that we will "read" this sign as a tree. The abstract or ornamental image that resembles and represents nothing is seen as an image because it functions like an image in a social practice. The image in this sense is not a representation, but a representative sample. It is a visual form that has meaning, even if it doesn't represent anything.

The straightforward, practical difference between words and images turns out to be much more complicated than it looked at first glance. In fact, the

situation threatens to become thoroughly paradoxical. We began with what looked like an obvious and clear difference, and yet the more we tried to give a theoretical explanation of that difference, the shakier it became. The sensory division of eye and ear both aligns itself with and cuts across the boundary between word and image, most notably in the phenomenon of writing or "visible language." The semiotic distinction between signs by convention and signs by resemblance also unravels as we pull at it. Words (like "quack") can resemble what they represent; images are riddled with convention, could not exist without conventions, and they need not represent anything.

My inability to discover a firm, unequivocal basis for the distinction between words and images doesn't mean, of course, that there aren't any real distinctions to be observed. And it also doesn't mean that issues like resemblance, convention, and the visual/aural division are irrelevant. What it does suggest is that the word/image difference is not likely to be definitively stabilized by any single pair of defining terms or any static binary opposition. "Word and image" seems to be better understood as a dialectical trope. It is a trope, or figurative condensation of a whole set of relations and distinctions, that crops up in aesthetics, semiotics, accounts of perception, cognition, and communication, and analyses of media (which are characteristically "mixed" forms, "imagetexts" that combine words and images). It is a dialectical trope because it resists stabilization as a binary opposition, shifting and transforming itself from one conceptual level to another, and shuttles between relations of contrariety and identity, difference and sameness. We might summarize the predicates that link word and image with an invented notation like "vs/as": "word vs. image" denotes the tension, difference, and opposition between these terms; "word as image" designates their tendency to unite, dissolve, or change places. Both these relations, difference and likeness, must be thought of simultaneously as a vs/as in order to grasp the peculiar character of this relationship.

If we were to go on with the search for figures of the difference between words and images, we would have to complicate the eye/ear and resemblance/convention distinctions even further, coordinating them with Lessing's classic argument that the categories of space and time (images seen in space; words read in time) provide the most fundamental basis. We would have to take up Nelson Goodman's distinction between "dense" and "differentiated" signs, images understood as dense analog symbols in which a great many features of visual appearance have significance, words construed as differentiated, digital symbols in which many visual/aural features can be disregarded as long as a minimally legible character is presented (Goodman 1976). The binary opposition of resemblance and arbitrary designation would have to be complicated by a third term, the semiotic notion of the "index" or "existential" sign, which signifies by pointing, or by virtue of being a link in a chain of cause and effect (tracks signifying an animal; an autograph signifying an author; a graphic mark signifying the activity of the artist) (Peirce 1931–58).

The pursuit of the word/image relationship would ultimately take us back

to the very notion of the linguistic sign as such. It will not have escaped the alert reader that my use of the word "tree" and its corresponding image evokes Saussure's famous diagram of the dual structure of the linguistic sign, with the word ("arbor") standing for the signifier or sound image, and the picture standing for the concept (Saussure 1966).

The picture of the tree in this diagram is consistently "overlooked" (in every sense of this word). It is taken to be a mere place-holder or token for an ideal entity, its pictoriality a merely accidental or conveniently illustrative feature. But the rendering of the signified concept as picture or what Saussure calls a "symbol" constitutes a fundamental erosion in the Saussurean claim that "the linguistic sign is arbitrary" (67) (that is, the linguistic sign is "empty," "unmotivated," and without any "natural bond" between signifier and signified). The problem is that an important *part* of the sign seems not to be arbitrary. As Saussure notes, the pictorial tree, the "symbol" that plays the role of signified concept, "is never wholly arbitrary; it is not empty, for there is the rudiment of a natural bond between the signifier and signified" (68). The word/image difference, in short, is not merely the name of a boundary between disciplines or media or kinds of art: it is a borderline that is *internal* to both language and visual representation, a space or gap that opens up even within the microstructure of the linguistic sign and that could be shown to emerge as well in the microstructure of the graphic mark. In Saussure's diagram, this space or gap is itself made visible by a Peircean index: the horizontal bar that separates the (iconic) tree from the word "arbor" is neither word nor image but an indicator of their relationship in conceptual space, just as Saussure's elliptical frame and the ascending/descending arrows that flank it, convey "the idea of the whole" and the circulation of significance within its structure.

The further one goes in pursuit of the word/image distinction, the clearer it becomes that it is not simply a question of formal or technical differences between sign types. More is at stake than conceptual housekeeping or a policing of boundaries between art history and literary theory. Understood as a dialectical trope rather than a binary opposition, "word and image" is a relay between semiotic, aesthetic, and social differences. It never appears as a problem without being linked, however subtly, to questions of power, value, and human interest. It rarely appears without some hint of struggle, resistance, and contestation. The defensiveness of art history in the face of textual studies is simply a professional, disciplinary reenactment of a *paragone* or contest between visual and verbal art that has been going on at least since Leonardo made his famous

argument for the superiority of painting to poetry. But variations on this contest are played out in all the arts and media. Lessing's *Laocoon* was written to defend the domain of poetry against what he saw as an invasion by the visual arts, and Clement Greenberg's aptly titled "Towards a Newer Laocoon" was an attempt to purge the pure opticality of painting from invasions by "literature." Ben Jonson wrote "An Expostulation with Inigo Jones" to denounce the dominance of the latter's spectacular set designs over the "poetic soul" of the masque, and Aristotle made it clear that *opsis* should be sacrificed to *lexis* in the working of dramatic art. Panofsky thought the coming of sound was corrupting the pure visuality of silent movies, and film theory, as Christian Metz has shown, "has found it difficult to avoid shuttling back and forth between two positions: the cinema as a language; the cinema as infinitely different from verbal language." (Metz 1974)

The "shuttling" of the word/image opposition is, moreover, almost invariably connected to larger social and cultural issues. Lessing's attempt to police the borders of poetry and painting was linked explicitly to his attempt to defend German literary culture from what he saw as an excessively visual French aesthetic and implicitly to an anxiety about the confusing of gender roles (Mitchell 1986). Greenberg's attack on the blurring of genres in "literary painting" was a defense of an elitist, avant-garde culture against contamination by mass culture. The word/image difference functions as a kind of relay between what look like "scientific" judgments about aesthetics and semiotics, and deeply value-laden ideological judgments about class, gender, and race. Traditional clichés about visual culture (children should be seen and not heard; women are objects of visual pleasure for the male gaze; black people are natural mimics; the masses are easily taken in by images) are based on a tacit assumption of the superiority of words to visual images. Even in the most basic phenomenological reflections on intersubjectivity, the "self" is constructed as a speaking and seeing subject, the "other" as a silent, observable object, a visual image (Tiffany 1989). It is these kinds of background assumptions about the relations of semiotic and social difference that make deviations seem transgressive and novel: when women speak out, when blacks attain literacy, when the masses find an articulate voice, they break out of the regime that has constructed them as visual images. When mute images begin to speak, when words seem to become visible, bodily presences, when media boundaries dissolve—or, conversely, when media are "purified" or reduced to a single essence—the "natural" semiotic and aesthetic order undergoes stress and fracture. The nature of the senses, the media, the forms of art is put into question: "natural" for whom? since when? and why?

From the standpoint of the word/image problematic, then, the difficult and deeply ethical/political task of art history may be somewhat clearer. If art history is the art of speaking for and about images, then it is clearly the art of negotiating the difficult, contested border between words and images, of speaking for and about that which is "voiceless," representing that which cannot represent

itself. The task may seem hopelessly contradictory: if, on the one hand, art history turns the image into a verbal message or a "discourse," the image disappears from sight. If, on the other hand, art history refuses language, or reduces language to a mere servant of the visual image, the image remains mute and inarticulate, and the art historian is reduced to the repetition of clichés about the ineffability and untranslatability of the visual. The choice is between linguistic imperialism and defensive reflexes of the visual.

No method—semiotics, iconology, discourse analysis—is going to rescue us from this dilemma. The very phrase "word and image," in fact, is a way of signaling this. It is not a critical "term" in art history like the other concepts in this collection, but a pair of terms whose relation opens a space of intellectual struggle, historical investigation, and artistic/critical practice. Our only choice is to explore and inhabit this space. Unlike Mieke Bal and others who have written on this matter, I do not think we can go "beyond word and image" to some higher plane, though I respect the utopian and romantic desire to do so. "Word and image," like the concepts of race, gender, and class in the study of culture, designates multiple regions of social and semiotic difference that we can live neither with nor without, but must continually reinvent and renegotiate.

SUGGESTED READINGS

Aristotle. 1978. *Poetics* XIV, translated by W. Hamilton Fyfe.

Bal, Mieke. 1991. *Reading "Rembrandt": Beyond the Word-Image Opposition.*

Berkeley, George. [1709] 1965. *An Essay Towards a New Theory of Vision.*

Bryson, Norman. 1981. *Word and Image: French Painting of the Ancien Regime.*

Crow, Thomas. 1994. "Yo Morris."

Deleuze, Gilles. 1988. "The Visible and the Articulable."

Foucault, Michel. 1982. *This Is Not a Pipe,* translated by James Harkness.

Fried, Michael. 1987. *Realism, Writing, Disfiguration: On Thomas Eakins and Stephen Crane.*

Goodman, Nelson. 1976. *The Languages of Art: An Approach to a Theory of Symbols.*

Greenberg, Clement. 1940. "Towards a Newer Laocoon."

Hagstrum, Jean. 1958. *The Sister Arts.*

Horace. 1978. *Ars Poetica* 361, translated by H. R. Fairclough.

Jonson, Ben. 1975. "An Expostulation with Inigo Jones."

Leonardo da Vinci. 1956. "Paragone: Of Poetry and Painting."

Lessing, G. E. [1766] 1965. *Laocoon: An Essay upon the Limits of Painting and Poetry,* translated by Ellen Frothingham.

Metz, Christian. 1974. *Film Language: A Semiotics of the Cinema,* translated by Michael Taylor.

Mitchell, W. J. T. 1986. *Iconology: Image, Text, Ideology.*

———. 1994. *Picture Theory: Essays on Verbal and Visual Representation.*

Panofsky, Erwin. 1955. "Iconography and Iconology."

———. 1979. "Style and Medium in the Motion Pictures."

Peirce, Charles Sanders. 1931–58. "The Icon, Index, and Symbol."

Sacks, Oliver. 1993. "To See or Not to See."

Saussure, Ferdinand de. 1966. *Course in General Linguistics,* translated by Wade Baskin.

Steiner, Wendy. 1982. *The Colors of Rhetoric: Problems in the Relation between Modern Literature and Painting.*

Tiffany, Daniel. 1989. "Cryptesthesia: Visions of the Other."

Wittgenstein, Ludwig. 1953. *Philosophical Investigations,* translated by G. E. M. Anscombe.

Yates, Frances. 1966. *The Art of Memory.*

Narrative

Wolfgang Kemp

Translated from the German by David Britt

Let us begin with a beginning. The early fifth century relief that forms the starting point of this discussion is to be found on the church door of Santa Sabina in Rome (Plate 5.1). It marks the beginning of a series of panels in an identical format, which make up a small Old Testament cycle consisting of episodes from the lives of Moses and Elijah. This row of panels must also be interpreted in its vertical context: above it runs another, analogous series containing episodes from the life of Christ. We must therefore assume that the panel containing the Calling of Moses was matched in the row above by a scene from Christ's life, now lost (Nativity and Annunciation to the Shepherds).

Which immediately leads us to interrupt our consideration of beginnings and to note that narratives—even narratives of beginnings—seldom come in isolation and are seldom "original." This relief belongs together with other narratives, and in itself it refers back to a narrative text: a text that exists in a fixed, canonical form but still remains—in Erich Auerbach's phrase—heavy with the weight of its becoming. Within that text, different versions of oral narrative overlie and interpenetrate each other; and its set, congealed form, in the Book of Exodus, is not by any means the last word. After the oral versions comes the text; then come the translations and retellings, the transpositions into other languages, cultures, and media.

Let us assume, for a moment, that the relief in question stands at the beginning of the iconographic tradition. That tradition in itself stems from a long chain of transmission: oral narration; Book of Exodus; translation into Greek, into Latin (Old Latin, Vulgate), and into an explanatory verbal brief for the sculptor; translation into bas-relief. To complicate the line of transmission still further, we must also build in the idea of typology. The life of Moses partly functions as a type, a pre-text, which is recapitulated and fulfilled on a higher plane in the figure of Christ. This is what the structure of the door makes so beautifully clear: the life of Moses functions horizontally as part of a story, and as part of the endless repetition and transformation of the "same" story; and it functions vertically as a "type," as the template for new stories.

This is narrative in its most basic and apparently most natural form, as a transcultural, transhistorical, and transmedial phenomenon. Roland Barthes:

> The narratives of the world are numberless. Narrative is first and foremost a prodigious variety of genres, themselves distributed amongst different substances—as though any material were fit to receive man's stories. Able to be carried by articulated language,

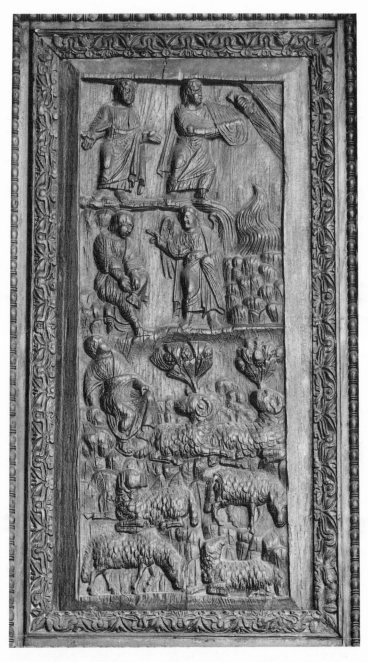

5.1 *Calling of Moses*, A.D. 432–44. Panel from the doors of the church of Santa Sabina, Rome. Bildarchiv Foto Marburg.

spoken or written, fixed or moving images, gestures, and the ordered
mixture of all these substances, narrative is present in myth, legend,
fable, tale, novella, epic, history, tragedy, drama, comedy, mime,
painting (think of Carpaccio's *Saint Ursula*), stained glass windows,
cinema, comics, news items, conversation. Moreover, under this al-
most infinite diversity of forms, narrative is present in every age, in
every place, in every society; it begins with the very history of man-
kind and there nowhere is nor has been a people without narrative.
All classes, all human groups, have their narratives, enjoyment of
which is very often shared by men with different, even opposing,
cultural backgrounds. Caring nothing for the division between good
and bad literature, narrative is international, transhistorical, transcul-
tural: it is simply there, like life itself. (Barthes 1977, 79)

It may well be true that narrative "is simply there, like life"; but that does
not mean that it is like life. It deals, as this relief does, with heightened, intensi-
fied life. And in Judeo-Christian terms a beginning is heightened by becoming
a scene of calling, a vocation. The fact of this, and the manner of it, stand for
the special form of communication attendant on a special relationship: the
relationship between God and the nation of Israel. Werner Zimmerli refers to
the "vocative character" possessed by this shared history of God and nation.
He interprets the "acts of the Lord" in relation to Israel—his self-manifestation
in events—"as Yahweh speaking to his people through history: a word that
expects an answer from man" (Zimmerli 1956, 17). This basic principle can of
course legitimately be applied to those specific narratives in which God literally
speaks to those chosen by him and summons them to serve and follow him. In
Exodus 3, this process is systematically prepared and intensified:

> Now Moses kept the flock of Jethro his father-in-law, the priest of
> Midian: and he led the flock to the backside of the desert, and came
> to the mountain of God, even to Horeb. And the angel of the Lord
> appeared unto him in a flame of fire out of the midst of a bush; and
> he looked, and, behold, the bush burned with fire, and the bush
> was not consumed. And Moses said, I will now turn aside, and see
> this great sight, why the bush is not burned. And when the Lord
> saw that he turned aside to see, God called unto him out of the
> midst of the bush, and said, Moses, Moses. And he said, Here am
> I. And he said, Draw not nigh hither: put off thy shoes from off
> thy feet, for the place whereon thou standest is holy ground. More-
> over he said, I am the God of thy father, the God of Abraham, the
> God of Isaac, and the God of Jacob. And Moses hid his face: for
> he was afraid to look upon God.
> And the Lord said, I have surely seen the affliction of my people
> which are in Egypt, and have heard their cry by reason of their
> taskmasters; for I know their sorrows; and I am come down to
> deliver them out of the hand of the Egyptians, and to bring them

up out of that land unto a good land and a large, unto a land flowing with milk and honey. . . . Come now therefore, and I will send thee unto Pharaoh, that thou mayest bring forth my people the children of Israel out of Egypt.

Exodus 3 is thus the classic instance of a *récit de commencement,* as defined by Pierre Gibert (1986). Two actors meet, one human and one superhuman; there is no third party to act as witness, since in this case the angel functions as a helper or hypostasis of the divine principle. The latter takes the initiative, by summoning the human interlocutor to perform a task which far exceeds his capacity and competence, but which he nevertheless undertakes.

Both in the text and in the relief, these structural elements are neatly arranged in sequence. First, the chosen recipient of the divine summons has his initial position defined. Moses is pasturing the flocks of his father-in-law, Jethro, on Mount Horeb. Then comes the encounter with the Divine (which appears in the middle register in two forms: as a burning bush, and as an angel or personification of the voice of the Lord, who speaks to Moses and commands him to take off his sandals). Then comes God's charge to Moses, interrupted—as in other Old Testament accounts of divine vocations—by objections from the receiver of the summons. The process concludes with a binding consent and a binding acceptance (Moses speaking and listening, on the left of the uppermost register; Moses receiving the scroll of the covenant from the hand of God, on the right).

Northrop Frye has declared the episode of Moses and the burning bush to be the ideal starting point, the initial image, of the whole biblical narrative. If the Hebrew Bible could begin here, Frye argues, this would eliminate the tricky question of how a bad world could stem from a good Creator: "In the burning-bush story, a situation of exploitation and injustice is already in existence, and God tells Moses that he is about to give himself a name and enter history in a highly partisan role, taking sides with the oppressed Hebrews against the Egyptian establishment" (Frye 1983, 114).

Frye sees the new beginnings implicit in Exodus 3 as revolutionary, with still-unresolved consequences for the thought of Judaism, Christianity, Islam, and Marxism. He names three of these consequences: "First, a belief in a specific historical revelation as a starting point. . . . Second is the adoption of a specific canon of texts, clearly marked off from apocryphal or peripheral ones. . . . Third is the dialectical habit of mind that divides the world into those with us and those against us" (Frye 1983, 114).

The Santa Sabina door relief does more than justice to the critic's high assessment of the potential importance of this scene as a beginning. Indeed, it even exemplifies his second point—which may seem surprising, since this has no direct authority either in the biblical text or in the context of Frye's argument. What has Exodus 3 got to do with the establishment of a canonical tradition?

What happens in this scene is simply that sacred history (*Heilsgeschichte*) makes one of its periodic fresh starts, a recapitulation of the structural formula of the covenant. And this situates the narrative, both as a whole and in its parts, within a context of promise and fulfillment, annunciation and event. God himself refers to this when he identifies himself as the "God of thy father," who has established his covenant with earlier generations.

The concept of the covenant has a cardinal importance in the structural study of narrative. Thus, Algirdas Julien Greimas and Joseph Courtés have this to say, under the heading "Contract":

> The contract, which is initially concluded between the giver [here God] and the receiver [here Moses, as the representative of Israel], governs the narrative ensemble, in that the course of the narrative takes the form of the execution of that contract by the two parties to it. The course followed by the subject of the action, which represents the receiver's contribution, is answered by the sign of approval shown to the recipient by the giver. (Greimas and Courtés 1983, s.v. "contract")

This concept has often been put under excessive strain; but here, in this relief, it has been taken literally. The pictorial narrator summarizes, as it were, the outcome of the dialogue between God and Moses by materializing it in the shape of a scroll. He does this for the sake of a "good" story, without any explicit sanction from the text; but it cannot be said that he is violating the spirit of that text. Implicit (in the etymological sense of rolled up) in God's promise of a covenant is not only the freeing of the people from slavery in Egypt, and their arrival in the Promised Land—an entirely pragmatic sign of divine approval—but also the next and culminating act of the establishment of the covenant: the giving of the tablets of the Law to Moses on that very same Mount Horeb or Sinai, which is a symbolic sign of divine approval. This brings us back to Frye, because everything that happens here is the material from which Moses will write—in scroll form—the books of the Pentateuch.

To return to the initial figure of Moses with his sheep: he is—as a good beginning requires—in a transitional state. In body and in function, he remains anchored in what has gone before; but his look and his posture involve him in the action above his head, which has himself as its object. It is significant, first of all, that the artist departs from the text by showing him in a "retentional," seated posture. The Moses of Exodus 3 is thoroughly active: he leads the flock; he comes to Mount Horeb; he talks to himself, telling himself to go to the burning bush; and so on. In the relief, he is comfortably seated, no doubt in order to take in the events above his head without shifting the center of gravity of the image away from its starting point. By so conspicuously sitting tight, he conveys the level and phase of the history of Israel that aims at possession and locates itself in pastoral closeness to nature.

At the same time, however, Moses looks around and upward, because it is within him that the decisive shift takes place: from sitter to leaver; from possessor to man possessed; out of the purposeless contemplativeness of pastoral life to the purposeful, arduous path of secession. Or, as we might also put it, from the static to the ecstatic; from earthbound origin to purposive beginning. Thanks largely to the lowest register of the panel, the pictorial narrative conveys a transformation that mediates a whole array of polar opposites, from shod/unshod, by way of sitting/standing, passive/active, profane/sacred, to man-and-beast/man-and-God.

This brings us to a number of principles of narratology, which center on the concepts of transformation, desire, and lack.

1. *Transformation*. Narrative is a form of expression that deals with transformations. In their poetics, the ancients recognized this, but their basically qualitative approach made them interested not in actual situational change (*metabole*), or time-as-process, so much as in specific and (shall we say) maximal forms of transformation: abrupt reversal (*peripeteia*), sudden recognition (*anagnorisis*), misfortune (*pathos*). They recognized change solely in terms of a dramatic change for the better or for the worse. Modern aesthetics takes a far more neutral and descriptive approach. This is illustrated by Arthur Danto's (1968, 236) tripartite formula for an event, defined as a transformation in time and of time:

(1) X is F at time t_1;
(2) E happens to X at time t_2;
(3) X is G at time t_3.

Danto's schematic presentation takes as its subject a historical or fictional character or characters, X; in the present case, of course, X is Moses. The outcome of the transformation is the difference between F and G (or F # G), the (undoubtedly momentous) difference between Moses the herdsman and Moses the man of God. Moses herding flocks (1) and Moses with divine vocation (3) constitute the *explananda: what the story seeks to explain*. What explains these (the *explanans*) is item (2): the process of vocation, the step-by-step release of Moses from the "state of nature."

The pictorial narrator chooses to show all three stages in one single pictorial field: the mode of narration defined by Franz Wickhoff (1912) as "the continuous style." But even in the alternative mode—Wickhoff's "distinguishing style," which establishes a 1:1 equivalence between unit of time and unit of narrative—time past, time present, and time to come must all be implicitly present. Lessing pointed this out in his *Laokoon oder über die Grenzen der Malerei und Poesie* (1766):

From a Nature in constant mutation, the artist can never adopt more than a single instant; and the painter can adopt that instant

only from a single viewpoint. . . . Clearly, that single instant, and that single viewpoint in that single instant, cannot be chosen fruitfully enough. But nothing is fruitful, except what gives free rein to the imagination. The more we see, the more we must be able to add to it in our minds. . . .

Painting, in its coexistent compositions, can employ only a single moment of the action, and must therefore choose the instant that is most laden with significance: that which makes most clear all that has preceded and is to follow.

Over two hundred years later, modern action theory, which defines "action as a differential event between past and future," echoes Lessing thus: "An event can be understood as happening in the present, only if one can see some way into its immediate past and its immediate future. The same is all the more true of actions" (Luhmann 1981, 60).

For Lessing's requirement "that, in great history paintings, the single moment is almost always to some extent expanded," the phenomenology of Husserl supplies the terms "retentional" and "protentional." Our awareness of time experiences the moment—the "position in time"—as something filled with retentions and protentions: memories and expectations. These are the "action contexts, which constitute the meaning of individual actions" (Luhmann 1981).

As important as the concept of the "action context" is the concept of "difference." We may not judge everything—as the ancients did in their poetics—in terms of dramatic contrasts (happy/unhappy); but we do expect that in a narrative—and above all in a compressed, pictorial narrative—in which the action makes a difference, that difference is seen through thematic contrasts; and this is the case in the relief under discussion.

2. Desire. Narratives are about protagonists striving to attain a goal, that is to say an object of value, which they attain or do not attain. This goal, whether material or ideal, may be self-imposed; or they may have had it imposed on them by a higher power, a "transcendental giver"—as in the present case. Along the course (parcours) which they have to pursue in order to reach their goal, and on which they carry out a taxonomically limited number of schematic actions (journey, test, combat, etc.), the protagonists are aided or resisted by other "actants," their so-called helpers or adversaries.

This is a greatly simplified version of a structural model derived from the Russian morphologist Vladimir Propp (1968) and elaborated by Greimas and his school. This approach works with formalized action elements (Propp's "functions") and action roles (Greimas's "actants"). Its linguistic character is easy to recognize: the narrative is construed as a sentence, with a subject, a verb, and an object. Taking the principles of desire and transformation together (as Greimas suggests), we can say that all transformations lead to a conjunction or a disjunction, or to one followed immediately by the other. The subject either receives something (such as a scroll bearing God's promise of the covenant) or is deprived of something.

The critical factor—the motor, as it were—of this rather static-looking system is the desire (or obligation) to act. With its motive power provided by the sense of lack, this desire moves the story forward out of equilibrium into disequilibrium or vice versa, so that the subject, in two senses of that word, is constituted. The statement "there is no subject without desire" cuts both ways: without desire, the story has no subject in the sense of "theme" and no subject in the sense of "protagonist."

3. *Lack.* Another model, very much more formalized and less fully worked out, reduces narratives to the following formula: "Lack–Lack Liquidated." Crude though this is in form, I want to introduce it here, because of its importance for what follows. Between the two positions, lack on one side and lack liquidated on the other, there lies an indeterminate number of actions and events, which lead either to a conclusion or to an intermediate stage at which a new sequence begins.

It will readily be seen that this third formula is more specific than the first (transformation) and less specific than the second (desire related to "actants"); but also that it cannot be obtained without a transformation's taking place, since by definition the state of affairs at the end is not identical with that at the beginning. It also requires an absent object of value, together with the motive impulse to gain it. In the course of the story, the object of value is transferred, so that the receiver moves from the debit to the credit side of the balance.

The text of Exodus 3 belongs within the context of the servitude of Israel in Egypt: undoubtedly a situation of lack, which inspires Yahweh, Moses, and the nation of Israel to yearn for liberation—though admittedly the Israelites are reluctant to tear themselves away from the "fleshpots of Egypt" or to undergo the hardships of the Exodus. Even Moses—and this is the subject of the relief panel—has to be persuaded to want change; he has to be dragged out of his comfortable situation. To define the initial lack, and to bring it to the attention of the protagonists, can perfectly well form the subject of a narrative, and of a vocation narrative in particular. Narrative development does not reside in action alone, but also in understanding and in giving to understand.

* * *

All these definitions, illuminating and helpful though they are, have one central deficiency. They convey the assumption that narrative exists in isolation: the narrative that narrates itself. Structural narratology tends to overlook the fact that narrative is a form of communication. There is only narrative by somebody and for somebody. Or, to put it more generally, with Sartre: "Art exists only for and through the other."

Narratology must take this into account by perceiving its object in its three main aspects at once: as *narrative* by a *narrator* for an *audience*. In the history of narratology, the sequential order of these three aspects emerges as an order of precedence. Most investigations—whether structural analyses or inquiries into the history of genres, of motives, or of presentation—have concerned and

still do concern the narrative itself. Then come investigations of the author and the narrator. It is only in the past twenty-five years that there has been a growth of interest in the dialogue between narrative, narrator, and audience.

The result is an expanded and integrative concept of narrative, very roughly as follows. A narrative is transactional, and not only in the previously described sense "that it mediates *exchanges* that produce historical change[:] it is transactional, too, in that this functioning is itself dependent on an initial *contract* between the participants in the exchange" (Chambers 1984, 66), those participants being the reader or viewer on one side and the narrator on the other. There is more to the covenant represented by Exodus 3 than the action as described. When we see, at the end of this brief narrative *parcours,* that a giver hands a scroll to a recipient, then this embodies another theme, that of what has been called the "narrative covenant": the covenant between the giver and the receiver of the narrative.

The relevance of insights derived from communication theory becomes evident if, for instance, we follow Evelyn Birge Vitz (1989) in making the following modification to the transformational model: "It is crucial—for there to be a 'story'—that the transformation be *awaited:* awaited if only by the narrator and *us!* And it is crucial that it be 'the' transformation: not just *any* transformation will do."

Vitz accordingly defines "story" as "an utterance in which an *awaited* (or desired) transformation ocurs." Her description of the Subject/Desire concept is equally acute: "I take the Subject to be the character (or a character) with respect to whose desires we consider the events and the other characters: a Subject is he whose interests and desires we regard as the (or a) frame of reference."

Again, the lack–lack liquidated scheme, too, must be paraphrased, and not only in proportion to our readiness to identify with the lack that one or more figures suffer. There is, in fact, a structural analogy between the subject and the reader/viewer of a narrative: they are fused like Siamese twins by their shared state of lack. The recipients of the narrative feel a lack because they have not yet heard or read it to the end: they are not sufficiently initiated or sufficiently astute to predict what happens next. Even where they know a lot more than the characters in the narrative, they suffer from another form of lack: they do not know when or how the information deficit suffered by the characters will be remedied or in what way this will influence the course of the action. Only at the end does the structural analogy lose its validity: whatever the outcome for those concerned in the story, the viewers/listeners/readers always have a gain to set against a loss: they gain an ending and lose a story. A new lack, and a good reason for starting the next story.

In other words, the approach based on the grammar of narrative needs to be modified in the light of the aesthetics of reception and communication. Narration does not consist in moving actors between opposing "terms" and

along a schematized *parcours:* it does this, but for the sake and with the help of its intended audience. This brings us to a celebrated distinction, which for many years has been articulated in terms of the paired concepts of *inventio/ dispositio* (classical rhetoric), *fabula/sujet* (Russian formalism), *histoire/discours* (Todorov), *story/discourse* (Chatman). This is the distinction, in Jonathan Culler's words, between "a sequence of actions or events, conceived as independent of their manifestation," and "the discursive presentation or narration of events." The key word here is "presentation." This distinction was originally applied only to the dual structure of the narrative, already mentioned, which takes *story time,* the "time-sequence of a plot," and uses devices of condensation, extension, segmentation, and transposition to carry it over into *discourse time.* But this takes no account of the communicative aims and the "evaluative function" (Labov) of such manipulations. Presentation must therefore embrace *all* of the means, and the conditions, that govern the transaction with the recipient of the narrative.

In this context, I would like to expand on one contribution made by art history. At the turn of the century, the analysis of pictorial narratives was much farther advanced than that of literary narratives. The archaeologists Franz Wickhoff and Carl Robert, and the art historians August Schmarsow and Dagobert Frey (the latter in the 1920s), concentrated on narrative form: i.e., the formation of narrative units, and the way in which pictorial narrative deals with the issue of time-lapse and narrated time—distinguishing, continuing, completing (Wickhoff), cyclic sequence and cyclic linkage (Schmarsow), and so on. At which point, art history rested on its laurels and largely missed out on the rise of structuralism and of hermeneutic approaches. This unfortunate state of affairs has tended to obscure the fact that Alois Riegl, in his last work (published in 1902 under the title *Das holländische Gruppenporträt*), had laid the foundations of a method of analysis that was to be revived from the 1970s onward in the discipline of film studies, with the use of such terms as diegesis, gaze structure, and "scopic regime" (Metz).

In his book, Riegl discussed a number of narrative paintings, but his principal concern (as the title indicates) was with group portraits and specifically with the question of how group unity is generated "by the linking psychological and physical functions of the figures." Riegl was the first to show that this internal communication is governed by the conditions of a "communicated communication." The painting can convey group cohesion only through specific kinds of relationship with the viewer. This relationship may be one of open interaction (Riegl calls this "external coherence"); or it may employ what Michael Fried calls "the fiction of the nonexistence of the viewer" (Riegl calls this "internal coherence"). Communicated communication means presented, represented communication.

Film analysts took up this idea, not only because looks supply the material whereby the relationships between characters are explained and narrated, but

because the mobile camera can of course slot itself into this network of glances and supply the viewer with a variety of "point-of-view identifications": "the spectator looking with a character, from near to the position of his or her look; or as a character, the image marked in some way as 'subjective' " (Heath 1981, 119).

Literary analysis, too, recognizes a variety of categories of perspectival presentation. From distinctions among types of narrator or narrative situations (authorial narration, third-person narration, first-person narration, etc.), which refer to the distancing or active involvement of the narrative medium itself, the available spectrum ranges by way of the narrative postures that define the narrator's information status—whether better, equally well, or less well informed than his or her characters—to the techniques of "focalization," of which more anon. All this has given rise to a whole subdiscipline of narratology in which art history has a very limited role, because the creations with which it deals are so much more static and unmediated than the film or the novel.

Visual art sets out to be an agent of optimal, unconditional visibility. It seeks to bring things and actions closer, not to push them away. We are meant to stick as closely to art as we do to the bas-relief I have been discussing, with its substitution of height for depth. There are exceptions to this, of course. One of these is Netherlandish mannerism; another is the deliberate reaction in late nineteenth-century painting, when British and French painters explored the possibilities of perspectival narration, principally by artificially limiting the visual field and adopting startling angles of sight. In relation to these, the relief under consideration represents the mainstream. For instance, the narrative perspective is largely neutral, so that we do not see the scene in "vision with" the narrator. We see the narrative just as if no intermediary existed to create a perspective. In spite or perhaps because of this, the conception and disposition of the image are not without importance.

In late antique and medieval art, communication is not so much communicated as taken as a theme: the viewer is meant to learn more about the possibilities of communication between God and human beings, and between human beings, and also about the conditions that govern access to communicative situations. In the present instance, the fact that we are allowed to witness every stage of the process of divine vocation has a value of its own: for, as a rule, "solitude as a setting for the transfer of divine knowledge to human agents is a familiar topos. God prefers to hold his conversation with isolates" (Saint Shapin).

Another noteworthy feature is the didactic thoroughness with which all the events shown are imbued with thematic significance; the successive phases of this vocation episode are marked out, as it were, as stages in the development of human culture, so that the result is a brief history of communication. Below, still immersed in his pastoral state, Moses is all *stupor*, all wonderment. In the register above, he is the recipient of a verbal message: he is addressed, he hears,

and he reacts. His new state is no longer one of wonderment but one of intentness. In the third scene he himself talks with God. We might also say, since the narrative form of the continuous style affords no place for any interlocutor, that Moses is all speech, all communication. In the fourth and last scene, he receives a written document from God: the party to a conversation has become a party to a contract. This opening sequence is also remarkable for its scope and consistency: from natural being to historical being; from mute, ahistoric origins to the pact with God, which also constitutes the social contract of the nation of Israel. No integrative perspective holds sway here: the narrative is studded with different "centers of attention," "focalizers," or "sources of vision," as Genette (1980) and Bal (1985) call them.

In programmatic terms, the relief begins with an individual turning his attention away from himself and his own present state to something else, which in this case is not altogether easy to define: the burning bush, the angel, the voice, the next phase. But what happens at this juncture, in the second register, has even more of a programmatic impact than the beginning. Here the angel, with his forefinger gesture, addresses and singles out an individual, who is "interpellated," in the sense of Althusser's theory of the "formation of the subject." The subject of the narrative is the subject: the analogous formation of our own identity through processes of perception and identification.

SUGGESTED READINGS

Bal, Mieke. 1985. *Narratology: Introduction to the Theory of Narrative.*

Brilliant, Richard. 1984. *Visual Narratives: Storytelling in Etruscan and Roman Art.*

Greimas, Algirdas Julien, and Joseph Courtés. 1983. *Semiotics and Language: An Analytical Dictionary.*

Karpf, Jutta. 1994. *Strukturanalyse der mittelalterlichen Bilderzählung: Ein Beitrag zur kunsthistorischen Erzählforschung.*

Kemp, Wolfgang. 1987. *Sermo corporeus: Die Erzählung der mittelalterlichen Glasfenster.*

———, ed. 1989. *Der Text des Bildes: Möglichkeiten und Mittel eigenständiger Bilderzählung.*

Kessler, Herbert L., and M. S. Simpson, eds. 1985. *Studies in the History of Art: Pictorial Narrative in Antiquity and the Middle Ages.*

Martin, Wallace. 1986. *Recent Theories of Narrative.*

Steiner, Wendy. 1988. *Pictures of Romance: Form against Context in Painting and Literature.*

Vitz, Evelyn Birge. 1989. *Medieval Narratives and Modern Narratology: Subjects and Objects of Desire.*

Context

Paul Mattick, Jr.

> Thus everything that is regarded as a thing in itself, as *one,* must be viewed
> . . . as a *complex.* Conversely, everything in a complex must be seen as *part*
> of that complex: as part of a *whole.* Then we will always see *relationships* and
> always know one thing through the other.
>
> —Piet Mondrian

The depth of the transformation wrought in the conception and handling of works of art around the start of the nineteenth century is visible in the critique of the museum made in 1815 by Antoine Chrysostôme Quatremère de Quincy. In his *Considérations morales sur la destination des ouvrages de l'art* he argued that the work placed in a museum has been "lifted from its original function, displaced from its birthplace, and rendered foreign to the circumstances that gave it significance" (Quatremère de Quincy 1989, 55). Decontextualization seemed to him, in an inversion of the Kantian identification of the aesthetic attitude with disinterested contemplation, an abolition of spiritual meaning: "one can hardly proclaim the uselessness of works of art better than by announcing in collecting them the nullification of their employment. What is it, to remove them all without distinction from their social destination, but to say that society has no need for them?" (37).

Already in 1796 Quatremère had protested Napoleon's planned removal to Paris of artworks from Rome. "The true museum of Rome," he argued,

> consists, it is true, of statues, colossi, temples, obelisks, triumphal
> columns, baths, circuses, amphitheaters, arches of triumph, tombs,
> stucco decoration, frescoes, bas-reliefs, inscriptions, fragments of or-
> naments, building materials, furniture, utensils, etc., etc.; but it is
> composed no less of places, sites, mountains, quarries, ancient roads,
> the particular placement of ruined towns, geographical relationships,
> the mutual relations among all these objects, memories, local tradi-
> tions, still prevailing customs, the parallels and comparisons that can
> be made only in this very place. (207)

The case made in these terms is clearly already lost. Rome itself, the only adequate context for antique statues and the paintings of Raphael alike, functions for Quatremère as a museum, a sort of theme park of ideal beauty, and no longer as a living city. He contrasts it with the modern city, unable to provide masterpieces with the temple their appreciation requires: "It is not amidst the fogs and smoke of London, the rains and mud of Paris, the ice and

snow of Petersburg; it is not amidst the tumult of the great cities of Europe, nor amidst this chaos of distractions of a people occupied of necessity with mercantile cares, that the profound sensitivity for beautiful things can develop" (221–22). The division between the active and the contemplative life, between the commercial "vapors, which obscure from our eyes the images of the beautiful and the true," and the premodern air to be breathed in Rome, is already established. The context of "art" is no longer the context of "life"; but it is just by the making of this division that the social practice of art, in its distinctively modern sense, was brought into existence.

As Quatremère's critique emphasizes, what has been called the autonomy of art appears with the extraction of art from its earlier physical and functional contexts. This has its clearest form in the literal removal of objects from an original site of use to the private or public collection or (as in the case of the Louvre) by the transformation of the site itself from one function to another. Yet Quatremère was mistaken in thinking that this was to make the objects useless. "Autonomy" is the name of new uses for them. The devotional picture moved from the church to the museum, or from the private chapel to a millionaire's gallery, lost its religious function. Its primary character became that of a *work of art,* object of a secular cult. As it once might have evoked the wealth, piety, and civic virtue of its donor, it can now in a museum testify to the dignity of the state and to the wealth, power, and cultured quality of those it represents, or, as privately owned, serve as a sign at once of a sensibility higher than commercial-mindedness and of the wealth that makes it possible. In this way it could be precisely the contrast between art and what is typically referred to in modern art writing as "everyday life," the activities of work and moneymaking whose natural home is the modern city, that gave the new practice its cultural power.

Preserving traces of its earlier use, with the transmutation (to use Walter Benjamin's terms) of "cult value" into "exhibition value," the artwork can embody continuity between present and past, and in particular the claim of the modern ruling class to be the rightful heirs of its predecessors. Nonetheless, the past is separated from present-day activity by the space defined by new practices—aesthetic experience, taste, appreciation of culture, art history—that draw on it for significance. These practices are discoverable in the new physical contexts of display: primarily, besides the museum, the commercial gallery space and the private home. With these comes a change also in the context of production: the studio, which ceases to be an artisan's workshop and becomes an arena for the exercise of creative genius.

Set at a distance from their original uses, past works can be joined by new ones produced specifically for display as works of art. Once shaped by contract for a particular function and place, which might dictate dimensions, medium, and even details of content, the artwork become autonomous acquires the character of a modern commodity, produced not for a particular "destination"—this

was Quatremère's complaint—but for a class of destinations, for anyone able and willing to buy. The artist, freed from guild regulation, and protection, on the one hand, and contractual relations with patrons, on the other, becomes the independent author of the image, a development leading to a growing emphasis on the idea of originality. The art market—that is, the network of relations connecting artists, collectors, dealers, critics, curators, and state institutions—constitutes a diffuse context, definitive even in relation to works produced in open defiance of any moment's fashions.

Its diachronic counterpart is the history of art, in which the modern practice is projected backwards into classical (and eventually even prehistoric) times, and forward to an imagined posterity. As a history of *art,* autonomous in relation to other social practices, it is structured by such categories as tradition, influence, style, and technique, which establish relations of continuity and difference among artists and determine a set of ideal contexts into which artworks can be set.

It is important to remember the variable content of the category of "art," given the heterogeneity of its users and uses. Art history as a territory of professional activity must be considered, as I suggested above, as a particular context among others; this implies the necessity of investigation of its own social history as an aspect of the history of the practice of art. The growth, during the last two decades, of attention to the social and political context of art is certainly to a great degree the product both of the impact on intellectual life of the student movements of the 1960s and of important transformations in art itself, in the direction of what might be called its desanctification and a franker acknowledgment of its connections with the rest of social—and particularly economic—life.

Chrétien de Mechel, who supervised the transformation of the Royal Collection of Vienna into a public museum in 1776, described his institution as "a Repository where the history of art is made visible." Less than a decade later von Rittershausen's commentary on the Vienna collection criticized de Mechel's work as an elevation of historical science over aesthetic sensibility, articulating already before the end of the eighteenth century the theme of an opposition between aesthetics and history. Indeed, unlike its predecessor, the *Wunderkammer,* the museum is at once an assemblage of marvelous things and a representation of relations between them, relations which, given the reference to the past fundamental to the practice of art, were necessarily historical. The heterogeneity of the contexts from which the museum's premodern contents were removed thus reappears subordinated to the organizing categories, most usually those of nationality, "school," and period.

Art history is therefore marked by paradox from the start. As an element of culture and an indicator of the worth of those who possess, display, and enjoy it, art is valued precisely for its purported transcendence of history. The object is collected and displayed as meaningful in the present, and not just as a trace

of the past. Yet this present value essentially involves its historical character or reference—even in the case of new art—so that such properties as authenticity and originality become important, especially as these categories come to structure the practice of art as a contemporary activity from the late eighteenth century on. The premodern definition of the meaning of a sculpture or picture by its physical and practical context explains the ease with which it might be altered or removed—frescoes painted over, altarpieces discarded, paintings cut down to fit new spaces. In the museum, in contrast, the work's new significance as element of the history of art spells its inviolability. From this point of view, the context from which a work has been removed must be reconstructed, if only in thought, for the work's original meanings to be retrieved.

An apparent solution to this paradox is the location of all relevant contexts within a conceptually unified art history. Such a history may for example be organized in terms of "styles" defined by relations between "form" elements identifiable across the range of works assembled in museums and completed by the photographic "museum without walls." In this way an autonomous history is created alongside, though in problematic relation to, the history of society generally. Thus, most famously, Heinrich Wölfflin utilized a distinction between matters "external" and "internal" to art to differentiate between the expressive and imitative *content* of art at different historical moments and the "*forms* of apprehension and representation"—or, as he otherwise calls them, "categories of beholding"—which provide "the vessel" in which impressions of nature can be caught and retained. Art history (or at least the history of Western art) is "a history of form working itself out inwardly," so that the description of the sequence of formal categories "must be regarded as the primary task of art history" (Wölfflin 1950, 226, 227, 232, 11).

Wölfflin himself recognized the problem of explaining the history of his categories of vision. While asserting the psychological intelligibility of (for example) the development from "linear" to "painterly" form, an explanation of the contrary "return from the painterly to the plastic" which he saw as central to stylistic change about 1800 points to an impetus located "certainly in outward causes," namely "profound changes in the spiritual world" as "occidental humanity . . . passed through a process of total regeneration" (223, 234). For Wölfflin, therefore, "every history of vision must lead beyond mere art" (237), though the "accompanying conditions" he imagines are the psychological and spiritual characters of the individual, "the school, the country, the race" (6), in one historical period or another. Nonetheless, the principles of formal development are distinct from the regulation of history generally; not only did the renewal of the linear in the early nineteenth century lead, in Wölfflin's view, ineluctably by the autonomous laws of form to the development of impressionism, but styles with originally specific historical reference ("classic," "baroque") became for him recurrent patterns of form.

As Arnold Hauser pointed out in a critique of Wölfflin's work, the latter's

paired formal categories are only in appearance simple classifications of visual structure and depend on a prior classification of historical material, including first of all the inclusion of certain objects in, and the exclusion of others from, the domain of art itself. "The notion that we start by making a collection and a review of the material is illusory. It is not a matter of first selecting and then interpreting and valuing the facts; the reality is that we register only those facts which we have already ordered in a historically meaningful series . . . facts, in other words, which have become a problem for us and are accepted as relevant" (Hauser 1963, 152). This is not to say that such classifications as "painterly" and "linear" are arbitrary, but that they represent a set of (historical, aesthetic, even political) interests on the part of the historian who constructs and uses them to organize the material.

Curiously, Hauser too draws a clear distinction between the artwork as an aesthetic object and as an element in a more general historical process. Because "works that always appear separate and complete in themselves for the aesthetic experience" are as such indescribable by the historian (155), that experience must be "destroyed" when the historian isolates aspects of an artistic totality in constructing series of works making visible historical continuities and changes. The work of art from "formalist" and "social-historical" viewpoints alike remains (to use the words of another methodologist of art history, Michael Podro) "both context-bound and yet irreducible to its contextual conditions" (Podro 1982, xviii–xx). We seem faced with an inescapable choice between an ahistorical appreciation of the artwork as an aesthetic object and a historical understanding of it that tends to reduce it to a symptom of its social-historical context.

What the viewpoint producing this dilemma ignores is the historical character of art's autonomy and of the aesthetic experience associated with it, underlying the construction of art as an object of historical study. The identification of an object as an art object—which simultaneously establishes what is not so identified as "context," thus differentiating between "internal" and "external" domains relative to a work—is itself a practice within social history. To view the work as a self-contained totality is to classify it in terms of a historically specific practice, not to undergo (as even Hauser imagined) a primitive and ineffable experience.

It is true, of course, that to treat the work historically necessitates considering it as an element in a pattern, as an example of a process. To cite Erwin Panofsky's example, to attempt to understand *The Last Supper* "as a document of Leonardo's personality, or of the civilization of the Italian High Renaissance, or of a peculiar religious attitude" is to "deal with the work of art as a symptom of something else which expressed itself in a countless variety of other symptoms, and we interpret its compositional and iconographical features as more particularized evidence of this 'something else' " (Panofsky 1955, 31). This dualism of individual and pattern is common to all objects of historical—or

any other—study. The "ethnic cleansing" of Bosnia is one more holocaust or one more episode in Balkan history, depending on the historian's focus, without each death thereby losing its individual reality. It is the constancy of the artwork under changed conditions of use that allows aspects of both its earlier and later utilization to be identified as contexts.

Many items of north Indian temple sculpture from the medieval period (A.D. 700–1200) exist in the West and in India in separation from their original positions in building complexes and from the ritual uses they had there. In Vishakha Desai's words, introducing the catalog of an exhibition of such pieces, they are parts "of an architectural whole, to be seen and understood as . . . component[s] performing a cosmological function, enabling one to visualize the 'manifested multiplicity' of the divine." Removed from this context, they have been assimilated, especially in the West, to the model of sculptures as individual artworks. This has led not only to difficulties in classifying these pieces chronologically and regionally, but also to judgments of inferior aesthetic quality. A grasp of their meaning and quality—even as the individual pieces they now are—is achievable, Desai concludes, only if we understand such sculpture as intended to function "as an integral part of a more comprehensive spatial experience and cosmological system" (Desai 1993, 29).

This is to insist on the inadequacy of the aesthetic encounter with the part away from the lost totality, and by the same token to insist that its meaning and even, therefore, its quality can be grasped only by an effort of transcending the object's limitations—a transcendence no longer, that is, located in the object but required of the viewing subject. Hence the need for modes of exhibition indicating the missing architectural and social environment (a rare event, despite its necessity for historical understanding), as well as the catalog's essays on architectural, political, and ideological contexts of the objects presented. By this means, of course, the original experience of the object is admitted to be irretrievable; the goal is not this but an experience framed, through the cultural-historical distance separating the historian and museum visitor from (for instance) medieval India, by the contemporary contexts of art history and museum display.

It is the same with objects created to be art in the modern sense, and even with the history of art in conscious view; only here the idea of the object's autonomy masks the context. Once art itself becomes a social practice, it animates physical context (typically disguised today as a neutral background for display of the work), saturating places and modes of display with meaning. Embodied in them it provides a set of ideal contexts: ideal in contrast to the concrete and specifiable contexts of the bespoke picture, and so identifiable only with more difficulty. I mean by "ideal contexts" such representations of artistic practice as "the nude," "originality," "realism," or the contrast between "academic art" and "art vivant" central to the Parisian art world in the period after the First World War. (A case midway between real and ideal is the status of a

set of objects as the possessions of a particular collector; thus some donors to museums have insisted on the display of their collections as wholes, on occasion in a simulacrum of the original domestic context.)

As is evident, ideal (or ideological) contexts are complexes of general cultural and political as well as strictly artistic practices. "Realism," for instance, essentially involves reference to "social class," itself a complex category of social practice, as well as (by way of negation) to a tradition of idealizing art. Identifying and unpacking such thematic contexts require an archaeology of discourse more often than the reconstruction of physical structures. What is required is to work out, with the aid of all possible sources of information, what T. J. Clark has described as the "possible uses" a work anticipated, "what viewers and readers it expected, what spaces it was meant to inhabit, and, above all, the question of how such a structure of expectation entered and informed the work itself, determining its idiom" (Clark 1990, 176). As such a program indicates, context here centrally involves attention to the social relations within which the viewers and producers of art are located and which structure their intentions and expectations.

Unlike the temple fragment, the autonomous artwork presents itself as definitive of its context: the relevant ritual is that of aesthetic attention. The focus on context as determinant of meaning leads back therefore to close scrutiny of the work, seeking in its ("internal") features the residues of intended action in the wider ("external") world. Such close reading can represent something other than an attempt to capture an imaginary context-free encounter with an aesthetic entity. Indeed, the recentering of art-historical attention from style to works that has come with the concern for context inherent in the rise of social-historical approaches has tended to undermine the idea of a shadow history of art, mysteriously paralleling the rest of social history like the Cartesian soul the body. The traditional supposition of a double character, transcendent and historical, of artworks is giving way to the search for social-historical content in form itself. This way of formulating the problem of meaning in art itself testifies to the continuing power of the traditional dualism. However, if the work is seen as itself an event, situated in a dense network of events, in history, its visual traits might no longer seem to belong to a domain of "form" as opposed to "content." These traits, that is, might appear not as the attributes of a transhistorical substance but as themselves a mode of historical action, within the complex of contexts which structure the making and reception of art.

Let us take, for example, a large drawing by Piet Mondrian, *Pier and Ocean,* made in 1914 or 1915 and hanging at present in the Museum of Modern Art in New York (Plate 6.1). Its presentation here sets it firmly into a particular art-historical context, a history of modern art as a series of styles, or art movements, dominated by the formal achievements of a few individuals. A central theme of this history is the gradual revelation of the autonomy of the artwork

6.1 Piet Mondrian, *Pier and Ocean,* 1914. The Museum of Modern Art, New York. Mrs. Simon Guggenheim Fund. Photograph © 1994 The Museum of Modern Art, New York.

as an object characterized by the materials and form of its construction, rather than by visible relations to natural and social life. The MoMA galleries which trace this story in Europe through the 1930s begin (I follow the rubrics in the floor plan given to visitors) with Cézanne, progressing through other Post-Impressionist artists through Fauvism and Early Picasso to Cubism. Cubism, joined by German Expressionism, opens to the dynamic eddy of Futurism, Kandinsky, Chagall; the path then passes through de Chirico to pick up the cubist thread again with Collage and Dada, Picasso and Duchamp. The next room is devoted to Mondrian. This room opens into Russian Constructivism, from which one door leads back to the Cézannian starting point, another to a break effected by a stairwell, after which the story starts again with Matisse, passing to Paris in the 1920s and '30s.

This arrangement, made in 1992, replaced an earlier one in which the museum visitor's path led through four rooms of various cubisms, with some stylistic relatives, to de Stijl—the movement in which Mondrian participated from 1917 to 1925—and Purism in a sort of cul-de-sac; the doorway out led not to further developments in modernism but to Monet's *Water Lilies*. (A hanging of the galleries after the 1984 rebuilding of the museum was intermediate between this and the current one.) The change suggests a reevaluation of Mondrian's work (visible also in its substitution as focus for de Stijl as a movement), perhaps in part a response to the appearance of minimalism around 1965–75 and the renewed interest in geometric painting since the 1980s, while leaving unchanged its narrative position as a development from cubism.

The general idea behind the itinerary mapped out by the sequence of rooms was illustrated in the famous diagram of the family tree of modern art on the cover of Alfred Barr's 1936 exhibition catalog, *Cubism and Abstract Art*. Cubism dominates this genealogy, leading directly, through constructivism and Mondrian's neoplasticism, to geometrical abstract art, and indirectly through surrealism, itself a descendant of expressionism, to nongeometrical abstract art. In the catalog Barr explained "the dialectic of abstract painting" as "based upon the assumption that a work of art, a painting for example, is worth looking at primarily because it represents a composition or organization of color, line, light and shade." The artists and architects of de Stijl earn their position in this dialectic for the formal focus of their work, whose "fundamental basis" was "in form the rectangle, in color the 'primary' hues, red, blue, and yellow" (Barr 1936, 13).

The arrangement of works in the room devoted to Mondrian follows this scheme. It starts with *Dunes and Sea,* an example of the neopointillist style he practiced shortly before he left Holland for Paris in 1912. Then comes *Pier and Ocean,* followed by *Composition with Colored Planes V* of 1917. A 1918 painting by Theo van Doesburg stands in for the collaborative activity of de Stijl, and the remaining canvases provide examples of Mondrian's work between the later 1920s and his death in 1944. The room thus provides an indication of Mon-

drian's path to abstraction from modernist representation, followed by a survey of his abstract painting. Yet nothing in the room indicates why Mondrian, his fellow participants in de Stijl, and the artists and others outside that circle who were influenced by him thought his compositions were "worth looking at."

In his own writings on art Mondrian traced a line of development of modern art similar to that embodied in the museum's layout, from the imitation of nature to pure constructive abstraction. In his view, however, this development was not to be understood as one in a distinct art history. In a text of 1917 he insisted that the artist is "only the more or less appropriate *instrument* through which the culture of a people"—what he also called "the spirit of an age"—"is expressed aesthetically" (Mondrian 1993, 42). The essence of the modern age is the increasing domination of nature by rational thought in all spheres of life, whereby the inner structure of nature, clarified by human understanding, comes to the fore. Abstract art thus exhibits in the artistic sphere the fact that "in all fields, life grows increasingly abstract while remaining real" (43). That is, what appears in Barr's account as the autonomy of form in Mondrian's later work represented in his view his subordination as an artist to the requirements of modern life.

The evolution of life in the direction of abstraction is held back, according to Mondrian, by forces of tradition. Bourgeois individualism, in particular, with its attachment to material things, blocks the completion of the task of spiritual rebirth: the achievement of a social order in which the individual's true interests are discovered to be those shared with others and in which material need, adequately satisfied, will be balanced by the claims of beauty. Due to their grasp of abstract ideas only artists and intellectuals are in a position to demonstrate the principles of the new arising order. The artist's role is paramount, because his work embodies the new spirit in real things, compositions in which the needed equilibrium of spirit and matter, universal and individual, is made visible. Oriented towards the universal, art must not represent particular objects. Nor should it express the vision of the individual artist, which must be subsumed in the collectively practiced principles of a style answering to abstract reality—de Stijl, *the* style.

As a result, while indebted to cubism in his working methods, Mondrian was sharply opposed to the version of modernism it represented. In artistic practice and theory alike, cubism claimed a connection to French art tradition (for instance, in the choice of subjects), and visible reference to nature was essential to the cubists' conception of artistic meaning as constituted by the individual artist's response to nature in terms expressive of the "modern spirit." At the same time cubism emphasized the autonomy of the artwork, which should be (in Pierre Reverdy's words of 1917) a "creation," not a "reproduction" or "interpretation" of nature. Reference to nature, one can say, made visible art's difference from it, its independence from "real life" as an autonomous sphere of activity (see Green 1987, especially chs. 14 and 15). For Mon-

drian, in contrast, art was to be an intervention into life, revealing the order of nature. The artist's task was the disengagement of universals from natural appearances, to create the spiritual preconditions for life lived collectively in accordance with modern possibilities. In words that may remind the reader of Quatremère de Quincy's, Mondrian wrote in 1919 that "people too often view the work of art as a *luxury,* something merely *pleasant,* even as a decoration, as something that lies outside *life.* Yet art and life are *one.* . . . If, for instance, we see that equilibrated relationships in society signify what is *just,* then one realizes that in art too the demands of life press forward when the spirit of the time is ripe" (Mondrian 1993, 78).

We know from letters and extensive passages of writing in his sketchbooks of 1912–1914 that Mondrian had evolved basic elements of these ideas by the time he produced *Pier and Ocean.* The two years he had spent in Paris had allowed him to assimilate cubist methods, but he had already moved far towards pure abstraction. Shortly before he left Paris in July 1914 for what was intended to be a brief visit to Holland Mondrian wrote the Dutch art critic H. P. Brem- mer that while inspired by nature he wanted "to approach truth as closely as possible" by "not saying *anything particular.*" He asserted the possibility of creating a "powerful and true" artwork "by constructing horizontal and vertical lines *consciously* but not *calculatingly,* . . . arranging them in harmony and rhythm," and specified that "it is necessary to interrupt a horizontal or vertical line continually; for if these directions are not opposed by others, they would start to say again something 'definite,' thus something human" (Joosten 1968, 211). By "human" he meant the viewpoint of the individual, caught up in the pleasures and pains of life whose deeper meaning can be seen only when viewed, to use the expression of Mondrian's Dutch forebear Spinoza, *sub specie aeterni- tatis.*

The drawing's title suggests its source in nature, and a sketchbook of 1913–14 contains a number of drawings of the sea at Domburg, where Mon- drian had painted off and on during 1908–10 and where he spent some time when the outbreak of the world war prevented his return to Paris from a visit to Holland. The "pier"—a double row of piles extending from the shore—is clearly depicted in a number of sketches. Although the MoMA drawing can be read simply as the interaction of ocean and pier, Mondrian identified the subject on several occasions as "Sea and Starry Night." This identification preserves the dualism of what may be the earliest of a set of related sketches of the ocean in the 1913–14 book, which stresses the horizon's central division of sea from sky. However, the oval shape that *Pier and Ocean* shares with this and other ocean drawings, adopted from the post-1910 practice of Braque and Picasso, by defining a clearly demarcated picture-space distances the image from refer- ence to a particular natural reality. Equally derived from cubism is the construc- tion of the image in the MoMA drawing out of intersecting planes, but the absence of faceting, the use of the square (whole and fragmented) as basic

element, and the reduction of pictorial means to intersecting black lines on a white field represent movement away from cubist representation.

The series of ocean drawings dissolves the horizon stressed in the first one into all-over compositions dominated by horizontal lines, though, following Mondrian's prescription, all lines are joined, cut, or terminated by perpendiculars. The idea of contrast and opposition is strengthened in a second series by the introduction of the pier, depicted as actively disturbing what can be read as wave patterns in the sea. In the MoMA drawing the vertical direction has become the clearest, with the long lines of the pier rising from the bottom center meeting a column of squares and fragments of squares descending from the top. Verticality is also emphasized by the near left-right symmetry of the image, most unusual in Mondrian's work. Yet horizontality remains, now diffused throughout the picture thanks to the differentiation of its upper from its lower half by the gradual decrease of space between the linear elements, which subtly re-creates the horizon line without producing a quadrature of the picture.

The opposition of horizontal and vertical thus also exemplifies an opposition of indefinite to definite, of the natural (sea and sky) to the human-made (the pier), held in balance in a structure in which an underlying order appears despite the interruptions of line that prevent the emergence of forms breaking the unity of the plane by becoming individualized figures on a ground. Like the horizon's distance and the difference between sea and sky, rhythmic movement makes itself felt despite the evident flatness of the plane; like the contrast between the oval shape and the straight-line elements of the image (the few curved or diagonal lines of earlier versions have disappeared), the opposition of art and life is held in a tension expressive of the idea of its overcoming.

The texts in which Mondrian explained his artistic conceptions—and the importance he placed on those texts—suggest the artist's rejection of the conventional distinction between form and content. The most striking pointer to the meanings intended by his forms is, perhaps, the repeated textual equation of the signified dualisms of universal/particular and spiritual/material with gender categories. In his 1913–14 sketchbook he wrote: "*Female:* static, preserving, obstructing element. *Male:* kinetic, creative, expressive, progressing element. Woman: matter-element/ Man: spirit-element/ Woman: horizontal line/ Man: vertical line/ Male artist: spiritual joy/ Female artist: material joy" (Welsh and Joosten 1969, 16).

Mondrian meant his formal elements to have more than allegorical force. In *Pier and Ocean* the female sea is acted on by the penetrating pier to create a pictorially actual unity of opposites. And he intended the very formalism of his pictures—their near abandonment of representation—to be an embodiment of meaning. *The New Plastic in Painting,* a text published in the first issues of the journal *De Stijl* in 1917, defines "representation of *any* kind" as "*predominantly female art*" (Mondrian 1993, 69). The historical dominance of representation is the expression in art of "oppression by the female, a legacy of the old mental-

ity," which "in our time . . . still weighs so heavily on life and on art that there is little room for male-female equilibrium" (68). The way to the establishment of this equilibrium can be shown by "abstract-real" art (Mondrian's earlier term for "neoplastic" art), where it is given form in particular by the relation between feminine horizontality and masculine verticality. The victory of the masculine principle of abstraction is evidenced by the disappearance of curves, with all lines "tensed," as Mondrian put it, by the dynamism of rational control.

Theosophy, in which (along with related mysticisms) Mondrian like numerous middle-class people of the time was intensely interested, made liberal use of the male/female duality central to various of the traditions it synthesized. But misogyny was not an important feature of a movement that was, after all, led by women and at times actively raised feminist concerns. Its centrality to Mondrian's conception of his work reflected deeper cultural currents. Like the occasional anti-Semitic remark in his letters, Mondrian's antifeminine opinions, aside from the resonances of his difficult relations with actual women, represent a particular version of commonplaces of turn-of-the-century modernism: along with the writings of such men as Friedrich Nietzsche, Otto Weininger, and D. H. Lawrence one could cite—more pertinently for Mondrian—F. T. Marinetti's futurist declaration of "contempt for woman" and metaphysical versions of this theme in writings of the Dutch neo-Hegelian philosopher G. J. P. J. Bolland, popular among intellectuals and artists of Mondrian's generation.

The equation of "woman" with both "nature" and "tradition," and the fin de siècle fascination with the dangerously powerful seductress visible in numerous images of sphinxes, vampires, and Salomes, represented specific forms of the "woman question" that had emerged with the reconstruction of gender categories as an aspect of the modern social order. These categories have had a long life in art theory—for instance, in the denigration of seductive color in comparison with clarifying line and of the "merely decorative" as against artistic revelations of deep spiritual truths—as well as in the prejudice against women artists that persists into the present day. Mondrian's view that the male artist can unify matter and spirit because he androgynously "represents the female and male principle" (22), while woman "in her innermost being" is "against art, against abstraction" (19), while related particularly to social currents of his time belongs to a structure of thought and behavior as old as the modern practice of art, though he meant to mobilize such categories against tradition and for the culturally new.

"Tradition" had a particular meaning for a progressive Dutchman in the first decades of the twentieth century, when industrialization and the development of Rotterdam and Amsterdam into international shipping and financial centers were transforming a country long based economically and socially on agriculture and colonial trade. Those engaged in this transformation expressed their understanding of it in terms of a conflict between "new" and "old"; they gave this conflict form in a variety of cultural phenomena, including the division between the traditionalist patrons of the Hague school of landscape painting

and the newer bourgeoisie of manufacturers and financiers who favored Paris-inspired modern art. It was members of the latter group who supported the work of de Stijl artists and architects; the stockbroker Saloman Slijper bought nearly two hundred paintings and drawings made by Mondrian between 1908 and 1921.

Trained at the Amsterdam Academy of Fine Arts and influenced in his youth by an uncle who was a successful landscapist, Mondrian broke with the academic milieu in the early 1900s and sought contact with the world of advanced art, joining with other artists to found the Modern Art Circle in 1910. In Paris two years later Mondrian found not only the newest art, but also the modern city, the metropolis which, as he was to write in 1917, "the truly modern artist sees . . . as abstract life given form" (Mondrian 1993, 59), with its buildings structured by horizontals and verticals, their plane surfaces emphasized by printed signs, and the absorption of the individual by the crowd. In what seems like an identification of cubist form in the ceaseless movement of people on the *grands boulevards,* Mondrian wrote elsewhere of the "annihilation of images and limitations through manifold images" (126). When he returned to Paris after the war Mondrian carefully designed his studio at 26 rue du Départ to echo the right angles of the city outside. The only touch of "nature" was a single tulip in a vase—an artificial tulip, however, and painted white. Mondrian explained this object to a visitor as a needed representative of the feminine; but it is surely no accident that Mondrian chose to pay his ironic and delicate tribute to the female and natural element in the form of the flower practically symbolic of "oud Holland."

Spending the war years in his native country thus meant a move from the "new" back to the relatively "natural" and "old." But in the work Mondrian did there he subjected Dutch motifs on which he had worked earlier—the sea, a church tower—to his new methods. Pictorial construction out of elements capable, because of their abstract character, of multiple denotation as well as metaphoric expression allow in *Pier and Ocean* for the equation of sea and starry sky, and so for specific reference to neither. In the same way *Pier and Ocean* is more closely related formally to a 1913 drawing based on a church facade, constructed from verticals and horizontals in a circular field, than to some earlier drawings of the sea. And both of these works transpose to Dutch subjects visual structures developed in response to buildings sketched in Paris, just as their grid forms anticipate paintings Mondrian was to make later in Paris, London, and New York.

In Holland, then, art was for Mondrian a domain in which active fidelity to the modern, through the creation of images of the dynamic equilibrium of spirit and matter, could be practiced in exile from the metropolis. It is noteworthy that despite his occasional self-descriptions as an anarchist, an antibourgeois, and a revolutionary, Mondrian shows no sign of interest in the tumultuous changes that took place in the Dutch left under the pressure of the war and the social movements to which it gave rise. The split in Dutch social democracy,

and the emergence of Anton Pannekoek, Herman Gorter, and Henriette Ro-
land-Holst as internationally significant activist-theoreticians of the ultraleft, are
unmentioned in his writing.

In 1919 Richard Roland-Holst, Henriette's symbolist painter husband, at-
tacked de Stijl's "amorphous painting, the kind consisting of square blocks,
which must be a relief for the harassed modern businessman" (Harmsen 1982,
47). It was in response to such criticism that Mondrian retorted, in his 1919–20
"Trialogue" on neoplasticism, that his art "is precisely free of 'bourgeois' charac-
teristics," even while insisting that the working classes also were incapable of
the spiritual advancement necessary for its appreciation. Mondrian's work was
usable as inspirational by modernists oriented to the ultraleft, such as the
Cologne progressives. At the same time, both Roland-Holst's comment and
some of Mondrian's own pronouncements resonate interestingly with Matisse's
famous 1908 statement of his "dream of . . . an art of balance, of purity and
serenity . . . an art which might be for every mental worker, be he business-
man or writer, . . . something like a good armchair in which to rest from
physical fatigue." In a text of 1926, "Home-Street-City," Mondrian wrote
of the home as the place where the advanced individual could create an
environment anticipating the future full integration of individual existence
into the urban collectivity. In the progressive home, "physical and spiritual
happiness . . . will be furthered by equilibrated oppositions of relationships of
proportion and color, matter and space" (Mondrian 1993, 211). Such a home
would provide an appropriate context for a Mondrian painting. In the 1919–20
text Mondrian explained that while in the future "we will be able to dispense
with all the arts as we know them today" (114) because the architectural envi-
ronment of daily life will be based on neoplastic principles, for the present
painting still had a function, that of meeting the advanced individual's spiritual
needs.

His own painting, however, "will look wrong if it is not seen from the right
distance: its relationships are so precise that they must also be properly related
to the room itself" (121). Its ideal use, however meditative in form, will not
be aesthetic in the sense of detachment from the concerns of life. Because they
incarnate the principles of future life, in fact, Mondrian's paintings call for
the construction of spatial contexts based on their own principles. Mondrian
accordingly devoted much thought and effort to the arrangement of his studio
to provide an environment adequate to the visual and spiritual demands of his
art. As a journalist visiting his Paris studio in 1920 wrote, "But what does the
painter think about his work—which in itself appears to be unresolved—being
framed, enclosed, placed in an interior? . . . Mondrian doesn't have to reply to
this question: his studio answers for him. The walls of the room with its pleas-
ing stereometrical shape are hung with painted or unpainted canvases, so that
each wall is actually a kind of larger-scale painting with rectangular fields"
([Henkels] 1987, 25).

Both *Pier and Ocean*'s original context and the drawing's distance from it are perceivable in its current physical state. What was most likely a cream-colored paper has darkened to brown, probably as the result of time spent tacked up in the studio (a 1926 photograph shows it hanging over the stove) and from its having been glued onto homosote between 1941 and 1968. As a result, the white paint with which Mondrian corrected some of his charcoal lines and began to fill in the spaces between them now adds an expressive aspect to the drawing that is completely at odds with the artist's intended deindividualization of imagery by reduction of pictorial means to black lines on a white plane. While Mondrian's pictorial intentions are visible in the New York drawing only in a distorted form, one realization of them can be seen in *Pier and Ocean (Composition No. 10),* the painting produced in 1915 after a year of drawings (now at the Kroller-Muller Museum in Otterlo). Mondrian's larger intentions can only be imagined. The neoplasticist utopia has not come into being, and the idea of the artist as prophet has faded along with art's claim to integral transcendence of its moment. If the studio was, from Mondrian's point of view, the ideal space for the presentation of his art, the museum, designed for the display of art history rather than for visual exhibition of the first principles of modern life, provides a context counter to the artist's hopes.

The subordination of Mondrian's drawing to MoMA's conception of the history of modern art does, however, situate his ambitions within their actual fate, since his pictures ended up as elements of art history rather than as instruments of more than artistic revolution. MoMA's history could certainly be improved on, for instance by providing materials explaining why someone in 1914 might think that painting abstractly could contribute to social change. Nonetheless, anyone who wishes to make historical sense of Mondrian's work today can approach his preoccupations only in relation to the cultural conflicts of the present—a moment in which, for example, the world-shaking claims of abstraction are likely to evoke rueful irony and modernist misogyny stands out like a livid scar.

This subjection to current concerns is not a limitation; it is the condition for historical knowledge. Quatremère's hope that the past could be preserved, if only for the happy few on a spiritually elevated grand tour, is clearly illusory. But excavation of the pasts to which our present interests lead us remains valuable, above all for the critical light shed, when all goes well and the findings are unexpected, on those very interests.

Acknowledgments

A number of people at the Museum of Modern Art, New York, were kind and helpful to me in the preparation of this essay, and I wish to thank them: Carl Buchberg, Robert Everen, Antionette King, Erica Mosier, and Clive Phillpot. I also thank Alan Wallach for helpful discussions of a topic central to his work, and Richard Shiff for a typically observant suggestion.

SUGGESTED READINGS

Baxandall, Michael. 1972. *Painting and Experience in Fifteenth-Century Italy.*
———. 1985b. *Patterns of Intention: On the Historical Explanation of Pictures.*
———. 1985c. "Art, Society, and the Bouguer Principle."
Belting, Hans. 1986. "Das Werk im Kontext."
———. 1994. *Likeness and Presence: A History of the Image before the Era of Art,* translated by E. Jephcott.
Clark, T. J. 1973a. *The Absolute Bourgeois.*
———. 1973b. *Image of the People: Gustave Courbet and the 1848 Revolution.*
———. 1985. *The Painting of Modern Life: Paris in the Art of Manet and His Followers.*
Crow, Thomas. 1985a. *Painters and Public Life in Eighteenth-Century Paris.*
———. 1985b. "Codes of Silence: Historical Interpretation and the Art of Watteau."
Dahlhaus, Carl. 1983. *Foundations of Music History,* translated by J. B. Robinson.
Gage, John. 1972. *Turner: Rain, Steam and Speed.*
Hauser, Arnold. 1963. *The Philosophy of Art History.*
Herbert, Robert L. 1972. *David: Brutus.*

Meaning/Interpretation

Stephen Bann

No poet, no artist of any art, has his complete meaning alone.
—T. S. Eliot

What I seek to defend here is the view that the search for meaning—the process that is commonly called "interpretation"—is a virtually limitless one, which can be terminated only by the atrophy of the individual subject's desire to know. This is not, however, tantamount to making the exploration of meaning a pursuit of wild, subjective fantasy. It is in the nature of works of art themselves that they should support and favor the process of interpretation. To pursue meaning is not like a game of Chinese boxes, where we open one at a time until we find what is bound to be the smallest and most secret box in the center. It is certainly a process in which one problem solved discloses another, but the movement is outwards, in the social dimension, rather than inwards, converging on a private truth. The semiologist Jan Mukarovsky effectively defined the issue by stating that every work of art has two components, the "work-thing" (which we can touch, purchase, and have restored) and the "aesthetic object" which is "laid down in the collective consciousness" (Mukarovsky 1988, 7). To interpret the aesthetic object is inevitably to measure its participation in the multiple codes which govern the collective consciousness.

Thus far I have confined myself to making a general statement about the nature of interpretation. But what does it imply in terms of practical criticism? By what stages can we move from contemplation of the work of art as a concrete object staring us in the face to the further interpretation of its multiple codes? Here it may be useful to look first of all at a detailed description of another mode of interpretation, whose premises I have deliberately tried to invert in making my initial statement of method. I would not have insisted so firmly on the point that interpretation aims at the social dimension, rather than at private truth, if the pioneering art historian Erwin Panofsky had not, to some extent, implied the opposite.

Panofsky indeed took the trouble to bring together a group of his most penetrating essays under the title *Meaning in the Visual Arts,* and in one of these essays he gave an especially clear description of the method of "iconography," which "concerns itself with the subject matter or meaning of works of art, as opposed to their form" (Panofsky 1970, 51). The method is defined in terms of three separate, sequential stages, and the example which Panofsky chooses is (perhaps significantly) not a confrontation with a work of art, but a

meeting with an acquaintance in the street. This acquaintance greets Panofsky by lifting his hat, and the first stage of interpretation is already under way: "what I see from a formal point of view is nothing but the change of certain details within a configuration forming part of the general pattern of colour, lines and volumes which constitutes my world of vision." The mist soon clears, however, and Panofsky is able to identify the "configuration" as being "an object (gentleman)" and in the change in the details as "an event (hat-lifting)." We have stepped beyond the stage of "purely formal perception and entered a first sphere of subject matter or meaning."

It is not a trivial objection to point out, at this juncture, that Panofsky's seemingly incontrovertible assumption about the nature of perception is, in fact, dependent on a relatively recent change in the concept of vision. Jonathan Crary has shown very effectively that the notion of an "innocent eye," occupied with a "primordial vision" of color and form, was inconceivable in the seventeenth and eighteenth centuries and was rendered possible only by far-reaching changes in the role of the observer which took place in the early nineteenth century (Crary 1990, 66). But let us allow Panofsky, for the moment, his transition from "purely formal perception" to "subject matter or meaning." There is then a further crucial transition to be made, when we proceed from the immediate "expressional" effect of the lifting of the hat, which is classed as part of his "practical experience," to the fuller interpretation of the act of politeness which is recognized as belonging to a specific, and historically conditioned, code: "This form of salute is peculiar to the Western world and is a residue of medieval chivalry: armed men used to remove their helmets to make clear their peaceful intentions" (Panofsky 1970, 52). What has been set up, in this example, is a hierarchy of two different stages of meaning, one "primary or natural" and the other "secondary or conventional." The art historian, of course, is the very person who is qualified to elucidate the secondary stage.

Thus far, Panofsky may seem to be developing his interpretation in much the same way as that recommended by the semiologist Mukarovsky. But when he transfers his example from the case of the meeting in the street to the encounter with a work of art, he makes it explicit that there is a further stage to be reckoned with. First of all, in the work, we perceive that "primary or natural subject matter" which may be "factual" or "expressional": we recognize that the "configurations of line and colour" represent natural objects like "human beings, animals, plants, houses, tools and so forth," and we attribute to them "expressional" qualities like "the homelike or peaceful character of an interior" (54). Second, we are equipped, by our previous knowledge, to detect in the attributes and poses of certain figures the codes of iconography: we realize that "a male figure with a knife represents St Bartholemew, that a female figure with a peach in her hand is a personification of veracity, that a group of figures seated at a dinner table in a certain arrangement and in certain poses represents the Last Supper." But we have to proceed beyond this stage to

identify a further level of significance which Panofsky describes as "intrinsic meaning or content." At this point, the outward movement, into the social and historical world, is counterbalanced by an inward movement, into the subjectivity of the artist: we are invited to discover how "those underlying principles which reveal the basic attitude of a nation, a period, a class, a religious or philosophical persuasion" can be "qualified by one personality and condensed into one work" (55).

It is at this crucial stage, where the study of "iconography" yields to what Panofsky terms "iconology," that the clarity of his analysis is overtaken by a degree of confusion. What are these values, described as "symbolical" in deference to the philosopher Ernst Cassirer, which underlie the forms and codes of the visual work of art? Panofsky seems to be saying that a work can "condense" the artist's deepest feelings, or it can "condense" the character of the society which surrounds it. But can these two possibilities coexist? How can we use a method which seems to point, on the one hand, to an extreme subjectivism and, on the other, to a bland notion of correspondence to the social world? Panofsky is clear that we have not got very far when we make the iconographical judgment that "a group of thirteen men around a dinner table . . . represents the Last Supper." But does it get us much further to suggest that we should then study the work as "a document of Leonardo's personality, or of the civilization of the Italian High Renaissance, or of a peculiar religious attitude" (56)?

These issues are not really settled in Panofsky's formal statement of his method, published originally in 1939. But they are raised in an implicit and excitingly problematic form in an earlier essay, collected in *Meaning in the Visual Arts,* which deals with Titian's *Allegory of Prudence* (National Gallery, London). Much the greater part of this piece is devoted to an absorbing process of iconographic detection: Panofsky tracks down the allegory—the conventional representation of Prudence as a figure with three conjoined heads—to the ancient world, and back, through the Middle Ages, to the Renaissance. But, in the closing pages, he lets slip the hazardous and seductive suggestion that the three heads shown in the work represent Titian himself in old age, his loyal son Orazio, and his beloved young relative Marco Vecelli; moreover that the painting is a document of "the period when the old master and patriarch felt that the time had come to make provision for his clan." Panofsky does not stop short at envisaging that the very document which condensed the aged artist's hopes for the future of his family was also, in physical terms, the means of access to his private papers: "Were it permissible to indulge in romantic speculation, we might even imagine that it was intended to conceal a little cupboard recessed into the wall (*repositiglio*) wherein important documents and other valuables were kept" (202).

Panofsky's analysis of the *Allegory of Prudence* thus demonstrates, in an almost exaggerated way, the odd distortions implicit in the use of the iconographic and iconological method. He spends virtually the whole essay in the patient

(and necessary) elucidation of the genealogy of the three-headed Prudence, and he finally chances his arm on this memorable "speculation" about the personal significance of Titian's work. But the very fact that the iconographic search has led us through an enormous number of different media—bas-reliefs, illuminated manuscripts, statuettes and coins—impels us to ask the question: in the end, how relevant to our interpretation is the fact that this is an oil painting, and indeed an oil painting by one of the greatest masters of the technique? Panofsky himself seems to anticipate this possible challenge in his final remarks, where he concedes that the "abstruse allegory" which is also a "moving human document" would never have been judged worthy of our attention if we had not first been captivated by the beauty of its form: "In a work of art, 'form' cannot be divorced from 'content': the distribution of colour and lines, light and shade, volumes and planes, however delightful as a visual spectacle, must also be understood as carrying a more-than-visual meaning" (205). It is as if, after the long iconographic haul and the sudden iconological insight, Panofsky had been anxious to reinstate, at least on the primary level, the notion of the "innocent eye." Titian delights us with the effulgence of his forms, the purely "visual spectacle," and the stern quest for "more-than-visual meaning," when it engages us in the process of interpretation, cannot be entirely disentangled from our initial experience of the sensuously appealing surfaces.

Panofsky's ingenious and intellectually dazzling analysis of the *Allegory of Prudence* is taken here as a counterexample: that is to say, the very confidence with which the method is used, and the clarity with which each stage emerges from the previous one, are for my purposes subject to critical revision and reassessment. The point is that Panofsky has welded together two modes of spectatorial awareness—on the one hand, the "innocent eye" which delights in "visual spectacle," and on the other, the informed consciousness of a spectator conversant with the obscure traditions of iconography. He betrays the fact, in this final quotation, that he is dissatisfied with the apparent cleavage between "form" and "content" that emerges. But he cannot explain how such a "more-than-visual meaning" might be elicited from the colors, lines, lights, and shades of the painting.

He is also (it hardly has to be stressed) taking for granted that Titian's authorship of the *Allegory of Prudence* forms an unquestioned historical datum. At the time of writing, he has some justification for his assurance. "The authenticity of [the] picture . . . cannot be . . . questioned" (182), as he asserts at an early stage in the argument. Yet the subsequently more vexed issue of the attribution to Titian reflects inevitably on the central use which he makes of Titian's authorship in the process of conducting his interpretation. It is not simply that we start with Titian, as the unquestioned author of the work, but also that we end up with Titian, as the old man who has put his deepest feelings into the "moving human document." As with the Chinese boxes, we have arrived at a secret inward space. But is this process in any way a general guide

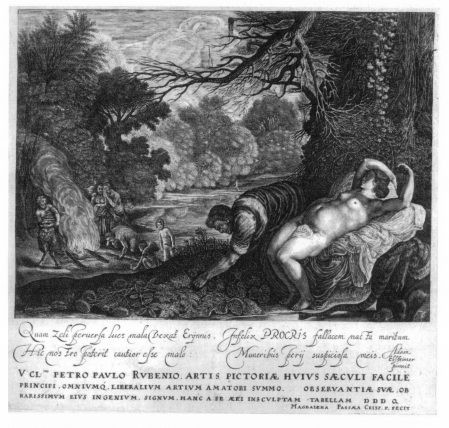

7.1 Magdalena de Passe, *Apollo and Coronis*. Engraving after Adam Elsheimer, ca. 1625. British Museum, Department of Prints and Drawings, London.

to the strategies that we might adopt in teasing the meaning out of any number of other, less seemingly distinctive works of visual art?

I intend to test the proposition which is implicit in this question by looking at a work which fulfills virtually none of the criteria met by Titian's *Allegory of Prudence;* and in this way, I hope to be in a position to reassess the mode of strong interpretation advocated in *Meaning in the Visual Arts.* The first point to be emphasized in introducing my example is that it does not have just one author. In fact, no less than four artists have left their mark in the textual material which accompanies the image. Thus the initial task is to sort out the complex personal and professional linkages that are implied by their simultaneous appearance in the text appended to this fine seventeenth-century engraving.

To look first of all in the bottom right-hand corner of the work (Plate 7.1) is the approach which pays off, here as with the majority of visual works in the

Western tradition. "Magdalena Passaea Crisp. F. Fecit." The discreet, neatly engraved capitals indicate that the print was "made" by Magdalena de Passe, daughter of Crispin de Passe, and hence of a member of a flourishing family of engravers working in the Low Countries at the beginning of the seventeenth century. Crispin de Passe was born in the Dutch province of Zeeland around 1564, and enrolled with the Guild of Saint Luke in Antwerp in 1584/85; he was, however, a member of the Protestant sect known as the Mennonites, and the capture of Antwerp by the Spanish forces in 1585 forced him to leave the city. After making his home in Cologne for some years, he was once again obliged to move on as a result of a decree published in 1611 and became established in Utrecht, where he died in 1637.

The bare details of Crispin de Passe's life have only recently been established (see Luijten and Van Suchtelen 1993, 313). They indicate a pattern which is familiar from the years in which the Low Countries gradually became divided, along religious lines, between the southern provinces controlled by Catholic Spain and the Dutch United Provinces of the North, which were vindicating their civil and religious liberty. Crispin probably trained as a draftsman and engraver in a Haarlem studio, then made his brief and unsuccessful sortie to the rich Flemish city of Antwerp: his later years, in Utrecht, coincided with the growing prosperity of the emancipated Dutch provinces and the consequent beginnings of the "golden age" of Dutch art.

Engraving was a collective affair for the de Passe family. A contemporary diary notes a visit to the artist's shop at Cologne in 1599, when his wife Magdalena de Bock (herself the niece of the Antwerp painter Marten de Vos) was in charge. Four of the five children born to Crispin and Magdalena trained in the family workshop as engravers, including their daughter Magdalena who appends her name (and her father's name) to this engraving. It seems as though the young Magdalena, who was born around 1600, traveled less widely than her three brothers, who were established at different times as far afield as London, Copenhagen, and Paris. She was married, shortly after 1624, and became established in Utrecht, where she died, the year after her father, in 1638.

These bare details merely scratch the surface of a prodigious amount of activity undertaken by the de Passe family over these years: it is calculated that their total output amounted to "more than 1,400 prints and 50 illustrated works" (313). Within the family, there appears to have been some degree of specialization as far as the different genres and subjects were concerned. Crispin de Passe himself acquired fame at Cologne by portrait studies of prominent citizens, which he was evidently authorized to dedicate to his sitters. He did, however, also work on mythological and allegorical scenes. Yet it is not directly to her father that Magdalena de Passe is indebted for the subject, style, and visual presentation of this engraving. The crucial link must be with another artist established in Utrecht during the period, but one who had developed a far more cosmopolitan acquaintance with the art of the period and whose noble

birth must have given him a special cachet in the artistic community: the engraver Hendrick Goudt.

With Goudt, the northern European context in which I have placed the de Passe family enterprise begins to appear inadequate. It can be borne in mind that Magdalena's maternal grandfather, Marten de Vos, had spent six years in Italy, at Rome first of all and subsequently in Venice, where "he is said to have worked as a landscape assistant to Tintoretto" (Murray 1989, 443). But Marten de Vos died in 1603, during Magdalena's early childhood. By contrast, Hendrick Goudt had spent a number of years in Rome, from 1606 onwards, and had formed a particularly close relationship with the German-born artist, Adam Elsheimer, whose remarkable oil paintings on copper plates he appears to have purchased and, from 1608, used as the basis for his own engravings. The work with which we are concerned, engraved by Magdalena de Passe, bears all the characteristics of this singular and specialized mode of production. Like Goudt, Magdalena de Passe composes her engraving "after" an oil painting by this particular artist: like him, she credits the painter in an elegant italic formula, "Adam Elsheimer pinxit"; like him, she includes a set of verses in Latin to sum up the moral implications of the scene depicted; like him, she includes a dedication to a prestigious figure as a prominent feature of the engraved text.

I have deliberately (but not, I hope, excessively) insisted on the multiple connections which are to be taken into account in interpreting this little work, by contrast with the splendid isolation of the individual author in the case of Titian's *Allegory of Prudence*. In this case, the work is enmeshed in a close texture of relationships which make it virtually impossible to separate out the stake of an individual authorship. Numerous interpersonal debts are involved here: that of Magdalena to her father Crispin, who taught her to engrave, as well as to her mother (and through her mother to the "Italianizing" Antwerp painter, Marten de Vos); that of Magdalena to Hendrick Goudt, who must have shown her his superb engravings, and possibly the work by Elsheimer after which she made her own; and finally that of Goudt himself to Elsheimer, which was no ordinary relationship of patron to artist. Just as Goudt's seven famous prints after Elsheimer established his reputation as one of the finest northern engravers of the century, so his success in publicizing the work of this northern artist who had made his home in Rome succeeded in establishing Elsheimer's fame in northern Europe (Luijten and Van Suchtelen 1993, 306). The print by Magdalena de Passe is the continuing evidence of the artistic debt contracted by Goudt to this outstanding, yet still mysterious painter of the early seventeenth century, who had died at Rome in 1610.

It may appear perverse—now that the cat is out of the bag, and Elsheimer's painting is acknowledged as the source of this engraving—for me to have chosen to concentrate on the engraving rather than the painting. This is for a particular reason, which will shortly become clear. But it is also for a more general reason, which I indicated in my brief epigraph from T. S. Eliot. The

point that no poet or artist "has his complete meaning alone" has been suffi-ciently appreciated in the case of literature. The critic Harold Bloom has gone so far as to assert that "there are *no* texts, but only relationships *between* texts," and these relationships depend on "a critical act, a misreading or misprision, that one poet performs upon another" (Bloom 1975, 3). The art historian Norman Bryson has extended this intuition by suggesting that, in the visual arts, tradition has an even more constraining effect because the image maker "lacks access to any comparable flow (at least before the mass dissemination of imagery)" (Bryson 1984, xvii). The example which I have chosen takes for granted the prior existence of the earlier painting as a constraining force: the priority of Elsheimer's painting is, after all, clearly declared in the textual mate-rial. But it also enables us to invoke a more useful notion of tradition, which is broadly implicit in the high-sounding dedication of the print not to a poten-tate of Rome (as Goudt was wont to do) but to the prince of Flemish painters: Peter Paul Rubens.

Elsheimer's special significance for Rubens is well attested. After entering the Guild of Saint Luke at Antwerp in 1598, Rubens traveled to Italy in 1600 and became court painter to the duke of Mantua. His meeting with Elsheimer in Rome took place in 1606, and the evidence of his letters shows the remark-able effect which these tiny, jewel-like oil paintings on copper exercised on the artist who was to become the most significant northern exponent of the ba-roque. When he learned in 1611 of Elsheimer's death, he wrote that "our entire profession ought to clothe itself in mourning . . . in my opinion he had no equal in small figures, in Landscapes, and in many other subjects" (Andrews 1977, 51). There is an immediate appropriateness in the fact that Magdalena de Passe, whose grandfather had been influential in bringing the Venetian style back to Antwerp, should have dedicated this engraving after Elsheimer to the artist who made Antwerp and Flanders the center of northern Italianate paint-ing: "Peter Paul Rubens, easily the first in the art of painting in our century and supreme lover of all the liberal arts"; and moreover, that she should have chosen to do so through the token of a work by a painter whom Rubens valued so highly.

I have deliberately chosen to focus, in this example, on a work where the stakes of authorship are not clearly indicated. But one thing is obvious. This engraving forms a kind of relay between Elsheimer and Rubens, or, more precisely, between the small, highly original works of a uniquely important northern artist who worked in Rome and the eventual achievement of another northern artist who contrived to establish the high style of the Italian baroque in a Flemish context. What kind of relay, precisely, does the engraving form? Clearly, it is not like the *Allegory of Prudence,* in Panofsky's interpretation, which is put forward as the possible cover of a "little cupboard" containing the artist's most private documents, thus giving access, either actually or metaphorically, to the inmost secrets of his mind. On the contrary, this engraving gives access,

purely and simply, to another work of art, which is the painting by Adam Elsheimer: Magdalena de Passe's personal stake may, at a later stage in the argument, be accessible to recuperation, but for the moment, it is difficult to discern. What we need to investigate next, therefore, is the precise relationship between the two works, and this will require, for the first time, an interpretation of their subject matter.

The German painter and biographer, Joachim von Sandrart, who included an invaluable life of Adam Elsheimer in his *Teutsche Akademie* (1675–79), gave his own forthright opinion on the relationship of Magdalena de Passe and Goudt as engravers, to the original paintings of Elsheimer:

> his works, of which he painted few, but excellently well on copper . . . were used by Magdalena de Pas [*sic*] and others for engraving . . . although [Goudt] often attempted to engrave [one of these works] on copper as faithfully as possible he was never able to reach complete excellence, because it is impossible that the art of engraving can equal that of painting. Although Goudt's engravings excel others, these engravings show up their inferiority when they are compared with the original paintings from which they were made—they are diminished in the same way as earthly light is diminished and shamed by the clear sun. (Andrews 1977, 56)

Here is an initial warning, then, about the limitations of the medium in which Goudt and Magdalena de Passe were working. Engraving could not, by its very nature, achieve the "excellence" of painting. It was condemned to be, at best, an interpretation or more exactly a misinterpretation of the original work. Sandrart carefully chooses the metaphor of the sun's relationship to earthly light to express this relentless subordination of the print to the painting. And we shall see in a moment that this choice of terms is specially illuminating in the case that we have before us. But as misinterpretation, in the technical sense of an engraver approximately translating the effects of a painter, has now become an issue, it might as well be admitted that this work by Magdalena de Passe is, in an even more direct sense, a misinterpretation. This sedulous engraver, whether consciously or unconsciously, actually misinterprets the scene from Ovid's *Metamorphoses* which was the chosen mythological theme of Elsheimer's painting.

A nymph is lying on her back, with her arms raised, to the right-hand side of the picture (in the painting by Elsheimer, she lies to the left, as the engraving necessarily involves a reversal of directions). By her side, a male figure is bending down to gather some flowering plants, while, in the background, a group of people are preparing a fire. I am trying, in this brief description, to remain within Panofsky's category of "primary or natural subject matter" which can be either "factual" or "expressional"; and I am already conscious of having trespassed into the "iconographic" domain by calling the recumbent woman a "nymph," just as I have restrained myself from making the equally coded point

that the person to the left of the fire is a satyr, with furry haunches and cloven feet. Nevertheless, I can try to make a little more headway in my interpretation by paying attention simply to those "expressional" features of the image. The recumbent woman is either sleeping or in a much graver predicament. When I notice the arrow at her feet, with its stained tip, and the troubled expression of the bending companion, I begin to suspect that the second alternative is more likely: I begin to detect a look of apprehension in the glance which the naked child directs towards the foreground scene.

Magdalena de Passe has made it unnecessary for the reader to puzzle more strenuously over the meaning of the scene by including four lines of Latin verse, in the same stylish italic hand as the acknowledgment to Elsheimer (Goudt habitually included verses of this kind in his prints after Elsheimer, and it is more than likely that Magdalena de Passe was following his practice, if not employing his poetic collaborator, Janus Rutgers.) These are cautionary lines, pointing out the dangers of an ill-directed zeal and drawing our attention to the "unhappy Procris" who perished at the hands of her husband, victim of the very gifts which she had endowed him with. To a person familiar with Ovid's *Metamorphoses,* a Latin text widely diffused during the post-Renaissance period, the very word Procris would have been enough to call forth the entire myth upon which the printed verses tendentiously comment. Ovid tells the story of the warrior Cephalus, married to the beautiful Procris, who had made him a present of a dog (originally the gift of the goddess Diana) and a splendid javelin. Cephalus had originally doubted the faithfulness of his wife, and the gifts had been the result of their reconciliation. But the javelin was to prove fatal to her in the end. As she, in her turn, spied on her husband while he went hunting, the deluded Cephalus, thinking he heard a "wild creature" in the woods, hurled his javelin in the direction of the suspicious sound and mortally wounded his wife. Despite a final reconciliation in the moments remaining to them, Cephalus was forced to witness his wife's death agony as a result of his own incautious action (Ovid 1955, 173–88).

The myth of Cephalus and Procris is not unknown as a subject for Renaissance painters. One of Piero di Cosimo's finest works is generally known as *The Death of Procris* (ca. 1500–10, National Gallery, London). It involves, in addition to the dead woman, what may be the faithful hound given by Diana and an attendant faun who, in a play by Niccolò da Correggio based on the Ovidian theme, is himself in love with Procris and led her to suspect her husband in the first place (see Fermor 1993, 49–54). But Piero di Cosimo's *Death of Procris*—if this be in fact the subject of the painting—includes neither Cephalus himself nor the javelin (*iaculum*) which did the deed. It depicts not the story as told by Ovid, but the process of "mourning" ensuing from it (50) which was indeed a prominent feature of Correggio's play.

What reason is there to suppose that Magdalena de Passe's engraving and the original painting by Elsheimer to which it refers do indeed represent the

Death of Procris and do so in a fashion which reflects more faithfully the Ovidian myth? The first point to be borne in mind is that the painting by Elsheimer and the engraving by Magdalena de Passe were both known under that title until 1951, when the German art historian Holzinger proposed another Ovidian subject for the two of them (see Andrews 1977, 151). But apart from what must now be seen as Magdalena de Passe's misinterpretation, there is remarkably little evidence for the labeling of the recumbent woman as Procris, and only an obstinate dedication to the traditional title can justify its retention (see Sello 1988, 75–78). To try to interpret the engraving in the light of the Procris myth is to be met, at each stage of the interpretation, by a puzzle or nonsense. In Ovid, Cephalus "tear[s] the dress from [Procris's] breast . . . [binds] up her cruel wounds, and [tries] to staunch the blood" (Ovid 1955, 178). But what is he doing here, as he rifles through the vegetation? Piero di Cosimo shows the clothed body of Procris as compatible with this description and includes Diana's dog, though the javelin has been cleared away. But here there is no dog, and indeed no javelin: the weapon that lies bloodied at the nymph's feet is unquestionably an arrow.

What are we to make of Magdalena de Passe's misinterpretation? The issue can be approached in several different ways. First of all, as has been shown, she had no direct acquaintance with Elsheimer. She may well have been acquainted with Goudt, who knew Elsheimer well enough to share a house with him and commission works from him, though the equivocal nature of their relationship is conveyed by Sandrart's claim that the painter was put into a debtor's prison because of his inability to complete the Dutchman's commissions (Andrews 1977, 56). She may well have accepted a title given by Goudt and seen no reason to check on the details of the Ovidian myth. What can be asserted without fear of contradiction is the fact that the Latin verses bring out the particular feature which, in representations of the *Death of Procris,* made such works appropriate for marriage gifts and wedding celebrations: reinterpreted as a *Death of Procris,* and glossed by the moralistic verses, it could be placed among "the class of images that functioned as examples of wifely virtue or of the consequences of inappropriate behaviour" (Fermor 1993, 51). Is it permissible to move in this way from a Renaissance painting, destined perhaps for a bridal chamber, to an engraving, whose decorative impact would, under any circumstances, have been much less significant? Is Magdalena de Passe uninterested in the subject and content with a text which at least constrains the iconography within a simple, moralistic theme, and may to some extent perhaps improve its salability among her Calvinist compatriots? The answer cannot be given unequivocally, and perhaps it is also impossible to get much further in assessing the stake of this dutiful daughter and (if the print dates from after 1624) wife in a representation of femininity which differs significantly from the one which Elsheimer intended. The mixture of history and speculation which has led to her immediate contemporary, the Italian painter Artemisia

Gentileschi, being credited with a direct subjective investment in the scene of male decapitation which she constructs (*Judith and Holofernes*) is inappropriate here (see Menzio 1979, 17–43). The skillful craftswoman effaces herself behind the scene which she has patiently re-created in another medium.

Yet it is precisely in this transcription to another medium, noted by Sandrart as an inevitable "diminishment" of the original painting, that the full extent of Magdalena de Passe's misinterpretation can be discerned. For the engraving does not simply suppress the "formal" values of the painting (Panofsky's "visual spectacle") in the necessary process of converting colors and tones into a network of black lines; it also abandons some of the features which work to establish the indissolubility of "form" and "content," giving a precise equivalent to Panofsky's "more-than-visual meaning." In order to appreciate this point, however, it is necessary to substitute for Cephalus and Procris the circumstances of another Ovidian myth: Apollo and Coronis.

The story of Apollo and Coronis can be found in book I of the *Metamorphoses* (Cephalus and Procris being featured in book VII). Again it is a tale of a jealous lover, misled by false testimony, who impulsively kills a blameless woman. The god Apollo "with the arrow that none can avoid, pierced the breast he had so often clasped to his own" (Ovid 1955, 66). Yet, besides the detail of the arrow, there is a constellation of features that betokens a more exact congruence between the circumstances of this myth and the scene of the engraving. Apollo, the god of healing as well as the relentless archer, attempts to "employ his healing art," and when this is in vain, snatches from Coronis's womb the son whom she was about to bear to him. We may read the image, then, as the record of Apollo's vain search for healing plants to avert his mistress's death, as the funeral pyre is already in preparation (another detail specified in Ovid's text). Abandoning the effort to save Coronis, Apollo will later "save from the flames" their son, who is destined to be the god of medicine, Aesculapius.

In declaring this interpretation to be more satisfactory than the one implied by Magdalena de Passe's textual additions, we are at the same time offering a test to our powers of imagination. The challenge is effectively this: can we see the central figure as a god, struck with remorse, searching the vegetation for healing balms? We may not find it easy to make any such interpretation of this clearly defined, anguished profile; we may indeed feel that if Magdalena de Passe interpreted the image as Cephalus and Procris, she may have wished to convey him as a simple huntsman, blessed with no healing powers.

At this point, there is every reason to transfer our attention to Elsheimer's painting, now labeled *Apollo and Coronis* (Walker Art Gallery, Liverpool). For the comparison between the painting and the engraving shows a surprising shift in tone and value, capable of bearing a "more-than-visual meaning." Where Magdalena de Passe has shown a meadow stretching into the distance beyond Apollo's profiled body, with a tiny figure striding along the sunlit sward, Elsheimer shows no perspectival depth, but a series of parallel bars of sunlight,

cutting through the dark trees (the tiny figure has evidently climbed one of them, to gather wood for the funeral pyre). In Elsheimer's painting, then, the death-dealing arrow at Coronis's feet is supplemented metonymically by these golden shafts, which also lighten the shoulder of the Sun God and kindle the cheek and forehead around his eye into a glowing half circle, as he tenderly adopts his healing role. Of this extraordinary interfusion between the theme of the Ovidian myth and the subtle plastic values calculated by Elsheimer, the engraving by Magdalena de Passe offers hardly a trace.

It may seem, by this stage, that the search for meaning has led us, paradoxically, to adopt an alibi; meaning lies, not in the engraving, but in the original painting. Yet, although I have used the term "original painting" as a methodological convenience, there is in fact no compelling reason to conclude that the work in the Walker Art Gallery was employed, directly or indirectly, by Magdalena de Passe. This particular *Apollo and Coronis* is indeed now regarded as "likely to be the original" (Andrews 1977, 151). But she may well have worked with other copies, since "few compositions by Elsheimer have been copied so frequently," and the effective misinterpretation, or reinterpretation, may have begun before she started her version.

And why should we stop at Elsheimer's *Apollo and Coronis,* once we have begun the task of working back, through the visual motifs which are transcribed (and traduced) in the engraving? It has always been recognized that Elsheimer's arrival in Venice, on his move from Germany to Italy, exposed him to an extraordinary wealth of recent painting in the Renaissance tradition, such as Tintoretto's immense cycle of works in the Scuola San Rocco (17). Despite the disparity between these vast paintings and the tiny oils on copper which Elsheimer produced, it is clear that his special talent (and the one appreciated by successors like Rubens and Rembrandt) was his ability to achieve the sureness of composition usually associated with these large-scale machines on an intimate, miniature level. *Apollo and Coronis* echoes Tintoretto in two specific respects: the recumbent Coronis recalls the female figure, also with a thrown-back arm, who occupies the left foreground in the *Massacre of the Innocents* in the Scuola San Rocco; Apollo reaching for his plants repeats the motif, even taking into account the oblique distribution of light, of the figure searching for stones in the left foreground of the *Martyrdom of Saint Stephen* in the Palladian church of San Giorgio. The fact that the former painting by Tintoretto illustrates a woman who is about to be deprived of her children, by violence, while the latter again shows a violent act in preparation, as the figure prepares to hurl his stones, is surely significant. Elsheimer has not only condensed these figures to a fraction of their size, but also expressed their destiny as beneficent, rather than violent: the unborn child will be saved, and Apollo's healing power transferred to him. The artist also interprets, and misinterprets.

Where Magdalena de Passe's engraving might lead us, as a further stage of interpretation, is still open at the end of this essay. I have tried to show that

Panofsky's ideal model of interpretation, though seductive in particular cases, prejudges many important issues, notably in its assumption of a series of distinct stages, from the "pre-iconographic" to the "iconological" and in its dependence on a stable notion of authorship. In my example, the stakes of authorship were more widely distributed, and the idea of a progression from "visual spectacle" through layers of iconographic meaning was replaced by a movement from the engraving to the "original" painting, whose plastic values were found to be integrally linked to its meaning. Have we abandoned completely Panofsky's iconological stage and the ultimate goal represented by the suggestion that Titian put his deepest hopes and fears into the *Allegory of Prudence*? In a sense this is so, and the obscure biography of Adam Elsheimer lends little support for any such speculation. But one thing is clear. Both in *Apollo and Coronis* and in his repeated subject of *Tobias and the Angel* Elsheimer concerns himself with the arts of medicine. In the former, he conjures up the circumstances for the birth of the god of healing, while in the latter he takes an obscure story from the Apocrypha, of a son who cures his father with the liver of a miraculous fish. To presuppose that Elsheimer was attentive to these fables of healing is not necessarily to assume that he had a personal psychological investment in this beneficent theme. It is also possible, for example, that he had friends, or even patrons, in professional medical circles. What may be the most attractive idea to pursue, elsewhere than here, is the possibility that he saw in the long, laborious work of painting his tiny images, and in the quasi-alchemical preparation of his pigments, a powerful and congenial analogy to the arts of healing: these would indeed be images to heal and save. To track this issue further, however, would lead not into the personal history of one man, but into the wider social and cultural history of the arts in the Western tradition.

SUGGESTED READINGS

Andrews, Keith. 1977. *Adam Elsheimer: Paintings, Drawings, Prints.*

Bloom, Harold. 1975. *A Map of Misreading.*

Bryson, Norman. 1984. *Tradition and Desire: From David to Delacroix.*

Crary, Jonathan. 1990. *Techniques of the Observer: On Vision and Modernity in the Nineteenth Century.*

Eliot, T. S. 1976. *The Sacred Wood.*

Fermor, Sharon. 1993. *Piero di Cosimo: Fiction, Invention, and Fantasia.*

Holly, Michael Ann. 1984. *Panofsky and the Foundations of Art History.*

Luijten, Ger, and Ariane Van Suchtelen, eds. 1993. *Dawn of the Golden Age: Northern Netherlandish Art 1580–1620.*

Menzio, Eva. 1979. "Self-Portrait in the Guise of Painting."

Mukarovsky, Jan. 1988. "Art as Semiological Fact."

Ovid. 1955. *Metamorphoses,* translated by Mary M. Innes.

Panofsky, Erwin. 1970. *Meaning in the Visual Arts.*

Sello, Gottfried. 1988. *Adam Elsheimer.*

HISTORIES

Originality

Richard Shiff

How did our world—everything—originate? Here are two classic Western accounts, one pagan, the other Judeo-Christian. In the *Timaeus,* Plato's creator gives preexisting from to preexisting matter, setting time in motion and instituting change. In the *Confessions,* Augustine's God performs a more radical act, creating "something, and out of nothing." For the historian these narratives serve much the same inaugural purpose, because history cannot proceed without both time and a "something," a material substance that grows or decays into everything we know and which, if unmoved or unanimated, might as well be "nothing."

We motivate and narrate history as if to imply it once had a beginning. Where do artists fit into this history? They enter rather than originate. In 1822, advising fellow painters to build upon the creativity of predecessors—that is, to start at some established point and with something in hand—Ingres uttered what was for him a simple truth: "You don't get anything from nothing" (Boyer d'Agen 1909, 91). As latecomers, artists can play neither pagan prime mover nor Christian God (Prime Innovator). Beginning with what has already been created (the something), they enter into historical traditions, their language of form having already been spoken.

Originality implies some sense of coming first or doing first, a priority or lack of precedent; it therefore cannot be divorced from considerations of chronology and historical sequence. It is also linked to issues of class, a kind of social priority or lineage (one inherits class status and property, just as one does an artistic tradition). If artists must use what has already been shaped, how can they and their artworks attain originality? Perhaps originality is transmissible (the artist as inheritor and bearer of original first principles, a set of universal truths). And perhaps originality is manifested when one alters existing directions or forces (the artist as countercultural deviator of a tradition or as social deviant).

Our problem is not that the question of artistic originality has no reasonable answer, but that reasonable opinion divides. The concept of artistic originality becomes subject to the same irony that characterizes other central cultural constructs: because different positions on the topic prevail in different eras, originality may lack an essence or fixed center, having instead an irregular history. So we can ask not only what might be the historical origin of a particular practice or tradition, but also what might be the origin of or motivation for a particular sense of originality. There exists no single correct solution to the

problem of originality; investigating it, we distinguish a "modern" attitude from its "classical" counterpart, and perhaps also a "postmodern" variant. Such categories have historical foundation, yet do not correspond to a natural evolution with a definitive chronological sequence. The modern does not follow necessarily from the classical, nor is the classical forever superseded; expressions of the classical position can be found in our present.

The question of originality becomes a matter of what people at a given time believe, why they believe it, and how they express their belief. By the early nineteenth century Western culture appears to have shifted from a predominantly classical attitude to a predominantly modern one, if only because European romantics proclaimed this momentous event, arrogating originality as their own (the self-conceived romantic or modern artist as original deviator, forever beginning anew). Given their stress on individual experience, romantics regarded classicism as a thing of the past for two reasons, one related to its normative values, the other to its communal identity. In its first capacity, as the bearer of order and hierarchy, classicism tended to regularize and restrain. It thus interfered with precisely those forces that constituted modernity and its particular originality—the private citizen's free movement and personal growth (furthered by the vicissitudes of individual experience) and the open-ended social evolution fostered by an emerging industrial economy. In its second capacity as a marker of community, classicism promoted the spiritual and social harmony so difficult to maintain in the wake of modernity's transformations of the social order. In this respect, the loss of classicism was mourned as much as celebrated by nineteenth-century theorists.

Historians have connected the shift from classic to romantic-modern with changes in class structure, including a decline of aristocratic social hierarchies and an accompanying rise of the bourgeoisie. In the social realm, a "classic" society—agrarian, rural, oligarchical—gradually yields to a "modern" society—industrial, urban, democratic. Exemplary members of oligarchical society are those who inherit and embody traditions of knowledge appropriate to their privileged class. Exemplary members of democratic society are those who educate themselves through individualized experience, which is different for each person but available to all.

Because classical values and methods tended to be codified (assuming textbook form, as it were), champions of modernity often called their more classicist colleagues "academic." The term suggested an artistic practice founded on rote learning rather than expressive idiosyncrasy and diversity; it also alluded to the professional recognition offered by institutions such as state academies of fine arts that, whether admitting to it or not, promoted standardization. So when nineteenth-century art critics advised painters and sculptors to find their model in nature (the "original" source they were to imitate), a political argument was implicit: artists, as well as anyone else, would prosper in the absence of authoritative, aristocratic antecedents in matters of culture or in any other aspect of political life. Facing nature freely and relying on their own experience, they

would find all they needed. Their compositions would be ready-made, with the picture—as critic Théophile Thoré argued in 1847—already "complete" in nature and superior to any academic reduction or recombination (Thoré 1893, 1:538–39). For Thoré, nature would do what art did for Ingres, providing the "something" from which to work. Yet this modernist claim to nature had a serious rival. Some argued that when classicists turned to Greek art for inspiration this, too, was to work from nature, since the ancients (as the first artists) had themselves no classical model to follow; they used nature directly, capturing its truth for the first time (Diderot 1957–67, 3:61–62; Quatremère de Quincy 1837, 103). Nature's originality could be adequately transmitted to the moderns through these ancient sources, whose style of representation had no precedent and therefore nothing from which to deviate.

Obviously, classical and modern variants of originality conflict. A number of antiessentialist and decentering perspectives have cast suspicion on both of them. Let me group such positions together under the rubric "poststructuralist"—here in preference to "postmodernist"—to signal the influence of such theorists as Jacques Derrida (his critique of the "origin" of language [Derrida 1974, 165–268]) and Jacques Lacan (his analysis of the construction of the self in language [Lacan 1977a, 146–78]). Poststructuralists argue that belief in originality as conceived in the Western tradition entails isolating a central origin; this is to privilege one term above all others from within what must be a continuously reconfigured matrix of language and representation, a system without a center. When the center is not evident, both classicists and modernists assume it nevertheless exists, but is hidden or has been "lost." It therefore becomes the object of an artistic search. For classicists, the center, origin, or privileged representational term might be God, nature, community, or truth; for modernists, it might be true feeling, unmediated experience, individuality, or the essential self.

We can leave poststructuralist doubt aside for the moment (it will quickly return) as we attempt to picture history with a center. Imagine (like a classicist, a modernist, or nearly anyone conducting his or her everyday life) that the history of human endeavor has a unique point of origin, and that history expands from this point like a big bang universe. History might therefore assume the form of a sphere with the original moment of creation at its center. Or better, a cone, since the position of the vertex will imply movement outward in one direction only, say, from left to right in a delimited pictorial field (like time moving forward). But already it is tempting to conclude—along with poststructuralists and others preceding them who questioned the absolute integrity of any discourse, medium, or mentality—that modes of representation prefigure what can be imagined. For without the frame being used to picture it, why should the cone have any particular orientation? Features of the preexisting representational or linguistic context give an image a sense of direction, a range of meaning toward which the image will tend.

The framed conical figure encourages us to conceive time as linear; yet this

figure also accommodates spatial and generational expansion (a widening of the cone), corresponding to our notion that events proliferate as they move ahead in sequence. Now, if history is a cone, do artists attain originality by referring to or rediscovering its vertex, the singular point of origin, as if to follow the stream of history backwards, narrowing back to its central source? Or does originality appear only when artists innovate, as if to move outside of, or to the margins of, or to divert, history's conical flow? If the latter, where is the source, the origin? And is it somehow transformed?

Before nineteenth-century romantics complicated the matter, classically minded art theorists had no difficulty distinguishing two modes of transformation: "imitations" of sources and "copies" of the same. With imitation they associated a certain originality. They argued that imitation is an interpretive act involving a degree of difference between the model (the "original") and its copy, whereas copying is an attempt at mechanistic replication (Shiff 1984, 92–93). Both procedures amount to the creation of a form analogous to that of its original. In the case of copying, the principle of transformation can be described in terms of a geometric or mathematical algorithm. An artist might "copy" either a natural scene or a painting by applying a grid and reducing all measurements to one half or one quarter the original, allowing no exceptions. Or an artist might systematically convert all hues to a set of ten or perhaps only three grays. Photography does something of the sort, often applying a systematic reduction of both size and color according to the specifications of the lens and film—hence the modernist charge that this medium inhibits the free exercise of originality. In the case of "imitation," however, the principle of transformation is free and irregular; it is as if new, potentially radical, interpretive decisions are made at every moment in the process. The source of such idiosyncrasy is an artist who follows no codified rule but responds at every moment to changes in his or her environmental and psychological situation. If the artist's practice follows a law, it is internalized and invisible: spontaneous rule by person rather than predictable rule by system. With "imitation," the individual artist becomes as much of a center as the model, perhaps seeking something hidden or lost within.

Does this mean that the originality to be associated with "imitation" must be the province of modernists? Not necessarily. Consider the classical position as presented in two related commentaries on the Renaissance master Raphael, commentaries by two citizens of early modern society; the authors in question are Sir Joshua Reynolds and A.-C. Quatremère de Quincy (friend and admirer of Ingres), both of whom presided over modern academies for which they composed "classical" theory. According to Reynolds (1774), Raphael took "so many models, that he became himself a model for all succeeding painters, always imitating, and always original" (Reynolds 1975, 104). Reynolds's "imitation" verges on a composite "copying." His logic may seem obscure to those immersed in late modernist forms of creation: How can such imitation end in a

fundamental originality? Reynolds appears to condone eclecticism and repetition, perhaps even plagiarism, at the expense of authenticity and innovation. An element of Quatremère's praise of Raphael helps to resolve this apparent contradiction: "Once a beautiful thought has been struck with the mark of genius, there is also genius in refraining from giving it a new imprint" (Quatremère de Quincy 1835, 241–42). Repetition, it seems, is not necessarily the enemy of genius. An artist can exercise creativity by acknowledging what ought to be reiterated.

But where does this leave originality? Given Quatremère's position, Raphael's choice of features worthy of the effort of his imitation makes him original in two senses. First, he creates particularly effective combinations, actually enriching the standard imagery with new, albeit hybrid forms derived from his multiple sources; classicists had a special term for this, calling it "invention." Second, Raphael imitates only the very best of all discernible qualities. If we presume that Raphael's antecedents did the same—indeed, in their commentaries both Reynolds and Quatremère invoke the precedent of Masaccio, and before him the precedent of the ancients—then we understand that at least some element of the earliest artistic form necessarily passes into Raphael's art through a timeless process of genius recognizing, emulating, and re-creating genius. What results is an expression of Western culture as a set of collective, anonymous values. There is further implication: the principle of classical anonymity entails that predecessors resemble followers as much as followers resemble predecessors; thus, classical originality has little to do with one's position in a sequence of "geniuses" but depends instead on whether one participates in transmitting a culture's primordial values. Priority becomes a matter of rediscovering and disseminating first principles which (it must be concluded) have no independent alternatives. Classical artists work not to innovate but to preserve established priorities. Their originality entails a certain sameness.

That, at least, is the classical position in the eyes of "modernist" artists. They assume the role of revolutionaries either by introducing change, returning to values long lost from the classical hierarchy, or representing truths in personalized, perhaps deviant, expressive form. It might be argued that in Italian Renaissance art the form had already become identified with its individual creator and was therefore "modern" (cf. Belting 1994, 471–72). Nineteenth-century romantics nevertheless adopted this position as their own, as if it were their exclusive property. Modernists have a certain hubris. Often arguing that they lack true precedent, they conceive of *themselves* (not their principles) as original and seek originality by realizing their inner feelings, thoughts, and character. Manet once represented his aesthetic by stating that he "sought simply to be himself, and not another" (Moreau-Nélaton 1926, 1:87). Accordingly, romantics and modernists associate artistic authenticity with an expressive manner so autonomous that it must also appear innovative, in opposition to the value a classicist might locate in selective repetition. Delacroix, for example, claimed

that because he had achieved mastery, others would copy him; but he would feel no need to imitate anything himself (Dumas 1867, 1:858). His contemporary Thoré characterized original artists as "sons of no one" who "proceed from their own innateness" (Thoré 1893, 1:289–90). Another critic of the time argued that the "true originality" of those like Delacroix would never be imitated successfully, being too idiosyncratic to be transmitted to pupils; whereas Ingres's classical style possessed a regularity that allowed his students to "simulat[e] any work whatever of [their] professor" (Chesneau 1862, 269). This accessibility rendered the master unoriginal by modernist standards. The lesson is this: classics repeat; moderns should not, except when reiterating what belongs to each one of them alone, their personal style.

Because a borrowed or preexisting form has already served as another's expression, priority for the modern artist becomes a matter of establishing a new principle in a new form, that is to say, an idiosyncratic manner of working. Originality is becoming the first of oneself: "I am the primitive of my own way," Cézanne was reported to say (Gasquet 1926, 138). The precise words are probably not the painter's, but the sentiment is quintessentially modernist; and that is why this mythogenic statement has so often been quoted by art historians and critics despite the questionableness of its witness. Modernist originality is marked by difference at the source ("my own way"). The source is the self, and mastery becomes self-mastery.

To seek originality by stressing one's deviation from others has consequences in the social realm; it encourages a certain personal competition which in turn has economic implications. Artists sell their unique difference, but not always easily. Modernists saw the irony of struggling for market recognition in a world ruled by fashion, which itself follows a principle of uniqueness of a peculiar kind: fashion is novelty produced in multiple and multiauthored edition. "Nobody wants my work because it is different from that of others," wrote Gauguin to his dealer. He added immediately: "Strange, illogical public which demands the greatest possible originality from a painter and yet will not accept him unless he resembles all the others—[but] I do resemble those who resemble me, that is, those who imitate me" (Rewald 1986, 190). Thus Gauguin as modernist understood not only the conflict between innovation and fashion, but also one of the classical truths of originality—its commutability, the fact that the first in line might seem indistinguishable from the last, given successful acts of mediating imitation. Such imitation need not "copy" (that is, reproduce every detail) but need only preserve elements of particular interest and value to the society. "Original" artists themselves become commodities, subject to reproduction with respect to each one's originality factor, the point of interest. Sometimes that factor can be marketed more effectively by those who borrow it than by those who create it.

Gauguin knew that although artists might strive to express an inborn originality, they were attributed originality only if others saw the signs of it in their

person, in their work, or in their identifiable following. So originality appeared as an attribute that might pass or be passed, like a sign or signifier, from one artist to another. Attributes or signs are communal entities, not private property; they can be appropriated by anyone with access to and authority to use the artistic language. Just as nineteenth-century artists and critics focused on the cultural value of expressing originality, so they doubted the entire enterprise because the general signs of originality and authenticity, like the more specific signs of individual identity and authorship, could be faked: "For those who aspire to truth . . . what temptation to imitate instead of creating, and to fall into the intentional and regulated naiveté that can only be a mannerism like the academic formulas" (Vitet 1841, 58).

The preceding critical commentary dates from 1841 and is hardly unusual; it indicates a general awareness that representation forever threatens to displace, or even to rule over and determine, original and authentic truth. But such fear was not enough to prevent artists from acting on their desire for originality and self-expression as they created one modernist innovation after another, or at least what passed for innovation. It was left to the critic to question the sincerity and effectiveness of each artistic manner. During the past two decades artists have internalized the critic's anxiety more than ever before to the detriment of claims to originality. If, among many contemporary artists, originality and other modernist values now seem discredited, it is because artists have radicalized old suspicions, adopting poststructuralist theory to make their case.

The most discussed case has been Sherrie Levine. During the early 1980s she violated modernist standards of originality and propriety, becoming known as "an appropriator of images" (Owens 1982, 148). She rephotographed photographs by the likes of Edward Weston and Walker Evans in order to expose her antecedents' own appropriation of imagery and the operation of their work as market commodity. Levine's practice denied the originality of authorship that nineteenth-century romantics had once struggled to assert; she did not fear but sought to confirm the fact that language or representation overrides claims to a unique self. Moreover, she created her photographic imitations in opposition to what such practice would mean to a classicist—homage to the work of another who was judged as manifesting original genius and emulation of that genius and its methods.

Levine's photographs are by no means the strictest of copies. They display a subtle yet noticeable visual difference from their "classic" modernist sources, a relative paleness which evokes the gradual material degeneration that usually accompanies mechanical reproduction. This effect resulted because Levine's actual sources were already reproductions: in the case of Weston, for example, a gallery poster provided the image Levine copied; in other instances she used art books. Her use of reproductions reminds her viewer that photographs themselves derive from reproduction, a single negative (or positive) being used to generate multiples.

Levine began her photographic copying of famous photographs in 1979; during the early 1980s she also drew and painted after reproductions of works by artists such as de Kooning, Monet, and Schiele. Commodified book reproductions thus mediated between Levine's copies and the original manifestations of her source images, whether these originals were photographic prints or unique paintings and drawings. Just as Levine's photographic copies exhibited diminished tonal contrast, she often rendered her copies after oil paintings and collages in the less materially substantial medium of watercolor, bringing about a reduction. These watercolors, however, replicated the dimensions of the book reproductions that served as their immediate models; and by comparison with such "originals" the watercolors were actually the more lively, enlivened by the play of the hand visible in the strokes of pigment. So there is justice in claiming, as Levine eventually did, that her copies (both photographic and hand colored) display a certain personality original to the artist. These works assume indexical properties linking them to the hand and mind of their maker, who freely determined their particularities. A play of gender is suggested as well, because a female artist is transforming what once belonged to the domain of male expression. Here, originality is seen in the form of Levine's artistic autonomy, romantic deviance is enacted in her play of gender, and both of these modernist elements enter into a postmodernist practice.

Initially, Levine's supportive critics argued that her project undermined belief in the photographic print's faithfulness to a living model in front of the camera. They wanted to counter the assumption that photographs show things as they actually were at a given moment, independent of any number of social histories—the history of the medium, of representational images in general, of the construction of values that convert undistinguished objects into subjects desirable for photography. Theorizing Levine's activity, Douglas Crimp reasoned that no photograph could be traced back to or grounded by nature because photographers, conceiving their images and posing their models, would rely on or be influenced by an existing language of representation. Levine's copy of Edward Weston's photograph of his nude son Neil became the prime example. Crimp argued that the photographer's construction of his son's image drew on classical Greek sculpture, particularly the example of Praxiteles (Crimp 1980, 98–99). This is in fundamental agreement with the traditional understanding that artists always know not only "nature, but also works of art" (Friedländer 1941, 144). It also recalls the classical theorists' conflation of prime Greek exempla and the primordial source, nature. Yet the emphasis has shifted: art is no longer a path eventually leading back to nature, but a trace recording nothing beyond or deeper than other instances of itself.

In the spirit of Levine's poststructuralism, one would have to say that it was not an actual lack of originality she provocatively flaunted, but the *appearance* of such lack, that is to say, a sign, an absence (in this case, therefore, an absence of a lack). Unsympathetic observers might recognize this sign only too insis-

tently and literally, claiming to see "nothing" in her art rather than "something": no investment, no commitment, no personality. In interviews Levine often paraphrased poststructuralist principles that had already been articulated by others—here, too, a signal (presumably intended) that originality is lacking, not only in herself, but elsewhere. On one occasion she stated (or restated) that "desire," which custom takes to be an original product of a genetically and experientially unique being, "is always mediated through someone else's desire" (Siegel 1985, 143). This implies that even the most deeply personal sensations derive from the perceived feelings of others, represented and communicated as an available image.

Informed by the poststructuralist challenge to expressive originality, Levine's art seems to address this issue with the clarity of an illustration. Her work readily lends itself to critical commentary. A parallel case, that of Vija Celmins, has remained much less a topic of critical review. Perhaps—it is difficult to say—this is because Celmins's art raises questions as yet only marginally informed by current theoretical debate or lying just beyond the comprehension of theory.

While Levine was copying reproductions of art, Celmins, her somewhat older contemporary, was making renderings by hand of either her own or anonymous photographs of sublime natural expanses—the ocean, the desert, the stars. Between 1977 and 1982 she was also involved in an exceptional project, creating a work of trompe l'oeil sculptural imitation, *To Fix the Image in Memory* (Plate 8.1). When interviewed, Celmins explained her intention: "to affirm . . . the act of looking and making as a primal act of art [and] to create a challenge for [the] eyes" (Bartman 1992, 17). Straightforward enough. "Looking and making"—these are the actions artistic imitation requires, for the source or model (the object of looking) must be assessed in coordination with some active means of figuration (the making).

Having performed her imitation, Celmins challenges her viewer to discriminate between reality and artifice, original and derivative. The catalog for a recent exhibition describes the medium of *To Fix the Image in Memory* as "eleven pairs of acrylic-painted cast bronzes and original stones" (Tannenbaum 1992, 89). Each pairing consists of a stone the artist found in northern New Mexico and a bronze replica painted with acrylics to simulate aspects of the surface appearance of the "original." Celmins remarked that she included the original stones so the viewer might "relive [the] process of seeing. Of course, on close inspection, one sees that the 'made' piece is invented—an interpretation" (Bartman 1992, 20). Why does Celmins refer to invention and interpretation? Most likely because she made a judgment as to which visible features of the stones could be translated (and would be mutually compatible when translated) into the volume and surface of the imitation. Celmins's display includes both the stones and their imitations in a space bounded and enclosed like a miniature artist's studio—a perfected, self-sufficient environment in which models and represen-

8.1 Vija Celmins, *To Fix the Image in Memory,* 1977–82. McKee Gallery, New York. Photo: Robert E. Mates.

tations resemble one another, neither one assuming precedence. Have Celmins's models been chosen because they are appropriate to a desirable mode of representation—individual desert stones being selected as suitable for casting and painting, expansive oceans and ethereal galaxies selected for painting or drawing alone? Or has the manner of representation been determined after the fact of an independent choice of model? Holding model and representation in suspended juxtaposition, Celmins's display renders priorities undecidable. In her strange way, she re-creates a self-sufficient classical harmony of art and nature, a harmony usually presumed lost to the modern world.

The Celmins exhibition catalog refers to the New Mexico stones as "originals" and uses this term without self-consciousness. Repeating it now, I feel the unease of the postmodernist instead of experiencing some classical grace. I would prefer to say that each bronze and acrylic stone simulates its selected model rather than some "original." This would avoid the implication that a stone might have its special status as "original" or "natural" whether or not one selected it. What, in fact, is original about the chosen stones? That they existed

before their imitations were realized? That they guided a process of replication? That they are simply natural or found, and neither artificial nor made? To the contrary, the originality of nature's stones would seem to depend on a selective difference to be perceived between their appearance and that of their imitations.

In some respect the artist must create (be the origin of) such difference. I see nothing original when stones of the sort Celmins chose lie beneath my own feet; in fact, they are hardly noticeable. But when I see them in a display case beside bronze and acrylic imitations I become aware of their distinction, just as the artist imagined her viewers would. Perhaps Celmins's *To Fix the Image in Memory* bears an entirely appropriate title: images are transient and insubstantial, like the surface appearances created by acrylic paint; referring an image to memory connects it to a substantial past (Ingres's "something") and lends it permanence in the way that a classic manner sets a representation permanently into tradition. The stones Celmins found enter art and history when she converts them into a model or exemplum (and even more so when others comment on her action). Because the artist invests herself in the stones by imitating them, they become worthy of being imitated by others and a memorable image themselves. When one set of stones refers to another, we recognize a truth in what Sherrie Levine repeated with regard to desire—it must always arrive mediated by another's desire. One stone produces for the other its value. As Gauguin learned equally well from his frustration with the marketplace, desire is not "original" to, derived from, or satisfied by any particular person, time, or place. Like resemblance and like fashion, it circulates.

When Celmins created *To Fix the Image in Memory*, she converted nature into a source for art, giving it human content by transforming it into a living model through her act of selective imitation. As I have suggested, academics have been arguing with increasing insistence that representations take their form not from nature but from other representations (the notion is already well developed in Quatremère de Quincy's early nineteenth-century treatises). Academics now regard this as an antiessentialist, postmodernist position: nature-as-origin becomes a rigid absolute, whereas representation-as-origin, whether a product of personal psychology or social ideology, fluctuates in response to a history of needs and desires. Yet it is hard to imagine that Celmins's bronze and acrylic stones have any model other than the natural products they resemble. Are we therefore faced with an instance of representation that involves no prefiguration—a naked encounter with the model in nature? This would be analogous to Weston's having photographed his naked son, unaffected by any preexisting tradition of figuring the human body as nude in images—unaffected, that is, by canons of beauty, by canonized and fixated desire.

The problem is complicated in a way that usually goes unnoticed, which might explain why, in recent years, Sherrie Levine's copies of reproductions have received more critical attention than any copies of natural substances, including Celmins's sculptural study in imitation, *To Fix the Image in Memory*.

Levine offers a somewhat counterintuitive lesson, yet one our current critical-academic discourse openly encourages us to learn and master. Perhaps this lesson has become all too easy in her case, the visual and verbal discourses having become overly complicitous, belying the condition of incommensurability that Levine's theorists would ultimately wish to assert. To the contrary, Celmins's lesson is either too obvious to require translation or too obscure to support it. Unlike Levine's, Celmins's meaning seems more accessible to sensory experience than to conceptualization. Whether or not bodily knowledge exists apart from intellectual knowledge (a question best left open), it is quite possible to speculate that it does, and Celmins's art encourages such speculation. A division between intellectualism and physicality might explain the differing attractions and effects Levine's and Celmins's works have had. This is not to imply that the one is cerebral and the other physical, but that the balance between the two factors is somehow different, or has been perceived differently, in the case of these two artists.

Prefiguration does, I believe, affect Celmins's artificial stones, but not in the form of a prototype image or a representational schema. The artist's experience with techniques of rendering as well as awareness of her own physical capacities—her cognitive and kinesthetic habits, her mental and manual skills—these are the factors constituting the prefiguration. When an artist attempts to work as directly as possible from nature, the material process itself may determine the results, more than any previous product. Celmins imagines which material and visual features of natural stones can be transferred to bronze and acrylic, what sensory experience of the natural stones might be drawn from artificial ones, how to think of the nature of stones as something representable, how to convert nature into a model or source. Whatever is "original" in either model or representation emerges from this process. There are features of nature that the artist neglects, not because she experiences a failure of objectivity, but rather something like a failure of imagination or creative agency: she cannot see certain features in terms of the materials in use. Such features become visible in a kind of unpredictable feedback process only after the fact of Celmins's necessarily incomplete act of imitation; they are visible in the model because they are lacking in its likeness, visible because of difference. The most obvious of these features—although it takes some looking, which is the artist's aim—is the sparkle of tiny flakes of mica in the natural stones. Perhaps this effect might have been imitated by tiny droplets of glossy acrylic medium. Even so, some other difference would appear even if, as a last resort, stone were used to imitate stone.

Celmins's work demonstrates that nature and representation, or representation and nature, *together* signify difference without hierarchy. As it assumes its innumerable forms, such difference remains doubly original: always already there (primordial) and always newly apparent (innovatory). Both factors to this difference—substance and time, permanence and change—configure our

consciousness of the most ordinary experiences, including the kind Celmins investigated with such intensity.

By now I have perhaps come too far around and have reestablished the commonplaces concerning agency, time, and matter with which I began. The historian can hold such conclusion or fixation in suspension, temporarily evading it or rendering it contingent—that is to say, demonstrating its status as an effect of history as opposed to an inescapable product of logic. The historian does this by tracking the particular form of originality's configuration and the motivation for that form. Romantic originality, for example, might be viewed as corresponding to ideals of a modern social order and its republican government. The historian's option is to study the relative privilege and purview granted to each of originality's two competing aspects, primordialness and innovation, as their configuration may vary with the era, the culture, or even the person. In the writing of it, history becomes a sequence of dynamic constellations determined by the perspective of the historian, his or her choice of significant elements, and the prevailing drift of the discipline.

Historians themselves have individual histories and belong, like their discipline and its topics, to cultures marked by the conditions of an era. Their theories, their data, and their conclusions—as well as my own conclusions, even when I hold them in suspension—are subject to a critical analysis like that I have imposed on "originality." Indeed, the issue has not been to discover a conceptual or historical derivation or origin for originality, but rather to investigate the network of its changing appearances and effects, its ongoing play.

SUGGESTED READINGS

Bann, Stephen. 1989. *The True Vine: On Visual Representation and the Western Tradition.*
Benjamin, Walter. 1968c. "The Work of Art in the Age of Mechanical Reproduction."
Bloom, Harold. 1973. *The Anxiety of Influence: A Theory of Poetry.*
Castor, Grahame. 1964. *Pléiade Poetics: A Study in Sixteenth-Century Thought and Terminology.*
Collingwood, R. G. 1938. *The Principles of Art.*
Derrida, Jacques. 1976. *Of Grammatology,* translated by Gayatri Chakravorty Spivak.
Godfrey, Sima, ed. 1984. *The Anxiety of Anticipation.*
Greene, Thomas M. 1982. *The Light in Troy: Imitation and Discovery in Renaissance Poetry.*
Krauss, Rosalind E. 1985. *The Originality of the Avant-Garde and Other Modernist Myths.*
Lacan, Jacques. 1977a. *Ecrits: A Selection,* translated by Alan Sheridan.
Lacoue-Labarthe, Philippe. 1993. *The Subject of Philosophy,* edited by Thomas Trezise, translated by Gary M. Cole.
Millon, Henry A., ed. 1989. Retaining the Original: Multiple Originals, Copies, and Reproductions.
Shiff, Richard. 1984. *Cézanne and the End of Impressionism: A Study of the Theory, Technique, and Critical Evaluation of Modern Art.*

NINE

Appropriation

Robert S. Nelson

Two routes lead to a cemetery in a Middle American city in Texas, where my family has lived for many years. One meanders past rows of older bungalows, now being gentrified; another, busier and faster, leads down a commercial avenue of newer shops and offices. The cemetery itself is a large, spacious lawn, an ordinary place, never to be celebrated or mocked like Forest Lawn in Los Angeles, but to be denied or forgotten by the automobile traffic that hurries by, or to be remembered by those bearing memories of loved ones buried within. This cemetery, like most in America, eschews the extravagant displays of memorials that jostle each other and the visitor walking down the monument corridors of European cemeteries. It is a quieter, more bucolic place of death. But it is also a place of business, a part of a corporation that sells funerals, flowers, tombstones, and cemetery plots. What is spatial, social, and always commercial is also an apparatus for symbolically defining and controlling the place of burial. Coded and coated in as many different ways as human societies can imagine, graves are remembered by means of the signs given them by immediate relatives and later makers of meaning.

My father's grave is no exception. Near a large live oak tree is a simple grave marker, a small marble plaque on the ground with his name, dates of birth and death, and a religious symbol. Recently I revisited the grave by the quieter of the two routes, absorbed in the psychological preparations required to traverse the cemetery's boundaries and its liminal gate. About to pass through, I was rudely roused from my memories, startled, and ultimately offended by the sculpture that had been placed atop the gateway since my last visit. Before me stood small versions of those four magnificent gilded bronze horses that have long cantered above the main entrance to the church of San Marco in Venice (Plate 9.1). These horses and their various sitings are the focus of my exploration of the connection between art and personhood or identity, whether individual, corporate, civic, or national.

Dispatched on tour some years ago, what have come to be known as the horses of San Marco then received the standard exhibition catalog. More recently they have been the subject of scholarly monographs (e.g., Jacoff 1993). Thus the bronze statues are fully enshrined within the canon of art history. I shall return to their intricate histories at the end of my essay. At present, it is enough to report that in 1983 the horses were removed from the church's facade for preservation and installed inside the church, where they are presently seen not in the former soft light of the Venetian lagoon, but spotlighted, as

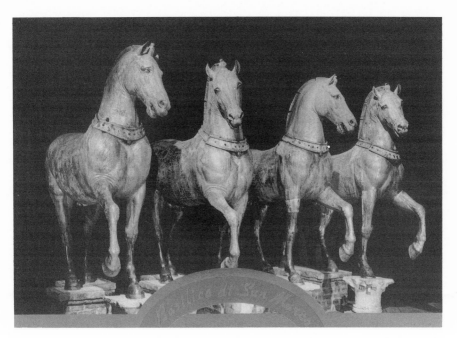

9.1 The Four Horses of San Marco, Venice. Roman, possibly 2d–3d century A.D. After a postcard, Ediz. Ardo, Venezia.

illustrated here, by that sharp, garish lighting common to museums and boutiques. Their replacements are dull, uninspired copies, wholly devoid of the aura of the historic original. But in comparison, the Texas versions are much less satisfactory, being the size of large dogs and made of some strange material, suspiciously synthetic in appearance, and being erected far from the Piazza di San Marco. Powerless to alter this symbolic manipulation of the cemetery's entrance and all within, including my father's grave, my only recourse as an academic, an art historian, and a student of Byzantine art, is what passes for the pen today, my keyboard, and my interventions in a process known as "appropriation." I will consider the term across several issues of contemporary art and art history.

Etymologically, the word "appropriation" could hardly be simpler or more innocent, deriving from the Latin *ad*, meaning "to," with the notion of "rendering to," and *proprius*, "own or personal," yielding in combination, *appropriare*, "to make one's own." Setting aside the governmental sense, as in appropriating or legislating funds for an organization, "to appropriate" today means to take something for one's own use and the adjective "appropriate" means annexed or attached, belonging to oneself, private, and suitable or proper. "Appropriate" also has more sinister connotations, implying an improper taking of something

and even abduction or theft. Taken positively or pejoratively, appropriation is not passive, objective, or disinterested, but active, subjective, and motivated.

Its application to art and art history is relatively recent and pertains to the artwork's adoption of preexisting elements. Such actions have been less successfully described as "borrowings," as if what is taken is ever repaid, or as "influences," that elusive agency, by which someone or something infects, informs, provokes, or guides the production or reception of the artwork. Michel Foucault has criticized the concept of influence, in particular, as belonging to a constellation of terms, which, if poorly understood theoretically, nevertheless function to affirm and maintain the continuity and integrity of history, tradition, and discourse. With typical syntactical complexity, but conceptual brilliance, he describes influence as a notion "which provides a support—of too magical a kind to be very amenable to analysis—for the facts of transmission and communication; which refers to an apparently causal process (but with neither rigorous delimitation nor theoretical definition) the phenomena of resemblance or repetition; which links, at a distance and through time—as if through the mediation of a medium of propagation—such defined unities as individual, *oeuvres*, notions, or theories" (Foucault 1972, 21). In regard to art history itself, Michael Baxandall (1985b, 58–92) also argued that influence occludes actor and agency. In contrast, the term "appropriation" locates both in the person of the maker or receiver. The difference between the two is the same as the grammatical distinction between the passive and active voices.

Theoretically, the term has been lately informed by the semiotics of Roland Barthes, especially his analysis of what he calls "myth." Myth, as he wrote in his book *Mythologies* of 1957, is a type of speech, a definition that consciously plays on the word's Greek origin, but also unintentionally reveals the linguistic basis and bias of French structuralism and poststructuralism. Myth is speech, for what Barthes is exploring is communication rather than an object or idea. He introduces the classic semiotic categories of the signified, the signifier, and their combination, known as the sign (for which see the entry elsewhere in this volume). Next he extends the concept of the sign by defining myth as a second order of signification. In myth, the first sign, the association of signifier and signified, is transformed into the signifier of a new signified and a component of the second sign. What once was complete and meaningful is taken over by the second system and made to stand for a new notion. Such a process can be repeated indefinitely. Barthes illustrates his theory with an analysis of the cover of a French magazine, which, like the horses at my father's cemetery, is described, not illustrated. Therefore before he even begins, Barthes makes an unacknowledged semiotic shift, the always complex translation of images into words (see chapter 4 on "word and image"). The same strategy is employed in another book, *Camera Lucida*, about a much discussed but never illustrated photograph of his mother.

What Barthes calls "myth" I should like to rename "appropriation," thereby

illustrating and enacting the theory by appropriating his myth. In so doing, I shift the meaning of his semiotic construction towards the personal so as to emphasize personal agency, not merely the play of signification. I also employ a word already used in English for similar procedures and one that is thus easier to reposition than "myth" with its firmer grounding in ordinary language. Appropriation is the process at work in the placement of the horses of San Marco atop a cemetery gate.

Once the four horses, standing before the city's major church and the doge's palace chapel, had been the signifier of Venice's greatness. In their shrunken version, the horses serve new masters, or rather the horses as sign of Venice, Art, or the Old World have become the signifier of a new signified. An ordinary cemetery is thereby redefined for reasons that I can only surmise. Was the intention to aggrandize the entrance through the application of art, even in the guise of poor copies, or merely to add more generalized signs of higher status, like the lions that provided a certain cachet to the entrances of newly built cultural institutions in America, e.g., the New York Public Library or the Art Institute of Chicago? Or was the basic notion of the horse itself the key value for the local culture? In Texas, the horse is still a vital sign of personal prestige, as it had been from antiquity and the Middle Ages (equestrian statues, knights in armor) until the Industrial Revolution and its replacement by the horseless carriage. The later application of equine names (e.g., Mustang) to automobiles serves to perpetuate the past and to disguise technological innovation.

In introducing appropriation, I have deliberately grounded the discussion in the details of my life, because the word, "properly" or etymologically, concerns the personal, giving the process conceptual power, but also semiotic instability. Like a radioactive isotope, appropriation or myth breaks down over time, either fading away or mutating into a new myth. Because appropriations, like jokes, are contextual and historical, they do not travel well, being suppressed or altered by new contexts and histories. Thus Ford, the company, not the car or the dead industrialist, spends millions to sustain the freshness and potency of its appropriations and to make them a part of collective discourse.

Appropriation, like myth, as Barthes explains, is a distortion, not a negation of the prior semiotic assemblage. When successful, it maintains but shifts the former connotations to create the new sign and accomplishes all this covertly, making the process appear ordinary or natural. The potency of the cemetery's horses, deriving from their previous associations, is now used to reposition, market, and advertise the cemetery, but all this is done rather quietly through the addition of reproductions at the entrance. Myth or appropriation is fundamental to modern advertising and to the abstracting and expropriating strategies of capitalism itself, which Marx attempted to describe in *Capital*. For Hal Foster (1985), the relation is concrete, not metaphorical, appropriation being the equivalent in the cultural sphere of capitalist expropriation of labor in the economic sphere. However, today these transformations are played out not in

the relatively simple economic structures of nineteenth-century cottage capital-ism, but among multinational industrial corporations, that economic landscape which Marxists wishfully like to term "late capitalism" but might, following recent developments, better be called post-Marxism. By whatever name, de-mand for products today is encouraged, if not created, by global advertising agencies, the true semiotic magicians of our world. For this contemporary economic order, the early work of Jean Baudrillard, a theoretician of symbolic capital, or David Harvey, a Marxist student of time and space, is helpful.

The signs that myth can appropriate, Barthes observed, are in some measure incomplete and therefore appropriatable. If complete or fully charged, the sign cannot be shifted—at least not covertly or without consequences. A case in point would be the many uses and abuses of the American flag in art and popular culture. There appropriation in excess of societal norms is continually subjected to proscription. When an appropriation does succeed, it works si-lently, breaching the body's defenses like a foreign organism and insinuating itself within, as if it were natural and wholly benign. Probably the horses at what I persist in calling my father's cemetery are ignored by most passersby. Accustomed to the appearance of animals at the thresholds of important struc-tures, motorists easily accept the imposition of animals atop a cemetery's gate and the proprietors' attempt to enhance the status of what they doubtless regard as their cemetery. Presumably the horses' long history of symbolic appropriation is little known to casual viewers driving by.

To defeat the working of myth or appropriation, one focuses, as I am doing, not on the end product of signification but on any of its prior stages, thereby thwarting the semiotic slide into myth and revealing the occluded motivating forces. The process, of course, results in further acts of appropriation, but ones that are personal, not impersonal. At this level of abstraction, however, the notion of appropriation easily extends to the very act of interpretation itself and to the individual's engagement with anything internal or external. Thus appropriation can be perception itself, the response to things seen, or even memory, the mind's reconstitution of the past. Taken this far, however, the act of appropriation becomes a theoretical Pac-Man about to gobble up all other theoretical terms and methods and thus to be rendered analytically useless.

For our purposes, "appropriation" is better confined to the visual arts and to contemporary modes of bringing the external into the work of art or simply making art art. Lately, "appropriation," together with another term, "allegory," has been applied to certain trends in contemporary art, especially that art prac-tice, concentrated in New York as usual, by which modernism is taken over, partially drained of its semiotic plenitude, and manipulated into postmodern constructions. The first to chart this development and its origins in earlier practices of collage and montage was Benjamin H. D. Buchloh; other critics of this movement, as it subsequently emerged in the 1980s, include Hal Foster, Douglas Crimp, and Craig Owens.

In contrast to the critics, many of the prime movers of what has come to be called "appropriation art" are female, and gender critiques are frequent. Artists, such as Barbara Kruger or Sherrie Levine, work, not as Duchamp or the dadaists with found objects of modern industrial life, but with appropriated images. Sherrie Levine appropriates various icons of modernism—the photographs of Walker Evans or Edward Weston—and thereby comments upon and counters modernist strategies, but she does not always escape the danger of any appropriation—the appropriated overwhelming the appropriator. Previously employed as a magazine layout editor, Barbara Kruger works in photomontage, the dominant mode of modern advertising and propaganda. Instead of joining images and captions into a seamless, natural, and powerful combination of mutual appropriations, Kruger's words and pictures repel not only each other, like opposite poles of a magnet, but also the viewer, for whom contemplating the word-image constructions can be like listening to two out-of-tune instruments. Kruger herself has used other metaphors, saying in an interview with Anders Stephanson (1987) that she was "trying to interrupt the stunned silences of the image with the uncouth impertinence and uncool embarrassments of language [and] disheveling the garment or at least splitting its seams in the hopes of exposing the underpinnings of what is seen and spoken."

A typical example of Kruger's work might be the profile image of a marble head of a woman to which Kruger has appended the caption, "Your gaze hits the side of my face," as if the represented object could answer back to the objectifying viewer (see also chapter 16 on "gaze"). Like Duchamp, certain art of the 1970s, or most advertising, Kruger's visual/verbal constructions address the viewer. To facilitate that confrontation, she captions her creations with the first and second persons that are common to advertising, rather than the abstracting and distancing third person that is standard for an informational illustration. And she works with photographic, not painted, images, because the photograph is still assumed, in spite of decades of manipulation, to have a direct, unmediated connection with the thing represented. The resulting montages of reconstruction and reappropriation question multiple categories: representation, especially the act of portraying the female, the objectifying properties of the gaze, and the viewer and the context of viewing. The work is a novel, original, and therefore marketable form of media reconstruction, but many aspects have been seen before. The hortative, rhetorical effects remind one of early advertising or propaganda, e.g., that army recruiting poster where Uncle Sam points and commands "I want *you*." The relevant semiotic tradition stretches back at least to antiquity and includes similarly inscribed vessels for ordinary use, epitaphs on gravestones, or icons and medieval manuscripts (Nelson 1989). These verbal/visual constructs succeed because viewers make themselves part of the communicative structures and appropriate, if only for a moment, one of the dialogic positions so skillfully constructed for them.

Although it is always unwise for historians to predict the future, the appro-

priative work of Barbara Kruger or Sherrie Levine may only be an intermediary stage in a larger phenomenon, which perhaps will come to be known as "post-photography," a topic of recent exhibitions and books. What this new world brings is the possibility of the total manipulation of the photographic image. The traditional photograph, as William J. Mitchell describes, yields an analog image, or what appears to be a continuous variation in space and tone of the image corresponding to the light rays striking the photographic film and then the photograph paper. In contrast, the new process is digital and more overtly discontinuous, being produced by a digitally encoded grid of cells, called pixels, stored in a computer. Because each pixel can be changed electronically, the image can, in theory, be manipulated indefinitely, and the technique is becoming increasingly common, especially in journalism. Traditional photomontage was a type of collage, but with digital technology, the marks of suture disappear. The artistic consequences of appropriate strategies of postmodern photography are not yet clear, but "computer collage" has already arrived technically. Now the rate of semiotic slippage for the photograph can potentially accelerate and blur yet further the traditional distinction between painting and photography and also that between text and image. In the computer, both words and images become digital, and word processing programs are directed by visual "icons."

Photography and photomontage have come to play crucial roles in another series of contemporary critiques of museums, exhibition installations, and the inevitable appropriation involved in collecting of any sort. Installation art has become an important category of contemporary art, and some artists, like Hans Haacke, have used it to disrupt the elisions between the two series, art–museum–audience and commodity–corporation–consumer, which can take place when corporations support the arts. Less strident and polemical and thus probably more effective are the quiet, lyrical photographs that Louise Lawler has been making of art in many contexts. Her images and extended captions are included in the recent volume of Douglas Crimp's essays, many of which are relevant to the present concerns. In the book, Lawler's photographs stand by themselves, but also indirectly support Crimp's criticism and draw attention to the ways in which art functions in the lived context of the office, gallery, and home. Thus framed print and photocopy machine, or painting and TV set, are shown sharing the same space and forming one *gesamtwerk*, whether *kunst* or not.

While contemporary art and criticism have been quick to exploit the latest French theory and Barthes's notion of myth is often evoked, other genres of French scholarship have yet to be incorporated into these discussions. The sociologist Pierre Bourdieu, for example, contributes to the understanding of the actual practice of collecting and identity formation in his book, first published in 1979 and later translated as *Distinction* (1984). From its subtitle, *A Social Critique of the Judgement of Taste,* it is clear that Kant is a major concern, but the empirical data assembled about the role that objects from kitsch to high

122

art play in the homes of various social classes anticipate many concerns of present art and art history. A social basis in class, income, and education is shown for taste, a category that Bourdieu extends to issues dear to art history. Buying art, or any of its variations, acquiring reproductions, joining museums, contributing to exhibitions, serving on boards of directors, is a means for accumulating "symbolic capital" and therefore gaining stature in a social group, a not unexpected conclusion. But wielding "symbolic power" can also achieve the same ends. Artists, art historians, and critics may lack the means to purchase actual works of art, but some have the power to transform ordinary objects into art and vice versa. In both cases, the quality or significance of the object transfers to the person, completing the appropriative loop.

A clear and obvious consequence of such social science methods has been a critique of the procedures by which the artifacts of other societies are acquired by "our" culture, variously defined, but usually referring to contemporary Europe or America (see also "primitive," chapter 13 of this volume). Sally Price's book, ironically titled *Primitive Art in Civilized Places,* nicely critiques and parodies the cultural asymmetries involved in the discovery, redefinition, and appropriation of tribal artifacts by the modern art world. Like Lawler, Price creates collages, in this case primarily verbal, not visual, in order to concentrate not on the objects or their makers, but upon their remakers or appropriators. Similar analyses of artifact, discourse, and colonialism now constitute an important subsection of contemporary anthropology. In terms of art history, that discourse has been most evident in reactions to the Museum of Modern Art's exhibition *"Primitivism" in Twentieth-Century Art: Affinity of the Tribal and Modern* (1984). James Clifford considers it and other general issues of cultural representation in his collected essays (1988). Contemporary investigations of cultural representation are also productively theorized in the emerging discourse of multiculturalism and postcolonialism. From that perspective, Homi Bhabha (1994) strikes to the core of the matter when he argues that what is needed is "the rearticulation of the 'sign' in which cultural identities may be inscribed"—in other words, a work of creative reappropriation of cultural representations of all types.

Strictly speaking, the full force of multiculturalism has yet to be felt in the broader areas of art history, but the manifold consequences of the act of representation, particularly the sense that to represent is to appropriate, is prompting a flurry of studies in many fields. For example, the implications of representing a person wearing no clothes—what used to be called a nude—are being examined, especially for the uses and abuses of pictures of unclothed women. The inquiry is shifting to the significance of male nakedness as well (Adler and Pointon 1993). Analyses of still-life painting or the depiction of household objects also have the potential to reveal larger attitudes toward material possessions and their representation. Here the obvious targets might be seventeenth-century Holland and what Simon Schama called its "embarrassment of riches"

in a book of that title or the consumer culture of our world. Norman Bryson and others have written perceptively on the earlier periods. What is the significance, for example, of the possession of flowers, either depicted in those gorgeous Dutch paintings or displayed at the entrance of a museum? For our world, what does it mean to bring into the home the myriad objects of consumer culture? How are consumers' lives reordered through their possessions? And how does the design of such objects, the subject of design history, facilitate that appropriation? Or how does pop art, the representation of mass consumption for elite audiences, ostensibly challenge but ultimately reaffirm consumer culture?

But perhaps the most active investigations into the relation of representation to appropriation are now taking place in the area of landscape painting. And within that field, English landscapes of the eighteenth and nineteenth centuries have been the focus of the most theoretically challenging work, whose goal, as W. J. T. Mitchell announces so succinctly in an introduction to a recent volume, is "to change 'landscape' from a noun to a verb." As a consequence of the new interpretations, that which the average museum visitor might have once regarded as pleasant if sometimes boring renditions of country life has become something different. What has emerged under the inspiration of the social history of E. P. Thompson is aptly called "the dark side of landscape" after the title of John Barrell's book of 1980. In eighteenth-century landscapes, Barrell explains, the rural poor were literally expected to be shown in the shade or background in contrast to the well-lit and foregrounded depictions of the wealthy. While all landscapes have a range of light and shadow, such a pictorial convention is prescriptive, not naturalistic, and the projection of a desired social order. A few years later, Ann Bermingham's book further deconstructed the notion that landscape was natural sign.

More recently, Elizabeth Helsinger has also considered the appropriation of rural scenes in English art and literature during the first half of the nineteenth century but shifts the inquiry to the collective and to the sense that landscapes are sites of competing and conflicting appropriations. Landscape, when considered "essentially English," is a means of establishing that very Englishness or sense of nation. Thus landscape depicts not only ideal social relations, at least for the wealthy, but also an imagined community for the middle and upper classes. Yet defining the nation through such images of nature, taken as natural images, also excludes, intentionally or unintentionally, people and spaces not shown. In Europe or America, landscape painting has been one among many strategies for constituting the modern nation-state and symbolically appropriating the land of that state, for it is the basic requirement of a nation that it have a territory, whether real or imagined. That possession must be reaffirmed in every generation, and important agents in that process are visual signs, whether landscape painting, photography, film, maps, or highway markers. As usual, the attempt is to make what is artificial and ephemeral, the governmental possession of any territory, appear natural and permanent.

However, the symbolic appropriation of the land begins neither with the modern nation-state nor the new art history, at least in its British version. In 1973, Oleg Grabar devoted a chapter of his book *The Formation of Islamic Art* to this matter, showing how that emergent religion demonstrated its symbolic, as well as its physical, possession of the lands of the former Byzantine and Persian empires through the monuments it erected. In the cases adduced—for example, the Dome of the Rock in Jerusalem—Muslim patrons and builders borrowed preexisting symbolic languages and adapted them for new messages, a clear demonstration of the operations of myth or appropriation. Some monuments, like the Dome of the Rock, continue to enjoy symbolic centrality to this day; others fade and disappear, like old myths and dead metaphors everywhere. An important factor here is the continued accessibility of the symbolic object. Today, with the many techniques of mass reproduction available, it is the object that is brought to its audiences; in the past, the opposite prevailed. Then the goal was to establish one's identity and possession in places where people gathered, such as crossroads, city squares, and prominent buildings, or at sites to which people traveled, especially places of pilgrimage like the Jerusalem of the Dome of the Rock or the Church of the Holy Sepulcher.

What made the horses of San Marco important was their prominent position in several historical contexts. Conversely, the intrinsic beauty, monetary value, and technical accomplishment of these four life-size gilt bronze statues ennobled, embellished, and enhanced the structures that supported them and the communities which interacted with them. Their early history is by no means clear, but they are thought to have been made during the second or third century A.D. Brought to Constantinople in the fifth century from the island of Chios and installed in the hippodrome or the city's main public arena, they stood above the starting gates from which the teams of horses and charioteers would spring forth. This Byzantine appropriation doubtless shifted their meaning. Although their prior context is totally unknown, horse groups, often in the form of a quadriga (i.e., chariot, driver, and four horses), were erected in similar positions on Roman buildings and arches to commemorate specific historical triumphs. Whatever their connotation on Chios, the races and imperial ceremonies that took place at the hippodrome would have given the horses a more generalized sense of victory or triumph.

Capable of holding as many as one hundred thousand people and directly connected with the palace, the hippodrome was the principal place in which the Byzantine emperor was presented to the people. Consequently it was well outfitted with symbols of governmental authority, and the horses were not the only statues that had been collected there, as Sarah Bassett has recounted. Better documented but no longer surviving is the colossal bronze figure of Herakles, made by the famous fourth-century B.C. Greek sculptor Lysippus and erected on the acropolis of Tarentum. After the Romans conquered Tarentum in 209 B.C., the statue was installed at the symbolic center of Rome, the Capitol, and when the capital itself was moved to the newly founded Constantinople, Her-

akles went along. Later joined by the four horses, this and other statues became one of the legitimating possessions of the New Rome's hippodrome, modeled after Old Rome's circus maximus.

The statues remained in the hippodrome until 1204, when the Fourth Crusade, with active Venetian support, was diverted and attacked not Muslims of the Holy Land but fellow Christians in Constantinople. Dazzled by the city's riches, the crusaders looted churches and palaces and melted down the hippodrome's bronze statues, turning them into coins and exchanging "what is great for what is small," in the words of a Byzantine historian. The four horses were saved for a different appropriation. Loaded onto a Venetian ship, they were dispatched to Venice and later installed at the entrance to the city's most important church. At San Marco, the horses once more became part of a major public space next to a palace, that of the doge; now they pranced atop another gateway and combined with other tokens of victory to celebrate Venice's triumph. Thus Venice appropriated Constantinople's appropriation. At each stage, partial knowledge of the previous sign survived the appropriation, exemplifying the semiotic distortion, not total negation, that characterizes Barthes's "myth" and my "appropriation."

According to Michael Jacoff (1993), the horses acquired yet another significance at San Marco. There they joined reliefs of Christ and the four evangelists, which were once also on the west facade, to become the quadriga of Christ. By the fourteenth century, the horses of the hippodrome had become a symbol of Venice, so that an opponent could threaten the republic's independence by proposing to bridle the "unreined horses" of San Marco. In the Renaissance, humanists appropriated the horses yet again, appreciating them as great works of ancient art and often assigning them with little reason to the aforementioned Lysippus. Once a genuine bronze by Lysippus had been available for the taking in Constantinople; now by another appropriation, works of Lysippus were made in Venice through the "symbolic power" of a newly valorized aesthetic discourse. In the early modern period, as the physical and social spaces around the horses were transformed by the enlargement of the piazza of San Marco and the creation of the piazzetta of the doge's palace, the performative contexts and hence ritual meanings of the horses also changed. Concurrently their placement on the facade of the church came to be criticized as inappropriate to their aesthetic dignity, and in his *Capriccio,* Canaletto depicted them on handsome classical plinths in front of the church (see Corboz 1982).

Yet the horses never lost their association with Venice itself, and when Napoleon had completed his conquest of the Venetian republic in the late eighteenth century, he took away what Venice had taken from Constantinople and Constantinople from Chios. He brought the horses to his newly imperial capital and paraded them before the citizens of Paris in 1798. Initially the horses were installed at entrances to the courtyard of the palace of the Tuilleries; later they were set atop the newly built Arc du Carrousel to honor Napoleon's victories, like the quadrigae of Roman triumphal arches. But empires and the spoils of

victory were and were not the same in the nineteenth century. When Napoleon fell from power, the horses were sent back to Venice but not to the Venetian republic. It was emperor Francis I of Austria who now controlled the city, and he presided over their ceremonial reinstallation at San Marco. In Paris, the horses had been made to pull Napoleon's victory chariot; now in solemn procession from wharf to church, it was they who were pulled by troops of the empire that prevailed for another century.

In Venice, the horses returned to what had become an aristocratic theme park, the first Euro Disney, and to a city that still lives off its heritage, studying, analyzing, copying, packaging, displaying its monuments for legions of tourists from the grand tour to the package tour and thereby effecting new appropriations with every year. Where Napoleon failed, experts have succeeded, and the horses have been removed to the expert's care, enshrined under the museum spotlighting, and marketed by that ubiquitous appropriation of our world, the postcard (see Plate 9.1). The horses have become full citizens of the world of art, in which the semiotic plenitude they might have once enjoyed as a political symbol is never possible and in which meanings fragment and mutate in ways that might seem arbitrary and capricious but are willed and motivated like all appropriations. This museum without walls owns nothing and everything. Ownership passes to all, and access increases with every technological innovation, digital imaging and computer networks being only the latest manifestations of a phenomenon that began with the invention of printing. And the techniques of mass reproduction place the horses anywhere, even in obscure Texas cemeteries, and give historians, who are committed to understanding past meanings and their transformations, a bit of semiotic vertigo.

However, appropriation is yet more complicated. As Edward Said has long understood, in every cultural appropriation there are those who act and those who are acted upon, and for those whose memories and cultural identities are manipulated by aesthetic, academic, economic, or political appropriations, the consequences can be disquieting or painful, like the personal example with which I began. To study appropriation is to question these semiotic shifts and to take responsibility for the ones that art history itself creates. Compared to traditional terms of art history—for example, "influence"—considering appropriation shifts the inquiry toward the active agents of signification in society and illumines historical context. It cuts away the privileged autonomy of the art object or at least permits the construction of that autonomy to be studied. At the same time, the notion of appropriation allows the art object's social utility in the past or the present to be reaffirmed openly, not covertly. Art was important, and it still is. The term "appropriation" encourages us to ask why and how.

SUGGESTED READINGS

Adler, Kathleen, and Marcia Pointon, eds. 1993. *The Body Imaged: The Human Form and Visual Culture since the Renaissance.*

Barrell, John. 1980. *The Dark Side of the Landscape: The Rural Poor in English Painting 1730–1840.*

Barthes, Roland. 1972. *Mythologies.*

———. 1981. *Camera Lucida: Reflections on Photography.*

Bassett, Sarah Guberti. 1991. "The Antiquities in the Hippodrome of Constantinople."

Baudrillard, Jean. 1981. *For a Critique of the Political Economy of the Sign.*

Baxandall, Michael. 1985b. *Patterns of Intention: On the Historical Explanation of Pictures.*

Bermingham, Ann. 1986. *Landscape and Ideology: The English Rustic Tradition 1740–1860.*

Bhabha, Homi K. 1994. "The Postcolonial and the Postmodern: The Question of Agency."

Bryson, Norman. 1990. *Looking at the Overlooked: Four Essays on Still Life Painting.*

Buchloh, Benjamin H. D. 1982. "Allegorical Procedures: Appropriation and Montage in Contemporary Art."

Clifford, James. 1988. *The Predicament of Culture: Twentieth-Century Ethnography, Literature, and Art.*

Corboz, André. 1982. "Walks Around the Horses."

Crimp, Douglas. 1993. *On the Museum's Ruins,* with photographs by Louise Lawler.

Foster, Hal. 1985b. *Recodings, Art, Spectacle, Cultural Politics.*

Foucault, Michel. 1972. *The Archaeology of Knowledge and the Discourse of Language.*

Grabar, Oleg. 1973. *The Formation of Islamic Art.*

Harvey, David. 1989. *The Condition of Postmodernity: An Enquiry into the Origins of Cultural Change.*

Helsinger, Elizabeth. 1996. *Rural Scenes and the Representation of Britain 1815–1850.*

Jacoff, Michael. 1993. *The Horses of San Marco and the Quadriga of the Lord.*

Metropolitan Museum of Art. 1979. *The Horses of San Marco Venice.*

Mitchell, W. J. T., ed. 1994. *Landscape and Power.*

Mitchell, William J. 1992. *The Reconfigured Eye: Visual Truth in the Post-Photographic Era.*

Nelson, Robert S. 1989. "The Discourse of Icons, Then and Now."

Owens, Craig. 1992. *Beyond Recognition, Representation, Power, and Culture.*

Price, Sally. 1989. *Primitive Art in Civilized Places.*

Said, Edward W. 1993. *Culture and Imperialism.*

Schama, Simon. 1987. *The Embarrassment of Riches: An Interpretation of Dutch Culture in the Golden Age.*

Stephanson, Anders. 1987. "Barbara Kruger."

Art History

David Carrier

On 22 February 1848 in Paris near the Place de la Concorde, just before nightfall a soldier provoked by the crowd stuck his bayonet into an unarmed man's chest. This was the first bloodshed of the revolution of 1848, which led to the downfall of Louis Philippe. The journalist Charles Toubin recorded this scene. Two days later, on 24 February, one man who had witnessed this episode was found carrying a shotgun from a looted store shouting: "We must go and shoot General Aupick." Aupick, the director of the Ecole Polytechnique, was preoccupied with persuading his students not to join the revolution; he was the stepfather of this man, the poet and art critic Charles Baudelaire.

In January 1881, Georges Jeanniot visited the studio of a friend of Baudelaire, where he saw a painting in progress. Jeanniot's account, published in 1907, describes the artist's posing of the model, the style of the work, and other visitors to the studio. Like Baudelaire, this artist probably believed that he was suffering from syphilis. He told Jeanniot that he needed to remain seated and spoke optimistically of expecting an early recovery. Overoptimistically, for two years and three months later Edouard Manet died. The work Jeanniot saw, *A Bar at the Folies-Bergère* (Plate 10.1), was Manet's last large painting.

Like Toubin, Jeanniot recorded an event interesting to historians because it is an incident in the life of a man who became famous. In his 1846 Salon, Baudelaire records a curiously optimistic political viewpoint; in his later writings he spoke bitterly of politics. Soon after his death in 1867, Baudelaire became famous, and so any documentary evidence about him became precious. Toubin's story would be interesting even were Baudelaire not involved, for it provides information about the events discussed by Alexis de Tocqueville and Karl Marx. But what now inspires the particularly intense interest in Baudelaire's 1848 activities is the highly influential Marxist commentary of Walter Benjamin. Any evidence about Baudelaire's actions during the 1848 revolution is extremely welcome. By the 1880s, Manet had achieved substantial recognition. *A Bar at the Folies-Bergère* was resold a number of times, at increasing prices, before being given to the Courtauld Institute in 1931. In 1965, Clement Greenberg described Manet as the first modernist painter; more recent commentators identify him as an artist whose work makes a political statement. Since he was not an especially verbal person, any early record about his painting is very valuable.

This description of these two anecdotes may suggest that historians and art historians work in essentially similar ways. Their raw materials are such stories,

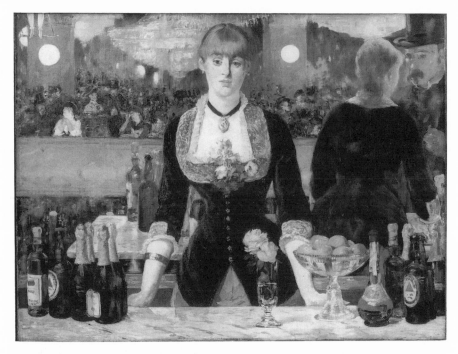

10.1 Edouard Manet, *A Bar at the Folies-Bergère,* 1882. Courtauld Institute Galleries, London.

which they present in a narrative giving information about the past. The goal of history is to identify, describe, and explain noteworthy events; it does in a very broad way what art history does in its narrower fashion. The story of the production of the artifacts preserved in the museum is part of a broader history. Historians study French nineteenth-century politics, economics, and social history; art historians are professionally concerned with only a small subset of the artifacts produced in that culture, the artworks.

Historians, like art historians, are centrally concerned with explaining change. Toubin's story is revealing because it helps identify the moment when the government of Louis Philippe lost its ability to command allegiance. What then needs to be added to create a history is background information about how this happened and why the authorities quickly lost control of events. The art historian, analogously, uses stories like Jeanniot's to explain the place of an individual artwork in an artist's oeuvre. In an essay begun in 1859, just before Manet produced his first independent works, Baudelaire presented the ideal of a painting of modern life. Contemporary artists need not repeat the themes of the old masters, he argued; contemporary life also presents heroic themes. *A Bar at the Folies-Bergère* seems an obvious realization of this prophecy, the culmination of twenty-some years of Manet's exploration of such themes.

130

We understand change by setting events in a broader historical framework. Linking the revolution of 1848 to the end of the Second Empire and the commune of 1871, a political historian will explain how finally the monarchy, a vestige of the ancien régime, was abolished. The street scene Baudelaire witnessed is part of this larger process. Analogously, a large-scale art-historical narrative can study the art of the painter Baudelaire admired and Manet copied, Delacroix. The first work in the 1983 Manet retrospective was *The Barque of Dante, after Delacroix* (1854?), hung at the entry of a show culminating in *A Bar at the Folies-Bergère*. A full political history of Baudelaire's France could look back before 1830, identifying the ways in which already Louis XIV was concerned with centralizing power, partly in response to a seventeenth-century rebellion, the Fronde. Analogously, a fuller account of Manet's sources would need to look at more distant influences, such as Venetian oil painting.

There is a certain arbitrariness to the ending point of such a story; history, like art history, naturally leads us towards the present. Just as a large-scale history incorporating Toubin's story might extend into the twentieth century, so an account building upon Jeanniot's anecdote could lead into a discussion of Manet's influence upon postmodernist art. The obvious analogies between the revolution of 1848 and the failed French student and worker revolts of 1968 may influence how those modern historians who experienced 1968 think about political change in the nineteenth century. Similarly, Manet's image appropriations and his play with gender roles influence viewers of Cindy Sherman's 1978 *Untitled Film Stills*. All the questions which Manet poses about the identity of his barmaid on display take on new significance when now an artist photographs *her*self engaged in role playing. Like the historian, the art historian is essentially a storyteller. All the conceptual problems that the historian faces in identifying an origin, and a conclusion for his or her narrative and finding a way to narrate that story are also concerns for the art historian.

Yet it is also arguable that art history is essentially different in kind from history. Treating Toubin's story as equivalent to Jeanniot's anecdote may mask this difference. A history is a story about events of importance told by a skilled witness. A written history presents events the reader could not have viewed. Tocqueville's *Recollections* and Marx's *The Eighteenth Brumaire of Louis Napoleon* make the events of 1848 in Paris "come alive"—a revealing metaphor—as if they were taking place in our presence. History writing is essentially concerned with re-creating the past. Although art history writing uses similar evidence, it has very different goals. I can stand in front of *A Bar at the Folies-Bergère;* I cannot view the revolution of 1848. Stories like Toubin's constitute the primary materials for the historian, the starting point for speculations about why in February 1848 Paris was ripe for change. Jeanniot's recollection is secondary material for the art historian, evidence to be tested against what now we can see in Manet's picture.

The revolution of 1848 exists today only as re-created in historians' narratives; Manet's painting is an object we observe. It is not surprising that various

131

historians describe that revolution very differently, for identifying the histor-
ical event requires picking out a group of actions by many men and women.
Tocqueville's personal involvement in those actions means that he gives a very
different reconstruction of the events from Marx. It may seem more surprising
that various art historians give radically different interpretations of *A Bar at the
Folies-Bergère,* for they are describing the same physical object. Identifying the
revolution of 1848 is complex, for the events in Paris may be linked with what
happened as far away as Russian Poland; identifying the start and finish of that
revolution requires controversial judgments about the causes of the scene Tou-
bin witnessed. Manet's painting is a relatively small physical object, created in
a temporal moment, 1881–1882, whose bounds are defined relatively precisely.

The art historian need not re-create past events, for what we experience is that
very artifact made by the artist him- or herself. When I view Artemesia Gen-
tileschi's *Self-Portrait as the Allegory of Painting,* Berthe Morisot's *Portrait of Cor-
nélie Morisot and Edma Pontillon,* or Agnes Martin's abstract masterpieces of the
1980s, what need have I for a history? I can see for myself what they made; I am
present directly in front of the surfaces they painted. Certainly I read art historians
to learn about these works' historical context. I may compare Gentileschi's alle-
gory with baroque variations on her theme; relate Morisot to her contemporary,
Mary Cassatt; and contrast Martin with a younger painter like Elizabeth Murray.
But my primary source of information about these artworks is the paintings them-
selves. Learning that good judges think a Martin painting I do not initially admire
excellent, I look more closely; reading about Gentileschi's iconography, I discover
that her portrait may be symbolic. But nothing that I read could outweigh my
immediate visual experience of the pictures.

When there is a conflict between what the books tell me about a painting
and what I see for myself, it would be absurd to think I have two kinds of
evidence which need to be compared. I might, of course, be influenced by what
I read to see a picture differently. (And reading that it was damaged or cut
down could influence me.) But if there is a conflict between what the books
tell me and what I see, unless I can learn to see this way for myself, what can
I reasonably conclude except that the books are wrong? In reconstructing what
happened on 22 February, I may need to balance Toubin's report against other
evidence. In trying to understand such events, such an anecdote has value if we
may support it with evidence from other observers. Jeanniot's account of Manet
doesn't have this status, for it must be weighed against the obvious authority
of my experience of Manet's picture. The historian reconstructs events. The
documents read or sites visited provide starting points for the narrative. The
art historian is concerned with describing artifacts. Documentary evidence is
ultimately of value only because it suggests ways of seeing the artwork itself.

Is it possible, still, to question this distinction between history and art his-
tory? The assumption that the unit of discourse is the individual painting may
seem problematic. When in one sentence I mentioned paintings by Gentileschi,

Morisot, and Agnes Martin, pictures I have seen only over some years, in Rome, Washington, and New York, I focus attention on these individual artifacts by linking them together in a narrative. Identifying the distinctive shared qualities of these paintings, I create a history, a fragment of my autobiography. Even as I describe art history as concerned with such individual pictures, my writing thus inevitably takes me away from these pictures themselves. Speaking of the individual painting as a self-sufficient object is a questionable convention. When I stand before Manet's *A Bar at the Folies-Bergère* in London, I can also think of that individual painting as one element in various sequences of works: Manet's oeuvre; nineteenth-century French painting; modernist art. What is within that frame in London, that thing I can see at a glance, is really but one small piece of these groups of things. The object I see in splendid isolation in the modern museum is but a fragment of a larger whole described in the art historians' narratives.

This argument against isolating the framed artwork is simplest to understand if we consider not this Manet, but another painting in London, Piero della Francesco's *Baptism of Christ* in the National Gallery. Originally it was the central panel of an altarpiece. The original frame has been dismantled; the panels originally set on the sides and at the bottom were not taken to London. The picture was removed from its original site, a now-deconsecrated church in Borgo Sansepolcro whose landscape may be shown in Piero's background. A detailed reconstruction of its original setting may be necessary to understand the meaning of Piero's image. Perhaps only when such paintings are preserved in situ, as they are still in some Italian churches, is it possible to see them as part of the social fabric. Seeing a photomontage of Piero's full original altarpiece, it is visually obvious that viewing in isolation the panel in London is almost as misleading as looking at a painting which has been cut down.

A very similar argument can be mounted, social historians of art argue, when we isolate a work from its original culture. *A Bar at the Folies-Bergère* is an easel painting; but today Manet's 1880s Paris, like Piero's Sansepolcro, needs to be reconstructed to explain what is within his image. Merely looking at the picture could not tell us that it depicts an expensive music hall; the legs of a trapeze performer at the far upper left corner are hard to see. Manet's and Piero's pictures can no more be understood in isolation than can any artifact. Were only one automobile tire to survive, a future archaeologist might reconstruct an automobile and envisage the roads and service stations needed by automobiles. Historians studying Manet and Piero are more fortunate; we know much about these artists' cultures.

To understand an artwork we need to adopt structuralist ways of thinking and see it as part of such a larger system. The methodological implications of these everyday working procedures of the art historian were made explicit by the philosopher Arthur C. Danto in his 1964 article "The Artworld." (A French form of structuralism was later popularized by various art critics, most notably

Rosalind E. Krauss in the influential essays collected in her *The Originality of the Avant-Garde and Other Modernist Myths*.) Danto shows that these ways of interpreting an artwork have far-reaching implications for the ways we understand art history. The individual "postmodern" work—Warhol's *Brillo Box* (1964) is his example—achieves its identity only in relation to other works. Warhol's work becomes an artwork only by an act of negation. Not expressive; not a representation of anything; not an attractive artifact: it is something more than a handmade copy of the Brillo boxes sold in grocery stores because it is situated within the art world. Using *Brillo Box* we can construct a simple chart. All artworks are either representations or not, and expressive or not. Warhol's work belongs within this structure because it is neither a representation nor expressive. The temporal development of art is mapped onto this spatial structure. Of course this four-place diagram is very simple, but it would be easy to work it out in more detail. This is a task for art historians. The philosopher's goal is understanding this procedure.

Even a simple-looking object can become richly meaningful when thus set in context. The social historian of Warhol's art would be interested in explaining why he picked this artifact and not something else from 1960s grocery stores. What interests the philosopher are the implications of Warhol's choice for how we think about all art. For the structuralist, the exact individual characteristics of the individual artwork don't matter. What is important about *Brillo Box* is not its individual characteristics, but that it permits the construction of this diagram, in which it is juxtaposed with earlier works which are representations or are expressive. A chess game is defined by relative positions of king, queen, and pawns, not by the color or size of these pieces. Analogously, what counts about Warhol's work is its role within art history. The individuating features of that object become irrelevant. *Brillo Box* is interesting because it generates a chart displaying the logical structure of art's history.

Earlier aestheticians compared spatial ways of thinking, associated with visual art, with writers' interest in temporal succession. Lessing's *Laocoon: An Essay upon the Limits of Painting and Poetry* (1766) contrasted succession in time, the province of the poet, with what interests the visual artist, coexistence in space. Lessing's concern was to contrast the goal of Virgil, who describes a sculpted shield, and the concerns of sculptors or painters who make something visible all at once. But his analysis extends, in an obvious way, to the contrast between the art writer, who must describe in a text, and the artist, who may feel that such a narrative takes us away from the artwork itself. Danto's structuralism provides a new perspective on Lessing's argument. If the art historian's narrative can be diagrammed in this spatial structure, then ultimately the visual artwork can be described in a spatial format.

Danto's analysis seemingly assumes that there is one correct way of identifying the structure within which to set *Brillo Box*. Poststructuralists such as Jacques Derrida questioned that claim. Is there one definite way of identifying

the context in which to set the artwork? It is hard to know why we would believe that, for it is easy to identify alternative contexts. The simple structure Danto imagined had no place for such novel modernist art forms as film or comic strips; nor did it deal with one kind of visual artwork which fascinated eighteenth-century aestheticians, the landscape garden. Identifying such additional structures permits us to deconstruct Danto's analysis.

Here, the poststructuralist can observe, treating chess as a model for art history is misleading. In chess, the ways in which king, queen, and pawns move are fixed by convention. But in art history the rules of the game are not fixed, except by tradition. And tradition teaches that there can be indefinitely many ways of setting any artwork within a structure. Since in identifying that structure we are not dealing with the artist's intentions, who has the right to say that an alternative to Danto's analysis is wrongheaded? There are, it would seem, as many ways to interpret Warhol's art as there are ingenious historians. Certainly some interpretations are more original, suggestive, or unconventional than others, and maybe some day historians will cease to find novel ways of describing his art. But until that happens, why think that any particular structure is in principle unacceptable? Interpretation of artworks may be an open-ended process.

Danto's argument against this form of poststructuralism emerged only in his writing of the 1980s. If, as the poststructuralist imagines, Willem de Kooning's painterly art changes how we see his source, Venetian painting, could not future art—in its turn—change, in as yet unpredictable ways, how we understand *Brillo Box?* The interpretation of art, this way of thinking suggests, is as open-ended as the history of art making. Danto's response is to claim that the history of art has ended. The structural chart is effectively complete. Much new art will be made, but no new kinds of art will appear—so Danto claims—for all the possibilities have been discovered. As in chess, the essential rules of the game have been laid down; all that now is possible are moves following those conventions. Maurice Merleau-Ponty in his *Humanism and Terror* (1947) drew one consequence of this way of thinking about history. How can we evaluate an action, he asked, until we consider the way it fits into a larger pattern of events? Some moralists think that an action can be judged abstractly, in itself. But this belief supplies little guide in politics. Perhaps an action which itself is wrong will turn out to be the best action possible in the circumstances; every other act, we may discover, would produce worse consequences. We can only finally evaluate an action, Merleau-Ponty suggested, at the end of history. For Danto, analogously, we can today identify the structure of art history only because we know that the history of art is concluded.

Is Danto's view of art history plausible? In his 1820s lectures on aesthetics, Hegel appears to claim that the history of art had ended. Today that seems an amusingly overoptimistic vision. Hegel knew little of non-European art; he could not imagine the modernism of Manet, Mondrian, and Pollock; and he

died too soon to witness the rediscovery of pre-Renaissance European art. Nor has Hegel's philosophical reasoning in support of this view withstood the test of time. He claimed that history has ended because he believed that in his day that Spirit whose life story is world history had found an adequate way to express itself in social institutions. Few present-day aestheticians or philosophers can accept this argument. But although Danto finds Hegel's particular view of art history hopelessly parochial, he accepts the crucial conceptual claim: the history of art ends when art becomes philosophically self-conscious, which is what occurred when Warhol's artifact was created. Now the structural relations within which individual works can be set have all been identified. Just as, for Claude Lévi-Strauss, the structures of what he calls "the savage mind" are revealed in the premodern human cultures studied by the anthropologist, so the nature of art is demonstrated by these categories. There are no new kinds of art to make, although of course new art continues to be made.

Claims that the history of entities such as states have ended are always questionable. The Venetian republic, after existing for a millennium, was destroyed by Napoleon's troops less than two centuries ago. But who knows what is possible in the future? Maybe the state of Italy will disintegrate, as did the former U.S.S.R., and Venice again will become independent. Even if that doesn't happen, surely other states will be created. Danto's argument doesn't rely upon such empirical considerations. The history of art ended, he claims, because everything had been done which could be done. Once it was discovered that objects like the readymades could be artworks, then what else could there be to discover? Once we learned that any object could be an artwork, then the field of artworks could not continue to expand. Danto's claim differs from the view developed by the Hegel scholar he cites, Alexandre Kojève, who believed that human history had ended. Kojève, following Hegel, identifies history as the grand narrative of significant events. Nothing of great significance remains to happen, he thought. Hegel's or Kojève's view of the end of history seems extremely vulnerable to counterexamples. Surely there will continue to be wars, revolutions, and other political changes. Danto makes a very different and much more precise claim. Now when anything can be placed in the museum, what more can happen? Of course there can be unpredictable combinations of objects, but that is not deep enough change to count as history.

No one would deny that Warhol made a very radical move. When the modern museum was created, around the time of the French Revolution, the concept of the readymade would have been impossible to understand. Eighteenth-century gardeners were interested in the ways in which nature could be seen "aesthetically," but they had no idea that someday ordinary artifacts could become artworks when set in the museum. Still, it is arguable that the way Danto thinks of this discovery shows he overestimates the importance of historical ways of thinking. In a 1965 essay naming the art movement called "minimal art," the philosopher Richard Wollheim reflected upon the way that Duchamp

and Rauschenberg made artworks. Making traditional artworks requires much labor; to create minimal art, the artist need only select an already existing object.

Traditionally, Wollheim argued, when viewing visual art we concentrate upon small individual portions of the world; we focus close attention on a canvas, or piece of paper, or stone. We look at these things for themselves. Nothing could be more deeply opposed to Danto's structuralism than this way of thinking of the aesthete. Wollheim rejects the view that an object like *Brillo Box* is as much an artwork as *Baptism of Christ*. Warhol made an impoverished kind of artwork. Structuralism overestimates the importance of gestures like Warhol's. Of course, Wollheim is not denying that we can treat an artwork in an essentially historical fashion. As Vasari already understood in the mid-sixteenth century, art making has a history. (And Vasari merely applies to contemporary art a historical view already developed in the ancient world by Pliny.) But Wollheim argues that Danto's focus on the historical nature of the artwork takes us away from its essence, as art. For the aesthete, a painting is first and foremost an individual artifact whose surface we attend to. Only in secondary ways are artworks elements which can be deployed in structuralist diagrams. Vasari would have a very hard time understanding the abstract expressionist art championed by Greenberg; but he could identify their shared conception of "the aesthetic." There are enough similarities between the art Vasari knew and abstract expressionism to speak of the concept of art shared by Titian and de Kooning. Treating an artwork as the basis for a historical analysis may be intellectually fascinating, but it does not treat artworks *as* works of art; it is like using a painting to cover a cracked wall or a sculpture to hold a door ajar. The readymades are only minimally artworks. Revealing the boundaries of our concept of art, they show the importance of the traditional link of art with "the aesthetic."

Wollheim's approach derives very naturally from his fascination with connoisseurship. Identifying the corpus of genuine works by Giorgione, distinguishing them from wrongly attributed works by other painters of his era and from later copies or forgeries are essential activities for the museum. Unless we can make good attributions, why take so much care with collecting and preserving these objects? This important practical task may seem unexciting. Social histories of art make it relevant to the historian; grand historical art histories suggest analogies between art's development and the history of the larger culture. By contrast, connoisseurship focuses on the individual artifacts. Some people distrust connoisseurship because of its obvious associations with collectors, art dealers, and museums. Connoisseurs like Bernard Berenson are often closely linked with the rich and powerful. (So too, of course, are many "anti-aesthetic" artists such as Warhol.) However we judge these political issues, what is philosophically important about connoisseurship is its challenge to the tendency of such otherwise diverse writers as Hegel, Wölfflin, and Danto to think of visual artworks essentially in historical terms. When Wollheim criticizes minimal art for undercutting our ability to focus on the individual artifact, he

really is pointing to the way in which preoccupation with art's historical character takes us away from considering its aesthetic qualities. The aesthete rejects the historical way of thinking of the structuralist.

Wollheim's demand that we see the artwork for itself is complex. We cannot do that merely by looking at it, for in many cases we bring to the artwork irrelevant associations or ideas. One natural goal of art history is to clear away any such sources of potential misinformation. The introduction to Heinrich Wölfflin's *Classic Art* explains how the word "classic" has come to have unwelcome associations. Here he reasons like a structuralist. It is hard to understand High Renaissance art, he claims, when we compare it to more seductive early Renaissance works. Unless we think historically, Wölfflin warns, we will find Raphael's *School of Athens* bewildering; we will ask why did not Raphael paint more attractive-looking scenes showing simple peasants. (Reading his text, we may recall, or guess, that when it was published in 1899 the reputation of Botticelli was being revived.) We need to understand, he is saying, how this classical style evolved out of the early Renaissance.

Wölfflin's elegant analysis raises, but does not solve, a deep methodological problem: How can we achieve an objective viewpoint on art of a historically distant period like the High Renaissance? Suppose we acknowledge that in 1899 the new interest in Botticelli made it hard to properly appreciate Raphael's work. Then a real problem arises for the structuralist art historian. Today, when Caravaggio, little discussed in 1899, has been revived, his "naturalism" will, for similar reasons, surely distort our view of art of Raphael's era. If our sense of art of any period is influenced by all the other works in our art world, how can we ever achieve an objective viewpoint?

In his critique of Wölfflin's methodology, Ernst Gombrich offers a highly ingenious response to this problem. The hidden norm, to which Wölfflin always appeals, is that of the High Renaissance. We cannot legitimately set the art of figures from two different periods, like Raphael and Botticelli, in one structural diagram. Since Botticelli did not know Raphael's paintings, it makes no sense to imagine him choosing not to paint in the manner of Raphael. (Nor can we say that Raphael chose to work differently than Caravaggio.) What an artist did not know, he cannot have rejected. Gombrich is giving an argument against Danto's structuralism, which in a far more sweeping way compares historically distant works. No doubt Gombrich is right: Botticelli did not choose to paint unlike Raphael, nor Raphael unlike Caravaggio. But does this show that a structuralist analysis is inevitably flawed? When Wölfflin compares fifteenth- and sixteenth-century Italian painters, or Danto compares the old masters with Warhol, we need not assume that these structures were graspable by all the artists included within it. Perhaps only the historian presenting that structure can understand all the elements within it. From his privileged position, the historian can understand that history better than those artists could.

This way of identifying the shared concerns of Danto and Wölfflin helps

explain Wollheim's opposition to structuralism. A modern historian would not hesitate to explain sixteenth-century politics using theories of economics or psychology unavailable within that culture. What prevents Gombrich from doing something analogous is his belief that Raphael's art should be interpreted in the terms in which it was described in the artist's culture. He is contrasting Wölfflin's historical vantage point on Botticelli with the view provided within that artist's own time. It is anachronistic to contrast Botticelli's figures with Raphael's.

It is easy to understand how these problems with an art history arise in reading a grand narrative like Wölfflin's, which aims to set the individual artworks in a broad history. But something similar happens, it is worth observing, when an art historian seeks merely to have us attend closely to an individual picture. When Robert L. Herbert discusses Manet's *Bar at the Folies-Begère,* he unavoidably is caught up in a tradition of recent debate about this picture and the role of women depicted in French art. In order to describe the woman in the picture Herbert needs to tell a great deal about such music halls, the social status of Manet's model, and the way the painter arranged the mirror reflection. Reading his analysis, I naturally find myself moving back and forth between his words and the excellent color reproduction in his text. What is most revealing is how arbitrary, at a certain level, is this distinction between what is inside the frame and what remains outside. Since standards of beauty change, when Herbert speaks of the beauty of the model, he must study sociological evidence. (Cindy Sherman's *Untitled Film Stills* of 1978, with its references to women in 1950s films, already needs explanation.) Without such background information, how could we even guess how Manet wanted his model to be seen? Herbert, as much as Wölfflin, must go outside the picture itself.

This simple example points to the central paradox implicit in the conjunction of words in the seemingly simple phrase "art history." The concept of a history is antithetical to the demand that we attend to the here and now for its own sake. To respond aesthetically to a painting is to see it for its own sake, as opposed to identifying it as a sacred image, a political statement, or a historical document. Very often, paintings have religious, political, or historical importance as well as aesthetic value. Of course, visual artworks have many legitimate functions. But the important conceptual point, which sometimes gets lost in critical historical accounts of "the aesthetic," is that identifying the genealogy of this way of thinking does not necessarily undermine its importance or diminish its value. No doubt the aesthetic way of seeing can seem apolitical, even antipolitical. But seeing an artwork aesthetically by no means excludes looking at it in other ways; no more than enjoying the language of Yeats's late poetry excludes critical evaluation of his political ideas.

Wollheim's aestheticism, implicit in the practice of many traditional art historians, finds its most challenging presentation in the beautiful writings of the English art writer Adrian Stokes (1902–72). Stokes thought that certain art-

works, those he identified as "Quattro Cento," communicate their meaning immediately, without reference to any iconography. (Stokes uses the Italian word "*quattrocento*," fifteenth century, with his idiosyncratic spelling, to describe such work from any period. He believed that much of the best Quattro Cento art was made in fifteenth-century Italy.) To understand these sculptures or paintings, we need know nothing of history. Carved stone reveals the medium, expressing its history in a way that is immediately accessible for a sympathetic viewer. Quattro Cento painting—Piero is Stokes's prime example—uses color in ways which avoid the tensions and rhythms of narrative art. We can read from the color relationships the story told in Piero's pictures without needing to study his iconography.

Art historians find much to question in Stokes's approach. There is little historical evidence that quattrocento carvers thought of their activity in his terms. As Stokes himself acknowledged in his later writings, his conception of the Quattro Cento is a kind of myth. By presenting the notion of "the aesthetic" in this extreme way, Stokes very usefully shows what is fascinating and problematic in this way of thinking. Can we ever really focus completely and entirely on an isolated material object? Probably not, for all perception involves making comparisons with other artifacts. But if the aesthete is involved with a myth, so too is the structuralist, who reduces the individual artworks to placeholders in a diagram. Manet made a succession of works, objects which can be arranged in chronological order in a retrospective exhibition. But the tendency of art historians to present these objects in retrospectives, each inevitably leading to the next in historical order, treats his oeuvre as a unified body of work. Is that not also a myth? Art historians tend to move from the observable discontinuities found when the works are set in chronological order to belief in an underlying continuity, identified by appeal to a theory of style.

Danto's structuralism and Wollheim's aestheticism are the two essentially opposed approaches to visual art. I do not believe that any argument can tell us how to choose between Danto's historical and Wollheim's antihistorical ways of thinking. What, for the philosopher, is interesting about visual art is that it can be understood in these essentially opposed ways. The problems art historians face really differ from those of historians. Probably art historians will continue to be fascinated by both the approach of the aesthete and that of the structuralist, for it seems natural to value artworks both for themselves and for their historical role. The task of art history is to do justice to the concerns of both the structuralist and the aesthete.

Stokes's view was anticipated in Walter Pater's *The Renaissance* (1980; 1st ed. published 1873), which treats one individual picture, Leonardo's *Mona Lisa*, as a condensation of the whole history of European culture. To see this picture properly, Pater implies, is to grasp not only the story of Leonardo's life, but also the entire history of oil painting. When we correctly attend to this one symbolic work, we can unpack a far-reaching history. At the same time,

Pater also offers a historicist reading of what I have called "the aesthetic." For Pater, following Hegel, this way of seeing artworks is a characteristic product of modern, that is, romantic, culture. The recent debate between Danto and Wollheim about the value and significance of the aesthetic, and the importance of "art history," was anticipated a century earlier. Pater is both an aesthete and a proto-structuralist. He both defends the view that the true value of the artwork is available right here and now to the sensitive viewer and offers a historicist way of understanding that aesthetic value. As Paul Barolsky has observed, when Pater collapses the distinction between these positions, he also is a proto-deconstructionist, anticipating in his elegantly condensed book both modernist and postmodernist ways of thinking about art history.

SUGGESTED READINGS

Barolsky, Paul. 1987. *Walter Pater's Renaissance*.

Burton, Richard D. E. 1991. *Baudelaire and the Second Republic: Writing and Revolution*.

Cachin, Françoise, Charles S. Moffett, and Juliet Wilson Bareau. 1983. *Manet 1832–1883*.

Danto, Arthur C. 1964. "The Artworld."

———. 1986. *The Philosophical Disenfranchisement of Art*.

Derrida, Jacques. 1987. *The Truth in Painting*, translated by G. Bennington and I. McLeod.

Gombrich, E. H. 1966. "Norm and Form: The Stylistic Categories of Art History and Their Origins in Renaissance Ideals."

Hegel, G. W. F. 1975. *Aesthetics: Lectures on Fine Arts*, translated by T. M. Knox.

Herbert, Robert L. 1988. *Impressionism: Art, Leisure, and Parisian Society*.

Kojève, Alexandre. 1947. *Introduction à la lecture de Hegel*.

Krauss, Rosalind E. 1985. *The Originality of the Avant-Garde and Other Modernist Myths*.

Lavin, Marilyn Aronberg. 1981. *Piero della Francesco's Baptism of Christ*.

Lessing, Gotthold Ephraim. 1965. *Laocoon: An Essay upon the Limits of Painting and Poetry*, translated by E. Frothingham.

Lévi-Strauss, Claude. 1962. *The Savage Mind*.

Merleau-Ponty, Maurice. 1969. *Humanism and Terror: An Essay on the Communist Problem*, translated by J. O'Neill.

Pater, Walter. 1980. *The Renaissance: Studies in Art and Poetry*.

Sherman, Cindy. 1990. *Untitled Film Stills: With an Essay by Arthur C. Danto*.

Stokes, Adrian. 1978. *The Critical Writings of Adrian Stokes*, edited by L. Gowing.

Veyne, Paul. 1984. *Writing History*, translated by M. Moore-Rinvolucri.

Wölfflin, Heinrich. [1899] 1968. *Classic Art: An Introduction to the Italian Renaissance*, translated by P. and L. Murray.

Wollheim, Richard. 1973. "Minimal Art."

ELEVEN

Modernism

Charles Harrison

There are few terms upon which the weight of implication, of innuendo, and of aspiration bears down so heavily as it now does upon modernism. Recent interest in the idea of postmodernism has done nothing to lighten this load. On the contrary. The more it has seemed desirable or necessary to articulate a change of sensibility or of epoch—to define a postmodern condition—the more urgent it has become to identify just what it is that we are supposed to have outgrown or to have seen around or through. Fully to inquire into the meaning of modernism would be to do much more than to gloss a critical term. It would be to explore the etiology of a present historical situation and of its attendant forms of self-consciousness in the West.

It is a problem for any broadly conceived inquiry into the meaning of "modernism" that the term acquires a different scope and penetration in each different academic discipline. The inception of modernism in music is typically located at the close of the nineteenth century, while to talk of modernism in English literature is to focus upon a relatively limited if highly influential body of work produced in the first two decades of the twentieth century. In the history of art, on the other hand, the student of modernism can expect to run a gamut from the French painting of the 1860s to the American art of a century later and may even be directed as far back as the later eighteenth century.

There are common features to each case, however. Alike in all the arts, modernism is at some point grounded in the intentional rejection of classical precedent and classical style. Modernism is always and everywhere relative to some state of affairs conceived of as both antique and unchanging. However else its parameters may be established, "modern history" is defined as the history of a period including the present but excluding the Greek and Roman epochs. "Modern languages" are those languages which are not ancient languages but which are still adaptable and transformable for the purposes of expression. To conceive the need for a modern art is to experience one's inherited resources of expression as if they were the forms of an ancient language, such that one's would-be spontaneous utterances are required to conform to established patterns of rhetoric. Loosely conceived as meaning a commitment to the modern, "modernism" thus serves to declare an interest in the revision or renewal of a language and a curriculum.

Within this broad area of definition, the concept of modernism has tended to function in the discourses of art history in three different ways, according to three different though interdependent forms of usage. Since these usages are

rarely explicitly distinguished, there is always a strong possibility of confusion in art-historical discussions of modernism. The first part of this text will therefore be devoted to an attempt to distinguish these different usages and to connect them to the respective interests they tend to represent. Once these differences are acknowledged it may be possible to reestablish some common ground.

First, then, and most widely, modernism is used to refer to the distinguishing characteristics of Western culture from the mid-nineteenth century until at least the mid-twentieth: a culture in which processes of industrialization and urbanization are conceived of as the principal mechanisms of transformation in human experience. At the commencement of his influential essay "The Metropolis and Modern Life," published in 1902–03, Georg Simmel wrote, "The deepest problems of modern life derive from the claim of the individual to preserve the autonomy and individuality of his existence in the face of overwhelming social forces" (Simmel 1902–03, 130). In this form modernism is regarded both as a condition consequent upon certain broad economic, technological, and political tendencies and as a set of attitudes towards those tendencies. This first sense of modernism may thus be said to have both a passive and an active aspect. Under the former it refers to that cluster of social and psychological conditions which modernization accomplishes or imposes, for good or ill. Under the latter it refers to the positive inclination to "modernize." As thus understood, modernism may be vividly exemplified through the stylistic and technical properties of works of art, but it will also be recognizable in certain social forms and practices and in the determining priorities of certain institutions, such as museums, or universities, or financial markets.

In our first sense, then, "modernism" is the substantive form of the adjective "modern," while the condition it denotes is virtually synonymous with the experience of modernity. When Charles Baudelaire issued his call for a "painting of modern life," what he was asking was that painters should seek to capture this experience by isolating the distinctive appearances of the age: "the ephemeral, the fugitive, the contingent, the half of art whose other half is the eternal and the immutable" (Baudelaire 1863, 12; see also Baudelaire 1846). To speak in this sense of the modernism of a work of art is to refer to its engagement with preoccupations and spectacles specific to the age. Thus Manet's *Olympia* of 1863 (Plate 11.1) might count as a work endowed with modernism by virtue of the figurative terms in which it reworks the classical precedent it invokes: the type of the reclining Venus as painted by Giorgione and Titian. It is of particular relevance in this connection that Manet's staging of his picture serves to place the nude woman in the contingent situation of a prostitute or, more precisely, that it serves to place the spectator in the imaginary position of a prostitute's client. By this means, we might say, the painting brings home a kind of truth about the meaning of love in a modern world—a world in which sooner or later everything is brought to the marketplace to have its value estab-

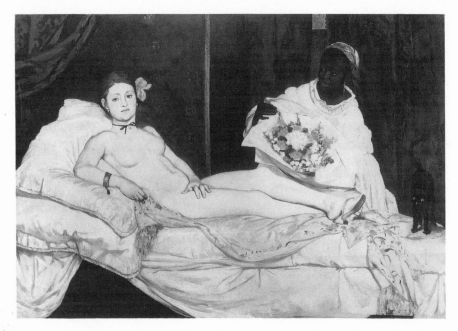

11.1 Edouard Manet, *Olympia*, 1963. Musée Orsay, Paris. Photo: Réunion des Musées Nationaux, Paris.

lished and to become a commodity. In the language of modernism the classical "goddess of love" thus becomes translated into "a prostitute."

The topicality of this image is easily enough established. In Baudelaire's "The Painter of Modern Life," for instance, a section on "Women and Prostitutes" follows the section on "Modernity." This highly influential essay was first published at the close of the year in which *Olympia* was painted. Historical research will further confirm that the prevalence of prostitution in the Paris of the 1860s was a matter not only of fascination in artistic circles but also of concern to the police and to the civil authorities. In this first sense of modernism, then, Manet's painting qualifies on the basis of its demonstrable relevance to the wider issues of contemporary social life.

The concept of modernism is also used in a more specialized sense, however, not to evoke the whole field of modern social existence but to distinguish a supposedly dominant tendency in modern culture. To employ the concept of modernism in this second sense is to convey an evaluative judgment concerning those aspects of culture which are found to be "live" or "critical." Modernism in this second sense refers specifically to the modern tradition in high art and to the grounds on which a truly modern art may be distinguished not only from classical, academic, and conservative types of art but also, crucially, from

144

the forms of popular and mass culture. The most influential spokesman for this view of modernism was the American critic Clement Greenberg. In his first major essay, published in 1939, Greenberg distinguished between the art of the avant-garde and "kitsch," by which term he derogated the synthetic products alike of the modern academy and of urbanized mass culture. The role of the avant-garde, he believed, was "to keep culture moving." Kitsch, on the other hand, was "the epitome of all that is spurious in the life of our times" (Greenberg 1939, 8–12).

It should be clear that where the impetus of modernism is thus associated with the practices of the avant-garde, the principal function of any generalization across different cultural forms and social practices must be to provide a background of contrasts. The point becomes clearer the more the concept of modernism is distinguished from its partial synonym, modernity. Modernity is a condition that the work of art both distills from and shares with the encompassing culture, which must include what Greenberg called kitsch. In its second form of usage, on the other hand, "modernism" implies a property that must be principally internal to the practice or medium in question. As thus understood, modernism is representative of the broad experience of modernity only insofar as that experience may have to be confronted in the continuing pursuit of aesthetic standards set by the art of the past.

These standards are defined by human capacities and they therefore remain as constant as those capacities themselves. The conditions of attaining them are continually changing, however, both because history entails change and because what has been once made cannot be made again as a vehicle for the same values. The achievement of modernism in art is thus seen as involving both a requirement of continuity and a crucial requirement of originality with regard to other—and specifically recent—art. According to the later suggestions of Greenberg, what specifically establishes the modernism of a discipline or a medium is not that it reveals an engagement with the representative concerns of the age, but rather that its development is governed by self-critical procedures addressed to the medium itself. "The essence of Modernism lies, as I see it, in the use of the characteristic methods of a discipline to criticize the discipline itself—not in order to subvert it, but to entrench it more firmly in its area of competence" (Greenberg 1960, 85). As thus understood, what modernism stands for is the critical achievement of an aesthetic standard within a given medium and in face of (though emphatically not in disregard of) the pervasive condition of modernity. The adjectival form of this "modernism" is not "modern" but "modernist." Thus, what Greenberg called kitsch may be modern, but insofar as it is defined as unself-critical and unoriginal, it cannot qualify as modernist.

According to this second usage, then, to label a modern form of art as modernist is to stress both its intentional and self-critical preoccupation with the demands of a specific medium, and its originality with regard to the prece-

dents that medium avails. Thus for Greenberg, Manet's paintings "became the first Modernist ones" not primarily by virtue of their picturing of circumstances redolent of modern life, but "by virtue of the frankness with which they declared the surfaces on which they were painted" (Greenberg 1960, 86). According to Greenberg's scheme, "Flatness, two-dimensionality, was the only condition painting shared with no other art" (87). Insofar as flatness is thus identified as painting's unique "area of competence," the frank acknowledgment of surface becomes the condition to which the self-critical modernist painting must tend. Viewed from within this framework of ideas, the significant encounter staged by Manet's *Olympia* is not the psychologically or sociologically topical confrontation between prostitute and client but the technically critical relationship between pictorial illusion and decorated surface. Where the aesthetic tuning of this latter relationship is seen as the crucial condition of the painting's individuality, the real-life scenario to which that painting makes reference must be relegated to the status of a mere starting point or pretext. Within this frame of reference it will not be appropriate to ask whether modernism's testimony to the historical character of the epoch is of an active or a passive nature. Rather, it is assumed that the real testimony a painting such as *Olympia* has to offer is the incidental but inescapable product of an engagement with problems which are primarily aesthetic. That testimony is the more reliable for being involuntary, and in that sense disinterested.

In this second sense of modernism it will clearly be inappropriate to speak in one and the same breath of a modernist artwork and a modernist institution. There is no reason to assume that the practices and priorities which govern the conduct of a social engagement or the running of a museum will be consonant with those which determine the production of a painting. Nor is there reason to believe that the relative modernism of an institution can be an issue *in the same sense* that it may be where the critical development of a painting is at stake. Indeed, for those subscribing to the second sense of modernism, there is every reason to assume the contrary. Michael Fried wrote in 1965,

> While modernist painting has increasingly divorced itself from the concerns of the society in which it precariously flourishes, the actual dialectic by which it is made has taken on more and more of the denseness, structure and complexity of moral experience—that is, of life itself, but life lived as few are inclined to live it: in a state of continuous intellectual and moral alertness (Fried 1965, 773).

The apparent implication of Fried's thesis is that it is *only* by divorcing itself from the "concerns of society" that modernist painting has been able to draw upon the creative dialectic by which its aesthetic or ethical virtue is sustained.

In its second sense, then, the term "modernism" is used to refer to a supposed tendency in art in which a special, "aesthetic" form of virtue and integrity is pursued at the apparent expense of social-historical topicality or relevance.

According to this usage, it is commitment to the priority of aesthetic issues that primarily qualifies modernist art as the high art of the age. In turn, what qualifies the artist is a subjection to the demands of the medium, which has become indistinguishable from the demand of truth to oneself.

And so to the last of our usages. This third sense of "modernism" is distinguished from the second not so much by a difference in field of reference as by a distancing from the terms in which that field is represented. This distancing might be thought of as the equivalent of a shift from *oratio recta* to *oratio obliqua*. In this last sense "modernism" stands not for the artistic tendency it designates under the second usage, but rather for the usage itself and for a tendency in criticism which this usage is thought to typify. A Modernist, in this sense, is seen not primarily as a kind of artist, but rather as a critic whose judgments reflect a specific set of ideas and beliefs about art and its development. (From this point on, this third sense of "modernism" will be capitalized in order to preserve its distinctness from the first and second usages.) Thus understood, a Modernist critical tradition emerged in France in the later nineteenth century, to be first codified in the writings of Maurice Denis, was developed in England in the first three decades of the twentieth century, principally by Clive Bell, Roger Fry, and R. H. Wilenski, and was brought to its paradigmatic form in America between the end of the 1930s and the end of the 1960s, notably in the work of Clement Greenberg and subsequently of Michael Fried. (In fact, as implied earlier, there is now a gathering tendency to trace the origins of Modernist theories back before the beginning of the nineteenth century. The identification of Modernism with Greenberg's writing remains so firmly established in the sphere of art, however, that to talk of a tradition of Modernist art criticism is in effect to consider the antecedents of Greenbergian theory as these may be established with benefit of hindsight.)

It should be clear that to distinguish this third usage of "modernism" from the second—or to distinguish between modernism (conceived as an artistic tendency) and Modernism (conceived as a critical tradition)—is effectively to stand outside the framework of Modernist criticism itself. For Greenberg and the early Fried, modernist painting and modernist sculpture were the forms of art, at once self-consciously modern and qualitatively significant, which their criticism was intended to pick out. What *they* meant by modernism was the property or tendency they saw as common to the works thus isolated—works by Manet, Cézanne, Picasso, Matisse, Miró, Pollock, Louis, Noland, Olitski— *not* the procedures by which their own singling out was done.

We have seen that Greenberg's sense of modernism depends upon the possibility of distinguishing an authentic, avant-garde, modernist art from an inauthentic, "kitsch" popular culture. From Greenberg's point of view these distinctions were intrinsically significant. From the perspective of broader cultural studies, however, no such distinction could be disinterested. It becomes clear that the ground on which distance is established from the valuations of the

Modernist more or less coincides with the first position regarding the meaning of modernism; with the view, that is to say, that the important distinguishing characteristic of a modern art is to be found—or ought to be found—in its manifest coincidence with the social and psychological condition of modernity. For the advocates of cultural studies—now certainly in the majority among students of the modern in art—there can be only one good reason to single out a modern *art* as "modernist"; that is when it is seen as subservient in practice to a Modernist theory already formulated in criticism or art history and when this subservience is regarded as a *limit* on its modernity. As regards such recent and current art as they approve, non-Modernists may well find the term "modern" sufficient. Indeed, it will be an *advantage* of this term that it enables and encourages theory to range over all forms of culture, high and "popular" alike.

An example will help to clarify the point. In discussing the "modernist art" of the 1960s, both Greenberg and Fried made various forms of reference to the work of the painters Jules Olitski and Kenneth Noland and of the sculptor Anthony Caro. What these critics intended to convey by such references was that the work in question was both original vis-à-vis the modern traditions of painting and sculpture respectively and of critical significance vis-à-vis the "mere novelties" of consumer culture and popular art. But in the utterance of those to whom Greenberg and Fried appeared as ideologists of Modernism, the labeling of Olitski or Noland or Caro as a Modernist was a means to convey a quite different valuation. For the non-Modernist, the term tended to carry the pejorative implication that the artist's work was submissive to a form of critical prescription, and was thus unoriginal. On the one hand this submission was seen as preventing the work in question from being fully engaged with the modern in all its aspects. On the other the supportive criticism was seen as masking the work's actual implication in forms of privileged consumership.

Controversy over the meaning of modernism can now be seen as having been central to modern debate about the meaning and value of art and culture. The relevant issues have conventionally been polarized along the following lines. Should we measure all forms of cultural production alike according to what we might summarily call their realism, meaning the extent of their implication in the pressing concerns of human social existence, the adjustment of their technical properties in the light of that implication, and the consequent breadth of their potential constituency? Is art, in the last resort, subject to the same kinds of critical demands as we might apply to any other component of the social fabric? Is *Olympia* to be esteemed for the truths it seems to make palpable—truths about the nature of exploitation and oppression (of one class and gender by another class and gender) and about the forms of hypocrisy and alienation which are required of the respective parties to the resulting exchanges? Or is a preoccupation with such issues in the end distracting from the actual properties of this or any painting, that is, distracting from those proper-

ties the painting has as distinct from such properties as may be attributed to the motifs it illustrates? Does the true critical potential of culture lie, as the Modernist would have it, in its autonomy vis-à-vis social and utilitarian considerations and in its pursuit of the aesthetic as an end in itself? Are the forms of *fine* art distinguished by the fact that they enable an unusually concentrated pursuit of this end? Should we aim to judge *Olympia* on its formal properties *as a painting* and thus to set aside whatever emotions may be aroused by the scene it depicts—or, as Greenberg would put it, by its "literature" (see Greenberg 1967, 271–72)?

As implied, the priorities of "realism" and Modernism are here presented so as to appear more clearly polarized than they tend to be in practice. I mean to make amends in due course. We should first acknowledge, however, that Modernism has indeed been widely represented as a critical tendency incompatible with realism—and with some apparent justice. In all phases of its development Modernist theory has rested upon three crucial assumptions. The first is that nothing about art matters so much as its aesthetic merit. In Greenberg's words, "You cannot legitimately want or hope for anything from art except quality" (Greenberg 1967, 267). The second is that for the purposes of criticism the important historical development is the one that connects works of the highest aesthetic merit. As already suggested, the true Modernist is interested in the whole "visual culture" only as the background against which exceptional works may be distinguished. Greenberg again: "Art has its history as a sheer phenomenon, and it also has its history as quality" (267). The third is that where aesthetic judgments appear to be in conflict with moral judgments, with political commitments, or with the concerns of society, what should be examined first is not the aesthetic judgment, which the Modernist considers involuntary and thus not open to revision (265), but the grounds of the moral judgment or the political commitment, or the relevance of the social concerns. In the words of the English Modernist Clive Bell, "when you treat a picture as a work of art, you have . . . assigned it to a class of objects so powerful and direct as means to spiritual exaltation that all minor merits are inconsiderable. Paradoxical as it may seem, the only relevant qualities in a work of art, judged as art, are artistic qualities" (Bell [1914] 1987, 117). This issue of relevance is crucial to Modernist concepts of the autonomy of aesthetic value. In Greenberg's view moralizing judgment is typically rooted in response to the illustrative content of the work of art and is therefore irrelevant to the quality of the work's aesthetic effect, *unless,* that is, it can be shown just how it is that that effect becomes "impregnated" by the illustrative content (Greenberg 1967, 271).

There are various questions which these assumptions have seemed automatically to invite. How are we to assure ourselves that what the Modernist critic represents as aesthetic merit is actually an objective and separable property of the work of art? Or to put it another way, why should we accept the view

that judgments of taste are involuntary and unsubjective and thus categorically distinct from mere assertions of preference and self-interest? What if it transpired that the supposed aesthetic properties were actually the reflections of the critic's own psychological disposition and self-interest? What if the Modernist's requirement of relevance to the quality of effect were a mere formalism—a methodological device serving to protect works of art, and judgments about them, from inquiry into the historical and ethical materials of which these works and those judgments may actually have been constituted? Whose interests are likely to be best served by maintaining high art as a realm insulated against troubling social considerations? It is not hard to see where this line of questioning might be taken. Nor is it hard to understand how it has come about that, while "modernism" remains available as a term of reference to Western culture during the course of a specific (possibly elapsed) historical period, "Modernism" is now often consigned to the company of such terms as "conservatism" or "the ideology of the ruling class" or "business as usual."

It is as well that these different points of view should be identified. As suggested earlier, discussion of the meaning of modernism is liable to be confused and confusing so long as it remains unclear what kinds of critical programs and positions are variously at stake. Now that the grounds of opposition have been described, however—perhaps, for the sake of argument, slightly exaggerated—we can finally attempt to reestablish some common ground. The aim is twofold: to sketch out a framework of practical observations upon which an understanding of modernism may be allowed to expand, and to see whether certain of the procedures and priorities of Modernism may not after all be rendered compatible with "realist" interests. With this end in view we return to the much-cited example of Manet's *Olympia*.

Let us say, for the sake of argument, that what is meant in talking of the modernism of *Olympia* is not adequately substantiated either by reference to the topicality or realism of its theme, *or* by reference to the self-critical frankness of its formal and decorative organization. Rather what is at issue is the position in which the painting places its spectator. The notion of a hypothetical position here functions to bring together in the experience of the spectator two aspects which Modernist criticism has tended to prize apart: the painting's topical pictorial aspect, or its "modernity," and its self-critical formal aspect, or its "modernism." Thus what I mean by "position" is the same imaginary state that is defined for the spectator not only by the painting's pictorial theme (when it has one) *but also* by its formal and decorative properties. What I mean by "spectator" is someone who is not only competent to identify the pictorial theme (when there is one), and not only disposed to view the painting's formal and decorative properties as significant of some human intention, but also disposed to exert his or her critical and imaginative faculties in pursuit of the intention in question. This spectator is a person who works.

As regards the pictorial theme of *Olympia*, we have already suggested that

Olympia's world, that is to say, is a world in which actions have imaginable consequences and pleasures are paid for, in which flesh bruises and others also have minds.

In 1965 Michael Fried wrote of Manet as "the first painter for whom consciousness itself is the great subject of his art" (Fried 1965, 774), thus revising the terms in which Greenberg had five years earlier set Manet at the commencement of modernist painting's trajectory. I do not think it matters whether or not it is Manet's consciousness that we see *Olympia* as representing: whether, for example, we conceive of what we "see" in looking past the client as the painter's empathetic projection into the *woman's* role. The point is that the form of attention the painting both demands and defines is one that results in a form of critical consciousness: a responsive awareness not only of the painting as object, but of the rich but determinate range of metaphorical meanings the surface of that object, in all its plenitude and its particularity, is enabled to sustain; a self-consciousness awareness, that is to say, of that which is other.

I propose that it is precisely in the painting's capacity thus to determine the attention of the spectator that both its realism *and* its modernism may be said to lie. And I do not believe that it would be particularly easy or helpful, at this juncture, to distinguish just which sense of modernism is at stake. What we can say is that it is just this possibility—the possibility that, however each and every spectator actually responds to the given work of art, insofar as any response is determined by the work of art, it is critically determined *in exactly the same way for each person*—that allows the Modernist to conceive of taste as possibly objective. For if the picture can indeed be said to be the final arbiter of that which it is relevant to say of it, then we will be availed of a powerful control on mere expressions of self-interest. Of course to propose that the work of art is the final arbiter of our relevant experience is to talk of how "experience" may be sensibly conceived for the purposes of criticism. It is emphatically not to attribute to works of art a mysterious agency which would allow them somehow to control interpretations. Nor is it to claim that all or any *accounts* of the experience of a given work of art must converge on a single pattern isomorphous with it. Why should we expect such convergence to be a tendency of our speakings and writings about art?

It will not be equally true of all works of art that they succeed in determining what it is relevant to say of them. Indeed, the degree of their success in doing so may be significant of other forms of relative success or failure. I assume that a painting which achieves an identification of realism with modernism will have earned its capacity to determine the spectator's attention. To put the matter in the form of a generalization, we might say that any and all art is impaired to the extent that, when it is considered as intentional under some description, modernism and realism respectively can with justice be predicated of different and separable aspects and properties. (The generalization serves to make the point that the "unity" of a composition is far from being a simply technical

issue.) A painting which fails or evades the challenge to identify realism with modernism may well find itself left without significant remainder in the face of *supervening* critical interests. To talk of conservative realism or of antirealist modernism is to conjure up forms of art capable of holding the spectator's attention only when critical and imaginative faculties are for one reason or another subjected or suspended.

In this essay much has been made to hang upon a painting now well over a century old. What of subsequent developments? I have meant to suggest that the supposed modernist "orientation to flatness" and the matching Modernist stricture on relevance may alike be interpreted as means to address the realistic conditions of self-consciousness in the modern spectator. Another way to put this point would be to say that the *continuing* function of a modernist culture—an "avant-garde" culture, if we borrow Greenberg's distinction—is to confront the occasions of fantasy and distraction with the requirements of imagination and critical self-awareness. Pictorial scenarios such as *Olympia's* are *among* the means by which the modernist work of art may summon up the inauthentic modes of experience—the dead areas of culture—that it means critically to diagnose and to distance. But, as Greenberg and subsequently Fried were concerned to make clear, however engaging such scenarios may seem to be—however vividly they evoke a history and a sociology—they are not *necessary* to the successful undertaking of the modernist critical task. This was the crucial lesson of the abstract art of the early twentieth century. Later painters such as Mark Rothko and Barnett Newman showed that a field of color could be enough, so long as it was made the occasion of some dialectical play between the literal and the metaphorical. It transpired that all that is required for the achievement of modernism is that the work of art should establish its comparability to some current *mode or style* of the inauthentic (the idealized, the sentimental, the euphemistic in our culture), and that it should be capable of making its own critical distinctness palpable in the experience of the imaginatively engaged spectator. I say "all," but of course this achievement is no easier or less complex in so-called abstract art than it is in figurative work. It follows that there are no reasons in principle why the realism of Rothko's work or Newman's should not be valued as highly as the realism of Manet's. Insofar as they have worked to explain the requirements in question, those labeled as Modernist critics can with justice be viewed as qualified representatives of modernism in art, while insofar as these requirements may still be relevant to the conduct of art, associations of Modernism with conservatism may require some reconsideration. A fortiori, announcements of the demise of modernism or of Modernism may turn out to be self-interested, or premature, or both.

SUGGESTED READINGS

Baudelaire, Charles. [1846] 1965. *Art in Paris, 1845–1862.*
———. [1863] 1964. *The Painter of Modern Life and Other Essays.*

Bell, Clive. [1914] 1987. *Art.*

Clark, T. J. 1985. *The Painting of Modern Life: Paris in the Art of Manet and His Followers.*

Fried, Michael. 1965. *Three American Painters: Kenneth Noland, Jules Olitski, Frank Stella.*

———. 1967. "Art and Objecthood."

Fry, Roger. [1920] 1981. *Vision and Design.*

Greenberg, Clement. 1939. "Avant Garde and Kitsch."

———. 1960. "Modernist Painting."

———. 1967. "Complaints of an Art Critic."

Harrison, Charles, and Paul Wood, eds. 1992. *Art in Theory 1900–1990.*

Simmel, Georg. 1902–03. "The Metropolis and Modern Life."

Wilenski, R. H. 1927. *The Modern Movement in Art.*

Wollheim, Richard. 1987. *Painting as an Art.*

TWELVE

Avant-Garde

Ann Gibson

Faith Ringgold's 1991 *Picasso's Studio* (Plate 12.1), number 7 in her *French Collection* series, exemplifies avant-garde as well as what have been called "anti-avant-garde" (Harvey 1989, 59), "anti-aesthetic" (Foster 1983, xv) or, simply, "postmodern" tendencies. Ringgold's quilt painting displays the intellectual iconoclasm and playfulness usually associated with the anarchic spirit of the avant-garde, but not its characteristic sense of "universal and hysterical negation" (Huyssen 1981, 30; Calinescu 1987, 125, 140). *Picasso's Studio* is self-reflexive: it is *about* the definition and the centrality of the avant-garde in the history of modern art. It thus extends the premises of the avant-garde into the late twentieth century by affirming some of its characteristics while critiquing others. Most useful for this essay, as an allegory of avant-garde production it reuses avant-garde strategies for "anti-avant-garde" ends, and so offers an opportunity to explore both past and present conceptions of the avant-garde.

Picasso's Studio is painted on pieced, quilted, and stuffed fabric. The artist has relegated Picasso nearly to the margin, crowded between a border of decoratively pieced flowered material, overlapping patterns of painted fabric, a bored but alert model, and his famous *Les Demoiselles d'Avignon* of 1907. At one side of the painting are numerous sketches of the abstracted female figure. Brush poised, Picasso—perhaps the twentieth century's most famous embodiment of the avant-garde—stands before a blank canvas. His model, an imaginary alter ego invented by Ringgold, represents what members of the avant-garde like Picasso were *not:* females of non-European descent who were more often, in Meyer Schapiro's words, art's "object-matter" than its makers (Roth 1992, 8; Schapiro 1957, 38). As an antipatriarchal parody, one that aims to "transgress the ideology of the transgressive (avant-gardism)" (Foster 1983, ix), it tells us about the avant-garde by "what [it] talk[s] about," that is, through its "*substantive* revision of, rather than [its] apparent *formal* allegiance to, the European avant-garde" (Suleiman 1990, 162, quoting Spivak 1981, 1967).

But art lovers may still feel indignation, on one hand, at seeing Picasso, the epitome of the heroic avant-garde, marginalized in terms of his model and, what's more, in a work whose narrative naturalism he played a part in discrediting. Naturalism was characterized by artists and critics like Baudelaire, Maeterlinck, and Mallarmé as well as later writers such as José Ortega y Gasset as falsely and superficially totalizing because it employed the surface likeness of mimesis, of the copy, instead of exploring the "deeper" similarities available to metaphor. The continuing vitality of this response to naturalistic representation

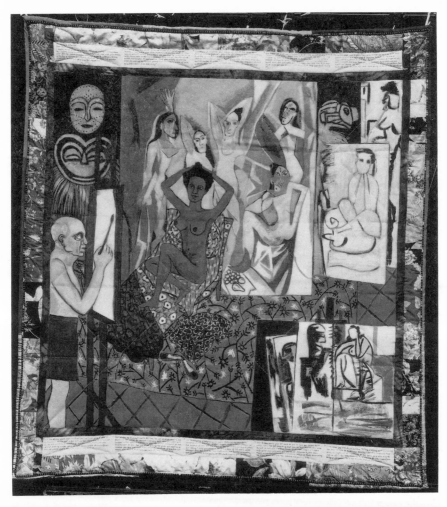

12.1 Faith Ringgold, *Picasso's Studio,* 1991, The French Collection, part I, no. 7.
© Faith Ringgold Inc.

is instructive because it represents as avant-garde an optimistic traditionalism, to which some would deny the title "avant-garde" altogether, calling this aspect of the avant-garde "modernism." Members of the avant-garde who worked in this modernist vein often sought a way to accept the flux of modernity with its ruptures and fragmentations. This is a part of the modernist criteria by which Picasso's abstractions—along with those of Manet, Cézanne, Proust, Torres-García, Pound, Kandinsky, Joyce, Benn, Mondrian, Eliot, Pollock, Stella, and other artists from the Enlightenment until at least the 1960s—remain of critical

interest. They have held out the hope that the disruption caused by modern progress in the arts and sciences will result in the end not only in the control of nature to humanity's benefit, but will also promote universal justice, moral progress, and happiness (Habermas 1981, 9; Huyssen 1981, 26–27; Calinescu 1987, 96–97; Fló 1992).

On the other hand, reactions of dismay to *Picasso's Studio* may also be caused by the absence in it of the "universal and hysterical negation" of that other anarchic and even nihilistic wing of the avant-garde rooted in elements of Dada and surrealism typified in the readymades of Duchamp and Man Ray, and seen in work by others such as Tzara, Brecht, and Warhol (Calinescu 1987, 140–41). However, as Nicos Hadjinicolaou and Andreas Huyssen have pointed out, the 1970s saw a revival of interest in the "*notion of avant-garde*" (Hadjinicolaou 1982, 39; Huyssen 1986, 25). One of the earliest signs of this revival was Robert Venturi's anti-avant-garde manifesto, *Complexity and Contradiction in Architecture* (1966). "I prefer 'both-and' to 'either-or,' black and white, and sometimes gray, to black or white," he wrote (16). The critical revival that this kind of thinking sparked, in terms of the outlines broadly and effectively suggested by Ringgold, is the springboard of this essay.

Using *Picasso's Studio* as its center locates the vantage point of this discussion firmly in the late twentieth century. In doing so it echoes what is perhaps the major surviving manifestation of the politics of what Peter Bürger has called the "historical avant-garde," evident in the tendency of some contemporary art and criticism "to name an identity and mechanism of oppression that structures it." This tendency, analyzed in an essay by Christopher Reed and demonstrated in the arguments mounted in two panel discussions published in *October* magazine in 1993 and 1994 on "the politics of the signifier," characterizes the current anti-avant-garde's rejection of purity as it extends and focuses earlier postmodernism's noncommittal play of recognizable and often socially significant images (Reed 1994, 281; Foster, Krauss, et al. 1993; Foster, Buchloh, et al. 1994).

In the United States, postmodern estimations of the nature and value of the avant-garde have frequently been funneled back through the conflicting claims of two readily available book-length studies: Renato Poggioli's *The Theory of the Avant-Garde,* published in Italian in 1962 and in English in 1968 (though conceived in the late 1940s) (Calinescu 1987, 113), and *Theory of the Avant Garde,* an amalgam of Peter Bürger's writings published in German in 1974 and 1979 and brought together in English in 1984. I will discuss their claims with those of some of their contemporaries and then continue, via Ringgold and theoreticians like Nicos Hadjinicolaou, Susan Suleiman, Carol Duncan, Daniel Herwitz, Rosalind Krauss, Richard Shiff, and Andreas Huyssen, to more current estimations of the avant-garde and its projects.

Poggioli and Bürger did agree that the term "avant-garde" was originally used to designate the conjunction of revolutionary sociopolitical tendencies and artistic goals. They saw the avant-garde as had Walter Benjamin, attempting

"to wrest tradition away from a conformism that is about to overpower it" (Benjamin 1968b, 255), interrupting the sense of continuous development in the arts by its transgressions against anything established as a given. They differed, though, in their estimates of what counts as exemplary avant-garde art and therefore in their descriptions of both its history and its legacy.

For Poggioli, the alliance of what he called "the two avant-gardes," one cultural-artistic and one sociopolitical, survived in France only until about 1880. What is commonly understood as avant-garde art, he wrote, concentrated after the third quarter of the nineteenth century on formal creativity, rejecting conventional habits and incorporating "the cult of novelty and even of the strange" (poet Ezra Pound, Russian formalists such as Victor Shklovsky, and critic Harold Rosenberg have all commented on this aspect of the avant-garde). But Poggioli claimed that his autonomous, cultural-artistic avant-garde did not leave behind its social task when it was no longer specifically critical of society. Unlike Mondrian, whose utopian goals for neoplasticism he saw as "antiseptic" (Poggioli 1968, 203), and also unlike Breton's surrealism, whose insistence on the " 'omnipotence of the dream' " Poggioli believed could produce only a "quasi-mechanical product, a passive reflection" (205), Poggioli held that the most effective avant-gardes reformed society by functioning as cathartic therapy for a language of art, music, and literature that had degenerated through thoughtless and habitual formulas. "It is absolutely indispensable to distinguish the spurious from the genuine avant-gardism which results in art," he wrote. The need for value judgments, he believed, must not be obviated by "nonaesthetic considerations" (164–65). Poggioli is thus allied with Theodor Adorno in his belief that art should be autonomous (i.e., that artworks should "point to a practice from which they abstain: the creation of a just life"). For Adorno (as for Poggioli), "every commitment to the world must be abandoned to satisfy the ideal of the committed work of art." Adorno supported this claim with the observation that apparently apolitical art (he used the examples of Kafka's novels and Beckett's plays) "have an effect by comparison with which officially committed [i.e., politically aligned] works look like pantomime" (Adorno 1962, 317, 314).

Bürger, on the other hand, saw Poggioli's definition of the avant-garde as too elastic. Bürger felt Poggioli, by permitting "avant-garde" autonomy to be identified as far back as the late eighteenth century, allowed the avant-garde to separate itself from "real" life and social issues. He preferred to understand art not as single works produced by individuals but, following Walter Benjamin, as entities within an institutional framework that includes artists, dealers, critics, museums, collectors, etc. (Bürger 1984, 83–92). This framework, he insisted, determines what art is supposed to be and do. Thus for Bürger, the avant-garde cannot be separated from society, but is inescapably implicated in it. For Bürger, the radical shift occurred at the beginning of the twentieth century, when aestheticism gave way to a historical avant-garde that attacked art as an institution.

Bürger's historical avant-garde (those instrumental in contesting the deadening effects of art's institutionalization) included Italian futurism and German expressionism to a limited extent, cubist collage, and especially movements of the 1920s, including dadaism, the Russian avant-garde after the October Revolution, and particularly surrealism (109 n. 4). In the radical break that produced this historical avant-garde, he posited, collage and montage techniques were crucial, since they broke not only with the idea that perspective was equivalent to representation, but also with the idea that to be art, a work must be an organic whole. While Bürger contested the validity of autonomous art supported by Adorno and Poggioli, he nevertheless found certain of Adorno's arguments useful. Citing Adorno's caveat that nonorganic structure may offer escape from a system whose preference for the organic has congealed and ossified it, Bürger embraced elements of the concept of allegory advanced by Walter Benjamin, who wrote that the allegorist extracts elements from life or art, isolating them from their function there, and then combines them into a new work of art. Allegory's artificiality offered just the kind of antiorganicism that Bürger saw in the historical avant-garde (68–73, 90–91; Adorno 1984, 242, 266–68). Although Bürger and Poggioli disagreed about surrealism's status as a model avant-garde (given their disagreements on art's autonomy, it was predictable that Bürger liked surrealism, and Poggioli didn't), they agreed, as Poggioli put it, that "when a specific avant-garde that has had its day, insists on repeating the promises it cannot now keep, it transforms itself without further ado into its own opposite" (Poggioli 1968, 223).

Poggioli's views were conceived before the ideas encapsulated in the term "postmodern" had achieved currency (Calinescu 1987, 113). He did not relate his definitions of the avant-garde to such issues as appropriation, meaning as audience reception rather than artistic intention, representation as the construction rather than the mirror of reality, originality as function rather than fact, or issues of gender or race. Peter Bürger, writing a generation later, found himself at the beginning of the widespread currency of these issues, but gave short shrift to what he called post-avant-garde art. He was unable to accept postmodern art's pluralism, its reenshrinement of narrative and mimeticism, and its insistence on the importance of the difference of artists who worked unrecognized, even when their anti-institutional strategies paralleled those of the anti-institutional avant-garde he affirmed.

Bürger notes that Herbert Marcuse's essay "The Affirmative Character of Culture" led him to model his focus on the avant-garde's anti-institutional strategies as opposed to the merits of individual works. But he was also much influenced by Marcuse's claim that while the idealistic, transcendent art favored by bourgeois society showed "forgotten truths," it also served to detach those truths from any influence they might have in real life. Art, wrote Marcuse, bestowed on its audience "a beautiful moment in a chain of misfortune," thus offering them "the illusion of a resolution of the contradiction between a bad

material existence and the need for happiness." It could present this illusion better than religion or philosophy because, unlike these disciplines, art could offer satisfaction in the here and now (Marcuse 1968, 94–96, 99, 102, 117–120). Although Bürger found Marcuse wanting in both theoretical and material sophistication, he nevertheless extrapolated from his definition of "affirmative culture" as autonomous art in which "freedom of the soul was used to excuse poverty, martyrdom, and bondage of the body" (Marcuse 1968, 109; Bürger 1984, 12–14).

Referring to Jürgen Habermas as well, Bürger argued that the historical avant-garde (in such manifestations as Duchamp's *Fountain*) negated the preconditions for "affirmative," autonomous art: the disjunction of art and life, individual production, and individual reception (Bürger 1984, 25, 50–53). But even avant-garde art's anti-institutional character could be destroyed by its incorporation in institutions such as museums and academia (27, 89). Bürger believed that reusing avant-garde strategies only confirmed their institutionalization (57–59). In this he followed Poggioli but focused Poggioli's complaint on art's institutional frame, elevating the "historical avant-garde" to the highest pinnacle of ethical worthiness. This permitted Bürger to see later art that attempted to repeat the manifestations of the historical avant-garde as merely derivative and later art that departed from this model, no matter what *its* historical motivations, as regressive. He was thus unable to come to a positive assessment of the "post-avant-garde," or the "anti-avant-garde" of postmodernism.

More recent investigators of avant-garde practices have criticized Bürger for his repression of the heterogeneity of the avant-garde's response to modern, popular, and industrialized culture, a response that included, but was not limited to, the goal of Berlin Dada (Bathrick and Huyssen, 1989, 8). As Maud Lavin pointed out, that goal *was* to protest the institutionalization of art in order to reengage it with life—but in conjunction with, not in opposition to, its embrace of "affirmative" popular culture. After 1922 Berlin modernism was not concerned primarily with rebellion, but with "how to respond to commerce, politics, and new forms of mass communication, and with which appropriately modern styles." However, meshing art with technology, mass culture, and popular entertainment seldom included an imperative to engage (as Ringgold does) the politics of race and gender. Even Hannah Höch, in Dada circles in Berlin, who in her collages displayed an exceptional concern for the objectified position of women, was less critical of her society's derogatory attitude toward ethnographic others (Lavin 1993, 50, 17–19, 160).

Thus Faith Ringgold may be seen as continuing and sharpening Höch's project. Like Höch's collages, Ringgold's quilt affirms qualities once considered the province of the avant-garde: its central plane of fabrics on which the model poses, for instance, which in traditional perspective would appear to be horizontal, and therefore perpendicular to the picture plane, is tipped up, à la Degas and so many other modernists, to coincide with the picture plane instead. It

161

meets Poggioli's demand that the avant-garde be formally transgressive. But in doing so with methods already established as elements in the tool kit of an earlier generation, it also performs both Poggioli's and Bürger's recipe for the avant-garde's opposite: by conforming to what is now expected of the avant-garde it thus adapts to the "theory-death" (Mann 1991) of its institutionalization.

Picasso's Studio, like *Demoiselles,* is a one-of-a-kind production, too, an object made by a nameable person—an "individual"—who has set herself both with and against a number of now-institutional conventions. One of these is the art market; since Ringgold's quilts have readily entered a number of collections, both private and public, she has aligned herself in this regard with the autonomous avant-garde. For Bürger, such an adaptation to the market accounts for the "arts-and-crafts impression that works of the avant-garde not infrequently convey" (1984, 53). One must recall that not all avant-gardes were obsessed with modern technology. The hand-making traditions emphasized by the British Arts and Crafts movement and Jugendstil were extended by the avant-garde arts and crafts workshops of Bloomsbury, de Stijl, the Bauhaus, Black Mountain College, and el Taller Torres-García. In deliberately making reference to "craft," (*Picasso's Studio* really *is* a quilt, complete with decorative stitching, printed, pieced fabric, and scrapcloth batting), Ringgold ratcheted up the pejorative ante with which the avant-gardes Bürger promoted viewed "craft" by making it synonymous with the ground whose materiality that same avant-garde championed. Rather than being (as it is in Matisse) merely a represented element or (as it often is in Picasso, Braque, and Schwitters) an element that brings reality into the picture metonymically rather than mimetically or metaphorically, Ringgold's printed fabrics form a part of the very base on which her figures are painted. They not only refer to, but are, the material from which quilts are traditionally made. So while she throws into question one aspect of the avant-garde's continuation of traditional art's separation of art and craft, she tacitly extends another.

Ringgold's painted story quilt also displays cubism's abstracted forms, juxtaposing them with their so-called "primitive" inspirations—the masks on the upper left—and their human source, the model. By collaging together not only Picasso's cubist transcriptions of African masks and feminine form but also simplified naturalistic representations of the masks and of a live model, along with the transgressive elements of "craft" processes and the actual narrative text in bars at the top and bottom of the quilt, Ringgold meets, and in fact exceeds, the revolutionary quality—the breaking of the illusion of organic unity—that Bürger ascribed to the admission of actual fragments of empirical reality when they were incorporated into artworks (Bürger 1989, 78). Not only does her collapse of the "decorative," supposedly superficial aspect of craft into the tipped-up plane of modernist painting exceed the imperatives of both Poggioli's autonomous avant-garde and the economic definitions of the institutions re-

sisted by Bürger's historical avant-garde, but her placement of an actual narrative on the quilt's surface catches all the elements on display in a net of meaning that reestablishes the organic congruence of the parts and the meaning of the whole that collage technique was supposed to destroy.

Ringgold's painting technique in *Picasso's Studio* throws into question a primary route through which the avant-garde has manifested its desire to produce works whose procedures and appearance place them outside of "art" conventions: primitivism. Her representation is constructed not only through crafts techniques and collage, but also acrylic paint with which she renders figures, furniture, fabric. Naturalistic but not academic, Ringgold's techniques are somewhat reminiscent of those of artists such as Horace Pippin, whose untutored style was sometimes called "primitive." Ringgold, however, is not untutored. She is a professional who took her M.A. in art in 1961 from City College of New York. "I'm using whatever method I need to use," she has commented. "It's not that I don't know how to do it another way" (Ringgold 1990, 7). Her "neoprimitive" style, then, might be more appropriately likened to that of other trained artists such as William H. Johnson, whose *choice* of an untutored technique has prompted critics to use this designation, or, more pointedly for the purposes of this essay, Picasso or Matisse (who, with his painting *La Danse* and his model, the same Willia Marie Simone, is the subject of another quilt in the *French Collection* series). Significantly, Picasso and Matisse, both of whom attempted to escape Europe's academic beaux-arts heritage via alliances with colonized nations' art and what were prevalently understood as its spontaneous art techniques, have not been seen as "neoprimitives," but as "avant-garde." In choosing this style, Ringgold might be seen as following them; but as Poggioli remarked, avant-gardists are opposed "to the principle of spiritual and cultural inheritance," and their favorite myth is "the annihilation of all the past, precedent and tradition" (Poggioli 1968, 47).

So, does this mean that Ringgold's quilt is an example of failed avant-gardism? I think not, since Ringgold's purpose in selecting a neoprimitivizing rhetoric is in an important way exactly opposite to that of most members of the avant-garde. Jürgen Habermas's observation on the avant-garde's use of the so-called primitive is instructive in this regard: it exhibited, he wrote, an "anarchistic intention of blowing up the continuum of history," often by replacing historical memory with "the heroic affinity of . . . a sense of time wherein decadence immediately recognizes itself in the barbaric, the wild and the primitive" (Habermas 1981, 5). Thus it could annex the stereotyped "wildness" of both internally and externally colonialized peoples without eliciting charges of plagiarism or political insensitivity. By painting in one nonacademic style to question the ascendancy of what has become another one, Ringgold raises questions that strike at the heart of this aspect of the avant-garde enterprise: In the attempt to break away from the status quo, whose reversals are acceptable? Who benefits? and Who decides?

Equally disconcerting is Ringgold's dislocation of what Rosalind Krauss has called "the originality of the avant-garde" and what Richard Shiff has termed "the technique of originality." Both Poggioli and Bürger remarked briefly on the importance of novelty to the avant-garde enterprise, although to different ends: Poggioli notes its usefulness in creating unpopularity and Bürger (following Benjamin's "The Work of Art in the Age of Mechanical Reproduction") its support of the aura, the mystique of art's ritual status as an irreplaceable product of an individual genius (Poggioli 1968, 50; Bürger 1984, 28). But for Krauss and Shiff, the demystification of the avant-garde's claim to originality was a crucial postmodern task. When the double, the copy, is seen *with* the original, wrote Krauss, the double destroys the pure singularity of the original (Krauss, 109). As both Krauss and Richard Shiff have remarked, originality, that prime directive of the avant-garde whose sign is spontaneity, or self-expression, is a quality that, paradoxically, is rather laboriously produced by copying (Krauss 1981, 162; Shiff 1983, 119). Following Derrida, however, Shiff identifies a yet more radical political potential of the copy. Observing that doubling merely reverses the avant-garde's priorities in the opposition original/copy, he concludes that the anti-avant-garde has not finished its work until the toppling of the myth of the original has been followed by the displacement of the entire system of which that myth was a support (Derrida 1977, 195; Shiff 1983, 118).

In *Picasso's Studio,* Ringgold does go further than the mere doubling of Picasso's painting. She presents a copy of *Les Demoiselles* accompanied not only by cubistic drawings—traditionally preparations for painting—but also by representations of two kinds of "originals" for the mask-faced nudes in the historic avant-garde painting: African masks and the slim figure of Simone, Ringgold's stand-in. Ringgold's repetitions accomplish several things: they push Picasso's "masterpiece" into the background, obscuring it with the sketches, the "star" of the painting, Simone, and the masks hovering hieratically in the background; and they deny Picasso's "masterpiece" its spontaneity and thus the originary genius of its maker by showing its sources and the preliminary kinds of labor needed to produce it. Ringgold questions not only the status that Picasso's presumed originality granted to him as representative of the avant-garde, but also the supporting role the art of colonialized nations and its feminine objects played in the avant-garde's modernist enterprise.

Following the insistence of theorists such as Susan Rubin Suleiman, I would claim also that a worthwhile theory of the avant-garde must include a poetics of gender (but I'd add to that a poetics of colonial and postcolonial experiences) (Suleiman 1990, 84). Ringgold's use of her invented alter ego, Willia Marie Simone, to demythify and historicize the nature of the split between the representor and the represented—often a gendered as well as a racializing separation—characterized the historical avant-garde as much as it had traditional art. "The virulence of kitsch, this irresistible attractiveness," Clement Greenberg

had worried, was "crowding out and defacing native cultures in one colonial country after another" (Greenberg 1939, 14). The implication was that popular, that is, non-avant-garde, culture was somehow seductive and diseased (the image of a prostitute leaps to mind) and, what is more, that this feminized populism (as opposed to the "real" art of the colonizers) would dilute and displace "pure" native cultures. The presupposition was that excellence was European and male and, as Andrew Ross has argued, that a "native culture" that responded to the Western images it received (as we in the West had, of course, responded to theirs) was both diseased and feminized (Ross 1989, 43–47). As Carol Duncan (and, more recently, Griselda Pollock) has pointed out, the avant-garde (or vanguard) artist had been universalized as male well before "Avant-Garde and Kitsch" was published in 1939, a status confirmed by opposing his active, heterosexual masculine agency to the passive, feminized and objectified status of his art and the females it so often represented. From late-nineteenth-century artists like Paul Gauguin and Edvard Munch through the beginning of the "historic avant-garde" (Picasso and Matisse), including fauves like André Derain and Maurice Vlaminck, Brücke artists Ernst Kirchner and Erich Heckel, dadaists and surrealists like Duchamp, Schwitters, Max Ernst, and Giacometti, to abstract expressionists Jackson Pollock and Willem de Kooning, women were the vehicle, not the drivers, of art that examined what were understood as the central problems of existence in terms of middle-class European males' struggles against the economic and psychological structures of modern bourgeois society. Even Duchamp's *Fountain* is a male fixture (though not unambiguously so) and his *Nude Descending a Staircase* is riven, like the architecture surrounding her, by a dynamized cubism, rather than being the agent of its activity. Michele Wallace has extended Duncan, arguing that the anti-avant-garde's deconstruction of the modernist avant-garde's primitivizing really echoes, rather than rejects, primitivism's xenophobia. Wallace, however, was interested also in another aspect of the avant-garde's apartheid, its exclusion of artists of color as the *makers* of important art because it understood the arts and artists of Africa and elsewhere in the third world as worthwhile primarily as inspiration for the European avant-garde. The understanding of African and Oceanic art as productions whose worth is dependent on European validation is repeated, Wallace claimed, by most postmodernists' inability to take into account anything but the production of European-descended artists and critics. Thus, she concluded, both the masculinity and the whiteness of the historic avant-garde was continued by the anti-avant-garde, the postmodern generation.

It is just this situation that is countered by the narrative told in the borders of this quilt painting in the voice of Simone, an artist herself, but also Picasso's model. In opposition to the usual silence of the one who is painted, Simone recalls her responses to her Aunt Melissa's advice, to the whispered observations she ascribes to the masks of her ancestors on Picasso's wall, and to the prostitutes in his painting. "My art is my freedom to say what I please," asserted

Simone in response. "*N'importe* what color you are, you can do what you want *avec votre* art" (Ringgold 1992, 33). The format and narrative style of the quilt itself represent Ringgold's position in the art world, since quilts, as Patricia Mainardi has noted, "have been underrated precisely for the same reasons that jazz, the great American music, was also for so long underrated—because the 'wrong' people were making it, and because these people, for sexist and racist reasons, have not been allowed to represent or define American culture" (Mainardi 1982, 344). Like jazz, the tradition of narrative quilts is strong in African-American communities, although its preeminence there is still undetermined (Grudin 1990, 13–17).

Ringgold maintains a subjectivity that combines artistic identity with a compound of retrieved African heritage and a feminine sexuality—a gesture that runs contrary to the merely metaphoric or metonymic (even when sympathetic) meshing of these terms by the creative roster of both the avant-garde and the anti-avant-garde. Her position as a subject is, however, situated on the idea that art offers an arena of individualistic freedom, a standard claim of one of Poggioli's two avant-gardes, the cultural-artistic one. This anomaly reveals the paradox at the heart of the avant-garde's claim to universal relevance (Huyssen 1981, 38; Reed 1994, 273): its freedom is circumscribed; its universality partial. As Daniel Herwitz has suggested, perhaps "the tendency of contemporary art and theory to treat theorizing about art and culture as if it is the one remaining avant-garde activity on the face of the earth" is the proper continuation of earlier avant-gardes (Herwitz 1993, 272–73).

Following Herwitz's observation, one could say that Ringgold not only reveals the paradoxes at the heart of the avant-garde, she participates in them. As noted, members of various manifestations of the avant-garde, especially at their most revolutionary moments, have been dissatisfied with art's commodity status in capitalist society and with the traditional hierarchy of media. Avant-garde status, however, is defined in relation to a society's traditions, and to achieve recognition or even embodiment it must take advantage of some of its resources. Clement Greenberg commented that no culture can develop without economic support and that the avant-garde, despite its assumption that it was cut off from the elite ruling class, was actually "attached by an umbilical cord of gold" (Greenberg 1939, 10–11). Historically, the avant-garde has negotiated this realization with a variety of more or less adaptive strategies. Nicos Hadjinicolaou and Peter Wollen, following Poggioli's formulation of "the two avant-gardes," observed that the twentieth century has seen the formation of a "progressive" left-wing and a "conservative" right-wing avant-gardism. The assumption that a political and revolutionary left wing tended to privilege realism, illusionism, and literature while an apolitical or counterrevolutionary right wing favored abstractionism, self-reflexiveness, and a Greenbergian modernism, however, is frequently contradicted in practice. Artists like filmmakers Sergei Eisenstein and even Jean-Luc Godard, as well as Picasso in *Les Demoiselles,* for

instance, notes Wollen, display a startling loosening of conventional connec-
tions between form and meaning, but without permitting their concerns with
abstract and experimental form to force them to abandon either realistic or
expressionistic treatment of their subject matter (Wollen 1982, 98–101; Had-
jinicolaou 1982, 44–46). Unlike the avant-garde productions most preferred
by Bürger, such as futurist and Dada performances, and the least salable of
surrealist constructions, Ringgold's quilts seem to affirm not only their status
as a commodity by appearing in galleries as luxury objects for sale but also to
assert the hegemony of painting, since its appearance on what is a nominally
usable object (i.e., "craft") promotes her quilts to the status of "fine" art.

However, there are two relevant points to be made here. The first is that
there is a difference between rejecting something one may reasonably hope to
attain and something that has historically been unavailable. Ringgold represents
a constituency—women of color—who, as a theme that runs through *The
French Collection* series, were rarely considered eligible to be members of the
avant-garde. Her identity marked her as one like those who had been considered
by the dominant society, including the avant-garde, to be much more likely to
produce "craft" than fine art. For an artist in Ringgold's position to *refuse* to
accept the roles assigned to her by the traditional avant-garde, by elevating
quilting to painting's status and then by selling it at painting's prices, was to
put herself outside of some definitions of the avant-garde, but to remain inside
others (as Hadjinicolaou notes, the "right-wing" current of avant-gardism has
since the beginning been the most powerful [1982, 45]). *Picasso's Studio* places
both definitions into question. But on another level, to break a cultural apart-
heid enforced by conventions that still, early in her career, were so deeply
imbedded in both avant-gardes (as well as in the burgeoning anti-avant-garde
in the ascendancy when this piece was done) that most institutions denied their
existence is to participate in what many commentators identify as the overriding
key to the most common definition of the term "avant-garde": to be inventive.
It also—and not incidentally—reflects a sociological understanding of avant-
gardism, one that sees it as opposing not only obsolete norms but also voids
in social memory where past artistic developments (like African art and women's
art) have been repressed (Hadjinicolaou 1982, 40, 48).

The second point regards originality. Despite her use of and reference to
avant-garde characteristics, Ringgold appears here to have set herself against at
least three aspects of avant-garde production: its frequent (though not unexcep-
tional) prejudice against "craft"; its refusal of narrative; and, perhaps most
significant, its outlawing of the copy in the name of originality. It might seem
as if Ringgold is really attempting to annihilate the avant-garde. After all, the
allegorical mode she employs in *Picasso's Studio* empties its objects, including
the idea of the avant-garde itself, of any claim to immanent meaning by reani-
mating them with her concerns. But, as Paul Mann has noted, even to talk
about the death of the avant-garde is to recuperate it, and recuperation is (also)

the spectacle of the internalization of the margins of cultural discourse that appears to be peculiar to the late capitalist culture that produced the avant-garde in the first place (1991, 14–15). It is more accurate, I think, to admit Ringgold's participation in the contemporary fracturing of the avant-garde "into a number of related shards, each of which retains one or more avant-garde features—political, stylistic, theoretical, rhetorical, obnoxious, and so forth" (Herwitz 1993, 273). This permits us to ascribe to *Picasso's Studio* a "triple-voicedness" (adapting a conclusion of Susan Rubin Suleiman's), and a "complexity and contradiction" (echoing Robert Venturi), that is composed of Ringgold's allegiances to the formal experiments and some of the cultural aspirations of the historical avant-garde. But through her feminist critique of the dominant culture and her postcolonial deconstruction of the racializing practices of the European and American avant-gardes, Ringgold moves beyond their limits.

SUGGESTED READINGS

Adorno, Theodor. 1962. "Commitment."

———. [1972] 1984. *Aesthetic Theory.*

Bathrick, David, and Andreas Huyssen. 1989. "Modernism and the Experience of Modernity."

Benjamin, Walter. 1934. "The Author as Producer."

———. 1968b. "Theses on the Philosophy of History."

———. 1968c. "The Work of Art in the Age of Mechanical Reproduction."

Buchloh, Benjamin. 1984. "Theorizing the Avant-Garde."

Bürger, Peter. 1984. *Theory of the Avant Garde,* translated by Michael Shaw.

Calinescu, Matei. 1987. *Five Faces of Modernity: Modernism, Avant-Garde, Decadence, Kitsch, Postmodernism.*

Derrida, Jacques. 1977. "Signature Event Context."

Duncan, Carol. 1982. "Virility and Domination in Early Twentieth-Century Vanguard Painting."

Fló, Juan. 1992. "Torres-García in (and from) Montevideo."

Foster, Hal. 1983. "Postmodernism: A Preface."

Foster, Hal, Rosalind Krauss, Sylvia Kolbowski, Miwon Kwon, and Benjamin Buchloh. 1993. "The Politics of the Signifier: A Conversation on the Whitney Bicentennial."

Foster, Hal, Benjamin Buchloh, Rosalind Krauss, Yves-Alain Bois, Denis Hollier, and Helen Molesworth. 1994. "The Politics of the Signifier II: A Conversation on the *Informe* and the Abject."

Greenberg, Clement. 1939. "Avant Garde and Kitsch."

Grudin, Eva Ungar. 1990. "Essay."

Habermas, Jürgen. 1981. "Modernity: An Incomplete Project."

Hadjinicolaou, Nicos. 1982. "On the Ideology of Avant-Gardism," translated by Diane Belle James.

Harvey, David. 1989. *The Condition of Postmodernity: An Enquiry into the Origins of Cultural Change.*

Herwitz, Daniel. 1993. *Making Theory/Constructing Art: On the Authority of the Avant-Garde.*

Huyssen, Andreas. 1981. "The Search for Tradition: Avant-Garde and Postmodernism in the 1970s."

Krauss, Rosalind E. 1981. "The Originality of the Avant-Garde: A Postmodernist Repetition."

Lavin, Maud. 1993. *Cut with the Kitchen Knife: The Weimar Photomontages of Hannah Höch.*

Mainardi, Patricia. 1982. "Quilts: The Great American Art."

Mann, Paul. 1991. *The Theory-Death of the Avant-Garde.*

Marcuse, Herbert. 1968. "The Affirmative Character of Culture."

Ortega y Gasset, José. 1968. "The Dehumanization of Art."

Poggioli, Renato. 1968. *The Theory of the Avant-Garde,* translated by Gerald Fitzgerald.

Pollock, Griselda. 1989. "Agency and the Avant-Garde."

———. 1993. *Avant-Garde Gambits, 1888–1893: Gender and the Color of Art History.*

Pound, Ezra. 1934. *Make It New.*

Reed, Christopher. 1994. "Postmodernism and the Art of Identity."

Ringgold, Faith, with Eleanor Flomenhaft. 1990. "Interviewing Faith Ringgold/A Contemporary Heroine."

Rosenberg, Harold. 1965. *The Tradition of the New.*

Ross, Andrew. 1989. *No Respect: Intellectuals and Popular Culture.*

Roth, Moira. 1992. "Upsetting Apple Carts: The French Collection."

Schapiro, Meyer. 1957. "The Liberating Quality of Avant-Garde Art."

Shiff, Richard. 1983. "Mastercopy."

———. 1983–84. "Representation, Copying, and the Technique of Originality."

Shklovsky, Victor. 1965. "Art as Technique."

Spivak, Gayatri. 1981. "French Feminism in an International Frame."

Suleiman, Susan Rubin. 1990. *Subversive Intent, Gender, Politics, and the Avant-Garde.*

Venturi, Robert. 1966. *Complexity and Contradiction in Architecture.*

Wallace, Michele. 1990. "Modernism, Postmodernism and the Problem of the Visual in Afro-American Culture."

Wollen, Peter. 1982. "The Two Avant-Gardes."

THIRTEEN

Primitive

Mark Antliff and Patricia Leighten

In assessing the "primitive" one should first note that the term does not consti-
tute an essentialist category but exemplifies a relationship. The relation is one
of contrast, of binary opposition to the "civilized": the term "primitive" cannot
exist without its attendant opposite, and in fact the two terms act to constitute
each other. Within the context of modernism, "primitivism" is an act on the
part of artists and writers seeking to celebrate features of the art and culture of
peoples deemed "primitive" and to appropriate their supposed simplicity and
authenticity to the project of transforming Western art. In Western culture the
term "primitive" has been applied with positive as well as negative valences,
but when ascribed to cultures external to Europe its connotations have been
predominantly negative. Above all we should think of the concept of the primi-
tive as the product of the historical experience of the West and more specifically
as an ideological construct of colonial conquest and exploitation. The ideologi-
cal import of the "primitive" and of primitivism can be best grasped from the
standpoint of a related set of oppositions mapped out in terms of time/space,
gender, race, and class.

Time/Space

With regard to temporality the "primitive" is part of what Roland Barthes
termed "mythic speech," for the label empties its referent of historical contin-
gency and cultural specificity and instead subsumes it within an unchanging
"nature." The condition of "timelessness" bestowed on the primitive also con-
notes the "primeval," for by not changing, the "primitive" is necessarily in
opposition to all that does change or develop, namely, the "civilized." In the
realm of art the temporal dimension of the primitive is most evident in the
difference between the manner in which Western art historians have studied
the products of their own culture and their analyses of the so-called primitive
art of non-Western civilizations. Whereas Western art is described in terms of
progression of stylistic developments or schools, each with a particular "master,"
non-Western art is frequently cast in what Sally Price, following Johannes Fa-
bian, has called the "ethnographic present—a device that abstracts cultural ex-
pression from the flow of historical time and hence collapses individuals and
whole generations into a composite figure alleged to represent his [*sic*] fellows
past and present." For instance, whereas the cultural artifact *Les Demoiselles
d'Avignon* (1907) is described as the creation of a particular artist, Pablo Picasso,
and a work that marks the historical emergence of a new art movement, cubism,

the creators of the various African masks said to have influenced Picasso in his treatment of his chosen subject remain anonymous, known only by their "tribal" or regional affiliation. Failure to identify the individual creator of a mask is a way of denying that individual choices, including aesthetic ones, were a motivating factor in its production. No longer grounded in the historical specificity implied by categories of stylistic development or artistic biography, the mask becomes a free-floating signifier for the past, present, and future production of a given people, all of which remains unchanged. Such artifacts are said to express collective religious beliefs, and the creative contribution of an individual maker of masks remains an unasked question.

In Western discourse the distinction between collective and individual forms of expression in art production is part of a temporal progression from a "less-developed" condition, wherein cultural production is related to material needs of instinctual drives, to the state of "advanced" societies, in which the creative intellect gains ascendancy over the realm of the irrational. As Price notes, such assumptions led the critic René Huyghe to celebrate the geometricity of Oceanic art as a reflection of "the universal biological principle of the conservation of energy," for its producers were "instinctively imitating the ways of nature." Rather than attesting to the cultural sophistication of Oceanic culture, the production of geometric form is said to result from the nonhuman forces of nature, those "universal biological principles" that govern the "instinctive" activity of non-Western peoples. Temporally, this art is not viewed by Huyghe as the product of a society in a state of development or as evidence of the inventiveness of this people, but rather as the product of nature's forces, the temporal patterns of which are cyclical, repetitive, and thus unchanging. The art mirroring such phenomena is then itself unchanging, without history; similarly, Huyghe roots its producers in mythic conceptions attuned to the changing seasons or other natural forces.

To declare such art changeless and primeval is to deny what Fabian terms "coevalness," the temporal coexistence of the producer of "primitive" art with his or her Western counterpart. Despite the fact that a given piece of Oceanic sculpture may have been produced at a time contemporaneous with Gauguin's *Spirit of the Dead Watching* (1892), the denial of coevalness assures that the latter is designated modern while the former is deemed primitive. This dismissal of temporal proximity has aesthetic implications as well, for it is only Gauguin who is influenced, or—if we are to allow the concept of "influence" its agency—it is only Gauguin who is capable of converting the foreign artifact into a work of art. The "primitive" artist, supposedly governed by instinct rather than imagination, is incapable of registering a reciprocal influence. (The work of such scholars as Suzanne Preston Blier and James Clifford counters precisely this notion by studying the abundant instances of cross-fertilization between the West and non-European cultures from the fifteenth century to the present.) In this discourse the actuality of physical and temporal synchronicity

is replaced by a typological time frame defined in terms of Western progress and primitive regression. The spatial and temporal are frequently combined in such discourse, for to leave the West and enter into a foreign culture is to leave one's own "mature" culture and enter into an "infantile" past: African, Oceanic, or Islamic cultures are said to mirror the "childhood" of Western civilization. As such the term "primitive" is part of a larger discourse concerning the role of temporal constructs in power relations between cultures or between alternative modes of organizing human activity within a given society. Historians such as E. P. Thompson and anthropologists such as Frederick Cooper have noted that the imposition of temporal rhythms associated with industrial production onto the labor patterns of nonindustrial cultures, all in the name of progress, is one way in which capitalism asserts its hegemonic control over noncapitalist societies. The value judgments undergirding distinctions between the modern and the primitive then are part and parcel of the role of temporality in capitalist and colonial discourse.

At the same time, Western conceptions of the primitive could have positive valences, particularly when Western culture itself was thought to be "overly civilized" and thus in need of rejuvenation through contact with societies in an earlier stage of development. Within Europe proper, nineteenth-century social critics frequently bemoaned the shift of the rural peasantry to industrial towns for this very reason. Writers like John Ruskin saw the transferal of populations from country to city as a sign of the loss within Western culture of a preindustrial, and thus primitive, agrarian society whose communitarian values and religiosity contrasted sharply with the decadent effects of urbanism. Such value-laden assumptions animated an artist like Paul Gauguin, who regarded his move from metropolitan Paris to rural Brittany in the mid-1880s as a rediscovery of the uncorrupted, medieval roots of Western civilization. By casting Brittany in this mold he denied the temporal coevalness of Breton culture with that of Paris. Ironically, as Fred Orton and Griselda Pollock have shown, the distinctive Breton clothing Gauguin associated with a medieval past was in fact the nineteenth-century "flowering of Breton popular culture in costume . . . predicated on the emergence of a more leisured and prosperous section of the peasantry," who could afford such newly available trade items as embroidered cloth and lace. Similarly the farming practices in Brittany eulogized by Gauguin as preindustrial in images like his *Seaweed Gatherers* (1889) were a form of agro-industry fully adapted to the international market economy of Europe. The form and content of Gauguin's images of Brittany thus constituted a myth of the primitive divorced from the historical realities of the day.

Gender

Gender distinctions are also fundamental to notions of the primitive. In a seminal essay titled "Is Female to Male as Nature Is to Culture?" the anthropologist Sherry Ortner drew upon Simone de Beauvoir's *The Second Sex* (1949) in an

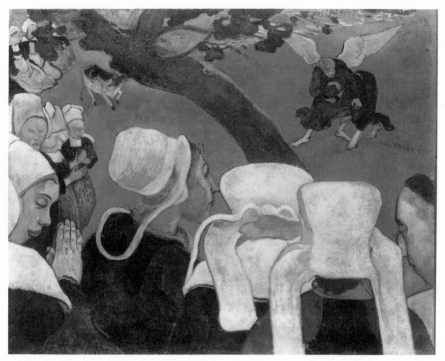

13.1 Paul Gauguin, *The Vision after the Sermon (Jacob Wrestling with the Angel)*, 1888.
National Gallery of Scotland, Edinburgh.

analysis of the pervasive association of women with the natural or primitive.
Since Ortner wrote this article in 1974, feminists in art history have drawn
upon her findings to illuminate the primitivizing motivations behind representa-
tions of women by male artists of the early twentieth century. In this section
we will periodically refer to such literature to underscore the art-historical impli-
cations of Ortner's study.

In her essay Ortner persuasively relates the second-class status of women in
all societies to an association of women with the natural and men with the
cultural sphere. As a result biological difference is imbued with power relations,
in the Foucauldian sense, in which a superior male is pitted against an inferior
female governed by "culturally defined value systems." The significance of
power in the construction of gender difference is related by Ortner to the role
of culture in the utilization of nature to meet human needs. Within this context
women are associated with "something that every culture devalues, something
that every culture defines as being of a lower order of existence," namely "the
givens of natural existence," before we subject this natural realm to cultural
transformation. Despite the fact that distinctions between nature and culture

are themselves arbitrary, it is nevertheless true that viable relations between human existence and natural forces are dependent upon the regulation of the latter. Human culture therefore expresses our ability "to act upon and regulate, rather than passively move with and be moved by," nature. Gender enters into the "mastery" of nature through culture because women are traditionally viewed as closer to nature than men, who are considered the primary cultural arbiters in society. Although women obviously play a role in the cultural life of any society, they are nevertheless seen as "a lower order of being, as being less transcendental of nature than men are." The primary reason for this bias is human biology: a woman's cultural functions are assumed to have a "natural" relation to her procreative capacity to bear children. The restriction of female activities to those that supposedly possess this natural relation does not impinge on men, whose physiology is not viewed as delimiting their capacities in the field of cultural production.

Art historians Marilyn Board, Carol Duncan, and Patricia Mathews have pointed to the gendered consequences of this construct with regard to theories of creativity. Writing about French symbolist criticism of the 1890s Mathews notes that mental instability among male artists was held to be a crucial component of their capacity to create, while female madness was said to differ in kind from that of men. Unlike their male counterparts, women could not channel their madness into creative activities, for their imaginative capacities were not harnessed and regulated by the intellect. Whereas the frenzied state of a male artist could result in mystical insight, mental transcendence of the material realm was totally inaccessible to a woman, whose madness was evidence of the overpowering of her mind by the base instincts and drives of her sexuality. Appropriately, madness among women was labeled "hysteria," a term whose etymological root in the Greek word for womb, *hysteron*, underscored its gendered origins. (This paradigm, as Sander Gilman has discussed, also operated to feminize marginalized males, such as Jews, through their presumed tendency to hysteria.) Duncan in turn charts the transformation of gendered notions of creativity in the early twentieth century, when creativity became associated with male virility rather than fin de siècle madness. As a result, male artists among the French fauvists and German expressionists linked their creative abilities to the sexual conquest of their female models, whose sexuality was the catalyst for the male artist's creativity. Once again, the ability to transcend nature through cultural production was restricted to the male domain, or men alone could transcend their sexual drives through the artistic act. As Duncan notes, such distinctions were urgently needed at a time when feminists were calling for an expanded role for women in a society that wished to restrict their activities to the domestic sphere, a realm supposedly closer to nature than to culture.

Such categorization and prejudgment of women as a genus in Western culture had profound consequences for the distinction within Europe between "primitive" and "modern" cultures and a more general differentiation between

Europe as a whole and the non-Western world. Within Europe proper, artists like Gauguin in his *Vision after the Sermon* contrasted rural Brittany with urban culture, deeming the former to be primitive by virtue of its spatial/temporal distance from an industrial "present" whose epicenter was Paris. Women predominate in Gauguin's representations of Brittany because that gender exemplified an instinctual level of experience, which Gauguin related to the naive religiosity of the Breton people. Non-Western cultures as a whole were in turn deemed closer to nature than to culture, with the result that—regardless of gender—the peoples of Africa, the so-called Orient, and Oceania were "feminized" in Western discourse. In texts such as Joseph Conrad's *Heart of Darkness* (1899) or Claude Lévi-Strauss's *Tristes Tropiques* (1955), a whole series of binary oppositions resulted that served to define "otherness" in terms of sex as well as race. Literary historian Cleo McNelly [Kearns] has charted the gendered implications of these texts in her analysis of the paradigmatic language that would imbue the spatial/temporal journey from Europe proper to non-European cultures with a mythic "return" to the primitive condition. In fact artists such as Gauguin in his book *Noa Noa* (1897) or Emil Nolde in the account of his trip to New Guinea before World War I echo the primitivist tropes found in the writings of Conrad and Lévi-Strauss. Thus writings of artists, novelists, and anthropologists constitute a body of travel literature grounded in the language of primitivism.

Fundamental to such literature is a binary opposition between home and abroad, couched in terms of a journey from the realm of a civilization typified by order and ennui to a native culture synonymous with a fecund but chaotic and uncontrolled natural condition. In the gendered language of the travel account, the tropical forest—the archetype of fecundity—is invariably contrasted with the patriarchal technology of Western industry that threatens to violate the feminized "virgin land." For any Westerner who abhorred this encounter, escape into the realm of the primitive was frequently cast as a quest for a mythical reunion of mind and body, intellect and instinct, which were supposedly torn asunder with the development of civilization. Thus Gauguin's decision to abandon Europe for Tahiti in the 1890s was motivated by a desire to rediscover his own sexual being and to escape the oppressive constraints Western culture purportedly imposed on his instinctual drives. The distinction between an overly intellectualized West and its instinctual counterpart resulted in further binary divisions: while one's civilized home was associated with the light of reason and an ability to understand through vision, the foreign other—what Conrad termed "the heart of darkness"—was associated with blackness, the tactile senses, and knowledge by way of feeling, "from within." On the scale of overarching generalizations, Western culture was deemed to be masculine and rational, while non-European cultures were categorized as feminine and instinctual. Within such discourses distinctions between European and non-Western men and women were also subjected to primitivist terminology. For

instance, in rhetoric that would separate white women at home from black women abroad, the contrast between civilized and savage was sexualized. In nineteenth-century travel literature male writers frequently identify the white women left at home with sexual sterility or motherly fidelity, describing their relations with their female counterparts as typified by friendship more than sensual desire. The dark-skinned women of Tahiti or Africa, on the other hand, are viewed as the very embodiment of sensuality, the natural women whose sexual energy mirrors that of the fecund forest surrounding them. Through sexual contact with the black woman, the European male seeks a redemptive union of mind and body unrealizable through contact with her European counterpart. In McNelly's words, "one of the key functions of this particular set of oppositions" is "to separate white women from black women, to insure that they relate only through men." This separation is exemplified in Gauguin's letters from Tahiti, wherein he casts his sexual adventures with the natives in the language of a redemptive return to a state of sensual innocence that his white wife could never bestow on him.

Such stereotypes were also operative in European images of Arab cultures in North Africa and the Middle East, which Europeans primitivized under the rubric "the Orient." In an essay drawing on Edward Said's text *Orientalism* (1978), Marilyn Board has charted the fauvist Henri Matisse's repetitive representation of the oriental "other" in the guise of the sensual, passive form of the female odalisque. "In the imagination of European scholars who defined it," states Board, "the Orient, like woman, came to signify an undiscriminating sensual paradise that constituted a revitalizing complement to Western man's divisive analytical compulsions." In his depiction of the oriental other, Matisse not only cast his European models in the role of odalisques in a harem, he abandoned the "analytical" method of single-vanishing-point perspective in favor of the flat, two-dimensional planarity and decorative patterning associated with Islamic carpets and wall tiles. Matisse's decorative vocabulary collapsed such diverse sources as Persian miniatures, Moroccan tapestries, and Moorish carpets into one "oriental" style, constructing an exotic environment in which an equally fantastic odalisque could be placed. In Board's words, Western cultures invariably represented the Orient as "inarticulate, enticing, and strange, constituting a passive cultural body to be controlled and acted upon by others." In short, the Orient was feminized as a passive cipher to be governed by an active (and superior) Western civilization.

By placing his European models in the sexualized terrain of the oriental odalisque, Matisse pointed to yet another paradigm within Western conceptions of the primitive: the association of the sexualized European woman with the racial "other." In the nineteenth century, both African women and European prostitutes were said to exhibit a natural tendency for sexual proclivity, and historian Sander L. Gilman notes that such sexual drives in European prostitutes indicated that their biology was inherently primitive, unlike that of their coun-

terparts among the middle and upper classes. To back up that claim, prostitutes were subjected to physiological classification in an attempt to define them as a breed apart from respectable European women. Gilman reveals that the physiognomic traits attributed to the prostitute were those associated with the African female, all of which pointed "to the 'primitive' nature of the prostitute's physiognomy." The logical conclusion of this chain of signifiers was that the sexual activity of the European prostitute was a sign of her physiological regression to the condition of the black female. The decision to become a prostitute was thus divorced from economic need and instead declared to be a direct result of degenerative, biological difference. In European art that difference was underscored by the juxtaposition, in images such as Edouard Manet's *Olympia* (1863), of the black servant with the European prostitute, to indicate the sexual proclivity of the latter. By imposing such qualitative criteria on the prostitute, the middle and upper classes were able to divorce themselves from social responsibility for the prostitute's condition.

Outsider groups within Europe's borders, such as Gypsies and Jews, likewise fell into primitivist categories suggestive of mysterious social and religious practices and an exotic sensuality fully compatible with orientalist paradigms. For instance, D. H. Lawrence in his story "The Virgin and the Gipsy" (1930) casts the male Gypsy as a figure naturally and perfectly in harmony with his sexuality and with few of the cultural constraints that would interfere with his seduction of a hesitant, inhibited English girl. In Lawrence's narrative, the Gypsy's sexually charged encounter with this European virgin miraculously transforms her into a woman imbued with self-knowledge and freed from the crippling sexual hypocrisy of Edwardian culture as Lawrence viewed it. This literary construction has its feminine equivalent in Matisse's *The Gypsy* (1906), which depicts in violent colors a blowsy woman with large, loose features exaggeratedly inviting the presumed male viewer to sexual pleasure, conflating prostitute and Gypsy even more directly than the prostitute/African analyzed by Gilman.

Race

Just as a qualitative distinction was drawn between European women and the African "Hottentot Venus"—mediated by her sexualized counterpart in the form of the prostitute—so cultural and racial theorists on a more ambitious scale have drawn qualitative distinctions between Europeans and other "races." Scholars such as Stephen Greenblatt and Christopher L. Miller have studied such attitudes previous to the earliest contact with inhabitants of other continents. In so doing they have highlighted the Eurocentric assumptions that Western explorers brought to their initial contacts with non-Western cultures. As Greenblatt discusses, according to his diary Columbus experienced the Caribbean Arawaks' *recognizing* his legal right to claim their island for Spain—despite its patent absurdity—because "I was not contradicted." Likewise explorers of the Enlightenment era, coming into contact with native inhabitants in

the New World, could feel that they were observing humans in a state of cultural "childhood," ready to be imprinted with the inevitable "process of civilization." The profundity of such convictions should not be underestimated in studying questions of racial and cultural difference.

Jean-Jacques Rousseau exemplifies the latter Enlightenment view in his trope of the "noble savage." Such a notion suggests that there is one humanity, broken up into peoples at differing stages within one civilizing process; the noble savage has yet to receive the necessary education and is thus a blank slate upon which civilization will be written. The "savage" or wild creature is noble because he or she, though unformed, possesses "natural" human feelings of gentleness and generosity (associated in Europe with the feudal nobility). It hardly needs pointing out that relations of aboriginals to European explorers— upon which reports Rousseau's idea was based—differed dramatically from those experienced later by European colonizers moving in to clear and farm aboriginal land, often with the use of slave labor. Theories based on racial essence, such as "ethnologist" Joseph de Gobineau's *Essai sur l'inégalité des races humaines* (1853–55), played an important role in the colonizing process, since post-Darwinian biological determinism justified institutionalizing categories of difference and simultaneously "explained" Europe's imperialist successes. Such nineteenth-century racial theories did much to displace Rousseau's Enlighten-ment trope of the noble savage—suggestive of an early stage of evolutionary development leading to the higher stage of European civilization—with a trope of fixed biological limitation suggestive of the subhuman. Both tropes define the native as "other" in a system founded on the European as a cultural norm.

Though notions of the primitiveness of other peoples have been important to virtually every historical culture, a special relation of power pertains to such notions when they are linked to imperial domination. The twentieth century, especially after the Second World War, has seen the end of the "Colonial Era"—though, significantly, not an end to Western economic domination over the "third world"—which has enabled the emergence of a postcolonial critique of primitivism currently agitating both academic and political discourse. In taking over a land to exploit the labor of its peoples and its natural resources, there is a clear economic and political advantage to viewing those people as savage, simple, and inferior—in a word, primitive—since it then seems justifi-able not to share with them the products of their land and labor. Such assump-tions are culturally shared rather than cynically concocted (though there is certainly evidence of the latter as well); hence sincerity is not the issue, but rather how the colonizers construct the native within preconceived categories of the human/subhuman and how this form of racism continues to play a role in our contemporary "global village."

The era of exploration beginning in the fifteenth century resulted by the seventeenth century in European colonization of previously uncharted lands, displacement or enslavement of native peoples, international trade in African

slaves, and a transformed economy in Europe based on such labor and its products. Local slavery among Africans and larger-scale slavery by Arabs already existed in Africa, and European marketing of African slaves resulted in the expansion of that trade to a global scale. Throughout the eighteenth century, wealth flowed to Europe from American tobacco plantations, Caribbean sugar plantations, and Indian tea plantations; by the end of the nineteenth century—with the last scramble for colonies in Africa—virtually the entire non-European world was colonized, and World War I was fought in no small part because of Kaiser Wilhelm's anger that Germany had the smallest part of the pie. With the rise of the great empires of modern Europe—Portuguese, Spanish, British, Ottoman, French—military and economic domination of the weak by the strong seemed the natural order. It seemed natural because those so dominated were viewed as incapable of properly exploiting their own resources or as undergoing a necessary "civilizing" process. Thus colonial discourse imposed conceptions of the "primitive" on native populations, which every interaction confirmed to the colonial mind.

Such attitudes by no means meant taking native cultures for granted. An enormous amount of ethnographic fascination with the conquered peoples exercised itself during the colonial period, coinciding with modern, primitivist art. (That it also coincided with the birth of the field of anthropology has led to much self-reflection in that discipline in recent years.) Missionaries and government officials collected quantities of information on local habits, all tending to support a view of native practices as irrational, instinctual, superstitious, animistic, and often bloodthirsty. For instance, such reports accompanied the French government's colonial displays in the Universal Expositions at the turn of the century as part of a series of exhaustive books on the economy of each of France's colonies, where they function to support the "civilizing mission" of Christianization and work discipline imposed by the rulers. Thus some early ethnography specifically supported French government policies, which varied between differing colonies of the Far East, West and Central Africa and the Caribbean.

The attitudes encoded in such publications help define the paradigms evident in both verbal and visual representations of the racial other and reveal the same two fundamental tropes. The range of colonial debate swung between two poles: (1) Enlightenment principles evoking an image of the black as noble savage, in a state out of which whites had long ago evolved and which could be addressed by assimilation into a superior culture; and (2) racial theory evoking an image of the black as unregenerate and barbaric savage, which subhuman condition could be mitigated through control of a superior culture but could not be altogether suppressed. The former attitude is visible in the General Act of the Berlin Conference on African colonization of 1885: "All the Powers exercising sovereign rights or influence in these territories pledge themselves to watch over the preservation of the native populations and the improvement of their moral and material conditions of existence, and to work together for the

suppression of slavery and of the slave trade." Here natives deserve and are capable of "improvement" of their moral condition, that is, they can become "like us." In 1898 King Leopold of Belgium, a signatory to this act, expressed his interpretation of its Enlightenment language, however, in the essentialist terms of racial theory:

> The mission which the agents of the State have to accomplish on the Congo is a noble one. They have to continue the development of civilization in the center of Equatorial Africa, receiving their inspiration directly from Berlin and Brussels. Placed face to face with primitive barbarism, grappling with sanguinary customs that date back thousands of years, they are obliged to reduce these gradually. They must accustom the population to general laws, of which the most needful and the most salutary is assuredly that of work.

Here natives are primitive, barbaric, and bloodthirsty, which features are virtually timeless, i.e., of their essence; Europeans must impose work discipline upon them gradually in order to "reduce," but not entirely eliminate, this character. Racial theory posits an absolute divide between developing racial geneologies: the European in a state of progressive development and the African in a state of degeneration, representing a false start of the human race. For Gobineau the African race does have the virtue of untrammeled creativity, which most overrefined Europeans have lost, but not the intellectual capacity to turn this creative flow into true art or music; that is, their creativity remains at the level of instinct and fails again to rise to fully human levels.

Turn-of-the-century avant-garde artists and their primitivist aesthetic maneuvers operated in and against this colonial world, whose missionaries, merchants, and administrators were responsible for bringing to Europe the art of native peoples. The modernists' aim was to critique the social and aesthetic order—in the case of the visual arts, state-sanctioned academicism—by embracing an imagined primitiveness whose authenticity they opposed to a "decadent" West, an attitude steeped in the Enlightenment tradition. For them, Islamic, Oceanic, and African art offered visual models of simplification and ornament representing authentic primitive expressions of thought and feeling. This attitude could even inform Gauguin's embrace of cultures like the Japanese, Javanese, and Egyptian, where denial of their historicity and cultural traditions could not be maintained. Such artists wanted to transform Western artistic traditions—and the social order in which they were implicated—by celebrating an elemental return to those imagined primitive states whose suppression they viewed as having cut off a necessary vitality. In this operation the artists themselves became the "primitives," in opposition to the "moribund" civilization they defined themselves against.

At the same time, modernists could both participate in and be sharply critical of colonial racial attitudes, variously exhibiting shared attitudes with the dominant

culture they opposed. With Africa, for example, far from extending their social criticism to a critique of the reductive view of Africans promoted by European governments for colonial justification, modernists such as Conrad, Picasso, and the dadaist Marcel Janco embraced a deeply romanticized view of African art as the expression of humans in a precivilized state. By associating such art with the worshiping of idols and enactment of violent rituals, these modernists were as willing as any colonial agent to mystify African culture. Such Africanist works as Picasso's *Les Demoiselles d'Avignon* or Janco's masks and sound-poem performances (1916) implicitly reject the trope of the noble savage by pointedly reveling in ethnic difference and attempting to draw power from an imagined tribal life and art that were irrational, magic, and violent, that is, by embracing precisely the symptoms of its degeneracy according to racial theory. Appropriately, early texts celebrating modernism, such as Gelett Burgess's "The Wild Men of Paris" (*Architectural Record*, 1910), highlighted the interest of André Derain or Picasso in African art to underscore their supposed primitive transformation. Modernists thus subverted Gobineau's theory of creativity by celebrating rather than deploring its reductive formulation and presented themselves as tapping into comparably deep and mystical sources for their own art.

Their subversion was especially offensive to the dominant culture because these artists valorized African sculpture as their aesthetic model. As Frances Connelly has demonstrated, French artists as far back as the sixteenth century connected concepts of the "grotesque" in two dimensions with caricature, ornament, and the fantastical, while the grotesque in three dimensions was associated with the monstrous and the horrific and was specifically linked to Africa. African sculptures, especially, were viewed as "idols" and "fetishes," representing to Europeans manifestations of the irrational, animistic, and frightening world in which they imagined the "primitive" to live. Conversion to Christianity routinely involved destruction (or exportation) of such too-powerful three-dimensional art, and the shock felt by eighteenth-century Europeans gradually took on shades of sarcasm and contempt as colonialization advanced. In embracing such art, the modernists sought to subvert colonial stereotypes, but their subversive revisions necessarily remained implicated in the prejudices from which they derived, so that they now appear no less stereotypical and reductive than the racist caricatures they opposed.

According to Patricia Leighten, primitivism among the modernists also sometimes expressed an artist's political concern with the plight of exploited and oppressed native populations, as with Picasso and his circle during the French Congo scandals of 1905–07 or Gauguin's alarm over the destruction of Tahitian religion and cultural life. Primitivism was thus much more than a method for revolutionizing style, since such formal radicalism simultaneously served to present an alternative to currently entrenched social and aesthetic forms, mingling concepts of authenticity, spontaneity, and freedom from the repression of bourgeois social, aesthetic, and moral constraints as well as politi-

cal oppression. The primitivism of such artists as Picasso, Matisse, and Derain, like that of Gauguin before them, thus gestured toward cultures whose transformative powers they admiringly offered as escape routes from the stultification of French culture and academic art, inspiring purposely or not the heated contempt of politically and culturally conservative art critics. Such primitivism focuses colonial issues tellingly, revealing the complex and ambivalent relations of modernity to issues of race agitating the modernists' own culture. We could equally consider such paradigms in other reaches of twentieth-century art, looking at the relations of, for example, the surrealists to makers of Easter Island and other Oceanic sculpture, the abstract expressionists to native North American artists, or performance artists of the last three decades to rituals of prehistoric peoples.

Class

Issues of social class likewise play a role in these pairs of binary opposites, constituting another category of "high" and "low," "us" and "them." According to Peter Stallybrass and Allon White in their essay "Bourgeois Hysteria and the Carnivalesque," bourgeois suppression of what Mikhail Bakhtin termed the carnivalesque and its projection onto the "other" of behaviors increasingly taboo for the middle class reinforced stereotypes of racial and class difference. They note that even as late as the nineteenth century carnival ritual involved most classes and that the disengagement of the middle class was slow and uneven, entailing "a gradual reconstruction of the idea of carnival as the culture of the Other," specifically the lower classes. Reacting against this bourgeois attempt to "preserve a stable and 'correct' sense of self," bohemians "took over in displaced form much of the inversion, grotesque body symbolism, festive ambivalence and transgression which had once been the provenance of carnival," whose forms, symbols, rituals, and structures are "among the fundamental elements in the aesthetics of modernism." They add that a significant aspect of this was a "compensatory plundering of ethnographic material—masks, rituals, symbols—from colonized cultures." Thus modernists, by embracing what the middle class marked out as "low" and "internalized under the sign of negation and disgust," present a mirror image of that repression by celebrating the very symptoms of bourgeois phobia.

Far from requiring a colonial other, modernists could as easily accommodate rural and urban peasants to primitivist categories of authenticity and outsiderhood, looking to folk art of the rural peasantry or popular art of the urban working class to lend greater authenticity to their own expressions of artistic and social criticism. As early as the mid-nineteenth century, Gustave Courbet evoked the anonymous and crudely folkish woodcuts known as *images d'Epinal* in his art, suggesting a complex of allusions that ranged from his elevation of peasant subject matter (genre painting raised to the scale of history painting) to the exaggeratedly signified spontaneity of his formal expression. The art of

such modernists as Edgar Degas, Henri de Toulouse-Lautrec, and Georges Seurat, on the other hand, was profoundly informed by the cartoons that contemporaneously proliferated in Paris. Paralleling the anonymous status of African sculptors, such satirical graphics—though often signed by individuals—were consumed as popular urban "folk" art in a city whose industrial outskirts doubled in population between 1871 and 1914 through an influx of displaced, and rapidly proletarianized, peasants. Modernist artists appropriated the "spontaneity" and "crudity" of urban working-class culture both in style and in their evocation of the cafés-concerts, nightclubs, bars, and cafés where workers and déclassé bohemians gathered after hours. Such primitivism firmly rejects the academic styles and subjects embraced by and servicing the bourgeoisie.

The admiration of rural folk art was equally central to turn-of-the-century modernists from Gauguin and the Nabis to Vassily Kandinsky and other members of the German expressionist movement. Imitating the primary colors and simplified forms of folk art, such artists asserted the superiority of an imagined folk simplicity of spirit and unity with nature that expressed a longing on their part to escape the complication of urban industrialized middle-class life. Such romanticization of peasant life could extend, for an artist like Emil Nolde, to sympathy with the racial theories of the National Socialists, which added a biological dimension to worship of the "folk." Such theories, which have been rife throughout the nineteenth and twentieth centuries, embrace the virtues of ethnic purity and see a spiritual essence in race that they hope will revitalize their particular culture as a whole. In this model, the Teutonic peasant becomes the noble savage and the Jew and Gypsy the degenerate subhuman, a biological model now internal to Europe's borders. As Sander Gilman notes, the Jew in nineteenth-century scientific discourse was said to have emerged from Africa, with the result that Jews shared the African's "natural" susceptibility to syphilis and other "degenerative" diseases. That such ideas led to the genocide of Jews and Gypsies during World War II and continue among neo-Nazi groups in Europe and white supremacists in North America reveals the political danger of racial theory at the other end of the primitivist spectrum.

The term "primitive" then is an inescapably political category, whether used admiringly or pejoratively. Though attitudes of racial superiority based on ethnic and cultural difference have been operative throughout history, the colonial period beginning with Columbus's "discovery" of the Americas focuses the question firmly on the issue of power. As we have shown, the concept of the primitive engages issues of time and space, gender, race, and class in thoroughly inseparable ways, though we have tried to treat these issues distinctly here for purposes of clarification. Although the majority of work on such questions has been done in the fields of anthropology, history, literary criticism, and cultural studies, the ways these social and intellectual structures operate both consciously and unconsciously in artistic culture is an increasing preoccupation in the field of art history.

Suggested Readings

Barthes, Roland. 1972. *Mythologies.*

Bhabha, Homi. 1984. "Of Mimicry and Man: The Ambivalence of Colonial Discourse."

Board, Marilyn Lincoln. 1989. "Constructing Myths and Ideologies in Matisse's Odalisques."

Clifford, James. 1988. *The Predicament of Culture: Twentieth-Century Ethnography, Literature, and Art.*

Connelly, Frances. 1995. *The Sleep of Reason: Primitivism in Modern European Art and Aesthetics, 1725–1907.*

Duncan, Carol. 1982. "Virility and Domination in Early Twentieth-Century Vanguard Painting."

Fabian, Johannes. 1983. *Time and the Other: How Anthropology Makes Its Object.*

Foster, Hal. 1985. "The 'Primitive' Unconscious of Modern Art, or White Skin Black Masks."

Gates, Henry Louis, Jr., ed. 1986. *"Race," Writing, and Difference.*

Gilman, Sander L. 1985. *Difference and Pathology: Stereotypes of Sexuality, Race, and Madness.*

———. 1991. *The Jew's Body.*

Greenblatt, Stephen. 1991. *Marvelous Possessions: The Wonder of the New World.*

Hiller, Susan, ed. 1991. *The Myth of Primitivism: Perspectives on Art.*

Leighten, Patricia. 1990. "The White Peril and *l'Art Nègre*: Picasso, Primitivism, and Anticolonialism."

Mathews, Patricia. 1988. "Passionate Discontent: The Creative Process and Gender Difference in the French Symbolist Period."

McNelly [Kearns], Cleo. 1975. "Nature, Women, and Claude Lévi-Strauss."

Miller, Christopher L. 1985. *Blank Darkness: Africanist Discourse in France.*

Ortner, Sherry B. 1974. "Is Female to Male as Nature Is to Culture?" In *Woman, Culture, and Society,* edited by Michelle Z. Rosaldo and Louise Lamphere.

Orton, Fred, and Griselda Pollock. 1980. "*Les Données Bretonnantes*: La Prairie de la Représentation."

Perry, Gill. 1993. "Primitivism and the 'Modern.' "

Pollock, Griselda. 1988. *Vision and Difference: Femininity, Feminism, and the Histories of Art.*

———. 1993. *Avant-Garde Gambits, 1888–1893: Gender and the Color of Art History.*

Price, Sally. 1989. *Primitive Art in Civilized Places.*

Rubin, William, ed. 1984. *"Primitivism" in 20th Century Art: Affinity of the Tribal and the Modern.*

Said, Edward W. 1978. *Orientalism.*

———. 1993. *Culture and Imperialism.*

Solomon-Godeau, Abigail. 1989. "Going Native: Paul Gauguin and the Invention of Primitivist Modernism."

Stallybrass, Peter, and Allon White. 1986. *The Politics and Poetics of Transgression.*

Stocking, George W. 1982. *Race, Culture, and Evolution: Essays in the History of Anthropology.*

Torgovnick, Marianna. 1990. *Gone Primitive: Savage Intellects, Modern Lives.*

Trilling, Lionel. 1971, 1972. *Sincerity and Authenticity.*

Social Relations

FOURTEEN

Ritual

Suzanne Preston Blier

My mother raised four children and a greater number of dogs. With each of us she struggled to teach and enforce ideas of architectural correctness—often involving prescribed (and proscribed) forms of ritual behavior. With the dogs it was relatively easy: sitting at specified times such as before being fed, going outside, or crossing the street. With us it was a bit more time-consuming— among other rituals, making our beds each morning, putting the napkins back in the napkin rings after meals, and standing when nonparental adults came into the room. Although a convincing majority of residents in my parents' house, we children and dogs were clearly architectural Others, obliged to follow preestablished ritual behaviors.

My experience with fieldwork has involved a similar process of familiarizing myself with foreign ritual prerogatives. The day I first arrived in the village in northern Togo that would become my Batammaliba home for a year, there was a funeral in progress. I can remember vividly my first concerns on that day: As an outsider, *where* am I supposed to stand? As a Ph.D. student, *when* will I ever make any sense of this? As a researcher, *what* of the dozen or so groups of activities do I concentrate on? And *how* can I photograph what is happening? The Batammaliba spent much of the year trying to teach me the ritual underpinnings of these and other activities.

I gained an understanding of some village rituals relatively quickly. For example, in most ceremonial contexts, men sit on the south (left) and women on the north (right), but I as cultural Other was considered bigendered (or better, degendered) and could usually choose—as could my research assistant in his newly acquired identity as indexical Other. So too, both my husband and I could attend ceremonies of men's and women's initiation—sitting generally outside both priestly and initiates' spheres. However, in a complex relocation of gendered identity, I but not my husband was allowed into the tiny second floor woman's bedroom to observe ceremonies taking place therein.

Some local rituals, once learned, I declined to follow. While it was perfectly "all right" to sit *on* the interior house altars during crowded ceremonies, I, considering it in some way sacrilegious, declined to do so. Still other rituals I was aware of and followed only grudgingly. Thus halfway through the research period, I purchased a guinea hen from a man who lived on the other side of town. The family I was staying with was very unhappy and, after calling a family meeting, informed me that I had acted improperly by not buying a bird from within "my own" family, thus depriving a "relative" of much needed

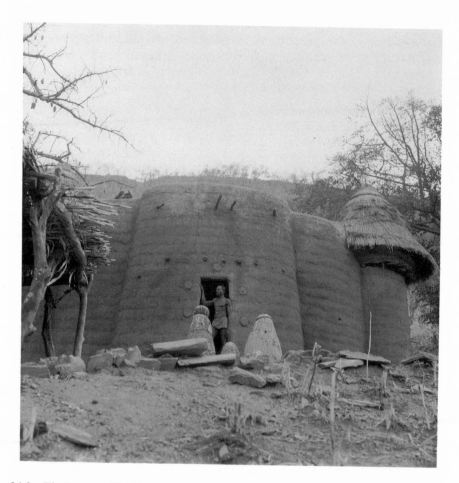

14.1 *The Batammaliba,* Togo, West Africa. The architect, Tchanfa Atchana, stands in front of the house he built for his brother. Photo: Suzanne Preston Blier, 17 January 1978.

money. That the family member was asking considerably more for the bird than the other man was not considered germane.

Many local rituals I became familiar with very slowly and, as above, often by mistake. Thus soon after my arrival I made a tour to look at the different styles of houses in the area (see, for example, Plate 14.1). Both in circumstances where there was no one at home and when people were sitting in front of the house, my research assistant would go up to the house entry, hold the sides of the door, and peer into the interior—even before greeting family members if

they were relaxing outside. I found his actions to be impolite but said nothing to him about this for several weeks. Trying to make my point by example, I overtly avoided looking into the houses and if someone was outside, went up to greet them as soon as I arrived. Eventually I approached my assistant about his "lapse" and learned that it was he who was being both polite and ritually correct. As I was to learn, Batammaliba ritual practice and courtesy require one to greet the house while positioning oneself in front of its door—its symbolic mouth (Blier 1987). Even when the owners were present and were sitting out in front, it is the house that one must acknowledge first because it is considered a sacrosanct guardian of its inhabitants, assuming essential qualities of a person. Today in the West, were one to make it a practice of regularly speaking to the house door, there is little doubt that one would be diagnosed as suffering from a psychological disorder. What is "reasonable" and "normal" in one society is not necessarily so in another. This was a lesson in differences, ritual imperative, and architectural otherness that I never forgot.

Ritual is defined generally as any prescribed system of proceeding (in religious or other spheres). Long a subject of scholarly interest, ritual is as significant to the poor as to the rich, to the "ancients" as to the "moderns," to the Viennese as to the Vietnamese, to children as to adults, to believers as to nonbelievers. Establish rituals early, parents are admonished (regular bedtimes, meals, holiday festivities); on such rituals depend the security and eventual individuation of the child. Ritualized behaviors such as re-capping the toothpaste, folding the newspaper in a particular way, or replacing rolled paper in a given direction are the sorts of conduct on which couples regularly disagree. In those individuals suffering from serious psychological disorders, ritualized behavior often becomes an end in itself. These rituals create a "reality" that gives their lives a sense of order. In this context and others, rituals serve as a means of making something one's own. For cats, dogs, wolves, and certain other animals, similarly, ritual behaviors such as spraying or urinating serve as important identity "markers." Rituals, as markers of life, offer through their formality and relative fixity a means of measuring, mastering, and making sense of the world at large.

Ritual typologies vary considerably, ranging from religious acts to those associated with political, social, sexual, economic, and other spheres. Rituals vary from daily to multi-yearly, from simple gestures to complex performances, from split-second actions to processes lasting many years. Some rituals survive for centuries (in the West, for example, traditions of shaking hands or cheering the arrival of the new year). Other rituals are invented as a means of remembering an important (if idealized) event or concern (Memorial Day, Independence Day, and Mother's Day, among others). With equal facility, rituals are forgotten. Few men today still tip their hats as a sign of greeting, even though just a century ago this ritual gesture was widespread. Quotidian life and special events are both defined by ritual, whether one is following a particular route home from work each day, blowing out the candles on one's birthday cake, or publicly

acknowledging defeat or victory after an election. In visual arts, rituals also surround each work, marking key points in the creative process, as well as in its exhibition, viewing, and discourses on signification.

Widely assumed to constitute actions which lie outside the rational thought or technological necessity, ritual actions generally are associated with the realm of prescriptive belief. For example the act of burying *sacra* underneath the walls of a structure is viewed differently from the laying of *surplus* bedding stone below the foundation. Both actions share the same fundamental concern, however, that the building endure. Clearly distinctions between assumed rational and irrational acts are never culturally or temporally neutral—a point also relevant with respect to terms such as "magic," "fetish," and "tradition" (Blier 1993). What makes rational and functional sense from one cultural standpoint can be seen to be irrational and largely unfunctional in another. The gesture of locking one's door as one is leaving the house illustrates the point. Few people today will leave their houses unlocked if they are traveling any distance. One does this by necessity. One does it as a rational choice. This essential act nonetheless has a clear-cut ritual dimension, even in everyday practice as defined among other things by the attention accorded key chains, the special delimitation of places on one's person or wall where the keys are usually kept, and the largely programmatic actions which are followed when keys are lost.

The ritual importance of securing the door is also brought home in cases of people suffering from obsessive-compulsive disorders. Such individuals sometimes will repeat the door-locking ritual numerous times before leaving. In both the above examples, the action of turning the key to secure the house (and its contents) has a base which is at once rational and ritual. While some may be tempted to view the actions of the person suffering from the obsessive-compulsive disorder as more "irrational" than the regular locking procedure, the difference between the two is one of duplication and degree.

Differences between "rationality" and "irrationality" in ritual acts necessarily depend on one's point of view. Thus, many of us living in urban and suburban areas now use name-brand sturdy locks on our exterior doors, knowing that while they are relatively secure, anyone who really wants to enter can do so by removing the door from its hinges with a crowbar. Locks in this sense are no more rational as a closure device than the inclusion of gargoyles at a structure's corners or the securing of a piece of Koranic verse in the ceiling of an entryway in their respective cultural contexts. Each of the above securing practices is intended to convey the idea that entry into the protected space is not worth the danger it entails—the sounds of a door being broken down might bring neighbors and the police; the trespassing on ground protected by God might bring divine retribution. Both forms of ritual architectural security mean the same thing: proceed at your own (potentially considerable) risk.

It is not surprising that more than many other human activities, ritual is characterized at once by elements of sameness and difference (specificity to a given time and place and qualities of more universalized meaning and intent).

One of ritual's larger concerns indeed is the transcendence of contextual grounding. Another architectural example, this one historical, will serve our purposes. I am referring here to accounts of the founding of a small city whose name has come down to us as Emor. A nineteenth-century description of related rituals which is based on an early native source tells us that the city founder, a man identified as Sulumor

> set up an altar, and lighted a fire upon it. This was the holy fire of the city. Around this hearth arose the city, as the house rises around the domestic hearth; "Sulumor" traced a furrow which marked the enclosure. Here, too, the smallest details were fixed by a ritual. The founder made use of a copper ploughshare; his plow was drawn by a white bull and a white cow. "Sulumor," with his head veiled, and in the priestly robes, himself held the handle of the plough and directed it, while chanting prayers. His companions followed him, observing a religious silence. As the plough turned up clods of earth, they carefully threw them within the enclosure, that no particle of this sacred earth should be on the side of the stranger. This enclosure, traced by religion, was inviolable. Neither stranger nor citizen had the right to cross over it. To leap over this little furrow was an impious act[;] it is an [Emor] tradition that the founder's brother committed this act of sacrilege, and paid for it with his life. But, in order that men enter and leave the city, the furrow was interrupted in certain places. To accomplish this, "Sulumor" raised the plough and carried it over; these intervals [became] the gates of the city.

The author goes on to tell us that information on the city's foundation has been preserved to the present by means of celebrations commemorating the town's inception which take place every year on 21 April. In this description we see the ways in which ritual is able to transcend contexts of religion, for the belief systems adhered to by local residents at the time of the city's founding are very different from those in the nineteenth century when the above passage was written.

What this example also makes clear is that both stasis (temporal boundedness, structure, similitude) and transitus (change, movement, difference) are central to ritual. Both the *plowing* around the perimeter and the *positioning* of the hearth at the city's center are critical parts of the foundation ceremony (and its later ritual reenactment). The above pairing complements historic (but generally now forgotten) distinctions which were made between rite (Latin *ritus*) and ceremony (Latin *caerimonia*), the first referring to the "order" or structure of a formal (generally religious) procedure and the second to the ritual "act" itself. The differences between "principle" and "practice" in the etymology and village foundation example above also suggest a striking complement with Saussure's separation of *langue* from *parole* (the rules of a language versus the ways it is actually spoken).

That the city described above is in fact Rome ("Emor" reversed) may well

surprise some readers (the founder here is Romulus, "Sulumor," the region is Italia, and the nineteenth-century scholar is Numa Denis Fustel de Coulanges). Fustel's discussion of foundation rituals in his *Ancient City* was based on Plutarch. Needless to say, the description would feel quite at home with certain changes in metallurgy or beasts of burden in a discussion of African, Chinese, pre-Columbian, or Near Eastern village foundations. (Fustel's discussion of Roman ancestor cults in this book also has a surprising fit with rituals related to deceased family members in other parts of the world.) Again, what this points up is that while rituals are necessarily defined by features of cultural and temporal specificity, and are indeed perceived to lie at the crux of a given religious belief system, these same rituals often are framed in such a way as to transcend specific contexts of worship and belief.

Art historians, anthropologists, historians of religion, and scholars in other disciplines have shared a long-standing interest in ritual form and meaning. For many, like Fustel de Coulanges, ritual serves as a "window" through which to examine related issues (Bell 1992). Associated questions constituted a veritable tool box from which one can extract, reduce, process, and creatively prepare information. Among the more important devices which have come into use are explorations into studies of the body (Mauss 1973; Hertz 1973; Douglas 1960, 1973), analyses of ritual structure (Durkheim 1965; Turner 1967; Bourdieu 1977), explorations into the relationship between hierarchy and ritual (Valeri 1985; Galey 1984; Cannadine and Price 1987; Wilentz 1985), and investigations of the role of ritual in the invention and reinvention of tradition (Hobsbawm and Ranger 1983; Bloch 1975; Moore and Myerhoff 1977).

Each discipline has its own unique interests in approaching ritual. In the social sciences, ritual has been viewed as central to understanding social institutions. In Western medical practice, for example, the white jackets and gowns which constitute part of the ritual apparatus of medical practice are as important to the art of healing as the gowns which figure so prominently in graduations and weddings are to those ceremonies. The psychological effect of receiving a shot or another medical intervention is largely imbedded in the emotional power of ritual (Blier 1995). To anthropologists, rituals also are seen as potent carriers of insight on society. If Durkheim and Mauss saw ritual as a critical part of the larger social system, Van Gennep explores the ties between rites of passage and ideas of transition more generally, pointing up the imperative of liminality in human action and thought. In architecture, following Van Gennep, the places of greatest ritual importance are spaces of transition—portals, crossings, corners, etc. Max Gluckman similarly has emphasized (1965) the importance of ritual as an agency of action, arguing that rituals "do things" as well as "say things," as in resolving conflict or healing. The influential work of Lévi-Strauss (1967) and other structuralists has emphasized the relationship between ritual and language, seeing associated binary oppositions as constitutive grammars.

In the field of religion, ritual has been viewed as a critical component to an understanding of culture and society more generally. The nature of ceremony and sacrament, processes of belief, priesthoods, and issues of gender are among the issues addressed (Brown 1991; Bynum 1987; Lewis 1980; Doty 1986). Ritual is widely seen to offer a means of both internalizing belief and making it at once "real" and individual. In performance studies, ritual similarly has been a subject of recent vital interest. These scholars emphasize that the repetition which is a central part of many rituals is never just rote: rather it can be seen to have an important performative role (Tambiah 1979; Turner 1982; Schechner 1985; Drewal 1992). Like a musical score, a ritual assumes a new identity each time it is repeated. As with the performance of a Mozart sonata, when a ritual is reenacted, it is at once redefined, rediscovered, and created anew.

In many of these disciplines, one sees a widespread interest in how rituals and images relate to each other. While art historians tend to look at art through ritual, scholars in other disciplines have been more inclined to look at ritual through art. If art historians generally emphasize the individual (the artist, artwork, patron, or critic), others, particularly social scientists, emphasize the religious system more generally. Several additional issues stand out in the art historians' long-standing interest in ritual: the importance to the discipline of symbols, signs, and signification generally, the primacy accorded worldview, interest in image typologies (altarpieces, reliquaries, and religious sanctuaries), artistic process, and questions of viewer response.

Today, questions such as the structure of a given ritual form, the functional role of ritual, or the relationship between ritual and worldview are seen to have relatively little inherent scholarly interest (scholars readily can argue and have argued both sides on each question). What are seen generally to have greater importance are questions of the inherent ambiguities of ritual and the ways in which rituals contradict and/or stand in contradistinction to society. Gregory Bateson (1958) for example argues that changes in ritual often serve as a means of averting real change; Marion Kilson (1983) documents how royal ritual and pageantry become more elaborate just as real royal power is decreasing.

Equally important questions have been raised about the multivalence of meaning in ritual contexts (Derrida 1978), the ways in which ritual forms resist interpretation (de Man 1979), and the ways that patterns inherent to the viewer bring forth particular forms of reaction (Jameson 1981). Also important recently have been the shifting influences of Freud and Lacan and their followers on the awareness of the sexual grounding and erotic draw of visual imagery in ritual and other contexts. Yet another important issue in recent scholarship has been the ways in which power is constructed, perpetuated, and manipulated through ritual. With this in mind, a range of individuals have sought to examine the ritual nature of power itself. Representing a diversity of orientations—French annales school, Frankfort school, and others—these studies have been

as interested in the creativity of ritual in contexts of power as they have been in the effects of rituals on those without such power.

Drawing on several of the above themes, the American anthropologist Clifford Geertz (1985) has focused his attention on what he has called ritual's "master fictions" (in other words, the lies that are held broadly by society to support its institutions even if acknowledged to be false). The French anthropologist Claude Meillassoux (1991) has raised provocative questions with regard to the logical contradictions which are found in the perceptions and institutions of ritual. Divine kingship rituals are particularly interesting to explore in light of the above. Like those of other mortals, a ruler's body is made of flesh, blood, and bones. Rulers also share with the rest of us both bodily pleasure and pain. Ritual and regalia thus play a vital role in repositioning the *person* of the king into the king as *political symbol* and *potentate*. The arts and architecture of royalty are particularly interesting to explore with this in mind because the power and status difference inherent in the "master fiction" and "logical contradiction" of kingship necessarily are constructed to a large degree on formal visual means. Reflecting this idea (as well as more ample monetary means) monarchs the world over have been important art patrons. Conceptions of "divine kingship" feed into the logical contradiction and master fiction of royal authority. The ruler, as the embodiment of mystical power, lives in a massive ediface incorporating features which complement those of a temple, emphasizing comparable aspects of presence, distinction, and distance. That one kneels before the king, as before the gods, serves to reinforce the obvious, that rulers are at once more than and less than they may appear to be.[1]

Disorientation, disjuncture, and distinction are a critical part of other ritual forms as well. In Christianity, for example, we are asked to believe not only in the virginity of Jesus' mother, but also in his divine birth, sacrosanct death, and eventual resurrection, certainly among the most important and complex subjects in Christian art. In rituals of the Eucharist prominent paradoxes also are displayed. To some scholars, the operative feature of ritual acts is their heightened sense of the ordinary. The primacy of table bread in the celebration of the Mass is a case in point. To others a ritual's power lies in its underlying "strangeness" (in the Mass, among other things, the potent cannibal trope of body consumption). Ritual serves to some extent as a means of both heightening the differences between the "ordinary" and the "strange" and helping to resolve inherent contradictions between the two. Related contradictions serve as an important impetus for artistic expression with artists seeking to create a sense of order (rationally, logically) out of conditions characterized more generally by features

1. For as Meillassoux points out, "To be divine was to accept the responsibility for supernatural manifestations which only a supernatural being could control: rain, calamities, the results of battles. The king's fate was bound up with the nation's destiny" (1991, 183). When things went wrong, kings were held accountable (Gluckman 1965, 216–17).

of confusion and contradiction. With both the Eucharist and divine kingship, rituals help to make the irrational seem not only viable and operable, but also understandable. The rituals of religion, like the rituals of etiquette—whether speaking to houses or standing for strangers—require at once a certain faith and an acknowledgment that things that are important are not always rational or understandable.

SUGGESTED READINGS

Bateson, Gregory. 1958. *Naven*.

Bell, Catherine. 1992. *Ritual Theory: Ritual Practice*.

Blier, Suzanne Preston. 1987. *The Anatomy of Architecture: Ontology and Metaphor in Batammaliba Architectural Expression*.

————. 1993. "Truth and Falsehood: Fetish, Magic, and Custom in European and African Art."

————. 1995. *African Vodun: Art, Psychology, and Power*.

Bloch, Maurice, ed. 1975. *Political Language and Oratory in Traditional Society*.

Bourdieu, Pierre. 1977. *Outline of a Theory of Practice*, translated by Richard Nice.

Brown, Karen McCarthy. 1991. *Mama Lola: A Vodou Priestess in Brooklyn*.

Bynum, Caroline. 1987. *Holy Feast and Holy Fast: The Religious Significance of Food to Medieval Women*.

Cannadine, David, and Simon Price. 1987. *Rituals of Royalty: Power and Ceremonial in Traditional Societies*.

de Man, Paul. 1979. *Allegories of Reading: Figural Language in Rousseau, Nietzsche, Rilke, and Proust*.

Derrida, Jacques. 1978. *Writing and Difference*, translated by Alan Bass.

Doty, William G. 1986. *Mythography: The Study of Myth and Rituals*.

Douglas, Mary. 1960. *Purity and Danger*.

————. 1973. *Natural Symbols*.

Drewal, Margaret Thompson. 1992. *Yoruba Ritual: Performers, Play, Agency*.

Durkheim, Emile. 1965. *The Elementary Forms of the Religious Life*, translated by Joseph Ward Swain.

Durkheim, Emile, and Marcel Mauss. 1963. *Primitive Classification*, translated by Rodney Needham.

Eliade, Mircea. 1959. *The Sacred and the Profane*.

Fustel de Coulanges, Numa Denis. 1956. *The Ancient City: A Classic Study of the Religious and Civil Institutions of Ancient Greece and Rome*.

Galey, Jean-Claude, ed. 1984. *Différences, valeurs, hiérarchie: Textes offerts à Louis Dumont*.

Geertz, Clifford. 1985. "Centers, Kings, and Charisma: Reflections on the Symbolics of Power."

Gluckman, Max. 1965. *Politics, Law and Ritual in Tribal Society*.

Goffman, Erving. 1967. *Interaction Ritual*.

Hertz, Robert. 1973. "The Pre-eminence of the Right Hand: A Study in Religious Polarity," edited by Rodney Needham.

Hobsbawm, Eric, and Terence Ranger, eds. 1983. *The Invention of Tradition*.

James, E. O. 1955. *The Nature and Functions of the Priesthood*.

Jameson, Fredric. 1981. *The Political Unconscious: Narrative as a Socially Symbolic Act.*

Kilson, M. 1983. "Antelopes and Stools: Ga Ceremonial Kingship."

Lévi-Strauss, Claude. 1967. *Tristes Tropiques,* translated by John Weightman and Doreen Weightman.

Lewis, Gilbert. 1980. *Day of Shining Red: An Essay on Understanding Ritual.*

Mauss, Marcel. 1973. "Techniques of the Body."

Meillassoux, Claude. 1991. *The Anthropology of Slavery: The Womb of Iron and Gold,* translated by Alide Dasnois.

Moore, Sally F., and Barbara G. Myerhoff, eds. 1977. *Secular Ritual.*

Schechner, Richard. 1985. *Between Theater and Anthropology.*

Tambiah, Stanley J. 1979. "A Performative Approach to Ritual."

Turner, Victor. 1967. *Forest of Symbols: Aspects of Ndembu Ritual.*

———. 1982. *From Ritual to Theater: The Human Seriousness of Play.*

Valeri, Valerio. 1985. *Kingship and Sacrifice: Ritual and Society in Ancient Hawaii.*

Van Gennep, Arnold. 1960. *The Rites of Passage,* translated by M. B. Vizedom and G. L. Caffee.

Wilentz, Sean, ed. 1985. *Rites of Power: Symbolism, Ritual, and Politics since the Middle Ages.*

Fetish

William Pietz

Fetish is a familiar word for an exotic thing. In ordinary usage everyone knows that it means an object of irrational fascination, something whose power, desirability, or significance a person passionately overvalues, even though that same person may know very well intellectually that such feelings are unjustifiably excessive. If one accepts that, like taste, there is no accounting for fetishes, then the term is not a problematic one. But when one wants to understand the logic behind these material expressions of personal or cultural fixation, one discovers 2½ centuries of elaborate theorization. From a simple curiosity about a strikingly explicit phenomenon, one soon enters a seemingly endless jungle of high theory and difficult concepts. Sociological theories of institutional reification, anthropological theories of primitive religion, psychoanalytic theories of sexual perversion, Marxian theories of cultural commodification, all these are integral to the history of the theoretical discourse about fetishism. Moreover, since the 1920s, and even more so since the 1970s, these theories have been refined, critiqued, combined, and appropriated by a variety of critical movements. What follows is a brief historical overview of theories of fetishism insofar as they have influenced art criticism and aesthetic theory.

* * *

The original theory of fetishism was a product of the same intellectual movement in eighteenth-century Europe—usually referred to as the Enlightenment—that legitimated the belief that the fine arts and aesthetic judgment form a self-contained domain of human experience. Indeed, both "aesthetics" and "fetishism" were eighteenth-century neologisms that became generally accepted in European intellectual culture in the third quarter of that century. "Aesthetics" was a term developed by the German philosopher Alexander Gottlieb Baumgarten, the volumes of whose unfinished *Aesthetica* were published in the 1750s and popularized during this period by his student and collaborator, G. F. Meier. The word "fetishism" was coined by the French *philosophe* Charles de Brosses, whose *Du culte des dieux fétiches ou parallèle de l'ancienne religion de l'Egypte avec la religion actuelle de la Nigritie* introduced the term to the French intellectual community in 1757.

Both aesthetics and fetishism marked philosophical attempts to theorize certain subjective processes and creedal effects specific to the perceiving mind's direct relation to "sensuous materiality," a dimension of human experience inadequately accounted for by the established rational psychologies derived from

René Descartes and John Locke. Although the theory of fetishism formed part of the Enlightenment critique of religious superstition, while that of aesthetics marked the successful effort to identify artworks and aesthetic feeling as forming a discrete domain of enlightened experience—one quite distinct from the domain proper to sacramental objects and religious sentiment and from that of utilitarian objects and economic reasoning—the underlying philosophical problem of understanding the powers and processes entailed in our passionate apprehension of sensuously material objects has ever since placed the idea of the fetish and that of art in a certain theoretical proximity. As early as 1764, in *Observations on the Feeling of the Beautiful and Sublime,* Immanuel Kant used the aesthetic categories of Edmund Burke's *Philosophical Inquiry into the Origin of Our Ideas on the Sublime and the Beautiful* (1756) to explain the quasi-religious fetishes that supposedly characterized African culture as products of a debased aesthetic sensibility whose degraded sense of the beautiful lacked all sense of the sublime. The common view of European intellectuals of the late eighteenth and early nineteenth centuries was that primitive fetishes were the exemplary cultural artifacts of the most unenlightened spirits and the least civilized societies, those remaining frozen in a historyless stasis before the threshold of true religious understanding and self-conscious aesthetic judgment. As G. F. W. Hegel explained in his lectures on aesthetics, fetish worship is "not yet art."

The work in which the term *fétichisme* was coined, Charles de Brosses's *Du culte des dieux fétiches,* was itself originally presented to the Academie des Inscriptions et Belles-lettres as an intervention in contemporary debates over literary hermeneutics. Attacking prevailing allegorical methods that interpreted ancient myths and cult beliefs as primitive intimations of the universal truths of Christian theology or Platonic philosophy, de Brosses argued that the primordial form of religion was wholly nonallegorical and nonuniversal. This still widespread form of religious belief he called fetishism, the direct worship of particular earthly material objects as themselves endowed with quasi-personal intentionality and divine powers capable of gratifying mundane desires. Drawing on the arguments of David Hume's *The Natural History of Religion* (1757), de Brosses explained fetish worship as the expression of a "metaphor natural to man." Driven by anxiety regarding the uncertain outcome of events necessary to meet their vital needs, primitive people fixed on certain material objects associated by chance with their fears and desires and, lacking any true scientific understanding of physical causality, they personified the unknown powers of particular material objects as gods whom they might worship and manipulate to bring about passionately desired events. Such a materialist religion was thoroughly nontranscendental and nonuniversal. It was, as the young Karl Marx put it in 1842, quite simply "the religion of sensuous desire."

The Enlightenment theory of fetishism was a theory of what we might call the primary process of unenlightenment, one lacking the reality principal of the

civilized that distinguished between subjective desire and objective causality, and hence between the moral sphere of society enabled by rational intentionality and human purpose and the impersonal sphere of nature ruled by mechanical laws and contingent events. Attributing intentional purposiveness to material objects associated by chance with the gratification of human desires, the fetishist both mystified the physical world by attributing to it a human-oriented teleology and reified the social world by subjecting all capacity for moral autonomy to mechanical rituals and dogmatic beliefs. In this light, one can view Immanuel Kant's *Critique of Judgment* (1790) as a solution to the problem of fetishism: the aesthetic faculty of a self-critical mind, for Kant, is one able to distinguish within sensuous experience between the purposiveness of its own subjectivity and the objective purposes found in natural teleological systems such as biological organisms. The recognition of the distinct faculty of aesthetic judgment by the enlightened mind evidences a self-consciousness that no longer confuses the desires and purposes of its own practical subjectivity with objective systems known through its empirical observations. Moreover, it is our aesthetic faculty itself that directs the mind toward those unexperienceable transcendental ideas that are the only ground of true moral conduct. The unenlightened fetishist, apprehending the material world directly from the perspective of his or her material desires, lacking the capacity for disinterested judgment, conflates subjective desire with natural teleology; the fetishist's lack of aesthetic discrimination is thus proof of an incapacity for moral autonomy and true freedom. Such, in any event, is the conclusion we find in such philosophers as Kant and Hegel and, generally, in European intellectual culture in the age of the African slave trade.

The Enlightenment concept of fetishism as a fixated chiasmus that projected the spontaneous intentionality of subjective desire into inanimate material things, while subjecting humanity's free will and power of decision to the false necessity of depersonalized institutional forms, expressed a conceptual framework suited to the self-enabling presuppositions of the nineteenth-century human sciences. The limits of this framework were most radically exposed in this period by the founder of sociology, the utopian positivist Auguste Comte. For Comte, establishing the true science of society meant not only replacing the false methods of theology and metaphysics with scientific positivism, it meant replacing the false religion of God with the true religion of humanity. Where Kant had secured the autonomy of our aesthetic sensibility by distinguishing it within our faculty of sensuous judgment from our capacity for teleological belief, Comte stressed the importance of that primordial state of experiential inquiry when the mind is as yet unsure whether the connections it suspects are causally objective or libidinally expressive. Comte argued that for humanity to achieve the scientific utopia he envisioned people had to recover their primitive capacity for "pure fetishism," that state of spontaneously impassioned surmise able to entertain radically new scientific insights into causal relations and also

able to express that self-constituting, fixational impulse toward irrationally absolute devotion which, in Comte's view, was the ground not only of religious worship but of personal love and collective loyalty. A scientific positivism supplemented by such pure fetishism represented, for Comte, the true religion, that of humanity and material life. Declaring himself the pope of this new dispensation, Comte designed a new catechism and a calendar of worship containing various "positivist saints" and material fetishes, including what he called "the Great Fetish," the earth itself. Comte himself practiced what he preached: each day in his living room he would worship a lock of hair clipped from his deceased mistress. In thus subverting the boundary between science and religion, between aesthetic experience and fetishistic obsession, Comte demonstrated the limits beyond which the new disciplines of the human sciences could not go without destroying the theoretical presuppositions upon which their own claim to intellectual authority depended.

Towards the end of the nineteenth century, respectable sociologists found a theory of primitive religion that they could live with: the theory of totemism. The general theory of totemism indicated that the truth of God and of sacramental objects was society, a group's collective existence as expressed and reinforced by institutional forms. From this perspective—for instance, in Emile Durkheim's *The Elementary Forms of Religious Life* (1912)—"fetishism" could be viewed as a secondary effect of collective representations upon the illusory pictures people have of themselves as singularly determined, autonomous individuals. The sociologist knows that it is not the psychological processes of idiosyncratic individuals but rather the institutionalized structures of collective life that determine a given form of life and that shape the lived worlds of individuals. This implies, of course, a particular sort of antiaesthetic theoretical position perhaps most forcefully expressed in contemporary writing by Pierre Bourdieu. In *The Field of Cultural Production* (1993), Bourdieu dismisses the conventional view of art as a self-contained domain proper to a distinct type of subjective activity grounded in human nature, arguing that the beginning of scientific wisdom is precisely to see that art is itself a fetish, an institutionally constructed object of lived belief. The scientific approach to understanding art as fetish is to analyze not only the processes producing the works themselves but also those producing the belief that there is such a thing as art at all.

Insofar as the scientific observer claims to possess a method for understanding fetishism that need not itself participate in the delusional experience it studies, the concept of fetishism being employed is likely structured along the lines of the original Enlightenment theory.

* * *

Part of the difficulty of reading contemporary discussions of fetishism in art is that one may encounter statements that sound very similar but that are grounded in very different theories. While a sociologist like Bourdieu might

well have written that "Greenbergian modernism was an apotheosis of fetishism in the visual arts in the modern period," the fact that this claim is made in an essay ("Tea with Madeleine" in the 1987 anthology *Blasted Allegories*) by the psychoanalytic critic Victor Burgin refers the reader to a very different theoretical tradition, one which brings us to the intellectual crisis of the early twentieth century.

To appreciate the complexity in modernist discussions of fetishism, we must first note three developments of the 1880s. One was the appearance of the notion of sexual fetishism. In 1887, Alfred Binet published an article, "Le fétichisme dans l'amour," which argued that the same psychological mechanisms responsible for religious superstitions in primitive societies cause sexual perversions in civilized society. The descriptive felicity of Binet's catachresis was such that the term was quickly accepted by the founders of the new sciences of "sexology" and clinical psychology.

A second development was the political emergence of a mass working-class movement, many of whose leaders adopted the theories of Karl Marx. Marx had noticed that the same logic that explained primitive fetishism as the primordial religion of sensuous desire applied just as well to the modern belief in political economy. If primitives irrationally overvalued the desire-gratifying powers of mistakenly divinized material objects, so moderns falsely looked to capitalized economic objects as the magical source of wealth and value. Thus both the new scientists of sex and the new critics of political economics turned an idea used by the civilized to distinguish themselves from primitives back onto those who identified themselves as nonfetishists.

A final development was the so-called scramble for Africa, the colonial conquest of that continent by European powers. This produced not only a new outpouring of quasi-ethnographic accounts of savage fetishism, but in time it led to a massive disillusion in some with the imperialist rhetoric that celebrated "the three C's": commerce, Christianity, and civilization. In his bitter story of the Congo, "An Outpost of Progress" (1896), Joseph Conrad scathingly remarks that "the storehouse was in every [trade] station called the fetish, perhaps because of the spirit of civilization it contained." Moreover, various fruits of conquest and pillage made their way from Africa to Europe in the 1890s and early 1900s. Some of these, such as the bronze sculptures acquired during the sack of Benin City in 1897, had obvious aesthetic merit in European eyes. Moreover, a number of artists found themselves struck by the power of the little African statues that began to appear in curiosity shops and natural history museums. Many art historians have agonized over which artist in what year (between 1890 and 1907) on what day at what hour had the decisive encounter with a primitive artifact that inaugurated the ongoing influence of "primitivism" in modern art.

One will encounter the term "fetish" quite a bit in writings on modern art and on the question of "primitive art" in the early decades of the twentieth

century. Some, however, dismissed the term as a misdescription even of non-European artifacts. In 1907, the same year that Picasso painted *Les Demoiselles d'Avignon* with faces inspired by African masks, a work embodying a shockingly brutal spiritual power that many critics rejected as not proper to art, the anthropologist Marcel Mauss decisively rejected the ethnographic value of the term "fetishism," arguing that it expressed "nothing but an immense misunderstanding between two civilizations, the African and the European." Even writers upholding the value of *l'art nègre,* such as H. Clouzot and A. Level in *L'art nègre et l'art océanien* (1919) and Paul Guillaume and Thomas Munroe in *Primitive Negro Sculpture* (1926), employed the term somewhat gingerly, using its exotic effect to make an appeal that aesthetic categories need to be broad enough to accommodate the cultural difference of non-Europeans. Despite its delegitimation by anthropologists, art catalog writers and museum curators have never ceased using this term to name various sorts of non-European artifacts. However, in recent decades a number of curators, most notably Susan Vogel, have developed techniques of historical contextualization to make the viewer interrogate his or her experience of aesthetically apprehending an object of "primitive art." The implications of such efforts have been discussed in such volumes as Vogel's *ART/artifact* (1988) and the Smithsonian collection *Exhibiting Cultures: The Poetics and Politics of Museum Display* (1990).

In the late 1920s, a few writers associated with the short-lived journal *Documents,* most notably Michel Leiris and Georges Bataille, attempted to theorize the idea of the fetish as a radical way to reconceive art or aesthetic value. In a discussion of the sculptor Alberto Giacommetti, Leiris argued that the categorical imperatives of Kantian philosophy and modern liberal society were in reality nothing but "weak fetishes" and that people have never ceased being moved and motivated by the "true fetishism" that lives in us at a much deeper level, which powerful works of art are capable of touching. "I challenge any art lover," exclaimed Bataille, "to love a canvas as much as a fetishist loves a shoe." In an essay entitled "The Use-Value of the Impossible," Denis Hollier has characterized the theoretical project of this group as an attempt to develop a "fetishistic materialism."

Such efforts were informed by a new sensitivity to the relation of both ethnographic and psychoanalytic theories of fetishism to certain modernist artists and movements. Moreover, there was an intention to acknowledge Marxian notions of commodity fetishism that had recently been emphasized by a number of politically radical theorists who had turned to cultural criticism after the disappointment of their hopes for social revolution. This turn was marked by the appearance in 1922 of Georg Lukács's essay on "Reification and the Consciousness of the Proletariat" and the founding in 1923 of the Institute for Social Research (known as the Frankfurt school). Among the latter, the thinker most influentially interested in art was Theodor Adorno. Arguing that "the greatest fetish of cultural criticism is the notion of culture as such," Adorno, in

essays such as those collected in the volume *Prisms* and in his unfinished *Aesthetic Theory,* urged critics to take into account the fetishizing impact on art of what he called "the culture industry." The insight that artworks within our culture have (at least) a double existence, as pure art and as commodities, is rather obvious to contemporary critics who have absorbed the lessons of Andy Warhol and Jeff Koons, but it was Adorno who first and most persistently attempted to develop a critical discourse ironic enough to take this reality into account.

The writer in this period who most successfully worked through the critical possibilities suggested by these various notions of fetishism was Walter Benjamin. In his unfinished "Arcades Project" and in influential essays found in the collections *Illuminations* and *Reflections,* such as "The Work of Art in the Age of Mechanical Reproduction," Benjamin developed a materialist method that approached cultural artifacts, be they works of art or common things encountered on the street, as "dialectical images" whose power to place people's everyday lives within an unavowedly mythicized present the critic must engage by combining research into the historical singularity of these objects with a subjective yielding to the dreamlike fantasies ossified within even ordinary things. As Susan Buck-Morss puts it in the opening of her study, *The Dialectics of Seeing: Walter Benjamin and the Arcades Project* (1989), what Benjamin proposed was precisely "a dialectics of seeing," a materialist phenomenology moving between historical analysis and enchanted credulity that takes seriously "the debris of mass culture as the source of philosophical truth." Or, as the anthropologist Michael Taussig puts it in *Mimesis and Alterity: A Particular History of the Senses* (1993), Benjamin was "addressing the fetish character of objecthood under capitalism, demystifying and reenchanting, out-fetishing the fetish."

While the Enlightenment sociological tradition carried on by such theorists as Bourdieu emphasizes the status of fetishes as socially constructed illusions, writers such as Leiris, Bataille, and Benjamin wished to interrogate the real power of fetishes. Can something important be learned by identifying the strange power exerted by sacred ritual objects, by seductively desirable commodities, by objects of perverse sexual fascination, and by certain deeply moving artworks? Such a question is asked when Michael Taussig examines a Cuna Indian curing ritual in which glossy magazine pictures of valuable Western commodities are incinerated in order to release their supernatural healing power. It is asked when the anthropologist Wyatt MacGaffey reconsiders Kongo ritual objects in terms of "magic or, as we usually call it, art." It is asked when the anthropologist and art critic Francesco Pellizzi considers the importance of an early bronze sculpture of the artist Ray Smith made from the plaster cast of a dead sheep that he had impaled on a vertical pike: "The animal bronze sculpture was, for Ray Smith, a means to a liberation (to a sort of initiation): it was an offering that exercised the power of death (the *ultimate* power, the Supreme Violence), not so as to deny it, but to 'comprehend' it. . . . *As fetish* it is an object of power, an object that gives power. In this case,

it provided the liberating power of making art which is, for Ray Smith, a strategy of survival."

Such treatments of fetishism raise questions for art historians, for aesthetic theorists, and for working artists. For art historians, it suggests the possibility that the fascination exerted by African fetishes over early modernist artists had less to do with their visual form relative to such movements as expressionism and cubism than with their historical substance as accursed objects transfixing the spiritual violence of the colonial savagery that brought them to Europe. For aesthetic theorists, it challenges the traditional exclusion of personal interest, social power, and material passion from our conception of the experience of art. For artists, it suggests that their productions may more accurately be regarded as power objects: in her "fetishes" and other mixed-media works, Renée Stout views herself as continuing a single tradition of making spiritually powerful artifacts, one that includes both African power objects, such as the Kongo *minkisi* that nineteenth-century Europeans regarded as exemplary primitive "fetishes," and modern artworks, such as the boxes of Joseph Cornell, that conventional critics would regard as belonging exclusively to a narrower tradition of "art".

<p style="text-align:center">* * *</p>

The most influential theory of fetishism among art critics since the 1970s derives from that peculiarly modern curing ritual, psychoanalysis. Since the 1890s, psychologists have accepted sexual fetishism as the model for sexual perversion per se. The fetishist is the exemplary pervert because he fixes on the most degradingly inappropriate object of love: an impersonal object or a depersonalized quality. From his early *Three Essays on the Theory of Sexuality* (1905) to his late essay "Fetishism" (1927) and the related fragment "Splitting of the Ego in the Process of Defense" (1938), Sigmund Freud returned again and again to the problem of fetishism. Freud's explanation is comprehensible only in terms of the scenario he proposes as the universal drama (or "family romance") by which the infantile mind attains maturity. This is called the Oedipus complex in reference to the Greek tragedy in which the hero unknowingly kills his father and marries his mother. Freud claimed that these are the secret desires of every little boy. Moreover, during his second or third year, every child has occasion to catch sight of his mother's genitals and become terrified that their lack of a penis is the result of castration. The fear that his father will chop off his own "organ of pleasure" because the son desires to replace him as Mother's lover is so overwhelming that the prerational consciousness "disavows" the sight of female genitals and the fact of sexual difference, believing instead that Mother really does have a penis. The boy later represses his sexual desire for his mother and his desire to kill his father around the time his increasing linguistic capacity allows him to learn how to follow social rules of good conduct rather than the spontaneous impulses of his passions. But for some, as adolescence brings on

the capacity for phallic orgasm, the first surge of unprecedentedly powerful sexual feeling can reactivate the infantile sexual crisis with its visual disavowal of sexual difference and its belief in the mother's penis. Since the mature conciousness of the boy knows that women don't have penises, this contradictory point of view is pushed into the irrational part of the mind outside the self-conscious ego. There it forms a secondary phantasmal reality that is consciously experienced without being acknowledged by the rational ego consciousness, that is, by the self we identify when we say "I." It is this lived but unacknowledged "splitting of the ego" that structures the libidinal activity of the sexual fetishist. The fetish object is thus a symbolic substitute displacing the disavowed mother's penis that the fetishist knows does not exist but, at the level of his conduct, that he believes in nonetheless.

Even during Freud's lifetime, the component of visual disavowal in his theory of fetishism suggested for some an intriguing approach to certain aspects of art. But it was the assimilation of new theories derived from the structural linguistics of Roman Jakobson to psychoanalysis in the 1950s that informs most contemporary psychoanalytic art criticism. This came especially by way of the structural anthropology of Claude Lévi-Strauss, whose *Elementary Structures of Kinship* (1949) had demonstrated that the fundamental institutional structures of premodern or kinship-organized societies were premised on the taboo against incest. This was the very prohibition that Freud had identified at the core of the Oedipus complex, whose resolution entailed the child's mature acceptance of the order of the patriarchal family and the laws and language of society. A theoretical discourse combining psychoanalysis and structuralism was established in Jacques Lacan and Wladimir Granoff's "Fetishism: The Symbolic, the Imaginary, and the Real" (1956). The relevance of this theory of fetishism for thinking about visual culture was emphasized in Lacan's later texts "The Signification of the Phallus" (1958) and "Of the Gaze as *Objet Petit a*" (1964). This led a number of influential thinkers to expand his arguments about fetishism into a novel theory of ideology.

In 1964, Lacanian theory was appropriated by the structural Marxist, Louis Althusser ("Freud and Lacan" in *Lenin and Philosophy and Other Essays*), as a general theory of ideology that explained how people misrecognize their personas within a given social structure as their true selves. An alternative "post-Marxist" theory was proposed by Jean Baudrillard in "Fetishism and Ideology: The Semiological Reduction" (1970). This offered a nonpsychoanalytic theory stressing the seductive attraction of apparently contradiction-free systems of symbolic exchange. Against such a reductive identification of fetishism and ideology, Jacques Derrida in *Glas* (1974) celebrated the fetishist's oscillation between undecidably contradictory positions as a powerful evasion of ideological fixation that was something like deconstruction in action. It was in the context of such discussions that many feminist critics focused on the curious fact that Freud's supposedly universal Oedipal scenario really applies only to

men and leads to discussing women in negative terms of their "lack" of a penis. Indeed, in its devaluing aversion to female sexual difference and its overvaluing fixation on a phantasmal phallus, Oedipal fetishism seemed to explain the perverse logic secretly informing the norms of male-dominated cultures. Significant feminist rereadings of fetishism along these lines are Luce Irigaray's *Speculum of the Other Woman* (1974), Julia Kristeva's *Powers of Horror* (1980), and Sarah Kofman's "Ça cloche" (1980).

These theories—one can use the grab-bag term, "poststructuralist" to characterize them—began to be introduced to Anglophone readers in the mid-1970s through the film theory of the journal *Screen* in such essays as Laura Mulvey's "Visual Pleasure and Narrative Cinema" (1975). In this approach, artworks are criticized, and, in the case of such artists as Mary Kelly and Barbara Bloom, produced, to expose the cultural politics entrenched in the lived ideology of our visual culture as a sort of fetishistic "phallocentrism." This term refers to the argument that the logic of our cultural symbolism is organized in a way that privileges a certain chain of "master signifiers"—Father, Law, God, Good, etc.—whose equation may be studied in the legitimized discourse of our philosophy and social theory, but whose ultimate anchoring in the mystified sign of the Phallus is usually revealed only in the mute testimony of our visual culture. In our art, and for that matter, as Linda Williams has discussed, in our pornography, we can find a phallus-fixated structure of domination aimed at gratifying the desires of men at the expense of women. Artworks enact this by orienting themselves to an aesthetic gaze which is that of a male subject who takes pleasure in women as mere visible objects. Such an aesthetic regime depersonalizes women by relegating them to the passive position of the viewed object while excluding them from the active subjectivity of the viewer's position, which is the position of freedom and value judgment. One problem characteristic of such arguments is the difficulty of distinguishing the oppressive desubjectification of fetishism from the expressive objectification entailed in the production of any artwork.

With the elaboration in the 1980s of gay and lesbian theories, as well as anticolonialist theories derived from the cultural studies movement, the discourse about fetishism deployed by postmodern critics of hegemonic textual and visual ideologies has become exceedingly complex and only promises to become more so. Because of the types of objects it has gathered under its name and the themes through which it problematizes these objects for theoretical reflection, "fetish" has remained a viable critical term for writers dissatisfied with the orthodox vocabulary of their own discipline.

SUGGESTED READINGS

Apter, Emily. 1991. *Feminizing the Fetish: Psychoanalysis and Narrative Obsession in Turn-of-the-Century France.*

Apter, Emily, and William Pietz, eds. 1993. *Fetishism as Cultural Discourse.*

Bourdieu, Pierre. 1993. *The Field of Cultural Production.*

Buck-Morss, Susan. 1989. *The Dialectics of Seeing: Walter Benjamin and the Arcades Project.*

Burgin, Victor. 1987. "Tea with Madeleine."

Davis, Whitney. 1992. "Homovision: A Reading of Freud's 'Fetishism.' "

Harris, Michael D. 1993. "Resonance, Transformation, and Rhyme: The Art of Renée Stout."

Hollier, Denis. 1992. "The Use-Value of the Impossible," translated by Liesl Ollman.

Kofman, Sarah. 1989. "Ça cloche," translated by Caren Kaplan.

Lauretis, Teresa de. 1994. *The Practice of Love: Lesbian Sexuality and Perverse Desire.*

MacGaffey, Wyatt. 1990. "The Personhood of Ritual Objects: Kongo *Minkisi.*"

McClintock, Anne. 1993. "Maid to Order: Commercial Fetishism and Gender Power."

Mulvey, Laura. 1993. "Some Thoughts on Theories of Fetishism in the Context of Contemporary Culture."

Pellizzi, Francesco. 1992. "*Speculum Animale*: Ray Smith and the Desire of Painting."

Silverman, Kaja. 1992. *Male Subjectivity at the Margins.*

Taussig, Michael. 1993. *Mimesis and Alterity: A Particular History of the Senses.*

Williams, Linda. 1989. "Fetishism and Hard Core: Marx, Freud, and the 'Money Shot.' "

SIXTEEN

Gaze

Margaret Olin

Like the other arts, the visual arts are not made in hermetic isolation but as a form of communication. As their name implies, these arts communicate through the visual sense rather than the tactile or aural. In the nineteenth century, a discourse grew up around the attempt to understand the work of art in terms of its status as a visually perceptual object. This discourse was centered on an opposition, current in psychological theory of the nineteenth century, between the optical and the tactile senses. According to early experimental psychologists, the tactile sense placed us in contact with reality, imparting the ideas of weight and solidity, while the optical sense transmitted immaterial colors and lights. The optical sense came to be regarded as the sense of the intellect, the spirit, or the imagination, leaving the tactile sense relegated to more earthbound tasks. The conclusion some theorists drew is that the visual arts should confine themselves to depicting the colors and lights typical of visual perception and avoid the representation of elements, such as outlines, more properly suggestive of the tactile sense. Paintings that privileged opticality strove for a miragelike appearance and avoided not only the depiction of three dimensions or hard outlines but also the straightforward acknowledgment of their status as painted objects. Optical perception seemed to unite the subjectivity of artistic vision with the objectivity of the external world. Impressionists and many symbolists were attracted by the spiritualism this conception of the visual seemed to entail, and vestiges of it survived in the work of critics of the mid-twentieth century who used formal criteria to interpret such artistic movements as abstract expressionism. This discourse was in part continued, but to a large extent replaced by the term "gaze."

In the discourse of opticality it was possible to talk about vision without saying anything substantial about actual people who do the looking or the conditions under which they do it. That is, one could conceive of a work of art as though in hermetic isolation. The term "gaze," however, leaves no room to comprehend the visual without reference to someone whose vision is under discussion. "Gaze" can be considered a subheading of a larger category usually called "spectatorship." "Spectatorship" covers a complex of terms with interchangeable meanings but different connotations. "Beholding," for example, has religious connotations, while "scrutinizing" suggests the involvement of intellect. In theoretical discussions hardly anyone just looks at a work of art, and glimpsing and peeking, watching, glaring or seeing have so far remained beneath the notice of most art theorists. Words for the agent of gazing are "be-

holder," "viewer," or occasionally "spectator" or "audience," especially if the work in question is a film. Related terms in the complex can characterize an attitude toward viewing. "Visual pleasure" is a straightforward characterization, for example, when compared to terms with a more academic ring, such as "ocularcentrism" or the Freudian "scopophilism."

"Gaze" is a rather literary term for what could also be called "looking" or "watching." Its connotation of a long, ardent look may bring to mind the intensity in which knowledge and pleasure mingle when I behold a work of art. While most discourse about the gaze concerns pleasure and knowledge, however, it generally places both of these in the service of issues of power, manipulation, and desire. There is usually something negative about the gaze as used in art theory. It is rather like the word "stare" in everyday usage. After all, parents instruct their children to stop staring, but not to stop gazing. A typical strategy of art theory is to unmask gazing as something like staring, the publicly sanctioned actions of a peeping Tom.

The choice of terms from this complex can offer a key to the theoretical bent or the ideology of the theorist. Generally, the subject is broached as part of an openly stated ethical or occasionally religious position. More precisely, it signals an attempt to address ethical issues that can be read through visual analysis of a work. The use of the term "gaze" is therefore emblematic of the recent attempt to wrest formal discussions of art from the grasp of linguistic theory, to focus on what is visual about a work of art and yet address the wider issue of social communication to which linguistic theory, applied to art, opened the discourse.

The term "gaze" is useful for uniting formal and social theory because unlike "opticality," it is a double-sided term. There must be someone to gaze and there may be someone to gaze back. In order to articulate this difference I shall consider a specific example in terms both of opticality and the gaze. My example is the photograph known as *Sharecropper's Wife* (Plate 16.1) from Walker Evans's 1941 collaboration with James Agee, *Let Us Now Praise Famous Men*. Considered topically, Evans's photograph reveals the hardness of outline produced by a straightforward light and the deep focus of a large-format camera. Evans could have produced a hallucinatory filminess by using soft lighting and shallow focus. He could have oiled his lens or softened the emulsion of his negative with a brush. That he chose not to suggests his investment in the reality principle of documentary photography as opposed to the spirituality of the expression of his optical perception. This analysis tells us something about the style of the image and about notions of documentary photography in the 1930s, but it fails to address some facts that might strike us at first glance, even before we begin to gaze: when we look at the image we look at a woman. Just as important, the woman in the image appears to look back at us. The term "gaze" alerts us to the fact that a work of art, like a person, can seem to gaze or be gazed at. Within a work, gazes can be exchanged. Who is object of the sharecropper's wife's gaze, and why? Why are we looking at her?

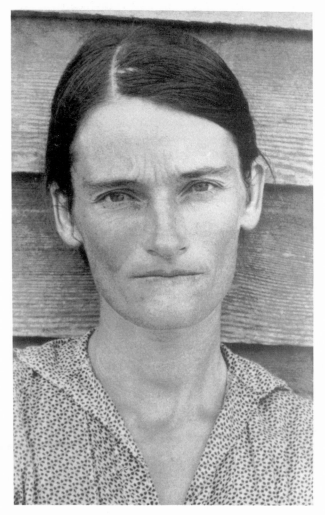

16.1 Walker Evans, *Annie Mae Gudger* ["Sharecropper's Wife"]. From Walker Evans
and James Agee, *Let Us Now Praise Famous Men* (1941).

The issues that have come to be represented by the term "gaze" were intro-
duced into the mainstream of contemporary discourse in the contrasting con-
texts of formalist theories of painting and feminist theories of film. In "Art and
Objecthood," published in 1968, Michael Fried first adapted the old discourse
of opticality to take in issues of spectatorship, initiating what proved to be a
remarkable sequence of ruminations on spectatorship. In it, he criticized then
current "minimal" sculpture as "literalist," comparing its relationship with its

beholder unfavorably with modernist painting, characterized as "important," "ambitious," or "high." Literalist art was concerned with the circumstances of the beholder's encounter with the work. A work would confront the beholder, making the beholder responsible for the effect of the work, the act of looking and being seen becoming the subject of the work. This dependence on the beholder for its effect, however, gave the work the inauthenticity associated with acting for an audience as in theater.

The "high art" of our time, on the other hand, overcomes theater and hence inauthenticity, according to Fried in this early essay, by seeming to exist entirely and outside of temporality. Its autonomy is exalting. Although the work is autonomous, it is linked to past art and past artistic problems, for Fried argues for the "need to perpetuate the standards and values of the high art of the past." We are inauthentic, watched and watching, most of the time. True art, therefore, takes us beyond everyday life. Hence it is not for everyday people. The kinds of seriousness demanded by the finest painting and sculpture of the recent past, Fried declared, "are hardly modes of seriousness in which most people feel at home, or that they even find tolerable." Fine art forces conviction, rather than drawing attention, as though we see manifest the world creating itself, a timeless state he termed "presentness." Fried's differentiation between the presence of the (temporal) object and the presentness of the (timeless) pictorial depended on the opposition between the optical and the tactile; for optical qualities imparted by modernist painters defeated the "Objecthood" of Fried's title, and the tactile qualities of the works of literalist art identified them as objects. The association of intellect and spirit with opticality also contributed to the elitism of the construction of presentness.

As a means of explicitly social criticism, the ideas associated with the gaze first became popular, along with the term "gaze" itself, in feminist film criticism. The classic essay is Laura Mulvey's "Visual Pleasure and Narrative Cinema" (1975), one of the most frequently cited essays in all fields of contemporary humanistic studies. Mulvey saw the "place of the look" as the defining feature of cinema. Cinematic viewing was the interplay between narcissistic identification and erotic voyeurism, an argument Mulvey supported by allusions to psychoanalytic theory. In her analysis men, shown in action and deep focus as figures in a landscape, in deep, "real" space, constituted figures of ego identification, like the idealized image of itself a child first joyously recognizes in a mirror and seeks to live up to as an ego ideal for the rest of its life. This theory of the "mirror stage," to which I will return later, is borrowed from the French psychoanalyst Jacques Lacan. Woman, on the other hand, is made into an object of eroticized looking, or scopophilia, a term lifted from Sigmund Freud's theory of the fetish. Scopophilia comes in two varieties, active and fetishistic. Active scopophilia diminishes the threat that its object, woman, will provide her viewer with an uncomfortable reminder of castration. If subjected to active scopophilia, the woman is investigated, her guilt discovered and punished.

Fetishistic scopophilia silences the woman in order to worship her. She is sequestered from the world of happening or becoming. Her background is invisible, her face rendered hallucinatory by soft mists that play over it, her body parts isolated for loving perusal in closeup. The gaze of the man in the audience and the gaze of the man active within the narrative, with whom the audience identifies, are both fixed on her. Time, the flow of the narrative, stops on the—timeless—image of the woman. Woman is the image; man is the bearer of the look. Power is on his side.

Once the sadistic erotic power of the bearer of the gaze is exposed, however, the pleasure of gazing is threatened. The audience becomes uncomfortable and it is more difficult to exploit the image of the woman or, in the world outside the movie palace, women themselves. As a countermeasure, Mulvey proposes the liberation of two other looks: the materiality of the camera and the detached, critical look of the audience. Some of these countermeasures have been implemented in photography as well as in film. The direct address of the spectator, for example, draws his attention to the voyeuristic quality of his gaze. In large part the project of Mulvey and other feminists is to awaken in the male voyeur, enjoying the female as spectacle, the shame that comes from discovering that someone is watching him. Hence in a famous work of Barbara Kruger a female profile in stone talks back to the viewer: "your gaze hits the side of my face." The phrase shames the male viewer with the aggression of his look. The woman, a found image Kruger has embellished with the caption, has perhaps been turned to stone by his Medusa-like gaze. Before Kruger added the caption, the image could be gazed at in undisrupted visual pleasure. The caption makes the image into a poster, giving the stone woman a voice to accuse her aggressor, if not a gaze of her own.

At first glance, Mulvey's feminist argument may not seem relevant to Fried's comparison between two groups of abstract artists. But if the cinematic style of the depiction of woman—lack of background, isolation, her outlines softened by mists—turns her into a fetishistic phallus substitute, similar visual strategies should be capable of transforming other images into phallus substitutes as well. Works of modernist painting like the ones celebrated by Fried's early essay are also beheld in a timeless optical presentness and, like Greta Garbo, are worshiped in splendid isolation. Are works of modernist painting therefore also fetishes, and do they function as phallus substitutes?

Before I take on this question, I have to admit that the comparison between the image of woman in film and the image of a modernist painting in a gallery is not self-explanatory. By using it I mean to point to the fact that to say we treat woman's body as an object is also to say something about the way we treat objects in the twentieth century: as commodities, as objects of possession. The comparison becomes comprehensible if the concept of the fetish is expanded to include not just sexual but commodity fetishism. Fetishism of capitalist objects of symbolic exchange works similarly to the fetishism of the female

body, which also has, after all, a role in market economy. Both kinds of fetish fill imaginary lacks, or lacks in the Imaginary (a Lacanian term for the developmental state in infancy prior to language acquisition). Once made into commodities fetishes are "mystified," that is, their status as commodities is covered over by rhetoric that treats them as quasi-religious objects. It thus takes only a slight modification of Mulvey's argument to begin to see, in the almost religious celebration of beholding in "Art and Objecthood," a patriarchal, or at least a capitalist, maneuver. The disinterested, spiritual appreciation of works of high art becomes a mystification covering over a commerical gallery system and a profession linked to a moribund class order whose members fear losing their privileges, or perhaps, in psychological terms, their "members."

Both Fried and Mulvey have richly developed the ideas first expressed in their essays. Mulvey's ideas, however, have drawn more attention than those of Fried, and more open opposition, much of it from feminists. They have begun to investigate phenomena not covered in the simple two-gender scheme upon which her argument depends, including the female gaze, the gaze of gays and lesbians, or multiple identifications. New issues have arisen in film theory that complicate the implications of her argument. Chief among them is the notion of "suture," an elaboration of Lacan's ideas first treated extensively by a number of authors in the journal *Screen*. This term pertains to the way in which the audience is made unaware of the constructed quality of the gaze. When I see a painting of a landscape framed in a museum it may not occur to me to question whose view of the landscape is depicted. It is Monet's view, or Rembrandt's, or simply the look of the land in France or the Netherlands. Now it is mine. In a film, however, when I feast my eyes on a beautiful landscape, I am likely to be told whose view this is. A long view of a landscape may close in at the beginning of a film as an "establishing" shot, to reveal the characters. But in the middle of a film, at the height of my involvement, a view of the landscape is likely to be preceded by a close-up of a character who appears to be looking at something, which I then identify as the landscape. A second close-up may then confirm that I am looking through the eyes of a character in the film. My own gaze is denied. The possibility that this view was put there only for my visual pleasure is sutured over by sandwiching it between close-ups of a character's gaze. The view of the landscape—or of the beautiful woman—appears to belong to a character. The hero/villain of the film is a peeping Tom, not I, and I, comfortably anonymous in a dark theater, enjoy with impunity.

Suture can be broken if one of the characters acknowledges the camera, thus making the audience aware of the implications of their own gaze and the manipulation of that gaze by the camera. Suture is often broken to comic effect. For example, in Tony Richardson's film *Tom Jones* (1963), Tom looks at the camera as he places his hat over it (and us) in a chivalrous attempt to protect an unclothed damsel in distress from our prying eyes. This amusing break in suture—which corresponds to the literary style of Henry Fielding's novel—only

corroborates its rule, however. Comedy is allowed to be subversive. Woody Allen's *Purple Rose of Cairo* violates suture for the sake of a more complex comic discourse over the relation between audience and work and the relative status of art and reality. Suture is broken with serious intentions in the work of feminist directors such as Yvonne Rainer or Mulvey herself, in her *Secrets of the Sphinx*.

While the value systems represented by Fried and Mulvey may seem directly opposed, in regard to the theory of suture certain points of contact between their readings become apparent. For Fried objected to theater not because of its beholder (modernist art has beholders as well) but because of its inauthenticity. Literalist art confronts the beholder, but, like illusionistic theater, it fails to acknowledge the fact that it depends utterly upon the viewer. The mechanism is much like suture. According to Fried, attempts to address the problem of theatricality in theater itself relied on strategies, pioneered by the playwright Bertolt Brecht, which acknowledge the presence of the audience or reveal the constructed nature of the work. These correspondences between the views of Fried and Mulvey are possible because although they begin from different economic and social principles, they share the notion of the pernicious power of the gaze. The gaze, it seems, destroys.

This notion has a history. Mulvey refers explicitly to Freud's essay on the fetish. But her work is fueled by many negative constructions of looking. The antiquity of this discourse can be sensed in such myths as that of the evil eye and Medusa, alluded to above, whose gaze could turn its object to stone. Folkloric representations of eyes sought to protect their wearers from the power of the evil gaze. Respect for the power of the gaze survives today in the injunction not to stare, and the need to ask permission before watching someone at work or play. Culturally determined precepts regulate photography, which involves having one's image looked at in one's absence. It is customary at least to ask permission, in some cases to obtain a release or pay a fee.

The gaze has taken on new villainous qualities in the discourse of twentieth-century theory. Freud's essay fastened on the psychological state of the gazer, not the effects of the gaze on the "gazee." But the gaze was also associated with power in early twentieth-century theory. German expressionism exploited this sense of power in images that stared out at the viewer menacingly. The charisma of the gaze came to a peak in Hitler, who prided himself on his hypnotic gaze. Jean-Paul Sartre's almost paranoid treatment of *"le regard"* (the look) in his treatise on existential philosophy, *Being and Nothingness,* portrayed the state of being watched as a threat to the self. This essay, which has been extremely influential on current theorizing about the gaze, may have been inspired in part by the example of Hitler; Sartre was writing it during the occupation of France.

The gaze was repsychologized in two theories of Lacan. In "The Mirror Stage," Lacan posited an initial identification with a mirror image that caused the child to identify with an externalized image of itself. Some understand this

image as the one others see when they look at the child, even regarding it as the incarnation of the missing part of the mother, the phallus whose lack the child supplies. Identification with this image is a primary misidentification and determines that the course of the ego is split, for its image of itself comes from the outside. This phase, however, represented a prelinguistic phase in childhood development. Mirror identification is replaced by desire when the child recognizes the lack not in its mother but, through the injunction of its father, in itself, giving rise to the desire for completeness. In a later work that elaborated the notion of the gaze in a different direction from that of Fried and Mulvey and his own earlier work, Lacan accounted for this dialectic of desire by postulating a split between what he called the "eye" and the "gaze." In this permutation the gaze was the unattainable object of desire that seemed to make the other complete. The subject that looks out is replete with absence or lack, which is, after all, the human condition. It has eyes not to look out but to be looked at, to reflect. The gaze is the "object a" that comes from outside. This gaze (at us) is not a blessing. It is an evil eye. Most paintings allow us to "lay down our gaze" and indulge our "eye" in the illusion of fullness. One-point perspective, which seemed to array everything for a unitary, complete subject, served this purpose. Not sensing any lack in ourselves, we are comforted and thus willing to help the painter earn a living. It is important to understand, however, that for Lacan, unlike some of the thinkers who follow, the eye and gaze, although split, are part of the same person; for the gaze is projected, imagined. It is not the gaze of a real person who wishes malevolently to deprive us of our independence as subjects, but the result of our own struggle for self-mastery.

The gaze, then, corresponds to desire, the desire for self-completion through another. There is a struggle over the gaze: one gets to look, to be master of the gaze; the other (or Other) is looked at. Therefore the power of the gaze extends beyond the struggle between the sexes. The gaze colors relations between the majority and the minorities and between the first world and the third world, whose inhabitants can be the object of the gaze because they are viewed as exotic and as living in a timeless presentness outside history. The subject-turned-object sees itself as the other sees it: it internalizes the gaze. Thus the poor self-image and limited sense of one's own possibilities that result when women see themselves as men see them, when minority groups see themselves as the majority sees them.

But the devastating effects of the gaze have been chronicled more generally, as they pertain to the whole of society. Foucault linked the gaze to forms of surveillance. Like George Orwell's Big Brother, it turns all of us into submissive objects of governmental gaze, although often it is our credit records, not our faces, that are its object. And it is no less debilitating to be the one who gazes. Guy Debord, for example, in his book *The Society of the Spectacle,* warned against the dehumanizing aspect of being a spectator. For him, the accumulation of isolated images in our culture threatened communal activity and enforced alien-

ation and isolation. He deplored the passivity of the gaze, the images of things that replaced lived experience. Like a parent advising his children to turn off the television and stop being couch potatoes, he exhorted his followers to take to the streets and live, a message that a group of Parisian student protesters eagerly embraced in May 1968. More recent politically motivated artists, such as Hans Haacke, have sought to stir the museum goers out of the complacence of their own gaze, subverting the traditions of exhibits to force an awareness of the extent to which the gaze to which the painting answers is not only an artistic one but also the powerful gaze of a wealthy patron or multinational concern.

<p style="text-align:center">*　*　*</p>

To return to Walker Evans's photograph, I hope you will notice that my discussion of the gaze has so far left the import of *Sharecropper's Wife* untouched. Our gaze does not hit the side of her face but the front. She looks at us and we meet her gaze directly. As I mentioned above, the returned gaze is not isolated in the history of art, but most images do not look back in quite the manner of the sharecropper's wife. From the mid-nineteenth century on, from Manet's *Olympia* to Picasso's *Les Demoiselles d'Avignon,* women characterized as prostitutes stared brazenly out of paintings. They could be interpreted as proffering a sexual invitation that could also be read as a threat to class distinctions. As provocative sexual images, modern advertising photographs often make similar use of the gaze. Other images look out at the viewer commandingly, above all the expressionist paintings and images of Hitler mentioned above. Even Uncle Sam looked at the viewer, addressing him in the language of desire: "Uncle Sam Wants You." But it is not in any of these ways that the sharecropper's wife confronts us. We are not caught in the act. We are certainly not being offered a sexual invitation or mesmerized with a hypnotic stare.

To understand *Sharecropper's Wife* it is necessary to introduce a counterdiscourse that imputes to the gaze a more positive role in human relations. Indeed, to conceive of the gaze as a threat, an invitation, or a communication implies a similar conception of human relations in general. The assumption behind most of the notions of the gaze that I have discussed so far is that all human relations are power relations. To acknowledge someone visually is to make that person a part of oneself, a possession, as though the person whose image is seen enters another's body through the window of the eyes and ceases to lead a separate life. Those who wish to argue against this view must think of the gaze as a socially positive act or at least imagine a scenario within which it could conceivably have redeeming social value. Some such attempts, such as that by Norman Bryson in his essay "The Gaze in the Expanded Field," have sought to find an alternative to the notion of the subjugating look in other cultures. More frequently, however, theorists espouse some form of dialogism, in which a totalistic, hegemonic gaze is replaced by the mutual gaze of equality.

These conceptions of the gaze are inspired by Martin Buber's attempt to supplant the I-it relation with the I-thou relation or by the heteroglossia (multiple, equally valid speaking voices) espoused by Russian literary theorist Mikhail Bahktin, himself inspired by Buber. The returned gaze, according to theorists seeking to restate Bahktin's literary theories in visual terms, rescues the beheld's sense of self. If you can look back, you cannot be possessed by the gaze of the other. What is proposed is not a stare-down. It is a shared gaze. Rather than emphasizing the power of the gazing one to make the one gazed at into an object, this idea suggests responsibility toward the person looking back at one. The face, according to the philosopher Emmanuel Levinas, imparts a command: Thou shalt not kill. The eyes of the sharecropper's wife are meant to urge us into a relation. We are asked to refuse to participate, by neglect or indifference, or by subscription to oppressive political or economic systems, in the killing of this woman. We are asked to be her partner, to offer her "respect," which means literally a returned look. Her look is intended to empower her. A similar strategy informs many photographic documentaries of social advocacy. Interactive works, whether artistic or informational, are based on a similar premise that input by both sides is mutually supportive.

The possibilities of the gaze are not limited to representations of people. Buber himself exemplified the I-thou relation with reference to a tree. Theoretically any object could be animated, given a soul, by the sense of a gaze. The possibilities of the gaze thus extend to ornament on objects of the applied arts or architecture, to landscapes, and even to abstract art. Certain constructions of the gaze can be associated with artistic styles. For example, Alberti's monocular and inflexible one-point perspective is usually associated with unfavorable constructions of the gaze, since it seems to arrange the image for the benefit of one privileged viewer. Attempts to subvert perspective can then be interpreted as attempts to subvert the gaze. Indeed, it must be apparent by now that art is not the only phenomenon with which we exchange looks. Schools that require uniforms manipulate the gaze so that rich, poor, or eccentric children will not attract the eyes of their fellow students. Home furnishings may be designed or purchased with the aim of attracting the gaze or of fading into the background to give center stage to a priceless painting or carpet. What attracts the gaze in such situations is culturally determined, because the gaze and its manipulation can properly be understood as part of a language of gestures that change according to the attitudes of the one gesturing and the one viewing. A wall covered with intricate intertwined garlands would startle the eye in a modern(ist) glass-and-steel corporate headquarters, but fade into the background in a country estate of the mid-nineteenth century.

Similarly the empowering look of one generation does not necessarily carry over into the next. The gaze of the sharecropper's wife can be and has been interpreted as just as exploitative as that of a pinup girl. For it is her representation, not her person, who looks back. She can do nothing to confront the

feelings of superiority with which we face her. Although we cannot avoid her eyes while looking at her, we can relax in the assurance that those eyes that look at us cannot see. Like a folkloric image that has entered a museum, the eyes that look out from it can no longer protect it from the evil eye. Even more, the sharecropper's wife cannot answer us. Her silent image is not accompanied by speech. The text that accompanies it, for all that it asks for respect, is not her own, but that of the journalist James Agee.

In fact, to seek to represent all that is meant by the gaze with a pair of eyes is perhaps naive. The famous passage from Sartre's *Being and Nothingness* concerning the gaze does not represent it by the sight of a pair of eyes but by a sound that causes one to imagine a pair of eyes looking at one: a rustling of leaves, or steps in a corridor that give us that uneasy feeling that our own presence may be detected. Indeed, in Sartre's example we are detected while spying on someone else through a keyhole. The shame of being watched watching can be even more powerful when the imagined gaze is conveyed by words. For example, if I hear my neighbor's voice in the dark theater, his quizzical "are you crying?" wrests me from the doomed lovers on the screen and reminds me uncomfortably of the sentimentality of the story with which I had thoroughly identified. The felt gaze is more powerful than the seen one. If you see the eyes, Sartre writes, you cannot see the gaze. Sartre's extreme oculophobia may make his example seem ill suited to the sharecropper's wife. But Levinas, who, as mentioned above, was more favorably disposed toward the eyes, also attributed the power of the face to its possession of a voice. Whether evaluated positively or negatively, it is the sense of a human presence who is alive to our own presence that constitutes the encounter theorized as the gaze. Depiction of eyes looking out from the image is only one way to seek to achieve such a presence. For the present-day viewer of the sharecropper's wife's image, the presence sensed, if there is one, is most likely the powerful one of Walker Evans, whose sensibility permeates this and all other images in the book. If a gaze was shared, it was between Evans and the woman in the photograph. Perhaps she allowed him to photograph her gaze because she trusted him. Perhaps he abused her trust, perhaps not.

A work of art is to look at. Theories of the gaze attempt to address the consequences of that looking. Sometimes, however, it is important to look at ourselves (looking). We not only need to "see ourselves as others see us," we also need to see ourselves seeing one another. But to visualize looking is not as easy as it might appear. What might seem to be a purely visual theory, or a theory of pure vision, has become lost in the mysteries of human relationships.

SUGGESTED READINGS

Bryson, Norman. 1983. *Vision and Painting: The Logic of the Gaze.*
———. 1988. "The Gaze in the Expanded Field."

Debord, Guy. 1983. *The Society of the Spectacle*.

Derrida, Jacques. 1993. *Memoirs of the Blind: The Self-Portrait and Other Ruins*, translated by Pascale-Anne Brault and Michael Naas.

Foucault, Michel. 1977. "Panopticism."

Fried, Michael. 1967. "Art and Objecthood."

———. 1980. *Absorption and Theatricality: Painting and Beholder in the Age of Diderot*.

Jay, Martin. 1993. *Downcast Eyes: The Denigration of Vision in Twentieth-Century French Thought*.

Lacan, Jacques. 1977. "The Mirror Stage as Formative of the Function of the I."

———. 1978. "Of the Gaze as *Objet Petit a*."

Levinas, Emmanuel. 1969. "Ethics and the Face."

Mulvey, Laura. 1988. "Visual Pleasure and Narrative Cinema."

Olin, Margaret. 1989. "Forms of Respect: Alois Riegl's Concept of Attentiveness."

———. 1991. "'It Is Not Going to Be Easy to Look into Their Eyes': Privilege of Perception in *Let Us Now Praise Famous Men*."

Oudart, Jean-Pierre. 1977–78. "Cinema and Suture."

Rose, Jacqueline. 1986. *Sexuality in the Field of Vision*.

Silverman, Kaja. 1983. "Suture."

Žižek, Slavoj. 1991. *Looking Awry: An Introduction to Jacques Lacan through Popular Culture*.

Gender

Whitney Davis

The essential feature of gender in representation is not so much "difference," as we are often told, but "agreement." To focus on agreement, as I will do here, enables us to deal not only with the genders depicted *in* a representation (for example, images of women) and with their relations of difference (for example, depicted distinctions between men and women). It also enables us to deal with the gender *of* representation—what has come to be called its "gendered" aspect (whether or not it depicts a gender or gender relations) in both its substantive and its intersubjective dimensions. In a representation gendered "male," for example, any depictions of women and of things or environments are bound and governed by the gender with which they must all contextually agree, namely, the male inflection spread through the enunciation. As we will see, usually it is too simple to say that whereas the objects depicted in a painting might be "female," the painting itself, as a painting, is "male." But it is crucial to recognize that the gender(s) *in* representation cannot be understood without reference to the gender(s) *of* representation and vice versa. We could consider this matter historiographically. For example, what has sometimes been identified as a first generation of feminist art historians concerned with gender dealt largely with the gender *in* representation, that is, "difference," while a second generation tackled the gender *of* representation, that is, "agreement." Available reviews along these lines, however, need not be repeated here (see Tickner 1988; Gouma-Peterson and Mathews 1987).

The two perspectives, in fact, should be treated synthetically. We can start analytically either with the visual marking of gender "difference" or with its gender "agreement." Either way, eventually we must come to terms with the fact that a *system* of differences is organized in *classes* of agreements. In so-called queer formations in representation, agreement does obtain, as it must in all gender, between referent and inflection, but inflection itself may differ among discrete context-bound mentions of the same referent, among different referents, or among different "speakers" or viewers. These variable structures might be as prevalent as the supposedly standard or "essential" formations in which an invariant agreement obtains between *all* gendered referents and an inflection of *one* universalized gender. The paradigm of such standardization in patriarchal societies has been said to be the representation of men gendered (conventionally) male systematically linked to a set of *nonqueer* or standard differences therefrom (see especially Pollock 1988). For example, representations of women must accord with the male inflection, which identifies certain properties

of the female referent, adds a distinctive, invariant formal contribution to them (changing the form through a revision or elimination of what it could otherwise represent and which it *might* represent in certain contexts of subversion or resistance), and designates or engenders this new whole "female." (The point has often been put slightly differently: in socially standard formations, the gender of the depicted object is invariantly inflected by the universalized "male" gender of the viewing subject, while in "queer" formations the assumed gender of the subject is variable and hence the inflection of the object is variable; see chapter 16 on "gaze." A comprehensive typology of formally conceivable gender formations—standard and "queer"—would be neither interesting nor feasible. Historians study the relatively small number of formations, whether complementary or competing, that are or have been actual in a community—that have been socially mediated, legitimated, and circulated in specific historical situations (see Fuss 1991; Davis 1994).

These remarks might imply that the approach to gender is formal, that is, "grammatical" or structural. A strict grammatical model cannot be fully extended to visual representation, and I employ it here simply as a suggestive analogy. Nevertheless, a formal conception is fundamental and indispensable: gender in the Western tradition is a grammatical concept, despite its extension to the whole field of sociocultural life. A formal approach does not preclude other kinds of insight, especially those offered by poststructuralist thinking or accounts based on theories of the sign or of communication—for these usually require an embedded theory of the "linguistic" structure of experience. Needless to say, gender systems or structures are complex, multiple, overlapping, and unstable at any given time and place and through time and across place. A formal approach is valuable precisely because it can handle this variation.

The outstanding theoretical issue concerns the origin of gender systems or structures. Does the genderedness of representation arise from the marking of sex difference? Or does the marking of sex difference arise from the genderedness of representation? For many purposes, this chicken-and-egg question does not admit a direct historical answer. Historians confront gender systems that are up and running, a full-blown conventionality in, or ideology of, representation: because representation is gendered—because it is in wide "agreement" with the marking of sex difference—the representation of any gender must be in agreement with the gender of the form used *for* that representation. This cultural circuitry must be assumed for nearly all historical situations—though we may wish, of course, to make it the very object of historical analysis as well.

Still, formal description or historical inquiry will be directed by theoretical views. For example, some writers have supposed that once real differences between the sexes—whether these are universal or locally constructed—have been marked in representation, they will generate wide systematicity as a result of the social interest of the supposed difference, the prestige of the means of

representation, and the power of its authors and users. But some have supposed, equally, that the gender systematicity of representation—no single agent or group invents it and all subjects are influenced by it—directs the marking of "real" differences. Again, some writers have supposed that gender(ed) representation requires the basis of a material or so-called essential gender identity; supposedly one inflects a representation "male" or "female" *as* a male or female. Others note that any such identity must itself be gendered; it must be in full agreement with the engendering of any (self-)representation of oneself, male or female, as "male" or "female." (The productiveness of this debate for art history can be traced through the two excellent anthologies edited by Broude and Garrard [1982; 1992].) Still others feel no need to choose between these options. Identity and representation must interact but neither fully absorbs the other (for important but quite distinct contemporary accounts of this interaction see Benhabib 1992 and Butler 1990); although one inflects an enunciation "male" as a male, he is himself inflected "male"—"masculinized"—by the system of representation he has inherited and employed. Interesting and controversial as these questions are, however, all of them are really about the generative properties of representation as such and its relation to subjects, agents, or users—problems for the theory of representation (see chapter 1) not limited to gender(ed) representation. We need to focus on the specific form of gender and genderedness in and of representation. And in this regard, as implied already, "agreement" governs "difference." The model I outline here develops a synthesis of several recent and partly conflicting approaches to gender—the semiotic (e.g., de Lauretis 1987), the poststructural (e.g., Pollock 1988), the performative (e.g., Butler 1990), the agent-centered (e.g., Benhabib 1992), and the "queer-theoretical" (e.g,. Fuss 1991; Davis 1994). Throughout I stress the underlying continuity and necessity of the "grammatical" concept of gender but urge, for the purposes of critical, historical, and political analysis today, that "grammar" is only realized, and revised and resisted, in use, in endlessly varying activations by inflecting actors, however minimal or modest their independent authority might be.

* * *

Both "difference" and "agreement" are being used here in a technical sense. "Difference" refers to the distinction, even the opposition, of terms or elements (or their properties) in a field of representational possibilities. For example, in the earlier (or first) version of Edgar Degas's *Young Spartans,* ca. 1860 (Plate 17.1), now in the Art Institute of Chicago, the group of girls on the left is clearly distinguished from the group of boys on the right. Each has been organized as a tight cluster of figures, separated by a pathway in the foreground continuing the vertical bisection created by the pavilion in the background. In the later (and much reworked) version of the painting, ca. 1860–80 (Plate 17.2), now in the National Gallery in London, Degas removed the pathway

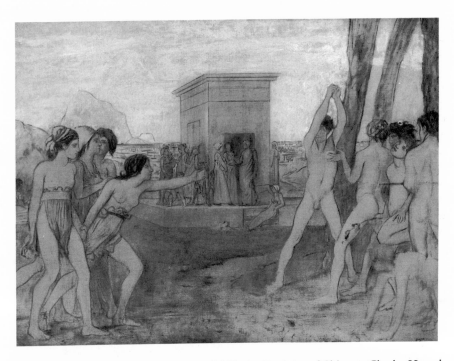

17.1 Edgar Degas, *Young Spartans,* ca. 1860. Art Institute of Chicago, Charles H. and Mary F. S. Worcester Collection, 1961.334. Photograph © 1994, The Art Institute of Chicago.

and pavilion. But he juxtaposed the two groups more dramatically by organizing gestures and glances to suggest a relay of responses proceeding outward from the same-sex clusterings toward a future, but quite ambiguous, amalgamation of the groups. By repeating the shape of the houses in the town in the distance, the pavilion in the background of the Chicago painting represents the ideal form of Spartan society. In front of it, a stately lawgiver (presumably Lycurgus) converses quietly with two sturdy, dignified Spartan matrons. This group indicates the social-psychic goal toward which the girls and boys should ideally develop—in the full history projected by the pictorial narrative—along the path initiated by their interaction in the foreground. But the wide space between foreground and background (in the London canvas, Degas clarified it considerably) shows that the boys and girls have some way to go. The girls are not (yet) matrons (though Degas, in an early study, did treat the gesturing girl as an older woman) and the boys are not (yet) Lycurgus. Thus there are two major orders of difference clearly marked in the composition—between Spartan girls and boys and between Spartan youth and adulthood. The visual prominence of the pictorial divisions suggests that the painting, whatever its specific

223

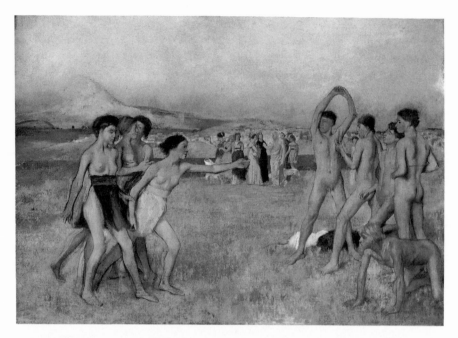

17.2 Edgar Degas, *Young Spartans,* ca. 1860–80. National Gallery, London.

theme, addresses the division of the sexes and their relations both because of and despite it—a narrative *of* gender difference relayed by the particular story of contest and courtship and, more important, of their psychic and social definition in a "Spartan" world known for its unique erotic and legal norms.

To explore this latter point, however, we must go well beyond the differences marked in the division of left and right and foreground and background zones. In both versions of the painting, many subtle similarities obtain between the girls' and boys' poses, gestures, and glances. These associations do not simply reproduce the basic compositional distinctions. In fact, it appears that Degas partly aims to suggest *less* difference between the sexes than might have been assumed by viewers familiar, for example, with the conventions of previous neoclassical history painting. The athletic Spartan girls actively engage the boys from a position of comparative strength, unlike the modest, helpless women in paintings like J.-L. David's *Oath of the Horatii*. The girls' half-nakedness and short hair differentiate them from the mature, married, childbearing Spartan women in the background and partly assimilate them—in body, in status, in erotic and gender identity, agency, and community—*to* the boys. Indeed, the painting implies—one of its strongest though certainly not exclusive pictorial effects—that Spartan girls are *virtual* boys until they become "women" (even granting that a Spartan matron was unlike her sequestered Athenian counter-

part). At the same time, of course, if the boys are to assume Lycurgus's position they must control the girls. But Degas depicts several boys to be virtually unsexed or as if they are at least partly "girls"—my first approximation of the elusive pictorial point—until they become "men." Distinct from the background domain of adulthood, both girls and boys are, in turn, inflected by youth. This status, Degas's sources recounted, permits same-sex eroticism, as the couplings in the centers of the two clusters imply, and even a kind of animality or savagery, those open displays of desire, strength, or fear—suggested by the centermost girl and boy and by the recoiling girl and crouching boy in the corners of the composition—which Spartan community set out both to encourage and ultimately to sublimate.

Beyond "difference," then, "agreement" (such as the grammatical agreement of a noun with its gender, number, and case) refers to the complex systematicities introduced into representation—not limited to the representation *of* any difference—by the fact that a difference is marked. The mere marking of sexual difference as such is of little inherent interest: languages often need to indicate the males and females of species. Such reference can be achieved, in fact, as much by the agreement of other elements as by direct designation. The most obvious visual signs of human sexual difference, for example, need not be strongly marked: although Degas indicates the genitals of two boys and the breasts of three girls, the young people's hair, faces, and slim, long-legged bodies, equally important in the pictorial metaphorics, are very similar in both groups. Sex characteristics can even be exchanged or wholly eliminated without confusing the reference. In *Young Spartans,* the girl cupping another's breast seems to lack developed breasts herself; she has even been seen by some commentators as a boy. Four boys have essentially unsexed forms, since Degas provides no direct sign of their sex. But clearly we are not meant to see hermaphroditic or genderless bodies here. Instead, the pictorial notation inflects the designation of male sex—established by the visual agreements between the body of the boy frontally facing us, showing his prominent if somewhat indistinct genitals, and the "unsexed" bodies of the others beside and echoing his outline—with the signs of immaturity, variability, transformation, and uncertainty.

In general, in fact, the mere marking of sexual difference cannot be observed outside of an extended system of explicit or implicit formal and thematic agreements. In the case of several of the girls and boys in Degas's painting, we cannot really identify and attribute sex outside the whole system of gender agreement. (As a matter of fact, Degas used a young male model to make studies for figures of both sexes.) Part of this system is internal to the painting itself, such as the relations of compositional placement and formal resemblance I have already noted. The remaining, perhaps more important, part is external; elements of the painting "agree" with the gender of *other* representations. Commentators have rightly noted that the vigorously gesturing girl echoes David's

brothers Horatii taking their oath, an allusion contributing to her inflection as virtually "male." The rightmost boy with back turned echoes familiar images of classical male athletes (in both their Greco-Roman and Renaissance-neoclassical replication). The boy with upturned face seems to echo images of Saint Sebastian as well as quotes, oddly, from Greco-Roman theatricals and other sources for his peculiar cry, delighted and pained. Such external agreements, like internal ones, do not always run in the same direction. A Polykleitan athlete and a Saint Sebastian (in the tradition of Antonio Bazzi or Guido Reni) have somewhat diverging connotations—more and less masculine, less and more homoerotic—which Degas enfolds in engendering the cluster of boys. One's sense that thematically the painting fundamentally narrates an episode in and a problem for a homoerotically organized male community is underscored by the way in which the perspective projection of the pavilion (it initially appears to be mistakenly drawn) constructs an indefinitely extended "male" world of undepicted but presumably all-male interactions, within which the viewer's own position is stabilized, off to the right of the scene and beyond the right edge of the painting; what the painting actually depicts, then, is literally at the edge of what its intersubjective universe really contains. (We could say, alternatively, that the viewer's points of view as constructed by the painting's perspective and by the painting's bilateral symmetry are disjunct; the viewer "exits" his right-hand position to occupy the painter's oblique station—literally enacting, in other words, the "pull" exerted by the feminine demand, his very doubt about which is figured in his [her?] personification in the leftmost "female" actor.) In this and other regards, the gender of the painting as a whole is slightly "queer," although what this could imply about Degas's and his viewers' gender identity or position, at least in relation to this painting and its depicted objects, would need our further analysis.

To repeat, the marking of gender difference depends on and can generate an extensive and complex systematicity through agreement. In this way, elements of the representation that do *not* depict a sex, such as nonhuman or inanimate things, can be gendered. These forms can, in turn, become engendering—for they can attract and promote the agreement of still further elements. In *Young Spartans,* the girls pictorially absorb the permanence and solidity of the mountains, which reproduce the horizontal lines and masses of their breasts; the springing sap of the plane trees imparts growth to the nubile boys. Such agreements—the relation of inflection which is partly an inflection of gender difference—have pictorial consequences, both formal and thematic. As a matter of fact, Degas probably began *Young Spartans,* at least in part, by conjoining female figure studies and a mountainous landscape copied from Leonardo. The association was preserved in the London canvas (Plate 17.2): among other changes, it replaces the pavilion with a hill—probably intended to depict the famous place above the town of Sparta where mothers destroyed their weak or sickly babies.

When the mere marking of sexual difference as such is governed by the agreements of gender—the systematicity required of any such marking—then the gendering of sexual difference is complete. It has been tempting to suppose that systems of gender agreement must have arisen historically from an originary linguistic distinction for the sexes and their different properties, an idea favored by romantic theorists of the origin of grammatical gender, or even out of real differences between male and female behavior (for details, see Baron 1986). But quite apart from the difficulty of analyzing a process of "coding" supposed to predate the point at which we encounter an operating code, the converse is more likely. An operating system of gender agreements ensures that the marking of sex difference, and of *many other kinds of difference* organized according to the same system, proceeds in a well-defined way. The social fact of a gender code does not preclude its variation and transformation. Degas's *Young Spartans,* for example, draws on gender conventions with which various groupings, placements, and renditions in the painting must agree, but it revised them by working out new—though perhaps ambiguous or partly illegible—species of agreement.

<p style="text-align:center">✳ ✳ ✳</p>

The system of gender agreement in representation is regulated by several principles. In *De lingua latina,* Varro supposed that all doves had once been designated by the feminine noun *columba,* but when they became domesticated, the analogical masculine form *columbus* was invented to designate males of the species. By contrast, the noun *corvus,* "raven," did not receive separate male and female forms because ravens never attracted sufficient human interest for the sex difference to matter—unlike doves nesting about the house or farm, or the *equus,* "horse," and *equa,* "mare," whose differences, real or imagined, had all kinds of biological, economic, and social relevance in Roman affairs.

Gender conventions—the *-us* and *-a* of Latin, for example—might be innocuous in themselves or even, as Varro implied, necessary and helpful. But they create many special problems for the ordering of words in a sentence. Latin speakers needed to use expressions in which an adjective must agree with a *noun phrase* containing two nouns whose genders differ, such as *equus* and *equa.* In *Rex & Regina beati,* "the king and queen are blessed," *beati* agrees in number with the noun pair but its gender (at least notionally) must be masculine—for, as William Lily explained in 1567, "the Masculine gendre is more worthy than the Feminine." As Thomas Wilson had put it in his *Arte of Rhetorique* (1553), referring to a comparable problem in English word order:

> Some will set the carte before the horse, as thus. My mother and my father are both at home, euen as thoughe the good man of the house ware no breaches, or that the graye Mare were the better Horse. And what thoughe it often so happeneth (God wotte the more pitye) yet in speakinge at the leaste, let vs keep a natural order, and set the man before the woman for maners sake.

Or, as Wilson summed up, "the worthier is preferred, and sette before, as a man is sette before a woman." Any other order, as early theorists put it, would be "preposterous" or "queer." What should be behind or below had been put before or above.

The fact of gender decorum—the system of reciprocally defined propriety and preposterousness in representation—follows from the way a system of representation organizes agreements around sexual designations and differences according to three interacting (but analytically distinct) principles: (a) social salience (e.g., *corvus,* but *columbus/columba*); (b) social distinction (e.g., *corvus* versus *columbus/columba;* or *equus* versus *equa*); (c) social hierarchy (e.g., *rex* before *regina*). A pure application of the second principle—distinction—would suffice for a mere statement of difference between males and females (or between gendered and ungendered entities). But such pure designation is never achieved even in the most pristine science. The mutual implication of the first and third principles—inherent, as Varro and others recognized, in the very extension of agreement—ensures that mere sex difference is always marked as a function of human interests (*this* sex difference rather than *some other* or *no* difference should be observed) and values (a sex difference should be observed in *this* rather than *some other* or *no* order). Hence grammatical gender is clearly a matter of convention and ideology, although much remains to be learned about the social and historical emergence of such formations of human consciousness. It is sometimes said, for example, that gender is "socially constructed" (for typical but sophisticated constructionist analysis in art history, see Adler and Pointon 1993). But although it is true that conventions emerge in social relations, they need not be designed by agents aiming at certain ends. This is a problem in the theory of culture or convention not limited to the conventions of gender.

The most important feature of gender, for my purposes, is an emergent fourth principle—(d) "government and binding" (apologies to Chomsky). Mutual implication of the principles of social interest, distinction, and hierarchy in the designation of sex difference entails that the whole system of representation will be bound and governed by any designation of sex difference: it "spreads through" the system due to the fact that (all) elements of the system ideally must possess a formal concord with (all) others, whether or not they designate sex difference or gender in themselves. (I will return to ambiguity and variation.) The defining representational outcome of gender, then, is neither the conventionality of particular sex-difference designations nor the fact that such designations derive from, and embed, particular interests, distinctions, and hierarchies. It is the wider, deeper fact that *whole classes of agreements* in the system of representation reflect—indeed help to reproduce—a sex-difference inflection, setting up relations of ideal concord between large numbers of elements, typed Gender A, but excluding many others with which no concord can properly obtain, typed Genders B, C, etc. The emergence of agreement classes might

"masculinize" or "feminize" representational elements if they spread "male" and "female" genders through the system. But as any developed concept of agreement classes will imply, gender is not limited to masculinization and feminization. The production of agreement classes, determined by social interest, distinction, and hierarchy and governing and binding the system of representation, is the essential observation of both traditional and recent gender theory.

<p style="text-align:center">* * *</p>

As a matter of descriptive and historical *method*, however, we must work the other way around. To identify agreement classes in the system and their reproduction in a particular instance of representation—relations of ideal concord to which elements must conform if and when they absorb the gender of the governing inflections—is to identify the emergent gender(ing), however complex, of the representation or of parts of it.

Rigorous application of this method, although it is still uncommon, will lead to unexpected results. As queer theory urges, agreements between elements can be specified at many scales or in many ways and need not have been *exclusively* governing or *comprehensively* binding in any particular instance. Indeed, in the system of representation there may be more agreement classes than superficial observation might suggest, such as the nine "genders" sometimes identified in standard English grammar. The small number of sex differences actually designated in a society's lexicon will probably be carried through all the agreement classes in the system of representation. But in the full conventional and ideological operation of the system, *emergent* agreement classes might strongly mark *virtual* genders, however notional or novel, within these gross groupings or wholly cutting across them. In order to remain faithful to this possibility, current work in the cultural history of gender—attending to phenomena like "cross-dressing" or "homosexuality" (see Fuss 1991; Davis 1994)—strongly supports the idea that research should track the gender-agreement classes of representation wherever they lead.

This method enables us to consider super- and subgenders or, more exactly, gender differentiation through sub- and superagreement and especially so-called sexuality, which we can define as the *sexual or erotic* interest, distinction, hierarchy, and binding of gender agreements. ("Sexuality," then, is both a principle of and emergent in gender, a form of its psychic and social salience and articulation.) For example, it might be useful to conceive male "homosexuality" and male "heterosexuality"—as articulated by a system of representation like Degas's—to be produced by discrete subgenders of the supergender "male." In other cases, male "homosexuality" and "femininity," as they are articulated in representational agreements, might accord with the supergender "female." In *Young Spartans,* as we have seen, girls and boys partly accord with the agreement class of the other gender as they are each marked in the image. As a whole, in fact, Degas's painting develops sets of agreements, distinctive con-

cords among its elements and with outside types, which are not wholly compatible with conventional masculinization *or* feminization. A more exact definition depends on investigating Degas's "misogyny," "feminism," "fetishism," "pedophilia," and "homoeroticism," among other things, as they were brought to and articulated by his representational practice. In general it would be too simple to find *Young Spartans*—that is, the painting, not its objects—to be gendered conventionally "male" because it depicts the Spartan girls, despite their masculinization, to be oriented toward stolid child rearing and the boys, despite their semi-neuteredness, to be oriented toward fatherly lawmaking. In 1860, of course, Degas could hardly have engendered the opposite, a "female" painting. (Substantive "feminism" was more likely on Degas's part ca. 1880, when the London canvas has been thought to engage, if not endorse, contemporary feminist ideas.) But the standard "male" gender(ing) of his painting was *sub*gendered homoerotically, permissible in nineteenth-century Euro-American society within certain bounds.

As Degas's sources recounted, the boys belonged to the Spartan *syssitia,* a homosexually organized communal band that prepared them for war and leadership. The conventional "male" gender of Degas's boys has been inflected, it seems, by this reimagined, sexualized gender (or "sexuality"). Apart from Degas's depiction of the slightly sadomasochistic eroticism of the boys' society, his early work for the painting included a study for a boys' footrace and (possibly) boxing match and an extraordinarily sexualized study for the boy on his hands and knees (losers in the Spartan boys' contests, it was thought, owed sexual gratification to the winners). In turn, these elements agree with the rest of the painting, spreading a *homoeroticized* masculinization to the girls. It is not incompatible to note, of course, that the *girls'* erotic bonding is transferred to the boys' group, which suppresses its overt marking. In the conventions of Degas's culture, partial "feminization" of the youthful male form could designate its erotic desirability so long as sexual arousal was not depicted (indeed, the feminizing inflection or emasculation prevented it), for such marking of the object would identify an improper pederastic interest of the observing subject. In the London painting (Plate 17.2), these homoerotic subinflections of male and female were *re*inflected more conventionally male and female; Degas reorganized the gestures and glances of the boys and reduced their number to help establish cross-sex rather than same-sex interactions. But the persistence of both "hidden" and "sexless" figures and of same-sex pairs in the London canvas suggest that for Degas the Chicago painting (Plate 17.1) had created a substantial inflection of conventional masculinity and femininity. In the Chicago painting, this subagreement was so extensive that the standard superagreements were destabilized. The painting could not be finished; alternatively, its thin handling and even, muted tone served as the best means of achieving overall binding across the whole troubled field.

As these comments imply, a particular "gender" can be seen as an *analytic*

individuation of gendering, the continuous social constitution, interrelation, and transformation of agreement classes tracking—or reflecting and reproducing—the designation of sexual difference spread by inflection through a system of representation. (The analyst's individuation need not conform to what he or she takes to have been a society's conventional representation *of* gender. Whether or not we adopt the society's own point of view depends on our critical purposes, a problem in general anthropology not limited to the anthropology of gender.) An agreement class can be constituted as gendered from within a representation possessing internal relations of concord among its elements; it will also exhibit partial concord with other agreement classes in other representations. Whether or not we describe these relations as a "gender," or sub- or supergendering, is a secondary issue. (We should acknowledge, however, that the logical implication of one strand within queer theory—there are as many "real" genders as there are virtual agreement classes in the inflection of representation—might be at odds with one strand within feminism, which would see the gender[ing] male/female to be both basic and overarching, to be, as it were, *the* causally primary supergender[ing] determining subgenderings "in the last instance.")

Despite its formal cast, this approach does not "deconstruct" gender or deny the determining role of the sexual and social interests, distinctions, and hierarchies it realizes. In fact, tracking sub- and superclasses of gender agreements enables us to come to terms with the psychic and social reality of gender difference—precisely because gender difference is constituted in the system of agreement classes. A "child," an "androgyne," or a "fetishist"—or a Spartan boy or girl—might not belong to a conventional gender. To force a classification could be to overlook a particularized sexual difference (or lack of difference) marked in and by representation.

* * *

To insist that gendering is the constitution, interrelation, and transformation of agreement classes is not only to observe how social interests, distinctions, and hierarchies in the designation of sex difference are carried through representation. It is also to observe how social interests in the designation of other real or imagined species of difference in the world are carried *into* the designation of sex difference and its agreement classes. Agreement is two-way. Here again we leave the strictly grammatical approach. Indeed, this is the crucial difference between true grammatical gender and gender(ing) in visual representation: unlike speech, which can attach a "pure" gender inflection like the *-us* or *-a* of Latin, it is impossible depictively to inflect gender *alone*. Because of the density of pictorial notation (see chapter 1 of this volume on "representation"), one must simultaneously depict a body's age, race, state of health, and so on. Through agreement, these signs actually become constitutive *in* visual gender(ing). In *Young Spartans,* the depiction of boys and girls in the left/right

axis is strongly masculinized, but this gendering must agree with the marking of youthfulness in the foreground/background axis. This need for two-way concord constrains Degas's ability to present secondary sex characteristics, especially of the pubescent boys. Similarly, questions about homoeroticism—is it a function of girls' and boys' Spartan *gender,* or of their youth, or of both?—remain pictorially unresolved.

Some perturbations in gender may be the result of conflict *between* gender-agreement classes. Others may be the result of conflict between gender-agreement classes and *other* agreement classes, bespeaking the simple difficulty of extending concord over a wide referential field or the direct clash of distinct social interests. In general, two-way concord can be difficult to achieve; probably it is unnecessary. It might require wholesale inflection of an incoming referent as conventionally gendered, preserving the gender-agreement class; partial revision of the existing gender in terms of the incoming referent; or partial ejection of the incoming referent or the existing gender. Most likely, when the interests, distinctions, and hierarchies attached to an incoming referent are at odds with an existing gender convention, the system of representation must tolerate considerable ambiguity. Both contest and clarification can result in consolidating or splitting genders, calibrating the social interest, distinction, and hierarchy of gender against other differences gender necessarily encompasses when it organizes a system of visual representation. In current theory, such differences include the major sociological categories of class or status, ethnicity or race, religion, and nationality, but there are many others, of course, that could be implicated in a particular gender(ing).

* * *

Finally, gender agreements in representation must be *realized* by the makers and users of representation—for example, by painters and viewers. In fact, agreements obtain not only between the formal and thematic elements of gendered representation, and between gender and other classes of formal and thematic concords, but also between representational inflection as such and the inflection introduced by the user. Although the user must be largely in accord with the agreements of representation—and thus he or she can be said to be engendered by representation—a representation is always marked to some degree by its agreement with the user's own inflections. When this emphasis is strong enough, a socially salient gendering—such as the "Queen's English" or "camp"—can be constituted along its axis. Although the substantive dimensions of representational inflections are the most accessible to stylistic and iconographic analysis, recent gender theory has explored the pragmatic or "performative" dimension—especially the possibility that transformative possibilities can sometimes lie in *non*agreement between the inflections *in* representation and the user's inflection *of* them.

Shifting analytic focus from the formal structure of agreement classes to the

active realization of inflection—in theory, of course, they are inseparable—requires art historians to examine multiple situations of painting and beholding as scenes of gender(ing). In fact, the material persistence of visual representations through time and space, compared to the physical ephemerality of speech acts, probably entails that they pass historically through multiple genderings and thus that gender in the domain of visual representation is extremely labile. In the end it makes little sense to speak of the gender *in* or even *of* a visual representation without determining how that representation subsists in ideal, partial, or negligible concord with its many viewers, many of whom have had numerous and variable encounters with the work. If the theoretical essence of gender is agreement, the essence of the study of gender is the history of its disagreeability.

SUGGESTED READINGS

Adler, Kathleen, and Marcia Pointon, eds. 1993. *The Body Imaged: The Human Form and Visual Culture since the Renaissance.*

Baron, Dennis. 1986. *Grammar and Gender.*

Benhabib, Seyla. 1992. *Situating the Self: Gender, Community and Postmodernism in Contemporary Ethics.*

Broude, Norma, and Mary D. Garrard, eds. 1982. *Feminism and Art History: Questioning the Litany.*

———, eds. 1992. *The Expanding Discourse: Feminism and Art History.*

Butler, Judith. 1990. *Gender Trouble: Feminism and the Subversion of Identity.*

Davis, Whitney, ed. 1994. *Gay and Lesbian Studies in Art History.*

Fuss, Diana, ed. 1991. *Inside/Out: Lesbian Theories, Gay Theories.*

Gouma-Peterson, Thalia, and Patricia Mathews. 1987. "The Feminist Critique of Art History."

Lauretis, Teresa de. 1987. *Technologies of Gender.*

Pollock, Griselda. 1988. *Vision and Difference: Femininity, Feminism, and the Histories of Art.*

Tickner, Lisa. 1988. "Feminism, Art History, and Sexual Difference."

SOCIETIES

Modes of Production

Terry Smith

> A specter haunts the revolutionary imagination: the phantom of production. Everywhere it sustains an unbridled romanticism of productivity. The critical theory of the *mode* of production does not touch the *principle* of production. All the concepts it articulates describe only the dialectical and historical genealogy of the *contents* of production, leaving production as a *form* intact. This form re-emerges, idealized, behind the critique of the capitalist mode of production.

I can still recall the frisson of reading, in 1980, these words, the opening flourish of Jean Baudrillard's *The Mirror of Production* (1975, 17). The economic base an "unbridled romanticism"? *Only* the dialectic, *only* historical materialism? What does this mean? What could be more basic than these? And *only* content, as if form were not its consequence, as if form were somehow equally, indeed more, powerful, reappearing as an ideality of some unfathomable kind, one which effected productivity itself! As I read on, this initial shock was followed by deepening horror, interlaced with flashing glimpses that *My God! he is half-right,* then slowly—enormous reluctance laced with astonishing speed—the deafening crashes, lurching motions, and greased lightning of a paradigm shifting.

What was at stake here? Why was the idea of production so central to critical, radical—or, as Baudrillard could still put it in the aftermath of May 1968—"revolutionary" thought? More specifically, what were the implications of this profound troubling of a key term in critical, radical, "revolutionary" art history, in—as we came to call it after T. J. Clark (1974)—the social history of art? These will be the concerns of this essay.

In the most general, dictionary sense, to produce is to give rise to, to bring into being, to effect, cause, or make something—an action, condition, or object. Two slightly less general meanings immediately follow: first, to bring a thing into existence from its raw materials or elements, or as the result of a process; second, to bring something or someone into view, to present, to exhibit. A production, then, is the action of producing, bringing forth, making, or causing. For example, the natural processes of mineral formation or the mechanical processes of product manufacture. But a production is *also* that which is produced to view, a presentation or exhibit, the product as seen, as ready for use. A play, for example, a shop-front display, a piece of evidence, an art exhibition, or a spectacle. In what follows I will show that, while Marxist art historians

traditionally approached art making and its social circulation mostly in terms of the first strand of usage, the social historians of art added elements of the second. Baudrillard's act of troubling was to try to shift the entire focus to the second, to see all production as occurring within a system of signs. We might call this the "Learning to Love Las Vegas" move: conjecturing the world as consisting of concentrated intensities of appearances occurring arbitrarily in empty deserts. For some postmodernists, this move excavates the very possibility of grounding altogether: reality disappears, only simulations remain. I will argue, against this, that both kinds of production have always been in existence and that while their internal economy varies enormously, one kind does not obliterate the other, even in postmodernity.

Marx, or The Production of Everything

All the operations of nature and art are reducible to, and really consist of *transmutations*,—of changes of form and of place. By production, in the science of Political Economy, we are not to understand the production of matter, for that is the exclusive attribute of Omnipotence, but the production of *utility*, and consequently of exchangeable value, by appropriating and modifying matter already in existence, so as to satisfy our wants, and to contribute to our enjoyment. The labour which is thus employed is the only source of wealth.

This is not Karl Marx, but one of his predecessors, John Ramsey McCulloch (1825, 61). Marx went further, insisting on naming those who populated the key points in this abstract system, emphasizing the actuality of the distribution of power in the everyday life of societies organized around the system, analyzing the technicalities of how the whole system worked, and tying this description to a historical narrative of revolutionary change. His use of the concept "mode of production" occurs as part of his overall theory, to other elements of which it is indissolubly tied. The most succinct formulation occurs in the preface to his 1859 *A Contribution to the Critique of Political Economy*. Describing his peregrinations between Germany, Paris, and Brussels as an activist journalist and intellectual fifteen years earlier, he retails how his efforts to use the new science of political economy as the basis for a critique of Hegel's social philosophy led him to his key hypothesis, the "guiding thread for my studies":

In the social production of their life, men enter into definite relations that are indispensable and independent of their will, relations of production which correspond to a definite stage in the development of their material productive forces. The sum total of these relations of production constitutes the economic structure of society, the real foundation, on which rise a legal and political superstructure and to which correspond definite forms of social consciousness. The mode of production of material life conditions the social, political and intellectual life processes in general. It is not the consciousness of

men that determines their being, but, on the contrary, their social
being that determines their consciousness. (1859, 181)

This famous passage has occasioned a mountain of comment. It projects an
almost geometric figure of what it is to be in the world of others. A configuring
of all human possibility into a matrixlike shape, at once open-ended, self-
generating, and utterly reductive. These words reveal plainly how embedded
within Marx's entire outlook were notions of production—indeed, everything
is production of one kind or another. Yet this is not a flat figure. One of
the two basic senses of production—process—is cast as the root cause of the
other—presentation. Life itself is a process of constantly creating and main-
taining relationships with others, that is, of producing one's life just in produc-
ing these relationships. These relationships are the basis of social interaction,
they are the economic foundations of a society. They constitute material life,
and they condition the life of the mind, including the production of works of
art, according to the historically possible mode. Being is social, and conscious-
ness is a consequence of the social production of self.

The process of producing oneself by exchanging representations with those
of others is, as Sahlins (1976) emphasized, a symbolic system. Production is
always cultural. But it is not, on Marx's model, a free-for-all. The scope of these
relationships is limited by historical possibility, by the kinds of production made
possible through the available means and in the relevant conditions. Looking
at these structures historically, Marx thought that, broadly speaking, "Asiatic,
ancient, feudal, and modern bourgeois modes of production can be designated
as progressive epochs in the economic formation of society" (1859, 182). These
were developments in social organization which, while internally antagonistic,
produced changes which led to human progress; whereas primitive societies,
by this kind of definition, did not progress. He set out the features of each
of these modes in other studies, particularly the monumental *Capital* (1867).
Capitalist production differed in mode from the feudal in that it consisted not
of dependent people working in return for services and payments in kind but
of two classes of "free individuals," those with labor-power to sell and those
who own the "means of production and subsistence." The core social relation-
ship is the meeting of these two classes "in the marketplace" in order to produce
commodities which would circulate between them to the profit of the latter
(1867a:1, passim, e.g., 167).

There is a distinction here between the specificity of "means" and the epochal
generality of "mode" which is often elided. The means of production (in capital-
ism, machines, factories, systems of transport, and the like) are not merely the
formal instruments enabling things to be made. Ownership of them is crucial
because it enables control of the social relations of production. They are there-
fore a prime site of social aspiration and political contestation. All this happens
within each of the broad modes, but is differently configured. Marx argued that
each mode carried within it the structural seeds of its own destruction. The

239

contemporary bourgeois mode, he believed, would be the last of these formations in the long "prehistory of human society" itself. Having overcome its internal contradictions, history would begin with a communist society (1859, 182).[1]

Where does art fit into all this? The general place of artworks as commodities within capitalism is obvious enough, although they have often been seen, mystifyingly, as embodying a special kind of value transcending those which Marx distinguished ("value," "use-value," "exchange-value," and "surplus value") (1867a:1, chs. 1–9). More relevant to the concerns of this essay is to think of art as a productive activity in which actual materials are transformed in order to communicate, or invite the consumption of, immaterialities such as images, feelings, and ideas. In the *Critique* Marx noted that during epochs of social revolution, when "the material productive forces of a society come into conflict with the existing relations of production," the economic foundation transforms "the entire immense superstructure." He warned that this transformation does not occur as an automatic replication from one level to another: the "legal, political, religious, aesthetic or philosophic—in short, ideological forms in which men become conscious of this conflict and fight it out" are no more likely to provide accurate readings of what is happening than is our opinion of ourselves likely to be a true judgment of our real qualities (1859, 181–82). Ideas, representations, media attitudes, artistic priorities, and strategies—all these are transformed when the basic social relationships are changed by upheaval of the economic forces. But this superstructural activity, particularly that which is about these transformations, does not necessarily picture them truly. Indeed, given the general dependence of such practices on material determination, and their tendency to mystification, they would be unlikely to do so.

However generously one reads these passages, however often one goes back to more flexible thinking in Marx's earlier writings and his occasional comments on art, it is obvious where the prior agency lies. This just is, inescapably, systemic determination. Men could, Marx also believed, make their own history. But only at propitious moments, themselves historically determined. What of revolutionary thought—and, by extension, innovatory art? This evidently occurred, but was exceptional: for example, Marx himself and Engels, along with a few other activist thinkers. They represented a body of individuals, or groups, enabled, in particular circumstances, to arrive through critical analysis at scientifically true understandings of particular situations and thus, in the course of their analyses, were able to generate unmediated representations of elements of those situations.

This has always seemed chancy, to say nothing of being subject to measurement and pronouncement by currently ascendant party people. There is a long

1. One of Francis Fukuyama's silly but telling errors in *The End of History and the Last Man* is to conflate Hegel and Marx as positing the same kind of closed "end of history" (1992, xii).

history of resistance by radical artists and thinkers to the idea of economic determination in matters aesthetic and philosophic. Two which had great impact in the 1970s were Raymond Williams's argument that the key elements, base and the superstructure, were exchangeable—were, indeed, in constant traffic across social spaces which should not be seen as a two-level, vertical hierarchy (1977), and Louis Althusser's insistence on the relative autonomy and revolutionary potential of theoretical work, ceding determination to "the economic" only in the last, not the first, instance (1971). Paralleling this, in the writings of Foucault (1986), Kristeva (1980), and Derrida (1987) about art, poetry, painting, and, indeed, *écriture* or writing as such, there emerged a strong defense of *poesis,* of the fundamentality of artistic invention, of the poetic imagination, as a source of transformation as valid and as powerful as anything coming from the structures or from the revolutionary activities of the people. There was much debate among artists and critics during the later 1960s and throughout the 1970s about the necessity and the nature of interventionist art practice, much trying out of different communicative forms, much searching for precedents, and above all a lot of fast learning as new contexts, and new audiences, set new demands. None of this should be underestimated in thinking about what happened to art history at that moment: for many of us it was very close indeed to cultural practice and has remained so (e.g., Smith 1975).

At times these debates broke down into complex splits between those seen as materialists and those seen as idealists, pragmatists and fantasists, or, more programmatically, the realists and the modernists, the politically engaged and the conceptualists, those still active in the art world and those who had deserted it for community cultural work—to say nothing of the infinite factions within each of these and other similar groupings. The binaries presumed here, and the argument over just which kind of historical necessity was doing the determining these days, were profoundly, and—by and large—usefully, questioned by feminism and poststructuralism. What happened to ideas of production, so central to the Marxist project in every sphere? Did they disappear into the rubbish bin of history, the embarrassing "early works" oblivion of neo–con artists' careers, and the unused slide drawers of the history of art history?

The short answer is no—production and mode remained relevant, but the terms were reversed and then set in relay between each other.

The Art of Work, or The Picturing of Production

Gustave Courbet painted *The Stonebreakers* in November 1849 using as models two laborers from Maisières whom he invited back to his studio. He wrote to Wey: "It is rare to encounter the most complete expression of wretchedness, so all at once a picture came to me" (Clark 1973, 79). *The Stonebreakers* is, as T. J. Clark notes, at once a particular scene and an image of a general condition. Clark goes on to describe it in terms which go to the heart of art which, while

241

picturing actual social production, is itself, evidently, a form of production, a kind of work, and, furthermore, in this case, an act of critical production.

> There are two figures set against the dark green of the hillside, and their physical presence has been set down with the utmost care. Look at the leather strap across the young boy's back and shoulder, and the puckered cloth of his shirt where the strap is pulled tight by his effort: the way these details register the substance of the body beneath them. Or the same effect, produced as the old man's waistcoat rides up his back; or the thick, resistant folds of his trousers at knee and thigh. This is painting whose subject is the material weight of things, the pressure of a bending back or the quarter-inch thickness of coarse cloth. Not the back's posture or the form of the cloth in movement, but the back itself and the cloth in its own right. Pressure, thickness, gravity: these are the words which come to mind, and which describe *The Stonebreakers* best. (1973, 79)

This takes Courbet at his word. Addressing a group of students in 1861 he said:

> I also believe that painting is an essentially CONCRETE art and can only consist of the representation of REAL and EXISTING objects. It is a completely physical language that has as words all visible objects, and an ABSTRACT object, invisible and non-existent, is not part of painting's domain. Imagination in art consists in knowing how to find the most complete expression of an existing object, but never in imagining or in creating the object itself. (Holt 1966, 349)

The intensity of both texts—not their exact words, but their rhetorical force—marks what is at stake. Nothing less than mimesis itself, the very possibility of a representation becoming, in some unsayable but real sense, that which it represents. Not a trompe l'oeil, a piece of trickery, a mis-seeing, a mistake correctable by a demonstration that it is false. Rather, a picturing that comes to stand for its subject, becoming it, perhaps more powerfully in some senses than the thing itself, obscuring it, even obliterating it—at least for one moment of concentrated viewing. Mimesis, as Michael Taussig has recently reminded us, is more than just an abstract category of representation through picturelike simulation of a referent. It always conjures its other, that is, alterity in general (1993; see also Benjamin 1978). And, as the predominant Western mode of pictorial production, it necessarily depends on the contrast to modes (usually non-Western) which it sees as magical, abstract, nonfigurative, as other than mimetic, but which have their own ways of securing extremely powerful effects. This shadow of the magical—of those invisible (better, unseeable) transformations which are utterly other than pictorial—haunts Western seeing, just at the point when it seems most objective, pragmatic, self-evidently realistic. It is this which is released when the visual language of realism reaches its limits;

it is this release which realism needs to secure its effects, chief among which is the effect of effectlessness, of direct encounter with the real.

Also at stake here is the very possibility of a writing which, in taking as its subject the question of how close a representation—*this one,* right here in front of us—can come to the real, itself desires to come so close to this mimetic moment that it, too, participates in, becomes part of the substance of, the same real. Great realist writing draws us into whirlpools of elision. It induces that swoon in which we fail, suddenly, to perceive the categorical difference between reality and representation. The borders between subject and object dissolve, we experience entire identification, we become what we see, it enters us, we are its body, our being is shared in—as Heidegger would put it—being Being as being (e.g., 1977a).[2]

What better vehicle of this kind of elision than pictures of workers working—particularly when they are given, as Courbet's key works of this moment were, in life-size scale? Our work of looking, our strained reaching for the real, our struggle to become that which we see, is a perfect parallel to the work of these men—even, sometimes, women—as they do battle with natural forces to make things grow, or grapple with the tasks of transforming raw materials, or interact skillfully with complex machines. Certainly, our looking happens at one remove, using the eye and mind more than the body and mind actively at work. But it is a kind of labor, mental and emotional. It is this, I believe, which has led many Marxist art writers to value highly the relatively few images of work in the history of art. It is also what led many intellectuals, writers, and artists to value Marxism and Marxist theory as a form of material, virtually bodily work (e.g., Althusser 1994, 215).

Marxist art writers for decades have had in mind an ideal, revolutionary artwork of this kind. It was the recurrent paradigm for social realism in many countries in the 1930s. The prescriptions of Soviet socialist realism turned it into a parody of itself. What simpler way could there be to remind the bourgeoisie—those masters of seeing everything as an abstract commodity—of the reality on which their wealth was based, the labor power of living men and women? (As if they didn't know, most of them, as a matter of daily experience.) Paintings and sculptures of people at work, realists believe, punctured the work of mystification which art mostly does in capitalist societies. Allegory, nostalgia,

2. For Heidegger (1953), Western thought since the Greeks had declined into a technology-dominated blindness to Being which he named "productivism." On this model, Marxism in general, and the social history of art in particular, would be as expressive of "productivism" as the American ideologies of mass production which Heidegger deplored (1977b, 116, 135, 153). His central concept *Gestell,* often translated as "enframing," included both *herstellen* and *darstellen* (that is, producing or setting there and presenting or exhibiting). Representing, in a typical formulation from the essay "The Question Concerning Technology," is "that producing and presenting which, in the sense of *poiesis,* lets what presences come forth into unconcealment" (1977b, 21; see also 131, 149).

pleasuring the senses, dreaming of exotic places, showing off one's property—all of this is harder when standing before an image of people working away. Especially when all the illusion-breaking, distance-collapsing devices of full-on realism are unleashed, such as life-sized figures, narrow foregrounds, infinite detail, appealing looks out, and pictorial narrative involving dramatic events, such as outrageous exploitation met with simple human resistance. Capitalists, look to your conscience! Workers of the world, unite!

Yet the social history of art, as it emerged in the years around 1970, was not merely an update of Marxist art history from the 1930s. Its practitioners saw themselves as inheritors of the cultural history of art inaugurated by Burckhardt and as able to use Panofsky's iconology as a subtle analytical tool kit. Further, it cast itself against the two prevailing schools of art-historical practice: the tradition of connoisseurship, seen as having descended into mere iconography, the cataloging of recurrent subjects, and modernist art history, from Wölfflin's formalism to Greenberg's recent version (Smith 1975; Belting 1987, esp. 34–46). What all of these approaches, including—indeed, especially—Marxism, had in common was their presumptive historicism and inflexible determinism.

They are also, evidently, masculinist. Apart from the model of men at work, there is, for heterosexual male artists and viewers, another paradigm of the ultimately real in perception available: the passage from voyeuristic caressing of a depicted female body or bodies to their mimetic penetration by the gaze. Courbet is one of many artists who have pursued this, in works such as *Woman with White Stockings,* ca. 1861 (Barnes collection), and *The Origin of the World,* 1866, owned for many years by Jacques Lacan (Faunce and Nochlin 1988, 176–78). The desire for self-obliteration, so strong that it overrides the violence, indeed rapacity, which realism harbors, is transparent here. In this phallic production of desire, process and presentation are crudely gendered: "Men act, women appear." Women are produced as above all presentations, as always available for men to process, lacking even figuration until men project (that is, perform)—or are imagined to project—their desires on them. Yet it should be said that the relationships here are not necessarily automatic: the imputed invitation to violation can be refused by heterosexual men. And obviously there is no simplistic gender fixation in these subjects as such: gay and lesbian viewers may be pleasured by certain renderings of them and repulsed by aggressively heterosexual treatments. Everything depends on how you do it, as artists in recent years have shown.

Art as Work, or The Production of Modes

Clark's description does not stay long with mimetic evocation. He soon moves to:

> But *The Stonebreakers* is also a picture of action: not of physical presence merely, but of physical labor (the kind we call, with cynical

euphemism, "manual"). And this is where the painting stops being simple. . . . It is an image of balked and frozen movement rather than simple exertion: poses which are active yet constricted; effort which is somehow insubstantial in this world of substances. What Courbet painted was assertion turned away from the spectator, not moving towards him: it is this simple contradiction which animates the picture as a whole. . . . Where, to put it another way, will the momentum of the stone breakers' actions carry them? Is the boy checked in his stride, the pannier balanced for a moment on his knee? Or is he striding vigorously back into the picture space? The clothes the men wear—for all their dense substance—actually prevent us from answering these questions. In *The Stonebreakers* the drapery (the very word seems out of place) articulates the figures' presence but not their particular configuration in space, and least of all does it indicate their movement. The man and the boy have no anatomy in the old sense (1973, 80)

For Clark, Courbet has gone beyond straightforward naturalism, "he turns the painting against itself," in order to show the deeper level which is the goal of realism, that of truth about the social relations of production. Courbet presents "an image of labor gone to waste, and men turned stiff and wooden by routine" (1973, 80). He makes, that is, a moral, even political, point and is prepared to both advance and compromise realism in order to do so.

In Clark's view Courbet's art was valuable not because he, a product of the economic forces most powerful at the time, dared to paint rural society on a heroic scale, lionizing its larger landholders, peasants, and laborers alike, insisting on an essential egalitarianism, simply to upset the Parisian bourgeoisie. It was because Courbet used his art—not just *The Stonebreakers*, but an ensemble of powerful images, including both the *Burial at Ornans* and the *Peasants Returning from Flagey*—about these subjects to intervene, with subtle yet unmistakable power, in the ideological struggles of French politics in the volatile years around 1850. Courbet had much more agency than any of the prevailing theories of history and of art would allow, although it was not limitless. His practice was strategic, aimed at maximal effect within the conjuncture of forces then in play. There are traces here of late-1960s interventionism—even of the situationist international. Realism was not a matter of subject matter, or style, or loud pronouncement of artists' intentions. Still less was it an essence of political correctness. Criticality was relative to the situation itself (this relativity was its limit). Specific effects were the essence of political art. All else was fantasy, or self-indulgence. Clark's evidence for Courbet's active sedition is compelling against those who would reduce him to a romantic individualist who strayed into anarchism (1973, 81).[3]

3. Interpretations of Courbet's art continue to be transparently ideological in character. In contrast to Clark, Bowness (1978, 14) manages to read the letter to Wey cited above as evidence of the nonpolitical character of Courbet's inspiration, saying that it was conventionally humanistic

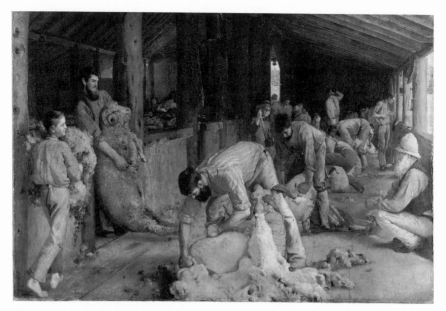

18.1 Tom Roberts, *Shearing the Rams,* 1889–90. National Gallery of Victoria, Melbourne.

Many of us were attempting, in the early 1970s, to rethink art history from similar impulses. Some of us still are. At one extreme, Nicos Hadjinicolaou (1978) devised a model "science" of art history which turned Marxist structuralism into a kind of machine for mapping artists' ideological positionings. At the other edge, Gwyn Williams (1976) carefully traced Goya's extraordinary range of political stances to a variable, but always critical, passaging through the labyrinthine politics of Spain and France in the early nineteenth century. I set out systematically every conceivable contextual condition which might have shaped the great icon of Australian popular art history, Tom Roberts's painting of 1889–90, *Shearing the Rams* (Plate 18.1) (Smith 1980). An image of work, of course, one which was already symbolic for the artist himself:

> It seems to me that one of the best words spoken to an artist is, "Paint what you love, and love what you paint," and on that I have

in its sympathy for these people and matter-of-fact in its acceptance of their fate. In the same volume Hélène Toussaint (1978, 156) attempts to depoliticize *The Stonebreakers* by citing popular rhymes about "jolly roadmenders" as proof that "it is an exaggeration to regard him as politically committed." Adding an adventitious depth to the aura of *The Stonebreakers* as an icon of political art is the fact that the painting itself was an innocent casualty of political conflict: it exists only in a grainy black-and-white photograph, the original canvas having fallen victim to the Allied fire-bombing of Dresden in World War II.

worked: and so it came that being in the bush and feeling the delight and fascination of the great pastoral life and work I have tried to express it. If I had been a poet instead of a worker with the brush, I should have described the scattered flocks on sunlit plains and gum-covered ranges, the coming of spring, the gradual massing of the sheep towards that one centre, the woolshed, through which the accumulated growth and wealth of the year is carried; the shouts of the men, the galloping of horses and the barking of dogs as the thousands are driven, half seen, through the hot dust cloud, to the yards: then the final act, and the dispersion of the denuded sheep; but being circumscribed by my art it was only possible to take one view, to give expression to one portion of all this. So, lying on piled up wool-bales, and hearing and seeing the troops come pattering into their pens, the quick running of the wool-carriers, the screwing of the presses, the subdued hum of hard fast working, and the rhythmic click of the shears, the whole lit warm with the reflection of Australian sunlight, it seemed that I had there the best expression of my subject, a subject noble enough and worthy enough if I could express the meaning and spirit—of strong masculine labour, the patience of the animals whose year's growth is being stripped from them for man's use, and the great human interest of the whole scene. (Roberts 1890)

Here speaks an artist very clear about art's role as an advocate of "the great pastoral life and work," of the value of direct experience of the driving forces in the economies of the Australian colonies. He seeks not to intervene in order to redirect, but to participate in order to promote. His audience was not only in his city, Melbourne, but viewers in the Royal Academy in London. He was writing in the local newspaper to defend his right to such engagement.[4]

The subtlety of Roberts's reply is that he does not defend "the fact" as such, nor the self-evidence of the real, nor even the uniquely Australian, definitively national character of his subject. He aestheticizes his perception, evokes its beauty, conjures its elevating impact, delineates its instructive power. In short, he absorbs its otherness, showing the ideal in the real, the symbolic in the material, the art-for-art's-sake lurking in realism. And he goes further: he presents his effort as a move from passive, then receptive observation, to an active, parallel working. To the making of a work of art. From art about work to art as work. Or, in the larger framework of this essay, the movement here is from picturing a mode of production in all its technical and social relations (which he does) to thinking of art making as the production of modes, of modalities, of form itself as a productivity, not merely as a means, nor as a machinery

4. After an anonymous writer in *The Argus,* 28 June 1890, had criticized this painting in classic Victorian terms: "The object of art is not to copy a fact, the object of art is to be artistic and to be artistic is to represent something beautiful or elevating or instructive."

which produces ultimately only aesthetic effects. This is more than a reversal of the terms "mode" and "production": it is a doubling of the relays between them.

Courbet and Roberts, working artists, sought to match the struggles of their subjects. Yet this was never a simple matter, either. While Courbet adopted the label "realism" for his independent, one-man exhibition adjacent to the 1855 Exposition Universelle, his introductory statement made it clear that, for him by then, the term was as meaningless as "romanticism" had become for the artists of the 1840s (Toussaint 1978, 77). Yet the concept was not void—Courbet wrote to Champfleury that the key work of this exhibition, *The Studio*, would show that

> I am not yet dead, nor Realism either, because there is realism in it. It is the moral and physical history of my studio, first part; the people who serve me, who support me in my ideas and participate in my actions. These are the people who live on life, who live on death; it is high society, low society; in a word, it is my way of seeing society in its interests and in its passions; it is the world that comes to me to be painted. (Holt 1966, 349)[5]

The painting is obviously a statement about Courbet's work as an artist. It is also evident that he considered this a subject worthy of treatment on a scale matched before only by *Burial at Ornans*. Many interpretations of this work are possible. I will emphasize the one relevant to the concerns of this essay. *The Studio* is a doubling, a simultaneous presencing, of both of the senses of "production" which we have been tracing. It shows the artist at work; it presents his means of production, including his models; it sets out the social relations of his production, that is, his relationships with his subjects, and their positioning within the larger social structure as he understands it; it chronicles his previous productions; and it does all this theatrically, as if it were itself a stage production. Thus his self-conscious conflation in the title: *A Real Allegory of Seven Years of My Life as a Painter*. The two main meanings of "production" are fused.

As (as we can now see) they already were in *The Stonebreakers*. Although the major emphasis in the earlier painting is on the identification with a work process, the two men are presented to the gaze of a spectator, who is not presumed to be a fellow worker, and who may, perhaps, be passing, in cart or carriage. Courbet was explicit about this social distance, in the painting as well as in his letter to Wey. Nochlin (1971, 146–47) and Clark (1973, 178) note his class-sensitive restraint in withholding signs which might invite readings in terms of personal tragedy or generalities such as the dignity of labor. In general

5. Toussaint (1978, 255 ff.) suggests that this letter was written to secure Champfleury's continued support and does not express Courbet's actual political beliefs.

terms we can see in Courbet's art a profoundly serious exploration of how painted representation might stand to the complex internal economy of production itself, in all its aspects, emphasizing now process, now presentation, but always examining both.

How does this interpretation relate to Michael Fried's argument (1990) that Courbet's realism was driven by the artist's personal need to secure the absorption of the painter and the spectator in each painting (or, at least, the most significant aspects of them), in contrast to the distancing, externally narrativized theatricality of the prevailing dominant traditions of French painting? There are obvious parallels between absorption and production as process, between theatricality and production as presentation. But my perspective sees the dialectic working within both this doubled production and the double of presentation and representation, not just between an internalizing absorption and an externalizing theatricality. In the case of Courbet, and indeed the whole realist enterprise, I see the dialectics of doubled production and representation working with and against each other, creating new conditions of limit and possibility as well as rich exchanges between them. Thus the differences in emphasis between the showing of process which is the burden of *The Stonebreakers,* and, in *The Studio,* not just a theatricalizing of absorption, but a bravura display (presentation) of the process of (re)presentation as painting-production, that is, as *work.*

Self-obliteration in absorption, I have already shown, is the driving dream of the realist artist and writer: to enter the image, to become part of the vehicle of representation, to immerse oneself in the real so thoroughly, to close the distance of perception, to lose sight of the object, to share its subjectivity, its being, and, in so doing, reveal its always particular truth to others. Fried recognizes this explicitly, at one point in his analysis of Thomas Eakins's *The Gross Clinic* (Fried 1987, 65). But this process has many layers, elements, pathways, speeds—all those I have been distinguishing. Thus I regard as limited and reductive Fried's arrival (after some acknowledgment of aspects of interpretations by Schapiro, Nochlin, Clark, and others) at the view that the primary purport of the two figures in *The Stonebreakers* is that they embody the artist's left and right hands in the act of painting and that they, on some level, also embody the artist's initials (1990, 105–08). Fried seems to be always trying out for the ultimate book on Jackson Pollock. Painting, as a practice, and personality, of the unique artist-genius, is not the end point. I believe that Courbet was after much more than this, in the end, conventional romantic coupling: nothing less than the fusion of the painter/spectator with the object of painting, with that other which, once seen, demands to be represented. (This applies both if we might want to say that Courbet saw the two men working and if we say that he saw the figure through which he could interpret their working.) In his reading of *The Stonebreakers* Fried misses the lack which draws drawing, which requires representation: the otherness of other beings and things is always in my being, my being is a being-to-them, their being a being-

to-me. His interpretation of *Burial at Ornans,* on the other hand, is compelling precisely because—despite his denials—it recognizes (through the fissure leading to the image of Buchon) the recognition of otherness as the deepest desire of the painting (1990, 129–43). Because, in other words, it is a realist reading.

These comments are reinforced when Fried, in his conclusion, attempts—through copious quotation of Marx on production and consumption!—to recuperate a politics for Courbet's project and his reading of it (256–63). This effort founders on Fried's inability to imagine audiences for Courbet, to see that, in realism, the artist's (subject's) absorption in the process of representing the other is an (impossible) attempt to disappear, to become invisible as a medium of representation, not for the sake of doing so but precisely in order to simultaneously present the being of otherness to the being of those others (one, two, an actual crowd at the Salon, particular groups, two classes in contestation, etc.) who—to displace his obsessive figure—stand *behind* the artist, beholding—or watching, seeing *through* the artist's act of self-obliteration, the object in the real. These viewers, then, have the agency to act on their new knowledge, an ability which makes politics possible.

Fusions of process and presentation occur frequently in the history of modernism. They are pivotal to its participation in the larger formations of social modernity (Smith 1996). Seventy years later, at another moment of crisis, a group of Russian artists sought to fuse the processes of transformation and presentation. The difference is that representation, in the sense of picturing, is dispensed with. Artistic practice becomes a matter of material production which is at the same time social construction. The Productivist Group, whose active members included Tatlin, Rodchenko, Punin, and Gan, saw themselves as revolutionary creators of a new society. The group's program, published in Moscow in 1920, stated:

> "Tektonika" is derived from the structure of communism and the effective exploitation of industrial matter. Construction is organization. It accepts the contents of matter itself, already formulated. Construction is formulating activity taken to the extreme, allowing, however, for further "tektonical" work. Matter deliberately chosen and effectively used, without however hindering the process of construction or limiting the "tektonika," is called "faktura" by the group. (Frampton 1971, 21)

Tatlin's found-object reliefs and his larger projects, such as the Monument to the Third International, exemplify this goal, as does the design practice of Rodchenko, Mayakovsky's poetics, and much else produced at that time.

Is not all abstract art, while being in a very general sense a particular mode of artistic production, at the same time a production of mode or, at least, of form? Perhaps so, but the term would lose all specificity unless some connection with the actuality of labor were retained. For example, to a display of traces of

its processes of making. As in Pollock's well-known painting practices, or de Kooning's.[6]

Modernity, or The Production of Modalities

The reversal of the terms "mode" and "production" has had even greater consequences for critical art history and theory. It is worth recalling that Baudelaire began his famous 1863 essay "The Painter of Modern Life" with a report of his reflections while musing over some plates in a fashion catalog. His realization that modernity itself appeared in a play of difference between the "ephemeral, fugitive, the contingent," the modern "half of art whose other half is the eternal and the immutable" (that is, the classical), was triggered by the emergent power of presentation in everyday life (1863, 13). Clark, in *The Painting of Modern Life*, foregrounded Manet as the innovator of modernism, the renderer of the signs of just this emergence (1984). Barthes developed Baudelaire's insight in his elaborate study of fashion's *systeme de la mode* (1983). Debord (1983) castigated the society of the spectacle, while for Baudrillard (1981, 1990), the disappearance of material production as the basis of our lives has led to a thoroughly mediatized existence in a world of simulacra, of signs imitating the real, of signs more real than real, of signs of signs in incessant, perhaps entropic, circulation.

The great shift here is more than a simple reversal. It is not just a switching of priority between things and ideas, economy and culture, base and superstructure, process and presentation, or production and consumption. Rather, the picture is one of a constant generation (production) of modalities (productions), an economy of endlessly variable presentations, a culture of incessant transformation. Dreams, needs, desires are just as generative as machines and factories. Deleuze and Guattari (1977) were among the first to offer an analysis of "desiring machines" and "desiring production" within the current Oedipal phase of capitalism.

These shifts have set many new tasks for critical art history. In my recent work I have identified the years after 1910 as a turning point in the modern history of these changes, one which prefigures the current "triumph" of globalized mass consumption, of the worldwide and everyday processing of presentation. I have taken up two key questions. What kinds of figures, what processes of configuration, made up the visual imaginations of those who conceived the major transformations in the nature of work which led to mass production? The records, writings, and statements of Frederick Winslow Taylor and his disciples have been my focus, along with the lantern slide images they used to

6. A fascinating instance, tying together both sides of the equation, is de Kooning's memory of the inspirational effect on *Excavation* (1950) of scenes of women working in rice fields in an Italian neorealist film, *Wild Rice*, by Guiseppe de Santis (Marriott 1975, 16). This would, of course, be just one of the pathways which trace the painting itself.

sell their system. It is the curious coincidence with *The Stonebreakers* that Taylor's ideal worker, the imaginary individual constantly evoked in explanations of his system, was a menial laborer "Schmidt the shoveler." His conception of the machine was similarly reductive. Scientific management must also be located within the immediate framework of the emergence of production engineering, particularly the revisualizations of machine work, as evidenced by the copious photographic imagery which was part of their enterprise. This kind of study can be extended to other, earlier and more recent, definitive imaginaries, such as those of postwar corporate management or of computer imaging. In Baudrillard's model, modernity is typified by the predominance of a "mirror of production," in which these imaginaries conflate modes of material transformation, labor, and value creation with those of the production of human selves (1975, 17). Close historical study shows a much more complex trafficking between realities and representations.

My second question is located at the level of the social spectacle itself. Why, in the United States in the years immediately after World War I, did many aspects of the world, certain modes of behavior, styles of dress, and ways of making things—that is, most current forms of processing and presentation—suddenly start to look old-fashioned to more and more people? In *Making the Modern* (1993) I traced the emergence of a visual imagery of mass-production modernity from the reordering of space in the buildings of the Ford Motor Company Plant at Highland Park, Detroit, in the years after 1910, to the orchestration of crowds of consumers of the symbols of modernity at the New York World's Fair 1939–40. Between those years, a new regime of seeing was spread through specific modes of visualization: engineering photography, specialist and general advertising, art, fashion, and industrial design. Widely understood as a shift from mass production to mass consumption in the 1920s, it might also be seen—in the terms of this essay—as a massive move from production as process to production as presentation. The specifics of history, however, are not so neat: not only were there many prefigurations of this move throughout the nineteenth century, but the Depression immediately disrupted the changeover, and provoked an imagery of dissensus. This was, in the later 1930s, gradually coopted by the alliance between the new corporations and the welfare state, leading to the integrated imagery of modernity which was part of the broad social consensus required by the war machine (Smith 1993). Nevertheless, on the macrolevel, studies of periods such as this allow us to imagine the possibility of histories of ways of seeing—inspired by Benjamin's *Passagen-Werk* project (1982; see also Buck-Morss 1990)—and of making concrete the current debates about the hegemony of vision within modernity (see Crary 1990; Mitchell 1994; Jay 1993; and Levin 1993).

Between the two questions there is, I realize, still a passage from base to superstructure. Yet the capitalist visual imaginary is now presumed to be already in the base, and the hard graft of economic transformation is recognized as

occurring also in the superstructures. The object of analysis for historians of the visual is the traffic between them, one which we can see to be so multidirectional that metaphors of levels or even layers have ceased to be appropriate. This amounts to a simultaneity of contingent connections, aspects or points of which can be temporarily halted, so that traces of the trafficking may be discerned. It would be absurd to examine, for example, industrial design between the wars or current modes of virtual reality in any other way. On this model, no modes of visual production are sacrosanct, including the creation of works of art.

The Other-Than-Modern, or the Production of Structures

Does this trafficking between process and presentation occur within societies which have not undergone the shift from the predominance of one to the other? This question presumes that there are peoples who have not been on the journey through modernity. While it is hard to imagine anyone alive who has not felt the effects of the modernizing forces which have driven Western societies for 2½ centuries, there are cultures, and even subcultures, which have continued to develop according to their own premodern trajectories. To tribal Aborigines in Australia, for example, modernity in all its forms is something to be lived through, adapted to, explored for survival purposes, but not, for the most part, joined. The cultures of these peoples are fundamentally based on ritual song cycles and visual designs, the performance of which reproduces both sacred and secular life (see Munn 1973; Myers 1986; Morphy 1993). Processing here only minimally transforms the earth in any material sense, and presentation is a constant of both ceremony and daily interchange. This could be described, in Western words, as an ongoing reproduction of structures, a determining of consciousness by social being, a domination of social life by inherited modes of both actual and symbolic productions.

How one describes the roles of visual imagery within the spiritual lives of these peoples—if such a description were possible—is only tangentially relevant to this essay. More to the point is the pressure on even the most reversed models of modes of production which has been exerted by the recent emergence of contemporary Aboriginal art in Australia. Broadly speaking, this takes two forms. The first is the creation by tribal Aborigines of paintings, sculptures, and decorative and craft works which, while based on sacred imagery, are made for secular circulation among others. They present, in general terms, elements of ancient dreaming stories, rendered in modes based on traditional designs and figures, but which coincide, often, with abstract notation. The other form is the work of nontribal Aborigines, people of Koori, Murri, Nungar, and Nyungah background, who use modes from any available artistic tradition and have developed often hybrid visual languages to communicate usually intensely political messages about matters of concern to Aboriginal Australians, especially land rights (Sutton 1988). These two forms have replaced representations of

the landscape and rural work in the manner of Tom Roberts as the most widely reproduced, and perhaps most popular, imagery within Australian visual cultures. Yet they are signifying *between* cultures in a complex exchange which simultaneously defines division and, at times, marks spaces for communication.

The terms and, more important, the values which have accrued around notions of production seem less pressing in such contexts. Something more is being asked of us. We are being challenged to think beyond the categories of Western thought, even those as apparently basic as the idea of production, no matter how doubled, and diversified we have seen it to be. Indeed, this detour has brought us to what is usually, fundamentally, at stake when the concept of production occurs in any context. Nothing less than the very idea of fundamentality itself, along with the presumption that anyone, from any one cultural tradition, can know what it is. This is the radicality of Baudrillard's opening challenge.

The Return of the Specter, or Production and Its Doubles

To sum up. Within critical art history, one-sided conceptions of production have been rapidly replaced. The "ideal" realist artwork, one which pictured production as tangible, fundamental truth, has evaporated, a victim of the recognition that the master narratives, even those of universal liberation, were always going to be repressive. The artwork which displayed its own work processes, which became itself a vehicle for manufacturing modalities of production, is still very much with us. Valued in and for itself, as pure abstraction or ideal modernism, it remains a mystification. But artwork which acknowledges its reflexivity as part of its nature, while it goes about working on the tasks at hand—questions of being, for example, of identity, of sexuality, of survival—continues to be productive.

What, finally, about art writing? Within Marxist modes of writing about art, however revised by structuralism, the basic drive was clear. What better way for an art writer to honor both workers and artist-workers than by trying to match their work at working by a writing output which strives to reenact both, to find words which will take a reader through their processes of making, as if the very act of reading was a working too, a working through of all these acts of work? If we add all the terms discussed in this essay together, this would be the ultimate act of elision. Workers, artists, art writers, and viewers in a four-part harmony, a simultaneity of perfect repetitions, not yet a rudimentary assembly line but a replication in places, a mimetic economy, an economimesis.

Yet the main thrust of this essay shows that this chorus, these days, is a residual fantasy. Real worlds, representations, and writing about both will never again settle into the closures of fully ramified systematicity. Art history must treat the practice of individual image makers and the styles of groups and of periods and places in terms of both the production of modalities *and* the modes

Commodity

Paul Wood

The would-be comprehensive theoretical study of contemporary art will no more omit commodification from its index of concepts than critics of an earlier epoch would have left out form and feeling. Yet for all its throwaway familiarity the notion is not often analyzed, either as such or for its specifically artistic implications. Marx, however, wrote that: "A commodity appears at first sight a very trivial thing and easily understood. Its analysis shows that it is, in reality, a very queer thing, abounding in metaphysical subtleties and theological niceties" (Marx 1867, 76).

The "commodity" is essentially an economic category. As such its relevance to the practice of art has to be established. At this juncture we will only note the general point, which it is the business of the present text to substantiate, that modern art has been fundamentally and doubly marked by commodification. On the one hand this marking extends from the depiction by artists of a world of commodities to more diffuse forms of meaning expressive of the effects of commodification (for example its effects on self-consciousness). On the other hand the productive system of art in the modern period itself became commodified. This is an important matter since its effect is implicitly to challenge the modernist work of art at its root, insofar as its actual condition as commodity within a productive system, an economy, stands at odds with its rhetorical condition as autonomous, pure, or free.

Commodification, that is, has had repercussions for both aspects of modern art: its symbolic aspect and its material aspect, the meanings it produces in respect of the world at large and its own mode of being in that world. It is one of the paradoxes of modern art furthermore, one which has laid it open to much subsequent criticism in regard of its claimed idealism and mystification, that the significance of commodification for artistic modernism increased in inverse proportion to its visibility in both aspects. Just as the widespread shift from depiction to expression in effect concealed commodification as a principal subject of modern art, so the intensified rhetoric of autonomy concealed commodification as one of its conditions.

True to form of course, we now behold the return of the repressed. As the sun of modernism sinks, the double shadow of the commodity lengthens across the field of art. Postmodernism has learned to love the commodity, embracing it as both subject and condition with an eagerness which betrays, perhaps, a deeper anxiety. Having set aside the alleged austerities and funless elitism of modernism, the postmodern spectator can relish the guiltless embrace of aes-

thetics and money. The gratification which modernism postponed appears to have become freely available across the board of a commodified culture. The question then, which any consideration of commodification in relation to art must face, is a question about the consequences of art's condition as commodity for the meaning of art now.

This is a densely problematic area, and one ultimately leading beyond the scope of the present essay. But it bears down heavily on our judgment of what commodification means for art, and at the heart of the matter lie contested conceptions of modernism itself. This is because the myth of freedom intertwines not only with the material condition of commodification, but with another avant-garde aspiration: the will to be critical. More sharply phrased then, our question concerns the consequences of art's material condition as commodity for its pretensions as critique. What room if any does wall-to-wall commodification leave for the aspiration to a critical art? It is the relationship of autonomy and criticism that remains unclear. The former is commonly interpreted as tantamount to the loss of the latter from modern art. Another possibility, however, is that it is not, but is in fact a precondition of it in modernity, i.e., in the condition of an *otherwise* commodified culture. This suggests a defense of modernism along the lines that the commodification of art is best criticized by ignoring it; or if not quite by ignoring it then by putting it in its (moral) place, by treating it as a distraction from the articulation of deeper and more perennial—human—values. Such an argument would be unfashionable but not necessarily wrong. In its favor, it accords art a pivotal position between commodification as a condition in history and a more persistent human nature, thus enabling connections between our lived experience and that of earlier ages and other cultures. Against it can be set the all-too-evident traps of an idealism whose lofty concerns are insulated from commodification by the very contingencies of wealth and leisure which it disparages as distractions from a properly intense engagement with human value. Such questions are ultimately, perhaps, things we have to live with rather than expect to decide about. But it is in that direction that reflection on the commodity takes us.

First, however, we must turn back to the ground of economics, albeit to do little more than note how the commodity began the long march culminating in its annexation of the sphere of culture. A commodity is something which is exchanged in the market for money or other commodities. It is usually manufactured or subject to some kind of productive labor or singling out and is produced for exchange before its ultimate consumption. Production for private consumption is not commodity production; "commodity" is the term given to products when the process of production is centered upon market exchange.

Beyond that barest of definitions, however, the term "commodity" is imbricated in economic discourse in a quite specific way, one which, moreover, has a bearing on the kinds of meaning, particularly the kinds of critical meaning, that coalesced around it when it entered cultural debate during the 1980s. For

the appearance of ideas concerning commodification in cultural debate does not occur as a result of any simple or direct transfer from the center ground of contemporary economic discourse.

C. A. Gregory has distinguished two forms of economic discourse, the second of which challenged and replaced the first in the late nineteenth century. The first was the discourse of political economy, as understood by Quesnay, Adam Smith, Ricardo, and (for all that he offered a *Critique* of political economy) Marx. As modern capitalism developed after 1870 this paradigm was overturned by the emergent discipline which became known as economics, that is, neoclassical, or more pejoratively, bourgeois, economics. During the twentieth century, economics has provided the dominant way of thinking the economic relations of capitalism. In the West at least, Marxist economics, the descendant of the earlier political economy tradition, has been subordinate. The relevance of this to our present concern is that the term "commodity" functioned within the conceptual schema of political economy. In modern economics it was replaced by the concept of "goods." The difference is important. For economics is organized around the notion of an abstract individual who seeks to maximize his possession of the goods he desires in a situation of relative scarcity, i.e., a situation in which he cannot obtain all the goods he desires. In the conceptual schema of economics, the mechanism which regulates the satisfaction of unlimited desires by limited goods is the market. Political economy, however, does not assume that individuals compete in this way but seeks to explain the reproduction of the socioeconomic system through the generation of surplus, taking note of the point that the societies in question are not composed of atomic individuals, but of classes. Political economy seeks, in Gregory's words, "to relate the surface appearance of things presented by the phenomena of commodities, to class relations in the sphere of production" (Gregory 1982, 7–8). Although the term "commodity" is obviously employed in bourgeois economics, it tends to have a quite specific meaning to do with the trading of basic goods such as foodstuffs and raw materials. Critical analysis of the commodity and its implications for society in a more general sense is thus not to be found in bourgeois economics, the dominant realm of economic thought in our society. The commodity received its fullest exploration in the Marxist tradition, as part of that tradition's fundamental analysis of the capitalist mode of production as a whole. It is in that sense in which the term is used in the present paper, and indeed it is in that sense in which it has entered cultural discourse generally in the recent past.

Insofar as we may employ the term "commodity" to refer to products in a process of production centered on market exchange, two further points may be noted. One is that the need for exchange itself arises very early in human societies wherever there is some division of labor or specialization of productive processes. As such the commodity has a longer history, and is in that sense more fundamental to human society, than the capitalist mode of production.

Anthropologists have, however, drawn a further distinction between the commodity exchange system and gift exchange systems. This distinction has become particularly resonant in postmodernist debate, as the very success of the market economy, of capitalism, has brought in its train mounting reservations about the values of a culture in thrall to apparently endless commodification.

It is not enough, however, to imply that gifts and commodities are simple opposites. One has to keep in mind here the difference between economic systems and conceptual systems. Certainly, socioeconomic systems organized around the exchange of gifts exhibit a different character from those organized around the exchange of commodities. It was long a staple of orthodox economics, and older anthropology, that gift economies and market economies represented successive phases of a single evolutionary schema. Gift systems were seen as the hallmark of variously "primitive" or "archaic," i.e., precapitalist, cultures, which would wither in the face of "superior" commodity-based systems. The implication of such theories in imperialism requires no further emphasis. However, recent economic and sociological studies of the effects of colonialism, and the related field of immigration studies, have pointed to the frequent persistence of gift economies within commodity-based economies.

This has had the effect, in one of those recursive twists which so often animate cultural studies (and indeed cultural practice), of opening up a field. Gift theory has emerged to a new level of critical resonance as it has seemed to offer a way of filling the gap which opens in the wake of doubts about the values of commodification. The result has been that an alternative cultural model which appears to privilege interactive human exchange over, or through, the exchange of objects has come to seem far from archaic. It can rather be reread as oppositional to the ultracommodification of late capitalism, a form of resistance offered in the name of the sociality increasingly sundered by the commodity. As Evans-Pritchard already observed in his introduction to the English translation of Mauss's essay of 1925 on the gift, "Mauss is telling us, quite pointedly, in case we would not reach the conclusion for ourselves, how much we have lost, whatever we may have otherwise gained, by the substitution of a rational economic system for a system in which the exchange of goods was not a mechanical but a moral transaction, bringing about and maintaining human, personal, relationships between individuals and groups" (Mauss 1966, ix).

However, it is important to be clear just what is in opposition to what. Gifts and commodities are certainly different. But conceptually the two are not opposites. Rather, both stand opposed to a third term, namely "goods." The concept of goods in neoclassical economics is both subjectivist and universal. The individual who seeks such goods is abstracted from actual historical circumstance; and the market on which he seeks them, the market which functions as the mediating factor between limited goods and unlimited wants, is rendered universal. In brief, the model of an abstractly functioning capitalism, the resolu-

tion by the market of the conflicting demands of equal individuals in conditions of relative scarcity, is naturalized. Actual circumstances which depart from this model tend therefore to be seen as aberrant, as impediments to the "natural" functioning of the market, that nexus of subjective want and objective exchange that capitalism is taken to be. Such aberrations which the market will overcome, if "market forces" are allowed their chance, include factors as diverse as state planning and traditions of giving gifts.

The tradition of political economy, most notably Marx's developed critique of political economy, sets out to investigate what he called the "laws of motion" of actually existent social formations—slave owning, feudal or capitalist. For political economy such formations are not composed of hypothetically freely interacting individuals, but classes. When such a form of analysis encounters a system of exchange which it cannot decode, it is not committed to ruling out that system as aberrant or imperfect. The way is open to seek another form of explanation. Such, in effect, is the anthropological conception of the gift exchange system: a conceptual development of the political economy tradition first advanced by Morgan and adumbrated in the twentieth century by Mauss and Lévi-Strauss. In Gregory's view,

> Like the early Political Economists, the central focus of analysis of these anthropologists is the social relations of reproduction of particular social systems. The central concept of their theories is the gift. This refers to the personal relations between people that the exchange of things in certain social contexts creates. It is to be contrasted with the objective relations between things that the exchange of commodities creates. The theory of gifts and the theory of commodities are compatible and together they stand opposed to the theory of goods with its focus on the subjective relationship between consumers and objects of desire. (Gregory 1982, 8)

To that extent, therefore, while it may be correct to say, as we have done, that commodities and gifts are economic concepts, they are not concepts of economics. Both derive their meaning in systems of thought which stand in a *critical* relationship to the paradigm under which capitalism seeks to understand itself.

This orientation carries with it certain implications for the way in which the notion of the commodity entered into the language of cultural debate in the 1980s, and for why it should have had such resonance. During the post–Second World War "long boom" there arose heightened levels of production and consumption of commodities, particularly in the United States but also, as a result of the "economic miracles" of the 1950s and 1960s, in the devastated nations of Western Europe and Japan. Certain artists and intellectuals engaged with this condition, offering varying degrees of celebration or criticism, notably pop artists in America and situationists in France. After the defeat of the radical upsurge conventionally flagged by the name "1968" (actually a phase extending

from the mid-60s to the early 70s) certain of these intellectuals were faced with a new problem. They had to try to come to terms both with the new formation of capitalism and with a Marxist tradition which seemed finally to have failed, failed not merely to overthrow capitalism, but seeming now to be in danger of failing even to understand it.

Particularly significant was Jean Baudrillard's criticism of Marx. The French intellectual-philosophical tradition was permeated by Marxism and its terminology far more thoroughly than the Anglo-American intellectual formation. Baudrillard, therefore, in his earlier works, used a Marxist terminology against Marxism to argue that commodification had proceeded to a new level, such that the principal commodity of late capitalism was no longer products in the traditional sense, but images. One of the effects of this analysis was to emphasize, even to glamorize, the power of culture: precisely that which traditional Marxism had rendered as epiphenomenal, under rubrics such as "consciousness" (as against "social being") and "superstructure" (as against "base"). Throughout the period, many artists remained preoccupied by the phenomenon of hyper-commodification, particularly where that condition was at its most intense, in America. The result was that when Baudrillard's post-1968 texts were translated into English in the late 70s and early 80s, in the wake of the translation of Walter Benjamin's earlier reflections on commodification, there became available a radical and sophisticated conceptual framework in which to discuss forms of art whose interests quite clearly diverged from those prescribed by the dominant critical language, namely modernism. The upshot was that a term originally articulated within an oppositional tradition of economic thought, which the course of twentieth-century history had moreover done much to marginalize (nowhere more emphatically than in the Anglo-American formation), re-emerged at the forefront of a *cultural* discourse preoccupied with the representation of a quintessentially American experience. It is also worth recognizing that Baudrillard's early analysis of the commodification of meaning was accompanied by a utopian vision of a noncommodified free symbolic exchange. This was rooted, practically, in what he had observed in the unregulated street culture of the revolution of May 1968, and theoretically in the "anthropological" branch of the political economy tradition, namely in Mauss's conception of the gift. It is through such subterranean channels that the state of affairs mentioned in the first sentence of this essay comes about.

Armed with this provisional understanding of the concept of the commodity in its economic application, and the manner of its recent transfer to a postmodernist discourse in culture, we can now turn back to survey the impact of commodification on the development of modernism itself. At the same time we need to note both some of the ways in which that impact was negotiated and absorbed and some of the costs of that process. The fundamental point is that capitalism has constituted the mode of production in a global sense— objects *and* ideas—in which the productive subsystem of modern art emerged.

The capitalist system is first and foremost a mode of production organized around the market; and therefore the commodity takes on a unique significance for production here, cultural production no less than any other form. Chapter 1 of Marx's *Capital,* first published in 1867, is entitled "Commodities"; it continues for a hundred pages.

From the point of view of an analysis of art and culture, Marx's most significant comments on the commodity occur in section 4 of chapter 1, titled "The Fetishism of Commodities." Marx had established in sections 1 through 3 the dual nature of the commodity, the way in which it embodies two distinct forms of value: use value and exchange value. In fact Marx's analysis is more complex than this and leads straight into one of the most fundamental, and contested, areas of his thought: the theory of value per se and its identification with the expenditure of human labor power, viz. the "labor theory of value." Clearly there are difficulties involved in applying this theory to the sphere of cultural production and especially to art. The labor involved for Malevich in producing a black square, or for Duchamp in nominating a bicycle wheel, does not relate to the exchange value of the resulting object in the same way as, say, the skilled work and technology involved in producing a car. Artworks are a special kind of good. But this does not mean that they are not produced and exchanged, only that their modes of production and exchange are specialized forms of a more general condition.

Whatever the difficulties of the labor theory of value, both as a thesis in economics and in its application to cultural production, there is an important point here for the relevance of the concept of the commodity to art. For as Marx notes, exchange value is bound up with use value. A commodity is a product made by a person and ultimately used (consumed) by another: the key relation is a social one. But what commodities get exchanged for on the market is either money or other commodities. That is, the most immediately noticeable relations into which commodities enter are relations between things. It is the consequence of the commodity's dual nature as use value and exchange value that Marx notices in his chapter on "commodity fetishism": that relations between people start to become treated like relations between things. Marx writes: "A commodity is therefore a mysterious thing, simply because in it the social character of men's labour appears to them as an objective character stamped upon the product of that labour . . . It is a definite social relation between men that assumes, in their eyes, the fantastic form of a relation between things." And he goes on: "In order therefore to find an analogy we must have recourse to the mist-enveloped regions of the religious world. In that world the productions of the human brain appear as independent beings endowed with life. . . . So it is in the world of commodities with the product of men's hands" (Marx 1974, 77). This is the process which Marx terms "commodity fetishism." In brief, the commodity becomes a power in society. Rather than a use value *for* people it assumes a power *over* people, becoming a kind of god to be wor-

shipped, sought after, and possessed. And in a reverse movement, as the commodity, the thing, becomes personified, so relations between people become objectified and thinglike.

Marx's analysis of the commodity then, a category fundamental to understanding the capitalist mode of production, immediately opens onto a range of other concepts whose primary import is not economic but sociocultural. Most important among these are the linked triad of "fetishism," "reification," and "alienation." These terms point to significant features of modern psychosocial relations between people and of people's conception of themselves. Such features can be understood as pointing to some perceived sense of loss: the loss of harmony, unity, of an organic relation to other people and to nature, and by contrast the permeation of our sense of being in the world by feelings of fracture, estrangement, and discomfort. This area of concern then can be recognized as a significant "hinge" between Marxism construed as a critical analysis of the social, economic, "objective" dimension of capitalism and that discourse which has focused on the psychic, personal, subjective dimension of bourgeois life, namely psychoanalysis. This interface between psychic and social, between subjective response to the world and objective condition of the world, has been one of the principal concerns of modern forms of art.

In the Marxist tradition, however, the implications of such ideas lay dormant. Commodity fetishism and its cognates received only fleeting additional mention in *Capital,* and the earlier writings by Marx in which such questions did receive philosophical discussion (the *Paris Manuscripts* of 1844 and the *Grundrisse* of 1857) remained unpublished and undiscussed until well into the twentieth century. It was only in the force field of the Bolshevik revolution of 1917 that these questions were raised again in a Marxist philosophical text. Georg Lukács's *History and Class Consciousness* of 1922 established two points of critical importance. First, that the commodity was of more than merely economic significance: that it amounted to "the central structural problem of capitalist society." And second, that in modern capitalism the commodity form influenced "the *total* outer and inner life of society": a life which Lukács went on to discuss in terms of its alienation and reification.

Lukács was subjected to severe criticism by the guardians of the official communist movement for what was deemed to be an overemphasis on questions of consciousness, and he himself recanted under pressure. But the effect of his text was to establish a politically radical perception of capitalist modernity as a form of culture. His reflections in *History and Class Consciousness* represented both a part of and a further stimulus to the emergence of an archipelago of unorthodox Marxisms in the interwar period. This dissident Marxism was diverse in its theoretical allegiances, and the discursive field to which it gave rise was by no means harmonious. But it offers the richest example in the period of an exploration of the cultural effects of commodification. Such exploration was given urgent stimulus by the failure of the revolution to spread westward

and the apparent stabilization of capitalism in the developed nations. What that implied was that in the increasingly spectacular commodity-based cultures of those developed nations, significant sections of the population felt their desires were being met.

The unorthodox Marxisms of the interwar period embraced projects as diverse as Gramsci's prison writings on the concept of hegemony and the work of the surrealist group in France. But of particular relevance here is the German-language debate associated with the Frankfurt school and its intellectual periphery. This includes the work of Theodor Adorno, Bertolt Brecht, Ernst Bloch, and Walter Benjamin, concerning the relations between avant-garde art ("expressionism") and more obviously commodified forms of popular culture. A sense of the internationalism as well as the theoretical intensity of this debate may be gleaned from the point that it was reading the surrealist Louis Aragon's book *Paris Peasant* which especially stimulated Walter Benjamin to undertake what is arguably the most sustained meditation on the cultural effects of commodification. This was his ultimately unrealized project to map the condition of modernity in mid–nineteenth century Paris through the work of Baudelaire and the urban commodity culture in which he moved, usually referred to as the arcades project (the *Passagen-Werk;* see Buck-Morss 1989). Though Benjamin himself was no ally of Lukács (not least because of his association with Lukács's adversary, Bertolt Brecht), this work of his registers in practice a point made in *History and Class Consciousness.* Despite Marxism's silence on culture, Lukács had already pointed out in his 1922 essay that there did exist a field which was centrally concerned to address the consequences of commodification, of the simultaneous estrangement of subjects from nature and from themselves: "a very real and concrete field of activity where [such issues] may be brought to fruition, namely art" (Lukács 1971, 137).

In their different ways Marx and Baudelaire were exploring a similar perception. The emergence to maturity of the capitalist system in the nineteenth century was accompanied by the flowering of the commodity as the highly visible evidence that a new form of life was in play; that the terms on which social existence was conducted now more than ever before were terms based on the production, distribution, exchange, and consumption of commodities. If Marx analyzed the structure of this condition, Baudelaire tried to grasp the experience of it.

Just as Marx saw how, under the impact of commodification, relations between people took on some of the objectified properties of relations between things, so for Baudelaire the commodities took on characters of their own: as when a group of luxury objects arranged in a shop window along one of Haussmann's new boulevards murmur among themselves and mock the inability of a poor passerby to purchase them. As Benjamin comments, "These objects are not interested in this person; they do not empathise with him"; whereas for Baudelaire it was precisely his "empathy with inorganic things," i.e., with

the commodity, which Benjamin understood to be one of the main "sources of his inspiration" (Benjamin 1970, 55). It seems to have been particularly in the Paris of this period, briefly home to both Baudelaire and the exiled Marx (as later of course to that other exile, Benjamin), that something new broke surface in human affairs.

That something which came up from the depths of the social, forcing itself onto the agenda of economics and poetry, was the commodity. Propelled to the surface by the massive forces unleashed at the origin of the modern in the eighteenth-century industrial and political revolutions, commodification demolished the walls separating the cultural from the political. Or rather, it simultaneously rendered the social subjective and socialized the aesthetic. Now not merely objects, which had been exchanged since time immemorial; and not merely bodies, which in a sense always had been things and as such open to being bought, sold, or hired out; but to an unprecedented extent minds, and all that follows in terms of needs and desires, came to the marketplace to seek satisfaction, to be met or refused but always to be rekindled.

The industrial production and exchange of *meanings* rose like smoke from the fires of the industrial production of things. From being an economic category, something you made in order to be able to sell, and buy, to eat and make more, the commodity came to permeate the secular cathedrals of modernity like a new incense. The shops, the boulevards, the arcades witnessed what Benjamin called "the enthronement of the commodity and the glitter of distraction around it"; while the world fairs "transmitted commodity character onto the universe." Benjamin further specified the mechanism through which the commodity became ascendant: "Fashion prescribed the ritual by which the fetish Commodity wished to be worshipped. . . . Fetishism, which succumbs to the sex appeal of the inorganic, is its vital nerve" (Benjamin 1970, 165–66).

In sum then, the commodity, the fetish, fashion, and reification form the constellation in terms of which the typical experience of modernity was constituted. Just as Marx mapped the route from an economic category to intensive features of our experience (though it was a route he himself followed no further), Benjamin in his study of Baudelaire and his Paris projected our cultural obsession with originality and authenticity back onto economics: to the cycle of novelty and consumption demanded by commodity production.

In the modern visual arts Manet's priority has been established. It is attested by commentators as diverse as Greenberg and Clark. He is the first artist of modernity, the Baudelairean painter of modern life. When he wrote to Baudelaire in 1865 complaining of the treatment he had received for his *Olympia,* the reply—as Clark has pointed out—was both sustaining and deflating: commending Manet to courage as the leading figure in his field who must as such learn to weather the criticism, but then ranking his priority as only "the first in the decrepitude of your art" (Clark 1985, 82). This sense of modernity as a Fall permeates the work of Baudelaire and Manet alike, and it is derived from

the perception that the modernity they had to represent, the truth they had to tell, was a truth of the commodification of everything. In Manet's late work, *A Bar at the Folies-Bergère* (Plate 10.1), all appears under the guise of commodity, from bottles to barmaid as well as what you cannot see—the spectacle behind you that all those people in the mirror have paid to consume.

Yet the point about Manet, what qualifies him as the painter of a commodified Baudelairean modernity, is that these are not "depictions" as such of commodities, in the sense of merely being images of things in a commodified world. More so than hitherto these figures are pictorial. Images of things are not necessarily images of commodities anyway, as the panoply of meanings associated with the still-life tradition attests. Depictions of objects may be used, according to particular conventions, to suggest human frailty, economic power, spiritual anguish, moral laxity, and much more. Manet is no longer able to do this. The still lifes in his *Déjeuner sur l'herbe,* or his *Luncheon in the Studio,* at most refer to an artistic tradition which could once be used to launch such plays of meaning; that is, they *refer* to its remnant but cannot *use* it (or cannot use it and mean it). By showing such arrangements as collections of studio props, Manet seems to imply that the repertoire of cultural meanings they could once draw on is now strained and artificial. The space in which they now function is not a common ideological space of shared meanings and narratives. It is two other kinds of space; and it is the relationship between them that is important to the character of the paintings. On the one hand is an increasingly fractured social space, the space of the commodity. And equivalent to it is a changed kind of pictorial space.

In *A Bar at the Folies-Bergère* it is as if Manet has caught what Marx called the "soul of the commodity" performing its "theological capers." What better site than a mirror to catch the commodity in the act of going through the looking glass from object to way of life? This effect, it should be underlined, is neither mystical nor accidental. It is a product of technique, though it is not easy to say how the effects are produced. It appears that Manet learned both how to dislocate and integrate and how to tune the balance between the two: in particular to dislocate the depicted subjects (through a repertoire of distracted glances and penetrating stares, vagaries of scale and placement) and to work this register of dislocation against an integration of surface (an all-overness of treatment giving a more evenly shared intensity to figures and grounds across the picture space). The effect is peculiar and specific: something like a shared condition of separation. This may help us to grasp both Manet's achievement as the painter of commodified modernity and that factor which makes us want to say that all appears "under the guise of" the commodity in his work. For despite the emergence in Manet's time of the artwork *as* commodity, Manet's work and some few others like it reinforce a desire to say of them that, while offering representations of commodification, they contain also the possibility of imaginative freedom from its thrall.

It is the self-consciousness which Manet both brings to his work and generates in his spectators that matters: the fact that the world of commodities (or the commodified world) is represented as simultaneously seductive and lacking. On the whole in the history of modernity, and certainly in the history of the modern arts, to use the term in its widest sense as ranging through popular painting through prints and photographs to popular song, the commodity has succeeded in dazzling any nascent sense of unease at its hegemony. That perhaps is the point about normal popularity: that it must not impede but stimulate consumption. Only quite rarely does an art form both achieve accessible address to the commodified world and establish the possibility of critical distance from it.

In the early days of modernity Manet and Degas managed it more than anyone, and Clark situates their achievement in terms of a balance of forces at work in the society. "The middle class in the late 19th century and even the early years of the 20th, had not yet invented an imagery of its own fate, though in due course it would do so with deadly effectiveness: the world would be filled with soap operas, situation comedies and other small dramas involving the magic powers of commodities" (Clark 1985, 229). In the later nineteenth century, a relatively fragile class power and a quasi-independent set of popular values faced each other across a space which was still capable of being filled by barricades, if not real ones then plausible memories of them. The result was that popular values had to be allowed a kind of voice, albeit a managed one insofar as possible. The result of *this* seems to have been that occasionally, when the meanings of the dominant met the meanings of the dominated, the fit was less than seamless. In its turn, this meant that in the hands of an acute observer, certain artworks were able to hold fast at a point in the flow of meaning which was revealing rather than concealing. Somewhere in the lack of fit between the barmaid and her reflection (or in Degas's case between the concentration of a performer and the distraction of the audience) was created the space for another sort of reflection: a reflection upon what had happened and what was still happening as social relations became coated with the gloss of the commodity.

To display the display case which modern experience had become was to interrupt the flow. Clark has described the range of products which the industry poured out to carry its captive subjectivities through the shallows of modernity without noticing how thin it all was: "It began with the feuilleton, the chromolithograph, and the democratization of sport and soon proceeded to a tropical diversity of forms: drugstores, newsagents and tobacconists, football, museums, movies, cheap romantic fiction, lantern slide lectures on popular science, records, bicycles, the funny pages, condensed books, sweepstakes, swimming pools, *Action Française*" (Clark 1985, 235). What he suggests there is of course the continuity between the ready consumption of commodified leisure and reactionary politics (a continuity which has its equivalents in our own world). Then or now, to display the display was to evolve mechanisms which, as it

were, caused one to choke on the flow. This element, the prerequisite of giving pause in the process of consumption, required forms of technical radicalism which with benefit of hindsight can be seen already to be pointing beyond depiction. Beyond Manet's *Universal Exhibition* and *A Bar at the Folies-Bergère,* beyond Degas's *Hélène Rouart* and Seurat's *Sunday Afternoon on the Grande Jatte,* and their like, where is there to go but the expanses of the picture plane seen as a place where the real world can be made over rather than faced on its own terms? In a markedly short space of time it seems the commodity won the battle of social life for mass consumption and the powers it served, and critical art's resistance took place along narrow passes in the high ground of the aesthetic.

At least that would be the case if history had stayed on an ascending curve of consumption. By and large, it has. But there have been interruptions. World war, for one thing. And the socialist revolution that in 1917 slipped through the rend in European modernity torn by the work of those other commodities, the wares of Messrs. Krupp and Vickers. Armaments and art met again for the first time since the Commune, and a resurgent disposition to realism forced the commodity back on the agenda after a period when the weight of overcoming alienation had been borne by the unlikely strengths of bathers, water lilies, and violins.

Conceived as the vehicles of expression for an authenticity of response which just could not be had from the bourgeois world of the commodity, such ciphers of the universal functioned as the commodity's Other: an imagined anchorage for a truth that could no longer be had from history, or rather could be had only despite history. It remains a moot point whether the avant-garde of the late nineteenth and early twentieth centuries, basically that is of postimpressionism and cubism, was guilty of an idealist evasion or clung to the only spar it could in the mystificatory torrent of commodity fetishism and bourgeois ideology: namely the self-definition of art. Or rather, since that phrasing—in the present "postmodernist" climate of hostility to the notion of autonomy— effectively decides the question, a further qualification is required. Much turns on whether that "spar," hurtling down the rapids towards a full-blown consumer society, is conceived as the self-definition *of* art, or as self-definition *through* art.

Be that as it may, the war changed things, changed the sense of what could, and had, to be done. It is noticeable how at the outbreak of the First World War an artist as committed to the representation of modernity as Fernand Léger conceives realism as pictorial, the effect of the interaction of pictorial components themselves in their independent state: tonal contrasts, pure colors, geometric and organic shapes, dynamic or static relations. Yet after the war, although the balance has irrevocably tilted away from naturalism (in that after Cézanne and cubism priority inescapably lies with the pictorial order), objects have made their reappearance.

269

A painting such as *Composition with Hand and Hats* of 1927 is deeply ambiguous. At one level it is a postcubist enumeration of commodities from what to us appears a rather quaint culture of white collar work and leisure: bowler hat, straw hats, cutlery, pipe, playing cards, bottles, and possibly motor tires and a typewriter or other keyboard office machine. But how it represents them is unclear. One might expect the objects' separateness to express a form of alienation, particularly when combined with the sightless mannequin head which crops up so frequently in the art of the period as a token of the reified and uncanny. But the effect is not that at all. The picture's monumental scale combines with the stability of its architectonic composition to convey if anything a solemn form of optimism: these objects are to be trusted.

If true, this points to something significant, namely that Léger is working out of a different sense of modernity than that encountered in Baudelaire, Manet, or Marx: one whose agenda was set by the apparent success of the Bolshevik revolution of October 1917. In short, although working in Paris, and although impressed by the Platonic ideals of the purists, Léger is oriented by the sense of a socialist modernity, at least in potentia. The point is of course that this prospect turned out to be no more than a hope. Modernity was capitalist and the ideological function of commodities was to enhance consumption while concealing the contradictions of their mode of production. A fully fledged socialist commodity never really emerged, despite the best efforts of Rodchenko and Mayakovsky in the nascent Soviet Union. Stalinism notwithstanding, it is a moot point whether Bolshevism as it historically arose was ever a realistic contender to bring about the kind of transparency in social relations which any nonalienated form of consumption must presuppose. It seems in retrospect to have been just too narrow, too mortgaged to the contingencies of its historical emergence to do other than shuffle the social opacities around a little.

Léger was the most Brechtian of visual artists: "reality changes; in order to represent it modes of representation must also change" (Brecht 1938, 82). But as well as constituting a benchmark of optimism in the face of mass consumption, his "new realism" must be accounted a kind of heroic failure. Circumstances never actually got that good, things never actually looked you in the eye and asked how they might be of service to people. Things served alright. But what they served was never people, rather the machinery that processed people into desiring mechanisms, made of them effects rather than causes of a system of production. It may well be that it is to the aesthetically less ambitious art of the German Neue Sachlichkeit that there falls the Pyrrhic victory of showing what mass consumption had actually come to mean: those calculatedly claustrophobic compositions where commodities look malevolently back at the viewer irrespective of whether their "souls" are those of a prostitute, a radio valve, a potted plant, or a carving knife.

A case can be made for modern art's having been forced onto its characteristic

terrain of subjectivity, expression, authenticity, and abstraction because of the absolute sway of the commodity in the historical experience of modernity. It is then a matter of the critic's choice how that move is interpreted: unwarranted retreat from the demands of realism or registration of the felt effects of alienation. Each stereotype had a place in the hall of mirrors that the twentieth century became after 1917. Those who attempted to occupy a tensioned middle ground, such as can be seen in Léger's Brechtian efforts, had a hard time establishing any real social resonance or independent path. In the end more of their weight rested on the foot planted in the avant-garde than the foot trailed in commodity culture, let alone in the socialist utopia.

The commodification of social life was continuous, involving a kind of concentric expansion in the century or so up to the outbreak of the Second World War. This is presumably why reading Aragon's *Paris Peasant* of 1925, all mildewed commodities swimming in the aquaria of the now grimy arcades, could have stimulated Walter Benjamin to begin excavating the sediments of Baudelaire's Paris. It is a fair question why he wanted to animate the detritus listed by Susan Buck-Morss as "corsets, feather dusters, red and green colored combs, old photographs, souvenir replicas of the Venus de Milo, collar buttons to shirts long since discarded" (Buck-Morss 1989, 4). This sounds like a description of the seabed of the ocean of commodities, whereas by replacing them in the world of their birth Benjamin could get a sense of what it felt like to be alive in the dawn of modernity, an experience hinted at by his own quotation from Balzac: "the great poem of display [which] chants its stanzas of color from the Madelaine to the Porte St. Denis" (Benjamin 1970, 157). Doubtless Benjamin loved the chase—a kind of weird commodity fetishism of its own displaced into the archive. But his express political hope for this project was to break the spell of the commodity: to provide a means of "awakening from the 19th century" (Buck-Morss 1989, 39).

It was as an outgrowth from his nineteenth-century studies that Benjamin produced his most radical reflections on the contemporary commodification of culture in "The Work of Art in the Age of Mechanical Reproduction." Much of its radicalism followed from a change of angle, a change represented in our terms by shifting attention from the symbolic dimension of art's representation of commodification to its condition *as* commodity. Even if it is allowed that modern art had been able to preserve a measure of truth in its expressed content by a strategic withdrawal from the terrain of the commodity, still the damage was done at a deeper level. For as art withdrew from the particularity of the world of commodities as depicted subject, its own being in the world as putatively spiritual product ("creation") was being undercut by the increasing commodification of the art object itself. The commodification of spirit made no exception for art.

Modernism is largely premised on the ability to bracket out one range of material factors while responding imaginatively to certain others: concentrating

on the text (both as material mark on a surface and as signifying in the picture space) and disregarding the context (both physical and, in particular, institutional-ideological). It is this diverting of attention that Benjamin refused. Instead he sought to do for the sphere of culture, understood as part of the superstructure, what Marx had done for the economic base of society, the capitalist mode of production: to analyze "the developmental tendencies of art under present conditions of production" (Benjamin 1970, 220). His maneuver is to relegate the categories in which modern art's then orthodox discussion was conducted—"creativity," "genius," "eternal value," "uniqueness," and "authenticity" are singled out—to the sphere of ideology; and instead to ground his analysis in material factors, most notably that art is produced and consumed *as,* and not just in, commodity production.

Part of the resonance, even the heroism, of Benjamin's essay is traceable to the justified contempt he feels for the cant surrounding art, for its treatment as a fake religion offering to its initiates experiences inaccessible to those preoccupied by the run of social experience in history. It is this aspect of his writing that has been an important exemplar to many who subsequently grew up in a culture organized very differently from Benjamin's own: one in which mechanical and electronic reproducibility have led to unforeseeable forms of cultural commodification. What has seemed to matter is the critique of elitism running through Benjamin's reflections on art and his explicit concern for a form of democratization in culture. Pointing out that, for all the religiosity surrounding it, art performed a by no means insignificant ideological role in the maintenance of a system of production consecrated around inequality had some of the character of a demonstration of the "emperor's new clothes." That said, however, the next move which Benjamin appears to license, and which many who would claim inspiration from him certainly make, is less secure: namely the argument that reproducible cultural products—photographs, films, records, videos, etc.—are fundamentally more democratic than painting or other traditional art media. When Benjamin argues that "painting simply is in no position to present an object for simultaneous collective experience" (Benjamin 1970, 236) the assumption is that "simultaneous collective experience" is an unqualified good. Under the impact of Bolshevism in general and Brecht's theater in particular this may well have seemed so. Whether such a belief deserves to survive Stalinism, Hitlerism, and Maoism is, however, not so certain.

Politically, Benjamin's essay tends to ultraleftism. Adorno was undoubtedly correct to see in it the apogee of Brecht's influence, of which he disapproved. More to the point, however, is the effect of the stance. In the name of historical materialism, Benjamin in the "Reproduction" essay leans towards a conflation of bogus spirituality with the imagination, a rhetoric of soul and spirit with subjectivity and contemplation per se. Unquestionably apposite as a rejoinder to the idealization of art, the essay downplays the possibility of the exercise of critical imagination upon the effects of art as a material force in history. It does

so because the productive system in which such effects are generated is implicated in the wider system of capitalist commodity production. Benjamin's argument effectively disallows relative autonomy in favor of a technologically grounded reductionism (as well as relying on a now surely questionable argument about film allowing the "correct politics" to be got across to its mass audience in a state of distraction). Adorno was quick to argue that Benjamin was guilty of romanticism by seeming to equate popularity with critical potential and just as quick to insist that the autonomy of a work of art was not synonymous with mysticism. For Adorno, both art and popular cultural forms "bear the stigmata of capitalism." Benjamin appears to argue that the commonly overlooked status of the work of art as a commodity makes over the rhetoric of art—as "value," "authenticity," etc.—into a symptom of commodity fetishism. Adorno by contrast insists that "consistency in the pursuit of the technical laws of autonomous art" does *not* "render it into a taboo or fetish" (Adorno 1936, 1977, 122–23). To the contrary, it is such concentration and consistency that makes of the work of art a (self-)conscious form of production which as such contains the seeds of critical interchange and learning. Adorno is able to accept that the commodification of production is total and that systemically art is not exempt—that art is produced under the *condition* of commodification—while preserving the possibility that as a bearer of *meaning* the independent work of art may enable reflection upon that condition.

The Adorno-Benjamin exchange took place in 1936, since when the status of the commodity and the implications of commodification for art have undergone further change. One of the points at issue concerns the nature of this change. Is it quantitative or qualitative? Has the process of commodification simply increased extensively such that more commodities, indeed more types of commodity, are around? Or has the process intensified in ways that have fundamentally altered the nature of "modernity": the context in which art gets made; and hence the relations of production, distribution, exchange, and consumption of art itself; and hence in turn, the kinds of meanings art can generate? In short the question is whether the contemporary situation of art in respect of commodity culture is continuous or discontinuous with the foregoing experience of modernity. This of course is the field of the postmodernism debate. Yet judgments about such issues in the field of art are complicated by parallel uncertainties about the relative balance of continuity and discontinuity in the economic mode of production per se (i.e., the question of post-Fordism); and not least also in politics (prompted by events such as the breakup of the superpower settlement—the question of a "new world order").

The present discussion has assumed that a claim for a kind of continuity can be made for the period spanned by Benjamin's work on Baudelaire (which begins with an observation about the arcades being constructed ca. 1830) and his "Reproduction" essay of 1936. Perhaps the salient point about commodification in this period is that, as Fredric Jameson has remarked of modernity

itself, it was noticeable because it could be contrasted with something which it was not: not modern, or not commodified (Jameson 1991). However far commodification went (and in Weimar Germany in particular the commodity form seems to have permeated society), various strands of cultural continuity, tradition, and value were in play which represented possible points of contrast and tension with commodified modernity. In addition there was the presence of a credible alternative form of social organization—in myth if not in reality—in the Soviet Union.

The period since the Second World War has, however, seen culture on a world scale increasingly dominated by the most consumption-oriented, and hence commodity producing, society in history. The global hegemony of the United States, in tandem with related technological developments, has resulted in a situation in which the commodity has become a kind of nature. Notwithstanding the persistence of "gifting" subcultures in the interstices of capitalism, there can be no doubt as to the pervasiveness of commodification. In particular the relatively recent explosion of information technology has seemed to reach into realms of subjectivity that, far from merely blurring the lines between commodity culture and nature, has generated doubts about the continuing viability of traditional distinctions between representation and reality itself. Of course for all its familiarity this is very relative. Stomachs still need to be filled. But at least in the developed economies there seems little doubt that people's conception of the world they inhabit is both more powerfully influenced by media representations of such a world than by any direct experience of it, and on a day-to-day basis is somehow more insulated from any checks of a fundamental "nature" than would have been imaginable only two or three generations ago. To the extent that the mind produces its reality (and any idea that the former merely reflects the latter is surely wholly untenable), the invasive commodification of desire, fantasy, play, identity, etc. which the new media technologies represent issues in forms of reality which are more commodified, more mutable, more provisional, and less "objective" than hitherto.

Such claims have become commonplace in the last quarter of the twentieth century, though their grounds were being laid in the preceding period, either side of the Second World War. As in the earlier phases of modernity, art continued to be affected along both its axes, as sign and object, although arguably it was not until the 1960s that the implications of the new levels of commodification permeating Western societies became the subjects of fuller theoretical engagement.

In terms of the framework employed in the present text, abstract expressionism can perhaps be seen as the limit of the avant-garde's resistance to commodification as subject. Given the reading of the impulse to expression offered above, no difficulty is presented by the apparent paradox whereby the most advanced artists in the most technologically advanced society on earth located their most fruitful resources of meaning socially in the depths of myth and psychically in

the depths of a conception of the integral self. For those who followed, the problem inherited from the first generation of the New York school was that the unforeseen effect of their work was now to have definitively commodified "expression" itself. Self-expression in art had become associated with a conception of autographic "style," particularly condensed around types of gestural abstraction; and such styles in the kind of art market that grew up in the 1950s became de facto trademarks serving to distinguish a range of products from its competitors in a marketplace. The principal ideological underpinning of the concept of expression in art had been the claim for its "directness" as distinct from the mediations and conventions of commodified modernity. Always philosophically questionable in principle, this claim was now exhausted in practice. The commodity had, so to speak, triumphed again.

With authentic expression reduced to cliché such truth as was available had now to be won not merely from but through the jungle of commodities. The strategy that emerged from this in the late 1950s and 1960s was one of citation, born of the perception of a distinction akin to that made in philosophy between "use" and "mention." If all was already subject to representation then perhaps that fact was itself not without contemporary significance. As different commodified forms were brought into juxtaposition on the plane of the artwork there was a possibility that something could be made to leak out around the points where their edges touched: between the quoted "expressive" brushstroke and the media photograph (Rauschenberg); between surface as painting and surface as emblem (Johns); or between the commodity and its multiple repetition, be it a can of soup or a Hollywood star (Warhol). The commodity stood guard over inwardness but, to paraphrase Althusser, the pup of critical reflection might still occasionally slip between its legs.

If, faced by commodification as the central subject of modernity, artists had recourse to increasingly oblique strategies of nomination, quotation, and marginally refunctioned display, then along the other axis of concern the commodification of the artwork itself proceeded apace. Beneath the impact wrought by hypercommodification on art at the symbolic level lay fundamental changes in the structure of advanced Western economies from the Fordist-Taylorist model of mass production, that is, away from commodity production in its standard sense, to what may be termed the production of commodified services. In the 1980s the production of manufactured goods in OECD countries increased by an average 3 percent per year. In the same period, between 1979 and 1988, the volume of trading on international equity markets rose from $73 billion to $1,212 billion.

This has had repercussions for the contemporary art market where trading has increased accordingly. Michael Carter has pointed out that even traditional trading in art, the buying of art from artists by dealers and its subsequent sale to collectors, was not wholly orthodox commodity trading. This was because the exchange values of art were not computable in terms of a labor theory of

value. Rather "the exchange value of the work of art resembles much more closely the ebb and flows of stocks and shares than it does the price of something like [a] can of soup" (Carter 1990, 105). Carter proposes a notion of "valorization," akin to the idea of "business confidence" in respect of the stock market (e.g., judgments of value and interest traceable to the support structures of art such as criticism, exhibitions, publications, etc.), as the source of art's exchange value. Carter describes this cycle as a mechanism of "simple reproduction," but argues that in the contemporary period this has been overlaid by a secondary system of valuations. "What marks the current situation off as different has been the rise and eventual domination of an investment market in art objects" (Carter 1990, 108).

The reasons behind this growth are varied, but one of the most significant is the reentry of the international system into cyclical crisis since the mid-1970s. Investment in art has become a form of defense against inflation at a time of widespread uncertainty in the economic system at large, somewhat in the way in which gold and other precious metals have functioned in the past. More so, in fact, given that at the height of the art boom in the late 1980s one of Van Gogh's *Sunflowers,* less than a square meter in surface area and presumably weighing no more than a few ounces, changed hands for $55 million. As Carter points out, in these circumstances once an artwork has entered the secondary circuit of commodification of investment and exchange between collectors "the exchange value of the original can become so concentrated and massive as to be almost radioactive with economic value" (Carter 1980, 123).

Such a state of affairs cannot but have an effect upon the practice as well as the theorization of art. What does it do to the critical power traditionally claimed for the avant-garde when a piece of work by a socially marginalized painter, whose own career was significantly marked by psychic as well as economic distress, exchanges for the price of a jet fighter? In terms of the *system* of art, the increased scale of the art market had the effect of further stimulating the cycles of innovation which had been a part of the modern system of the arts from the beginning. Artists and dealers alike sought the kind of differentiation from other products in the market which both conferred the related values of individuality and originality (themselves components of the "valorization" process) and also promised a share of the spiraling exchange values. That is, market success, or even market survival, fed back more powerfully than ever as a determinant on the form of production. What that process did to the public at large was to generate extreme scepticism about the use value as well as the exchange value of such art and to render it part of the fabric of hegemony rather than critical of it.

Supercommodification has had a dual effect on art at the level of its content: first, to render some form of address to commodification a sine qua non of adequacy; and second, seriously to undermine the distinction of avant-garde culture from more widely popular forms. This distinction had been a corner-

stone of modernism, as exemplified in the title of Clement Greenberg's 1939 essay "Avant Garde and Kitsch." In the literature of postmodernism (no more prey to self-doubt than its predecessor) it has now become commonplace to question such a distinction. John Tagg is only one author to have remarked—in the context of a discussion of the work of Martha Rosler—on a "situation in which it has become difficult to distinguish between the turn-over of styles of the newly successful art and that of other commodities" (Tagg 1992, 160), in particular those products of the entertainment industries which in a field determined by the dilation of information technologies have become arguably the most powerful sources of individual commodity purchasing *and* of self-image acquisition in the contemporary world.

It is the acceptance of just such a state of affairs as the ground of artwork that has underlain Jeff Koons's exploration of the boundaries of commodification: from the complete implosion of any distinction which might have been made between avant-garde and kitsch in terms of some primary authenticity to the character of the author figure himself ("My art and my life are totally one"). Koons has taken the normal artifacts of popular culture and brought out their strangeness often by doing little more than isolating them from the contexts in which they are usually encountered. Basketballs float in tanks. Vacuum cleaners, stacked two or three high, are lit by fluorescent lights in plexiglas display cabinets (Plate 19.1). Executive toys are cast in stainless steel. More recently, fugitives from the underworld of kitsch ornament see their coziness and sentimentality turned into a threat merely by the device of a change of scale or some other departure from the norm: an eight-foot-high wooden teddy bear; a life-size porcelain Saint John; a white Michael Jackson. More so even than Warhol and Duchamp before him Koons has laid out his identity as artist on the supermarket shelf, along with the videos, shampoos, and contraceptives. Posters depicting the artist as glamorous star advertise exhibitions. There are appearances on TV talk shows. Sexually explicit images of the artist and his wife, "La Cicciolina," transferred the display of commodified sexuality from the despised margins to the cultural center ground of the art gallery. And the whole thing is embedded in a seamless discourse of beauty, timelessness, and awe—the language of elevation, cheapened by commodity culture and repeated till the meanings come loose and float away. It is in this increasingly anomic realm in which we all now seem to live, where disasters jostle with fashion shows on the evening news, and religion and art have their slots in the schedules, that Koons's strange truth—the mirror of a mirror—arguably lies.

Koons's work poses serious questions cleverly, about jokes and authenticity. But that said, the snare that lies in wait for the postmodernist artist eager to declare her or his prepackaged subjectivity is scarcely less fatal than the pit into which the dinosaurs of abstract expressionism fell. Authenticity became commodified and to that extent expressively redundant. The problem for the postmodernist is that confessions of profound autocommodification have be-

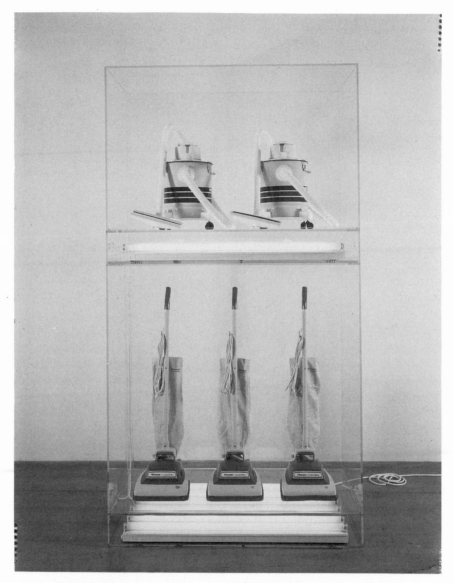

19.1 Jeff Koons, *Five Vacuum Cleaners, Plexiglas, Fluorescent Lights*, 1980–87.

come fashionable; and no marketable commodity can afford the next step—which is to become boring.

It seems clearer than ever that art is one form of commodity production in a wider field of cultural commodity production. What remains open to debate, however, is the extent to which the meanings generated by the resulting prod-

ucts can accrue added value. That is, the extent to which they can retain and articulate critical distance from the commodity system at large; or whether the "drag" of embeddedness at the economic level in the circuits of production, exchange, and consumption vitiates the possibility of distance at the level of the imaginative-symbolic.

Yet as the mode of production in developed economies itself undergoes transformation, even the grounds on which this question is posed are open to dispute. Fredric Jameson has written that the imperative to innovation in product lines "now assigns an increasingly essential structural function and position to aesthetic innovation," a situation which in his judgment demonstrates that "aesthetic production today has become integrated into commodity production generally" (Jameson 1991, 4–5). The English sociologists Lash and Urry view the situation somewhat differently, however. Following Baudrillard, they refer to an increase in "sign value," such that in Western economies "what is increasingly being produced are not material objects, but signs" (Lash and Urry 1994, 15). This, they claim, leads to a situation which "confounds the orthodox Marxist commodification theory of culture in which the culture industries become more similar to other industries in that what they produce becomes increasingly like any other commodity" (Lash and Urry 1994, 137–38). The point for Lash and Urry is less that cultural production has become commodified than that commodity production has become aestheticized.

In conclusion, then, while it would be premature to propose answers to the far-reaching questions of postmodernism, two observations can be reiterated. First, the influence of commodification has been pervasive on the arts in the modern period both economically and symbolically, and this pattern persists with mounting intensity however it may be precisely theorized. Second, a vital point at issue, though doubtless exacerbated at the present time, is of perennial standing: Is the realm of the commodity now seamless and total, and if so what are the implications of that? Or can independence from commodification be if not practically, then at least imaginatively, sustained? At the present time the possibility remains open that art can represent limits to the realm of the commodity, without recourse to fantasy and nostalgia. But the price is high in terms of the desire for popular resonance no less than the desire for political relevance. Representatives of resistance to total commodification may, indeed must, share more with the bathers and violins than they do with kitsch and propaganda.

Suggested Readings

Adorno, Theodor. [1936] 1977. "Letter to Walter Benjamin."
Aragon, Louis. 1971. *Paris Peasant,* translated with an Introduction by Simon Watson Taylor.
Baudrillard, Jean. 1981. *For a Critique of the Political Economy of the Sign.*
Benjamin, Walter. 1968. "The Work of Art in the Age of Mechanical Reproduction."

———. 1970. *Charles Baudelaire. A Lyric Poet in the Era of High Capitalism.*

Bloch, Ernst, Georg Lukács, Bertolt Brecht, Walter Benjamin, and Theodor Adorno. 1977. *Aesthetics and Politics.*

Brecht, Bertolt. 1938. "Popularity and Realism."

Bryson, Norman. 1990. *Looking at the Overlooked: Four Essays on Still Life Painting.*

Buck-Morss, Susan. 1989. *The Dialectics of Seeing: Walter Benjamin and the Arcades Project.*

Carter, Michael. 1990. "The Work of Art as Commodity."

Clark, T. J. 1985. *The Painting of Modern Life: Paris in the Art of Manet and His Followers.*

Gramsci, Antonio. 1973. *Selections from the Prison Notebooks,* edited and translated by Quintin Hoare and Geoffrey Nowell Smith.

Greenberg, Clement. 1939. "Avant Garde and Kitsch."

Gregory, C. A. 1982. *Gifts and Commodities.*

Jameson, Fredric. 1991. *Postmodernism, or the Cultural Logic of Late Capitalism.*

Koons, Jeff. 1992. *The Jeff Koons Handbook,* with an Introduction by Robert Rosenblum.

Lash, Scott, and John Urry. 1994. *Economies of Signs and Space.*

Lukács, Georg. 1971. *History and Class Consciousness: Studies in Marxist Dialectics,* translated by Rodney Livingstone.

Marx, Karl. [1844] 1975. "Economic and Philosophical Manuscripts," translated by Rodney Livingstone and Gregory Benton.

———. [1857] 1973. *Grundrisse: Foundations of the Critique of Political Economy (Rough Draft),* translated by Martin Nicolaus.

———. [1867] 1974. "The Fetishism of Commodities."

Mauss, Marcel. 1966. *The Gift: Forms and Functions of Exchange in Archaic Societies,* translated by Ian Cunnison, with an Introduction by E. E. Evans-Pritchard.

Tagg, John. 1992. *Grounds of Dispute: Art History, Cultural Politics and the Discursive Field.*

Collecting / Museums

Donald Preziosi

Already there is trouble with this title: this "critical term" may itself be a modest sign of the disciplinarity which is in fact one of the subjects of the essay. One of the pragmatic effects of the conflation of "museums" and "collecting" and of their unstable oscillation may be a masking of the revolutionary political history of museology in its Enlightenment beginnings (not to speak of in present debates), in favor of a (more seemly?) scenario of a technologically neutral "modernization" of earlier, more personalized or *dis*-ordered institutions—the curio cabinets, the private and princely collections, the Kunst-und-Wunderkammern of the sixteenth and seventeenth centuries. This still remains the most commonplace picture of museological "evolution" not only for the lay public but also among some museum professionals, even today—the modern, historically organized public *museum* being construed as a more rationally or systematically ordered version of these earlier "idiosyncratically" organized *collections*. But perhaps we can just leave this for now and not prolong an essay which might just as well be renamed "Museology and Museography," for such a title more closely suggests what the following is about, which by the way is organized in centripetal fashion:

(History (Art (Subject (Stage/craft) Subject) Art) History).

History

The museum is one of the most brilliant and powerful genres of modern fiction, sharing with other forms of ideological practice—religion, science, entertainment, the academic disciplines—a variety of methods for the production and factualization of knowledge and its sociopolitical consequences. Since its invention in late eighteenth-century Europe as one of the premier epistemological technologies of the Enlightenment, the museum has been central to the social, ethical, and political formation of the citizenry of modernizing nation-states. At the same time, museological practices have played a fundamental role in fabricating, maintaining, and disseminating many of the essentialist and historicist fictions which make up the social realities of the modern world.

The modern practices of museology—no less than those of the museum's ancillary discursive practice of museography (also known as "art history")—are a dimension of the distinctively modernist ideology of representational *adequation,* wherein it is imagined that exhibition and display may be faithfully "representative" of some extramuseological states of affairs; some real history which,

it is supposed, preexists its portrayal or re-presentation in exhibitionary or discursive space.

Museums are commonly constru(ct)ed as repositories or "collections" of objects whose arrangements in institutional space frequently simulate the geographical relationship, chronological situation, or evolutionary development of a form, theme, or technique, or of a person or people. In this regard, they are understood as being representational artifacts in their own right, portraying "history" or the past through objects and images staged as relics of that past. Despite the often fragmented or abstracted state of such specimens, their association in the museum constitutes a system of representation which in turn endows each item with an evolutionary direction and weight. Passage through museological space (which as we shall see is anything but Euclidean) is commonly formatted as a simulation of travel through historical time.

Museology and the various forms of museography which came to be professionally organized since the early nineteenth century—art history, connoisseurship, art criticism—have sustained the particular ideological practices and affordances of historicism, wherein the import, value, or meaning of an item is a direct function of its relative position in an unfolding diachronic array. Both have also operated in a complementary fashion to naturalize certain essentialist notions of the individual social subject and its agency: in this regard, both "objects" and their "subjects" may be seen as museological productions. For some two centuries, the museum has been a powerful and effective crucible in which modern historiography, psychology, ethics, and aesthetics have been brought into mutual alignment as coordinated and complementary systems within the Enlightenment project of commensurability—the transcribing of all human experience and expression into a common, universal frame of reference, into a common "language."

Art

The most powerful agency (or "frame of reference") by which the discipline of museology has been successful in its virtually universal colonization of the world's cultures is the totalizing notion of *art*. As one of the most remarkable of modern European inventions, "art" has been one of the most effective ideological instruments for the retroactive rewriting of the history of human societies.

Art has been the paradigm of all production from the beginnings of the Industrial Revolution onward: its ideal horizon, and a standard against which to measure not only all forms of manufacture, but also all kinds of individuals and societies. At the same time, the *artist* is the very paragon of agency in the modern world and remains so today.

The modern individual or subject is interpellated into its own position in the social order as a composer of its own life, in all of its facets. Ordinary habitation in the modern world is above all an occasion for the dramaturgy of

the self, as this may be reflected ("represented") in a subject's relationships to the objects (from pitchers to paintings) with which it surrounds itself—which it may have "collected"—and with which it carries out the routines of daily life.

This is an *ethical* practice of the self. As ethical artists, we are exhorted to compose our lives, from the most minute and private details to the larger public practices of careers, vocations, and social obligations and performances of all kinds, as "works of art" in their own right, and we exhort each other to live "exemplary" lives—those which may themselves be legible as representative artifacts, worthy of emulation. In no small measure, the languages of ethics and of aesthetics are virtually palimpsests of each other in the day-to-day enterprise of modernity.

The practices of museology thereby constitute a concordance between religion, psychology, historiography, and individual and collective governance (the Enlightenment ideology of "representative" government, wherein delegation, exemplarity, and substitutability constitute social representation). In this respect, the institution is a key ideological apparatus, a *discipline* for the production of the social realities and subjectivities of the modern world. That this has been a successful institutional enterprise may be clear; but the degree of its success is little appreciated, even today, for (as with most functionally effective ideological practices) the seeming luxury, marginality, or even disposability of the museum may be read in fact as the very mark of its totalizing achievement.

In the contemporary world, virtually anything can be deployed as a specimen *in* a museum, and virtually anything can be staged or designated *as* a museum. The very existence (and contemporary ubiquity) of the institution transforms most things into museological matter—into objects which, whether or not they might come to be (literally) situated in institutional space, invariably come to bear a concerted relationship to whatever is or might be so sited (cited). The entire made environment and its parts—indeed the entire biosphere itself—are touched by museological practice of some kind, to the extent that things not in museums are perforce "things-not-in-museums."

As the theater's existence ironicizes imagined divisions of behavior into the natural and the artificial, so the museum, by marking the world into the museological and the extramuseological, renders paradoxical distinctions between original and copy, reality and fiction, presentation and representation, while at the same time keeping such dualities in play. Whilst masquerading as an assemblage or "collection" of what pillage, patronage, or purchase has bestowed upon its treasuries, the institution in fact constitutes a *system of representation*—an ideological apparatus—that operates upon its users' imaginary conceptions of self and social order so as to render desirable and needed specific forms of social subjectivity and social reality.

It may be clear that within such a system of representations, "art" thus came to be *the* object par excellence of Enlightenment disciplinarity and its more

recent offsprings. What is less obvious is that this is an "object" which is at the same time an *instrument* of that enterprise: both the name of what might be museologically instantiated and museographically cited, as well as the (now largely forgotten) name of the *language* of study itself.

It is in this sense that the Enlightenment invention of "art" should be understood—as both a thing and a framing device or medium of expression; a parergonal instrumentality. As with the term "history," denoting equally a disciplinary practice of writing—historiography—*and* the referential field or "object" of that scriptural practice, "art" will be best understood in its fullest sense as the instrumentality or metalanguage of the museum's historiographical and psychical confabulations, as well as that confabulated world of objects itself.

"Art," in other words, is what museology and museography *practice,* as well as what that practice instantiates. The instrumental valence of the term has been largely (and quite successfully) submerged in modern museography in favor of the "objecthood" of art and all its metaphysical baggage.

Subject

As it has since the end of the eighteenth century and the rise of great civic and national public museums, the object of the museum—art—constitutes a method of organizing whole fields of activity so as to make legible, to give structure and point to, certain notions of the subject and its agency. Museum objects are formatted as representatives or even simulacra of the character or mentality of the subjects who produced them (individuals or peoples) and stand to be read as these effects or traces. At the same time, the work and its maker are transformed into a new disciplinary unity: the man (or the people)–*and/ as*–its–work.

The museum object in this sense serves to legitimize a subjectivity organized around notions of composure, consistency, and homogeneity of spirit and mission, as well as of order and clarity of purpose no less than of gender and station in life. In fact, this is the familiar bourgeois ideal of the social subject with a determined and determinate biography or trajectory; a curriculum vitae which must be tended carefully according to its position in the social order; a life which must be clearly legible as an ethical and moral masterpiece (however modest) in its own right.

Museums are heterotopic sites within social life which provide subjects with some of the means to simulate mastery of their lives whilst compensating for the contradictions and confusions of daily life. Virtual realities have always been what museums and art histories have engendered. What they have accomplished since the nineteenth century, in concert with their sibling Enlightenment disciplines and institutions, was nothing less than the disciplining of whole populations through a desire-driven interaction with objects that were object lessons in at least two principal ways: as documentary indices of a history of the world and its people, construed as teleological dramaturgy ("evolution"), as having a

direction and point and leading up to the spectator at the apex of this journey; *and* as simulacra of a richly varied series, a veritable cornucopia of subject-positions (ways of "being"-in-the-world) which might be admired, desired, emulated, eschewed, or forgotten.

Just as the museum object comes to serve as a perspective or window on history and evolution of styles, attitudes, values, or peoples, and on the wondrous diversity of human existence and expression, so also does the new modern social subject itself come to be constituted as an anamorphic perspective on the bits and pieces of its own life and experience. What the museum subject "sees" in this extraordinary institutional and disciplinary space is a series of possible ways in which it can construct or compose its life *as* one or another kind of centered unity or consistency which draws together in a decorous and telling order all its diverse, fragmentary, and contradictory experiences, its sundry device and desires. Museums put us in the picture by teaching us how to *be* picture-perfect. Ethics and aesthetics, in this virtual reality, are portions of the same museological Möbius strip, surfaces which only at first glance appear unconnected.

Stage/craft

The mechanics of this discipline are stunningly simple, even if their effects are enormously complex, subtle, and far-reaching. Consider the semiotic and epistemological status of the museological artwork. It has, in fact, a distinctly *hybrid* epistemological status, staged (as it has been since the modern invention of the museum) in a spatiotemporal framework of oscillating determinacy and causality.

On the one hand, the object's significance is perpetually deferred across a network of associations defined by formal or thematic relationships. Staged as a specimen of a class of like objects (which may or may not be physically present in the same space), each of which seems to provide "evidence" for the progressive "solution" to similar problems of representation, the object's meaning is literally "elsewhere" (in museographical space).

On the other hand, it is invariably foregrounded (whether or not specifically pedestalized) as unique and irreplaceable, as singular and nonreproducible, its significance or meaning rooted in its emblematic and expressive properties relative to (representative of) its maker or origin. In this respect, the very form of the work is always in some manner the figure of its truth—a truth connected directly and transitively to the vision, mission, intentions, mentality, or character of the maker or source (person, people, ethnicity, gender . . .).

As deployed in museographical exegesis and museological stagecraft, the museum object is thus simultaneously *referential* and *differential* in character. This "simultaneity," however, is akin to that of a "visual illusion," wherein there is an *oscillating* determinacy (as for example in the famous Necker cube), where either one or the other character is foregrounded at any one time, only to be

subject to a perpetual slippage or alternation with its other. In short, referentiality is paradoxically both the foreground and background to differentiality, and vice versa, in an oscillation or slippage which can never fully be fixed in place. Of course, historically, it has been this very oscillation or "incompleteness" of any one mode of (for example) art-historical "explanation" which has literally kept disciplinary discourse "in play" for so long. Rather like an alternating current, this oscillating determinacy is virtually invisible in "ordinary" (exegetical) light and is palpable primarily anamorphically, by reading or seeing "against the grain." . . .

All this is in fact epistemologically similar to the "object/instrument" character of "art" itself on a broader plane, wherein museological stagecraft (and museographical argument) generates a paradoxical, enigmatic, and indeterminate field of legibility. In attending to the "artifice" of museological stagecraft (and that of museographical demonstration and proof), the bivalent character of this extraordinary "object" may be rendered more visible.

In rendering the visible legible (which after all is the *point* of the discourse on "art"), museum objects are literally both *there* and *not there,* and in two distinct ways. In the first place, the object is both quite obviously *materially* part of its position (situation) in the historiographic theater of the museum (it's physically present in truth). Yet at the same time, it is unnaturally borne there from some other milieu, from some "original" situation: its present situation is in one sense fraudulent (this museum is not "its" place). In the second place, the object's *significance* is *both* present and absent, in the manner described above: its semiotic status is both referential and differential; it is both directly and indirectly meaningful.

For the museum user, then, the object's material properties, no less than its significance, are simultaneously *present and absent*. In being induced to reckon with—to cope with and think with—the truths of a museum object by imaging what might plausibly lie "behind" it, in its historiographic or art-historical reality as "specimen," the subject is nevertheless equally bound to it, "fascinated" with it (from the Latin *fascinare,* to bewitch), as somehow "containing" (or "being") its "own" explanation. Formalism and contextualism, as may have been clear all along, are prefabricated positions in the same ideological system of representation, codetermining and coordinated facets of the sociopolitical project of modernity.

Here, at the heart of the essay's center (rather than at its beginning), it might be useful to insert a quotation. It reads:

> Psychoanalysis and historiography thus have two different ways of distributing the *space of memory*. They conceive of the relation between the past and present differently. Psychoanalysis recognizes the past *in* the present; historiography places them one *beside* the other. Psychoanalysis treats the relation as one of imbrication (one in the place of the other), of repetition (one reproduces the other in an-

desire, must be continually (re)adjusted. (There's *always* more than meets the I/eye.)

History

On a global scale, art has come to be a universal method of (re)narrativizing and (re)centering "history" itself by establishing a standard or canon (or medium, or frame) in or against which all peoples of all times and places might be *seen* together in the same epistemological space, on the same botanical tables of aesthetic progress and ethical and cognitive advancement (historiographic anteriority and posteriority). Once this remarkable invention came to be museographically and museologically deployed, it proceeded, inevitably, to "find" itself everywhere, in all human productivity. Works of art were construed as the most distinctive and telling of human products, the most paradigmatic and exemplary of our activities, more fully revelatory and evidentiary in all their details than any other objects (apart from "subjects" themselves) in the world. All the world's things are thereby galvanized into greater or lesser approximations of this ideal.

To each people its proper and unique art, and to each art its proper position as a station on the historiographic grand tour leading (up) to the modernity and presentness, the always-alreadyness, of Europe (or "the West"). Against that, all that which was not (of) Europe was "objectified" as *anterior*. To leave Europe (this brain of the earth's body) was to enter the past (an alterity in the process of being transformed into the future anterior of political, economic, and social colonization and domination; into the field of play of entrepreneurial opportunism), the realm of everything that might be framed as prologue.

In the broadest sense, art is the very *esperanto* of Western hegemony. Museology and museography have been indispensible instruments of the Europeanization of the world. As a device for distributing the spaces of social memory within a totalizing schema of coordination and commensurability, art provided the means for envisioning all times and places and peoples within a common and universal and "neutral" frame. For every people and ethnicity, for every race and gender no less than for every individual, there could be imagined legitimate and proper art histories, theories, and criticisms, each in relationship to an aesthetic practice with its own unique "spirit" or soul: its own birth, maturity, and decline; its own archaisms and classicisms; its own stylistic and representational problem-solving adventures; its own respectability and its own geographical and chronological home or address. Neither mannerism nor Lower Manhattan neodeconstructivist parking meter graffiti should come as a surprise to anyone, for most museographic categories or art-historical "movements" are artifacts of the museological system of representations itself, and could have been predicted from the stagecraft of the post-Revolutionary Louvre of the early 1800s to that of New York's Museum of Modern Art of the 1930s.

The sheer brilliance of such a colonization—which (as with any heterotopia)

compensates for dominance and marginalization through the dissemination of essentialist and historicist fantasies of seemingly limitless horizons and great personal and collective satisfactions (however much, like a library book, they must be regularly renewed)—is quite truly astonishing. There is no "artistic tradition," no "aesthetic practice" anywhere in the world today which is not formatted or scripted through the terms of this epistemological technology and its system of representation. All this takes place, quite naturally (of course), in the very hands of the colonized (ourselves and others).

And the modernist ideologies of nation-statism, with all their terrors and salvations, are naturalized and "demonstrated" through the apparatus of the museum and the disciplinarity of art. One simply cannot today *be* a nation-state, an ethnicity, or a race without a proper and corresponding art, with its own distinctive history or trajectory which "reflects" or models the broader historical evolution of that identity—which bodies forth its "soul."

It is in this sense that museology and museography have so very profoundly *enabled* identity and allegiance of all kinds, and in all dimensions, from the ethnic group to the individual. They have been so indispensible to modernist identity, whether this is linked to ethnicity, class, gender, or sexual politics, that there is today the natural presumption that *any* conceivable identity must have its corresponding and proper (and presumably unique) material "aesthetic." To be lesbian no less than being Liberian (whatever else these might mean) necessitates "having" an art (and/or "enacting" one) within the contemporary enterprise of modernity—if one cannot be found immediately, one can be scripted and staged: art historians are grateful for the work.

As with other grand modernist fictions (such as "race") which form the "real" bases of social entitlements, art, once having been invented, not only structures thought and reorders perception (to the extent that it no longer has an outside that is clearly distinct—almost anything can "be" art in some context for someone, just as almost anything can be designated as a museum), but art also makes it difficult to imagine that there was ever *not* such a thing. To think our way back beyond art has always been to think our way back beyond the human.

So also does the museum, once having been invented and deployed, make it difficult to imagine a world in which a made thing could be anything *but* the reflection, effect, product, sign, or "representation" of some prior state or capacity, some intention or purpose. Which (to bring this essay full circle) is of course another way of scripting theology.

SUGGESTED READINGS

Bann, Stephen. 1984. *The Clothing of Clio: A Study of the Representation of History in Nineteenth-Century Britain and France.*
Butler, Judith. 1993. *Bodies that Matter: On the Discursive Limits of "Sex."*
Carruthers, Mary. 1990. *The Book of Memory: A Study of Memory in Medieval Culture.*

De Certeau, Michel. 1986. *Heterologies,* translated by Brian Massumi.

Déotte, Jean-Louis. 1993. *Le musée: l'origine de l'esthétique.*

Derrida, Jacques. 1987. *The Truth in Painting,* translated by Geoff Bennington and I. McLeod.

Finn, David. 1985. *How to Visit a Museum.*

Hooper-Greenhill, Eilean. 1992. *Museums and the Shaping of Knowledge.*

Impey, Oliver, and Arthur MacGregor, eds. 1985. *The Origins of Museums: The Cabinet of Curiosities in Sixteenth- and Seventeenth-Century Europe.*

Lacan, Jacques. 1978b. *The Four Fundamental Concepts of Psycho-Analysis,* translated by Alan Sheridan.

McClellan, Andrew. 1994. *Inventing the Louvre: Art, Politics, and the Origins of the Modern Museum in Eighteenth-Century Paris.*

Pearce, Susan. 1992. *Museums, Objects, and Collections: A Cultural Study.*

Preziosi, Donald. 1989. *Rethinking Art History: Meditations on a Coy Science.*

———. 1992. "The Question of Art History."

Walsh, Kevin. 1992. *The Representation of the Past: Museums and Heritage in the Post-Modern World.*

Value

Joseph Leo Koerner and Lisbet Koerner

Value would seem to be the most critical of terms. It is that which criticism, as an act of judgment or evaluation, decides about its object: whether, or to what degree, the object is true or right or beautiful. At its founding in the seventeenth century, the modern criticism of art took as its task evaluating works through a separation, or *krisis,* of the beautiful from the ugly by means of the faculty of taste. Interestingly, although taste was deemed to be more subjective than reason, the very activity of submitting an object to free critique, to a judgment whose rules were unaffected by beliefs in an absolute, was the legacy that art criticism bequeathed to philosophy. Indeed because of its distance from practical life, art—and with it the cultivated criticism of its value—opened up the possibility of those more subversive critiques of absolute values (Church, State, Law, and even Reason itself) that constituted the European Enlightenment.

The modern age was, as the critical philosopher Immanuel Kant put it in 1780, "in especial degree the age of criticism, and to criticism everything must submit." And criticism, the "test of free and open examination," began with the study of art. It first found its voice in the so-called quarrel between the ancients and the moderns, waged in the French academies in the late seventeenth century, in which the absolute value of tradition was contested by the different, and therefore relative, value of the present.

Yet at the same time as value judgments are criticism's goal, value and judgment themselves are—and were from the start—the troubled objects of criticism. Even as it submitted "everything" to critique, human judgment was itself open to critique. Indeed, within the critical tradition inaugurated by Kant, judgment was deemed the origin of those values it appeared to adjudicate. And once again, it was the criticism of art that framed this inversion. For what taste demonstrated most clearly was that the source of value lay not in the judged object but in the judging subject. Discussions specifically about art's value thus occupy a privileged place within modern thought about value generally, and it is this philosophical tradition that we shall first review before turning, in parts II and III, to specific economic and critical theories of value in art.

I

Modern aesthetics began as a science of *subjective* criticism, of an evaluation of the object not *as it is,* but as it is *for us.* Voltaire's definition of beauty in the *Philosophical Dictionary* (1764) expresses nicely this essential relativity of the

aesthetic by imagining the beautiful from a perspective radically dissociated from "us:" "Ask a toad what is beauty, the Beautiful, *to kalon,* and he will answer that it is his she-toad." In this variation on the antique argument about the anthropomorphism of the gods, aesthetic evaluations bear the image of the critic (as Voltaire himself betrays when he presupposes judges to be male and the judged to be female). Thus the obviously subjective character of the values particular to art gave art a new centrality during the age of criticism, as the privileged instance of the subjectivity of all values, whether religious, political, or ethical.

It is this self-critical legacy of the term "value" that is dominant in contemporary art history. To speak of value today is rarely to reach a judgment on the beauty of an art object. Such evaluations, held to be mere relative judgments of values that are themselves relative, have been largely purged from academic practice and annexed to the journalistic practices of "art criticism." Or they have become part of the discipline's self-policing activities, where they thrive within judgments reached not about artists, but about other art historians (in book reviews, recommendation letters, and pedagogy). Value, as a critical term today, functions instead to submit to a higher court those judgments which— erroneously—propose themselves as objective statements about the artwork. It functions to expose such judgments as projections of the evaluating subject and to ask how, given their relativity, they acquire authority.

And of all the values which contemporary art history renders relative, the most central is that of art itself. Art, it is discovered, is not a quality of the object, but a valuation by the subject; like beauty, art is in the eyes of the beholder. This verdict is commonly reached against what is postulated as the "common" opinion (or superstition) which would hold that aesthetic value is an inherent property of objects and a kind of ineffable thing. The history of aesthetics, however, reveals how rarely such an opinion was ever current. Since for centuries the commonplace had been that *de gustibus non est disputandum* (there is no disputing concerning matters of taste), it would seem that the critical debate over value in art remains stalled at its shadowy origins in the baroque quarrel between the ancients and the moderns. More specifically, in the absence of any seriously held modern aesthetic absolutes, historians of art today forget that their critical position is not only old, but also normative within the aesthetic tradition that we seek to overturn. For, to reiterate, since the Enlightenment it has been art's founding task to submit all absolute values to critical judgment.

The central modern problem for the study of value in art, then, has been neither the invention and maintenance of universal norms, nor the relativization of such norms through critique, but rather the investigation of how, in spite of our "common" expectation of the radical subjectivity of taste, there exists any consensus about the "greatness" of certain works of art. The most sober and compelling account of the social and institutional conditions of aesthetic

consensus is that of the sociologist Pierre Bourdieu. Writing against what he terms "the religion of art," Bourdieu sets out to discover the essentially social function of art. It might seem, he argues, that the experience of art, and the values that derive from that experience, are available to all people equally and individually, in, say, the "public" museum, and, further, that good taste is innate (a sort of secular state of grace). In reality, however, aesthetic experience is a learned disposition, and therefore an inherited privilege mediated by the institutions of family and school. Art's value in modern society, Bourdieu argues, derives from this play between private subjectivity and social reality. Value *seems* to be a judgment made freely by the individual in his or her irreducible subjectivity, and good taste *appears* therefore to be a natural proclivity. *In fact,* these are ways of maintaining social distinctions by masking the real privileges that enable judgments in the first place. Here we encounter one "objective" approach to the subjective value of art, for it discerns in the realm of the aesthetic, and in the value of privacy and subjectivity cultivated there, the social negotiation of power. Since the late 1960s, this critique of taste has been extended beyond Bourdieu's emphasis on class to dismantle other socially reproduced "distinctions" such as race, gender, and ethnicity.

In his ironizing treatment of the art lover as last true believer in predestination, and in his controlling analogy of art and religion, Bourdieu links back, via Karl Marx's attack on religion as "opiate of the people," to the Enlightenment critique of all prejudices and superstitions. Yet in his insistence that judgments of taste are the inherited markers of social class, Bourdieu is also heir to Friedrich Nietzsche, who argued in the *Genealogy of Morals* (1887) that the logical distinctions between true and false, as well as ethical ones between good and evil, are in the end distinctions of taste, which are themselves the results of "genealogy," the consequences, that is, of high and low birth. The foundation of values in aesthetics, and the grounding, in turn, of aesthetics in class, leads Nietzsche not to a sociology of art, however, but to the contrary: an aesthetization of the social. His philosophy, a self-proclaimed "reevaluation of all values" that took as one of its guiding aphorisms that "there are no states of fact as such" but "only interpretations," aspires to be a new form of art. For Nietzsche believed that only art, the most subjective of values, can express the concealed subjectivity of all values. This had also been the position of the early German romantics who, at ca. 1800, argued that the highest form of philosophy was art criticism and that the highest form of art criticism was the artwork.

Here is proclaimed the "religion of art" Bourdieu so detests, where the singularity of the aesthetic object replaces monotheism's God. Yet at its founding, modern aestheticism did not celebrate art as an absolute value, but rather as the fullest consequence of absolute value's historical impossibility. Modern art or, more precisely, art produced as emblematic of modernity, as "avant-garde," declared its own value to be precisely the *revaluation of value*. It might seem today that the moment of "modern" art is over, with its celebration of the

more than exceptional artistry, the Renaissance began to champion craftsman-ship. In 1435 Leon Battista Alberti even stated that the painted simulation gold was better than real gold. And in the modern period, craftsmanship became eclipsed by the value of artistic genius, which, because of its historical rarity, was believed to make the chance stroke of a pen more valuable than either gold or golden illusions. Of course, this neat historical scheme fits only for some areas of culture. Even in the Renaissance, objects of expensive materials were priced higher than great paintings; and today the mass-marketing of collectibles (e.g., products of the Franklin Mint) continues to appeal to a faith in material value by advertising in the object the presence of gold, pewter, leather, oak, etc.

In this century, the concrete history of value has even historicized the historicism of *Bildung*. The ideal of *Bildung* assumed that, however different the past is from the present, its value both then as now lies in its being *experienced* by the subject. Historians of premodern literature, such as E. R. Curtius and Erich Auerbach, as well as materialist historians of art, such as Baxandall, have uncovered radical differences in the social and perceptual uses of art. Within these concrete histories, the Middle Ages becomes the quintessentially other past. For the Renaissance, antiquity had been the privileged historical culture. Yet even as it differed from the present, and even more so from the immediate past (those ages mere "middle" and rejected as "dark" by the Renaissance), antiquity's value was as a timeless norm set against the vagaries of fashion and the threat of decline. At around 1800, the new taste for medieval art effected a different historical consciousness. The Middle Ages were valued not as time-less, but as a time of different values, as a period which, by its grotesque departure from normative aesthetics, evidenced the historicity of value.

The otherness of the Middle Ages supported modern art's break with the past, as well as the romantic cult of originality, which universalized difference itself as the index of value. And it proved that each epoch defines art differently, demanding that values be explained historically. Reconstructing the local histo-ries of "art in context" thus became one of the first tasks of the nascent discipline of art history as it emerged in the nineteenth century.

Both the "religion of art" and its critique thus had roots in the romantic reception of the Middle Ages. Art was sacralized as the response to a dual awareness that the sacred, which was believed to have dwelt with humanity during the medieval "age of faith," had withdrawn during the "age of reason," and that "art itself," as Hegel wrote in the *Aesthetics*, "considered in its highest vocation is and remains for us a thing of the past." The historical study of art, which brackets judgments of value and avoids analyzing contemporary art, begins by confronting the pastness of *both* value-certainty and "true" art. Hence-forth, art's value is constructed nostalgically, in innumerable antimodernisms which, as Nietzsche does, tap the artwork with "a hammer" and hear the "fa-mous hollow sound" of the idol.

Even a critic as radical as Walter Benjamin works within such a nostalgia. In his essay "The Work of Art in the Age of Mechanical Reproduction" (1936), Benjamin argued that the transition from the Middle Ages to the modern period meant, for art, a dwindling of its value. The medieval cult image, always singular and tied to one time and place, possessed a power or "aura" lacking in the modern art object which, through printing and photography, is infinitely reproducible. Modernity, effecting art directly through new production technologies, reveals (so Benjamin argued) its bankruptcy through the hollowness of its images. The ability to see through the aesthetic value of the present thus seems to engender an idealization of a vanquished past. The rehabilitation of the Middle Ages, which founded art history's relativizing stance towards aesthetic value, at the same time established the value of history itself. By 1903 the great Viennese art historian Alois Riegl, in his essay on "The Modern Cult of Monuments," could place aesthetic value outside his purview and treat only age value and historical value.

II

Of course, there exist approaches to the value of art that are free of nostalgia. If one were to want to analyze the value of art on wholly relative grounds, there exists an entire discipline that has value-relativity as its basis, namely neoclassical economics. For contemporary economics understands that individual human intentions and beliefs are largely unavailable to systematic analysis; it therefore leaves these unstudied—"black-boxes" them, as it were—defining value as exchange quantified in price. An economics of art thus would not explain the value a culture accords to art as such. Rather it would classify art objects (alongside other valuables like gold coins and tulip bulbs) as both monetary instruments and commodities. Nor would the economics of art easily explain differences in the value among art objects, or historical shifts in taste (e.g., why the 1920s bought rococo art, while the 1980s cared for impressionism). Instead, an economics of art would investigate the structure and periodization of art markets, the economic properties peculiar to artworks, and the role of state powers in determining supply and demand. And it would study the networks of dependencies among the agents which evaluate art: auction houses, dealers, museums public and private, artists, art schools, collectors, critics, and art historians.

In an economics of art, liquidity of capital would be a key variable. For the premodern period, wealth is largely in the form of land, which is largely illiquid. When in 1754 the king of Saxony bought Raphael's *Sistine Madonna* for about £8,500 (about $280,000 in 1994 U.S. dollars), this was the highest price ever paid for an art object in the West. The art frenzy of the 1770s, 1920s, and 1980s, by contrast, were correlated to "new money" (from sugar, oil, and finance) which occasioned inflated prices for top-end *unica* such as art objects and antiques.

An economics of art would measure the availability of art objects, as well. Again this is largely a function of modernity, when on an unprecedented scale individual artworks were pried loose from their hereditary surrounds: for example, the French Revolution's looting of noble property and Napoleon's secularization of church property and confiscation of works of arts as war indemnity—most famously from the pope in 1796. In England, one key event was the Settled Lands Act (1882). To help an aristocracy rich in assets and short of cash, the act allowed the sale of entailed chattel (provided that proceeds went into trust). Led by the Duke of Marlborough, the British aristocracy began alienating heirlooms to—as *The Times* put it in 1884—"the Rothschilds, or Vanderbilt."

* * *

An economics of art would also study the establishment of sales channels such as auction houses (e.g., Christie's in 1766), alongside the rise of public art institutions, such as the Louvre (1793) and the Metropolitan Museum (1870). For museums support the value of a marketed art object by reverentially displaying its "priceless" twins, rather like the gold once held in public trust against paper currency. Moreover, as art objects pass into the museum, the numbers available for private purchase decrease. As location theory in economics predicts, these "flagship" organizations also become nuclei for geographic clustering of art production and consumption—e.g., the postwar New York "art scene" with its mutually supportive, because competitive, network of producers, consumers, agents, and banks (i.e., museums).

An economics of art would also study the economic peculiarities of the art object itself: a consumer durable not depreciated over its lifetime and (excepting works by living artists and by forgers) in shrinking supply. The art collector's faith that art has increasing value translates into inflation-hedge hoarding. The possession of art also implies an elite economy of heirlooms, and it evidences its owner's taste. And this prestige is intrinsic to the purchase. A New York art gallery sells not only an art object, but also an experience—that of belonging to an imaginary commonwealth of connoisseurs. Also, as Thorstein Veblen proved (in *The Theory of the Leisure Class,* 1899), at the top end of the market the price of an object is *itself* part of its customer-perceived value.

Finally, an economics of art would have to frame twentieth-century art markets in the context of state powers, such as currency-exchange controls, tariffs, and criminal law. Since the reporting duties of art dealers lag behind those of financial institutions, art objects are vehicles for money laundering (i.e., the transfer of criminal profit into the formal sector). A more central variable, however, is tax law. In postwar Europe, Japan, and the U.S., death duties for the wealthy range from about 50 percent to over 100 percent of the total estate. Art objects, however, are commonly taxed differently at death (their price being decided, according to some tax laws, by the estate itself). The boom in impres-

sionist art in Japan in the 1980s, so often explained in cultural terms as an exotic potlatch, was driven partly by the way artworks were exempt from certain death duties (Japanese corporate tax laws played a role, as well). Art can also be donated to a public institution in lieu of tax payments, which helps explain the transfer of art into the public realm. An economics of art would thus draw forth a central irony of the twentieth-century history of art's value. For among private collectors, art is typically celebrated as priceless, that is, as part of a family lifeworld opposed to the commercial and contractual nets of obligation cast across ordinary society. Yet the family artwork, passed down the generations, and acquiring the aura of an heirloom (token of love and loss), is also again made, through the mechanism of death duties, commercial.

Neoclassical economics black-boxes human intentions and beliefs by assuming that people are autonomous, self-interested maximizers of utility. Value is thus equated to price. Cultural anthropology in turn opens that black box and encounters a person's or a culture's own narrative of meaning (what Clifford Geertz calls "thick description"). Value is thus taken to be a relative and culturally specific category of thought particular to the observed subject. Anthropological studies of marginal or non-Western people often set out to prove there exist no transcultural values for art. Nicholas Thomas's model of "entangled objects," for example, traces how the valuation of things changes as they pass across cultural lines. Thus if an economics of art is a material and mathematical macrotheory of how art objects circulate, an anthropology of arts is a nominalist record of local narratives of that circulation as told by its agents. Cultural anthropology and neoclassical economics thus complement each other. Both are descriptive, enumerative, Baconian sciences, which limit themselves to recounting their subjects' own notions of value in art (anthropology) or the material effects of those notions (economics).

III

The present-day discipline of art history makes use of more generalizing accounts of the value imputed to art, however. The four dominating influences here, received from the fields of economics, anthropology, linguistics, and psychology, respectively, are Karl Marx, Marcel Mauss, Ferdinand de Saussure, and Sigmund Freud. Current critical theories of the art object as a valuable are usually patchworks or bricolages of all four, mediated by a host of revisionists and earlier *bricoleurs,* until they achieve a quite bewildering complexity. Uniting most such attempts, from Georges Bataille's "general" or "sacrificial" economy to Jean-François Lyotard's "libinal" economy and Jean-Joseph Goux's "symbolic" economy, lies the attempt, mounted against neoclassical economics abstracting rationalism (which is viewed not as an explanation, but as a symptom of the modern economy), to account for the irrationality of art value without falling into a reactionary aestheticism.

The basic project of explaining culture through a more fundamental econom-

ics is modeled, of course, on Marx, who, in *Capital: A Critique of Political Economy* (1867), argued for a historically situated, yet universally valid, concept of value in art, which could only fully emerge in a communist utopia, located at the far end of history. This value he located in the *work* that went into the art object. Work, properly, was the site where "man" realized his true nature in an immediate encounter with the material world, an encounter uncontaminated by societal exchange relations (that is, commercial production, trade, and a money economy). Thus Marx located the value of an object of art in its particular manner of production. Since he also periodized history according to how goods are produced and circulated, Marx was able to fashion a critique of value for the present, which more broadly took the form of a critique of ideology.

Marx's account turns on the distinction between appearance and reality, a distinction which, in turn, he founded in a notion of value. "Value, therefore, does not stalk about with a label describing what it is. It is value, rather, that converts every product into a social hieroglyphic." From the outset, then, Marx assumed that capitalism's cultural forms are categorically false, and this can be discovered in a philosophical reflection on value. "Later on, we try to decipher the hieroglyphic, to get behind the secret of our own social products." "Secrets" and "cryptography" are, then, the founding epistemological metaphors for historical materialism's hermeneutics of suspicion, which purports to unearth through its critique of capitalism's self-presentation the hidden substrata of its "reality."

In *Capital,* Marx argued that within capitalism a man-made object is, from the point of view of its "use value," only "a thing," "a useful thing." Yet from the point of view of its "exchange value," it embodies a quantity of "abstract labor," which he conceptualized as the (quantifiable) work that had gone into its making. Here he attempted to mathematicize Adam Smith's labor theory of value, arguing that since it is possible to exchange commodity X for commodity Y, it follows that X and Y have a common content over and above a money value expressible in price. (The reasons Marx assumed such a common content are complicated, relating to German idealism and to the moral critique of money economies ubiquitous in nineteenth-century German thought.) Marx reified the supposedly common content of commodities as "abstract labor," which he then used to turn the premises of his argument into the conclusion. His analysis of value closes with the statement that for commodities produced within "the *differentia specifica* of capitalistic production," "abstract labor" is the basis for "exchange value."

Having established his critical labor theory of value, Marx then developed a theory of value specific to art. He argued that bourgeois aesthetics are a half-involuntary, half-deliberate screening technique intended to mystify the true nature of the activities it purports to portray (which is to say, the capitalist mode of production and its extraction of "surplus value" from working-class

labor). As Marx also put it, cultural production under capitalism aims to hide the "mathematical" fact that "in capitalistic production, [man] is governed by the products of his own hand." Marx theorized that governance in terms of what he called the "fetishism of commodities." "A commodity is therefore a mysterious thing, simply because in it . . . a definite social relation between men" assumes, in their eyes, "the fantastic form of a relation between things." Commercially manufactured objects, he charged, were "grotesque" "social things" or "fetishes"—akin in their functions to spiritualist sessions, black magic, necromancy, and the "mist-enveloped regions of the religious world" generally (see the essays in this volume on "commodity" and "fetish").

The term "fetish" derives from *"fetisso,"* a pidgin word originating in sixteenth-century Afro-Portuguese trade jargons along the coast of West Africa and denoting indigenous African spiritual practices, and particularly small cult objects such as amulets. In the Enlightenment, its elaboration became the basis for a theory of primitive religion, shorthanded as "fetishism" and characterized by a misplaced reliance on hypostatic concrete loci for expressing value. For Marx, who had hit upon the "problem-idea" of the fetish in 1842 when reading Charles de Brosses's *Du culte des dieux fétiches* (1760), the term shorthanded how capitalism induces false consciousness, or "fixes personal consciousness in an objective illusion" (William Pietz). Thus by use of the analog of the fetish Marx distanced himself from the false values of his *own* culture by making that culture into an *other,* comparable even to what in the nineteenth century was considered as savage black Africa.

By the early twentieth century it became clear even to Marxists that the Western working classes, instead of becoming increasingly impoverished, had become consumers, "extending the circle of their enjoyment." In consequence, Marxist philosophers began to turn their attention from production to consumption. How, they asked, is mass consumption perpetuated? By what mechanisms are we turned into consumers, in the sense of people whose psychic structures are dependent on repeated purchases? In *History and Class Consciousness* (1923), Georg Lukács coined the term "reification" to describe what Marx had called the "fetishism" of commodities and described as "the fantastic form of a relation between things." Here, Lukács argued, the bourgeoisie isolated discrete aspects and moments from the complex and changing reality of late capitalism and attributed to them a thinglike status. Along these lines, Theodor Adorno, and more generally the "critical theory" of the Frankfurt school, argued that reification had become the central organizing thought mode in modern capitalism, pervading every aspect of society. They thus explained the ongoing consumption of artifacts in our society as a sort of systemic error of categories within the realm of value.

The critical understanding of value received new frameworks through French thought in the late 1960s. In the context of political upheaval, and under the influence of Saussure's semiotics (the "science which studies the role of signs

as part of social life"), philosophers in France aspired to fashion a new, radical economics. Today, Jean Baudrillard's *For a Critique of the Political Economy of the Sign* (1972) is perhaps the most remembered of these attempts. Following Lukács, Baudrillard emphasized consumption over production as the key economic and social activity, and he treated it as a form of labor that utilized neither tools nor objects but rather signs, which he argued "simulated" objects to create a "hyperreal" social order. Lukács had already attributed to commodities the "objective forms of bourgeois society together with all subjective forms corresponding to it." Baudrillard further specifies commodities as those signs whose manipulation constituted the work of the consumer. And borrowing from Saussure the doctrine that signs do not signify individually, but "diacritically," in their twofold difference from what they represent and from the system of other signs, Baudrillard proposed that while consumption seemed to consume the object (the commodity), in fact it consumed and thereby reproduced the whole code or "system of objects."

Baudrillard's "economy of the sign" reopened the Marxist theory of fetishism, as well. Where Marx had set fetish value against use value as false against true, Baudrillard declared use value to be itself a fetish, the last vestige of "magical" essentialism in Marx. And tracing the word back to its Latin roots, he argued that the fetish was above all a "*fabrication,* an artifact, a labor of appearances" substituting the "manipulation of forces for the manipulation of signs." Economics therefore fell under the purview of semiotics. The production, exchange, and consumption of commodities was no longer a science of abstract values measured as price, but had become a signifying practice no more rational or stable than art.

Baudrillard acknowledged that this cultural interpretation of economics owes much to anthropology, and particularly to Mauss's monumental essay on the gift (1925). Mauss sought to uncover the "reason" behind a system of exchange that seemed, to observers familiar with market economies, unreasonable: the elaborate gift-giving practices of "archaic societies." By studying the total system of goods and services within these societies, Mauss discerned the logic of the gift. Given freely, with no explicit demand for payment, the gift nonetheless brings with it an obligation to reciprocate. Gift economies are thus exchange economies in a different form. Individuals give gifts not in order to receive greater countergifts, but to represent their status through the scale of their gift. Where Marx argued that commodities replace relations of men with relations of things, Mauss discovered in the gift an exchange system where things were regarded as persons, indeed where the gift bore the "persona" and sometimes even the portrait of its giver, and where, through the obligation to reciprocate, that persona would return to the person in the fullness of time.

The most elaborate and apparently "irrational" form of gift giving, in Mauss's account, were the potlatch rituals of indigenous peoples of the American Northwest. There gift giving was an overtly competitive power struggle; victory was

judged by the size of the given gift; and consumption and destruction of goods went "beyond all bounds." Yet even here Mauss discerned "a system of law and economics" as coherent as our own. In keeping with his teacher Emile Durkheim's founding assertion that "there are no religions which are false," Mauss extends anthropology's relativistic approach to value into the domain of economics.

Where Mauss discovers in potlatch a form of reason in a seemingly unreasonable economy, Baudrillard exposes the irrationality of the rational market economy by reading it as potlatch. If in the economic order accumulation was privileged, in the "order of signs (of culture), it is mastery of expenditure that is decisive." Since commodities function by their being consumed, and since what is consumed is the total system of commodities, modern society is constituted in an ongoing, though veiled, potlatch. For Baudrillard, the clearest emblem of this conflagration of goods as signs is the art auction. There, within a competition of expenditure, pure economic signs (money) are exchanged for the pure signs of culture (paintings), proving that even while art's value is fully relative, this "irrational" relativity is what maintains the social order of consumption.

The outlines of Baudrillard's critique are not new. They owe much to Veblen's theories of sumptuary value and to Bataille, whose *Accursed Share* (1967) proposed a "general economy" of excess, sacrifice, and reckless expenditure which would subsume conventional economic theories of scarcity and use. And it is anticipated by Werner Sombart, who in 1922 traced the origin of modern capitalism to late medieval culture's demand for luxury goods (Richard Goldthwaite's *Wealth and the Demand for Art in Italy, 1300–1600* [1993] is an interesting inflection of this view). What Baudrillard and other semiotic receptions of Marx provide for critical art history are the tools, on the one hand, to treat economies as legible signs, and therefore as representations analogous to art and, on the other hand, to treat art objects, alongside all other "things," as having "a social life" (Arjun Appadurai), thereby opening the discipline to the whole of material culture.

Crucial to the economics of the sign's applicability to art value is its account of aesthetic pleasure. Baudrillard, like other French theorists such as Louis Althusser and Julia Kristeva, derives this account largely from psychoanalysis. Freud himself explained art value by the theory of "sublimation," which held that sexual desires are "diverted" from sexual aims towards new ones constitutive of culture. However, critical value theory, perhaps because of its Marxist foundations, or perhaps because it rejects sublimation theory's elevated notion of culture, looks instead to Freud's theory of fetishism for its account of aesthetic pleasure. In *Three Essays on Sexuality* (1905) and the essay "Fetishism" (1927), Freud analyzes cases where "the normal sexual object is replaced by another which bears some relation to it, but is entirely unsuited to serve the normal sexual aim. . . . Such substitutes are with some justice likened to the fetishes in which savages believe that their gods are embodied."

Freud's account of the origin of the fetish is a classic instance of psychoanalytic myth making. The fetish, Freud proposes, "is a penis substitute." And well aware that this definition is a "disappointment" to his reader, he identifies it as "a particular, quite special penis" that was important to childhood but was lost, namely "the woman's (mother's) phallus which the little boy once believed in and does not forego—we know why." The boy cannot countenance the "lost" penis because its absence foretells his castration; he denies its absence by substituting for it something in which his interest had been "held up at a certain point" in the events leading to his discovery: his mother's shoes, stockings, underclothes, etc.

Freud classifies fetishism among the "perversions," defined as deviations from the "normal" sexual aim: the "union of the genitals." Constructed within the little boy's ocular retreat from the mother's genitals to something else, fetishism becomes the master plot for all wishes that do not achieve their end. Since in Freud copulation is banal compared with "perverse" expressions of desire—for example, in intimate life, all play and pleasure around copulation; in psychopathological life, the symptoms which are Freud's working material; in cultural life, art, thought, and psychoanalysis itself—fetishism maps the massive detour of most of our pleasures and activities. To explain our culture's overvaluation of art as fetishism is not to criticize it as false, but simply to trace it back to the underlying structures of want, loss, and exchange that, as Georg Simmel argued in *The Philosophy of Money* (1900), establish the idea of "value" as alone commensurate with that of "being."

The efficacy of fetishism for defining value as a properly critical term for the history of art has more specific grounds than this, however. Both for Marx and for Freud, the fetish is a function of *sight*. In Marx, commodity fetishism's substitution of objects for subjects occurs in the "eyes" of men, and Marx compares the error to mistaking "the subjective excitation [of light] of our optic nerve" for "the objective form of something outside the eye." In Freud, sexual fetishism originates in the voyeuristic glance of the boy's eye at the absence of the mother's phallus, and the retreat of the eye to the fetish that fills in that absence. The preeminence of the eye in narratives of fetishism suits well a discipline devoted to visual objects. Of course, in its original early modern usage, the term "fetish" or "*fetisso*" named the non-Western Other's valuables—or art objects—as idols, or even worse. Marx's critique of commodity fetishism, like Nietzsche's "twilight of the idols," stands both within the Enlightenment critique of religion as "superstition" and within Judeo-Christian iconophobia, which conflates idolatry and wealth in the figure of the Golden Calf. Even fetishism's scandalous past in the language of colonialism works to the advantage of a self-consciously critical art history, for, turning the charge of idolatry and magic back on to Western art, it figures the art historian not as idolater of aesthetic value, but as iconoclast. Fetishism thus defines value as a critical term not *for* art history, but *against* it.

In sum, assumptions about value are inescapable in the study of art. Even

the most iconoclastic histories, which expose as fictive the intrinsic worth of their object, art, presume the value of iconoclasm itself. Art retains its traditional value as the privileged site of cultural critique.

SUGGESTED READINGS

Appadurai, Arjun, ed. 1986. *The Social Life of Things: Commodities in Cultural Perspective.*

Bataille, Georges. 1991. *The Accursed Share: An Essay on General Economy,* translated by Robert Hurley.

Baudrillard, Jean. 1981. *For a Critique of the Political Economy of the Sign,* translated by Charles Levin.

Baxandall, Michael. 1972. *Painting and Experience in Fifteenth-Century Italy.*

Benjamin, Walter. 1968c. "The Work of Art in the Age of Mechanical Reproduction."

Bourdieu, Pierre. 1984. *Distinction: A Social Critique of the Judgement of Taste,* translated by Richard Nice.

Ferry, Luc. 1993. *Homo Aestheticus: The Invention of Taste in the Democratic Age,* translated by Robert de Loaiza.

Freud, Sigmund. 1962. *Three Essays on the Theory of Sexuality,* translated and revised by James Strachey.

———. 1963. "Fetishism," translated by Joan Riviere.

Geertz, Clifford. 1973. *The Interpretation of Cultures.*

Hegel, Georg Wilhelm Friedrich. 1975. *Aesthetics: Lectures on Fine Art,* translated by T. M. Knox.

Kant, Immanuel. 1987. *Critique of Judgment,* translated by Werner S. Pluhar.

Lukács, Georg. 1971. *History and Class Consciousness: Studies in Marxist Dialectics,* translated by Rodney Livingstone.

Marx, Karl. [1867a] 1954. *Capital,* edited by Friedrich Engels, translated by Samuel Moore and Edward Aveling.

Mauss, Marcel. 1966. *The Gift: Forms and Functions of Exchange in Archaic Societies,* translated by Ian Cunnison.

Pietz, William. 1985, 1987, 1988. "The Problem of the Fetish."

Riegl, Alois. 1982. "The Modern Cult of Monuments: Its Character and Origins," translated by Kurt W. Förster and Diane Ghirardo.

Simmel, Georg. 1990. *The Philosophy of Money,* translated by Tom Bottomore, David Frisby, and Kaethe Mangelberg.

Sombart, Werner. 1967. *Luxury and Capitalism.*

Thomas, Nicholas. 1991. *Entangled Objects: Exchange, Material Culture, and Colonialism in the Pacific.*

Postmodernism/Postcolonialism
Homi K. Bhabha

I

No critical term, in recent memory, has developed such instant street credibility as "postmodernism" did in the late 1970s and the 1980s. Earlier intellectual movements certainly generated their more public cultural moments, but their *succès de scandale* depended upon a certain bookishness, a paper trail of ideas and attitudes that accompanied them out into the street. Existentialism, for instance, encouraged a taste for pavement cafés, the revival of a strict mind-body distinction in matters of (nonmonogamous) sex, the celebration of the late, doomed James Dean, and the torchlit *chansons noires* of Juliette Greco. Deconstruction had its own patch in Derrida's contribution to the public gardens of La Villette, architectural tributes in the work of Eisenman and Koolhaas, and even a short clip in Hanif Kureishi's film *Sammy and Rosie Get Laid*. But the glamour of these popular appropriations was built upon some form of intellectual affiliation and engagement. Not so with postmodern *chic*. Jean-François Lyotard was careful to point out in his pioneering work *The Postmodern Condition* that the relation between modernism and postmodernism was an intercessive and aporetic one—"the postmodern would be that which, in the modern, puts forward the unpresentable in presentation itself" (Lyotard 1992, 1014). However, the subtle casuistry of such definitions was largely lost when the term was taken over, in the Anglo-American context, by journalists, media gurus, fashion consultants, disk jockeys and advertising copy-writers.

Postmodernism in the metropolitan centers of the West, had a punchy, anti-elitist, "if-it-can-happen-on-the-street-or-the-'hood-it-can-happen-to-anyone-anywhere" kind of naive and hopeful populism about it. This should not be misread as a yearning for a new democratic will, or an attempt to enlarge an emancipatory ideal. Postmodernism, in the popular media discourse, was largely an attempt to herald a form of individualist pluralism in a period of conservative ascendancy—Margaret Thatcher in Britain, Reagan/Bush in the United States—that was busy celebrating the triumphal march of free-market mechanisms over the failing, and flailing, socialist economies of the Second and Third Worlds. The end of the cold war brought only the unfolding of a turbulent and terrifying peace. In this context, then, the *jejeune,* journalistic promotion of everyday life as postmodern participated in a much more sinister form of political populism: it became part of the celebration of a "value-free" life-style in the midst of epochal *ideological* shifts in global cultures, a celebration that accompanied conservative economic readjustments and the assertion of authoritarian political regimes.

If the Benjaminian *flaneur,* ambling melancholically along the Paris arcades, became a representative figure of a fledgling modernity, then postmodernity had its own immediately recognizable street culture. Roller bladers, garland yourselves with Sony Walkmans; power walkers, bedeck yourselves with boom boxes, and set out to meet the world. Shrouded in circles of self-selected sounds, scream loudly if you must speak or are spoken to, for it is no easy thing to penetrate these protective skins that form "personalized" public spheres. Stay tuned, and make your way down metropolitan streets bristling with postmodernist signs. A skyscraper clad in polished aluminum or sheet glass dizzily reflects the vortex of the world around it in a free-falling *mise en abyme*—and then the ironic, postmodern signature: what appears to be a mock-medieval castle keep at the very crown of the building is no more than a decorative coiling tower. Press on toward the water's edge, approaching Venice Beach, where the roller bladers work out and hang out. In the late afternoon, a palpably Mediterranean feel and an oddly French, *provençal* light prevails that is at odds with the glare of sand and sea, the flat metallic bands of beige and blue, bordered by green verges. And suddenly, in the midst of the display of musculature, a quiet meeting takes place. Almost archaic in its decorousness, there is something ironic about this event, something in the air familiar and suggestive in an iconic way. Two portly gentlemen greet each other, one resting on a cane, the other leaning on an outsized paint-brush, a third stands aside, his head bowed. A closer view reveals the trick in the tableau: a staged meeting between the artists Peter Blake, David Hockney, and Howard Hodgkin at Venice Beach (as portrayed in Blake's painting *The Meeting, or Have a Nice Day Mr. Hockney* (1981–83) is a translation/transposition of Courbet's *The Meeting, or Bonjour Monsieur Courbet* (1854). In the move from the *provençal* landscape to Santa Monica, from realism to a kind of post-pop-postmodernism, there is a recasting of the figure of the artist. Where once Courbet looked arrogantly askance at the respectful, awed greetings of the collectors Bruyas and Fajon, now the British expatriate Hockney greets the "English" artists Blake and Hodgkin. Their studied poses, replicating the Courbet painting, recall a European painterly past surprisingly restaged in the midst of the southern Californian landscape of youth, lust, and leisure that has largely been invented, in the pictorial imaginary, by David Hockney. It is this palimpsest of Courbet/Blake/Hockney that Charles Jencks uses as the cover picture for his book *What is Post-Modernism?* which announces that "the Post-Modern world is the age of quotation marks, the 'so-called' this and the 'Neo' that, the self-conscious fabrication, the transformation of the past, and recent Modern present" (Jencks 1990). Neo this? What's that about fabric? . . . fabrication? Don't miss the women dressed by Vivienne Westwood, strolling down in their mock-Victorian corsets and bustieres worn to be seen, brushing past the grunged-out oatmeal-and-slate distressed linens worn by wan, beautiful boys who are almost indistinguishable—give or take a *comme des garçons* vest or a *dolce e gabbana* loose-limbed

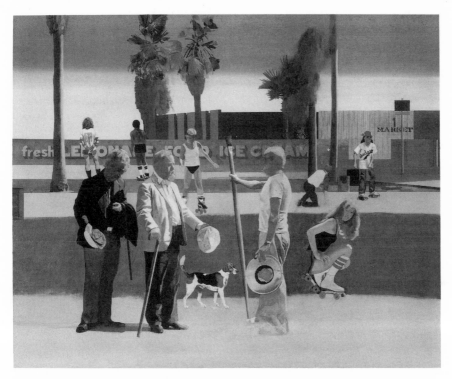

22.1 Peter Blake, *The Meeting, or Have a Nice Day Mr. Hockney.* Tate Gallery, London.
© 1996 Peter Blake / Licensed by VAGA, New York, NY, and DACS, London.

jacket—from the grungy, Salvation Army–handout-clad young, homeless men and women sheltering by the subway, shyly selling stale copies of *StreetAction*. So ubiquitous and indulgent was the naming of the present as postmodern in the mid-1980s that the artist Donald Judd complained that the term "includes more everyday, . . . claiming a presentness and a popularity supposedly superior to that of acknowledged art" (Judd 1992, 1032). And it is hardly surprising that in the early 1990s Hal Foster was not the only one asking, "Whatever happened to postmodernism? The darling of journalism, it has become the Baby Jane of criticism" (Foster 1993b).

However, my hyperreal mockup of a postmodern streetlife makes a larger point about the nature of representation in the discourse of postmodernism—the concept of "simulacral" signification. To introduce the concept of the post-modern by means of a *tableau vivant* is my attempt to capture something quite specific about the postmodern aesthetic as the representation of the "unpresentable in the presentable." For the *tableau vivant* as a living picture captures something of the uncanny, repetitious, or "retro" (to use a "po.mo." buzzword) structure of the simulacrum. The representational desire of the *tableau vivant* lies in the pleasure of producing a copy that elides and eludes the original not simply by displacing it but by doubling it; an image that "catches its breath" to appear still, dead, fixed, in order to infuse the tableau with life and exceed the presence of imaging itself; a reproduction of similitude where the surface of the scenario is the signifying site of a "difference" that consists in substitution and subversion at the same time. The *tableau vivant* is a genre particularly suited to the epistemology of the postmodern, where "the referent is lifted but reference remains: what is left is only the writing of dreams, a fiction that is not imaginary, mimicry without imitation, without verisimilitude. . . . [O]n that side of the lustre where the 'medium' is shining" (Derrida 1981, 211).

The discourse of postmodernism is at once a postmortem report on the end(s) of modernity and a postpartum report on the origins of the present, our own epoch, still struggling to be born. This temporal indeterminacy, here the repetition of the past (Freud's *Nachträglichkeit*, or deferred action) is unrelinquishable while the restitution of the future is never fully realizable, wages a war on concepts of "meaning" and "history" envisaged as forms of synchronous or serial "totality." The temporality that I've described focuses our attention on the realm of aesthetic value as constituted by the liminal and partial locations that structure the art object itself. "Appropriation, site-spefficity, impermanence, accumulation, discursivity, hybridization—these diverse strategies characterize much of the art of the present and distinguish it from its modernist predecessors" (Owens 1992b, 1056). The alternative to historicist holism in poststructuralist thought is not, as is often popularly claimed, a runaway social atomism or a libertarian fragmentation of the subject. The disjunctive and doubling grounds of the discourse initiate a lateral or metonymic movement that effects a shift in the question of value as it features in cultural and aesthetic judgment. And this is how I described the process in *The Location of Culture*:

Hybrid hyphenations emphasize the incommensurable elements . . . as the basis of cultural identifications or aesthetic evaluations. What is at issue is the performative nature of the production of identity and meaning: the regulation and negotiation of those spaces that are continually, contingently "opening out," remaking the boundaries, exposing the limits of any claim to a singular or autonomous sign of identity or transcendent value—be it truth, beauty, class, gender or race. . . . [W]here identity and difference are neither One nor the Other but something else besides, in-between, [there is an *agency* that finds its creative activity] in the form of a "future" where the past is not originary, where the present is not simple transitory. It is, if I may stretch a point, an interstitial future, that emerges *in-between* the claims of the past and the needs of the present. . . . The "present" of the world that appears in the art-work through the breakdown of temporality signifies a historical *intermediacy,* familiar to the psychoanalytic concept of *Nachträglichkeit* (deferred action): "a transferential function whereby the past dissolves in the present, so that the future [of identity or art] becomes (once again) an *open question,* instead of being specified by the fixity of the past." (Bhabha 1994a, 219)

The value of art lies not in its transcendent reach but in its translational capacity: in the possibility of moving between media, materials, and genres, each time both marking and remaking the material borders of difference; articulating "sites" where the question of "specificity" is ambivalent and complexly construed. It is in conformity with such ideas that Baudrillard suggests that the postmodern passes beyond representational forms of icon, image, and symbol, where hermeneutic truth is finally determined in the mirror of "nature." He urges us to engage with an aesthetic and cultural space where "the real and the imaginary are confounded in the same operational totality . . . [involving] a kind of subliminal perception, a kind of sixth sense for fakery, montage, scenarios . . . , a kind of ciphering strip, a coding and decoding tape, a tape recording magnetized with signs" (Baudrillard 1992, 1051).

My postmodern precinct deploys this strategy of the ciphering strip, the "confounding" process of coding and decoding (central to the postmodern aesthetic), in order to read the critical discourses that have constituted its "thick description." For I have populated by street scene with simulacral representations of figures that have been central to the genealogy of postmodernity in the western academy. For instance, my Sony walkperson, sealed into the cool and concealing medium of a solipsistic sound bubble, immediately brings to mind Fredric Jameson's iconic use of Munch's homunculus in *The Scream,* as an exemplary figure that articulates the difference between the angst of modernity and the "waning of affect" in the postmodern condition (Jameson 1992, 1074–80).

This kerbside encounter of uncanny doubles—the Sony walkperson with plugged-in ears, the Munchean homunculus without ears—brings us to the

heart of the postmodern discussion, which is the struggle for the soul of the "subject." For Jameson, Munch's painting represents the high modernist "aesthetic of expression" and its dependence on a subject—figure, author, intention, agency, "centredness"—that presupposes a metaphysics of *depth*. The depth-charge of this hermeneutic requires four fundamental concepts: the dialectics of essence and appearance, and its effects on theories of ideology and mediation; the Freudian model of latent and manifest, with its possibilities of "symptomatic" reading; the existentialist model of authenticity and inauthenticity (alienation and disalienation); and the semiotic opposition between signifier and signified (ibid.). Munch's scream is man at the perilous edge of this fourfold schema; yet it is symbolic of the survival of its lifeworld and part of its "expressivist" ethics of authenticity and disalienation. For despite the howling silence of the scream, the painted surface bears the marks of "those great concentric circles in which sonorous vibration becomes *ultimately visible,* as on the surface of a sheet of water—in an infinite regress which fans out from the sufferer to become the *very geography* of a universe in which pain itself now *speaks and vibrates through the material* sunset and the landscape" (ibid., my emphasis). The "deafness" of the scream turns into a perspective of depth that generates the fourfold schema, even at the point of its extreme fragility.

With the Sony walkperson, Jameson would argue, it is quite otherwise. Here the concentric circles of sound do not resonate and reverberate through the material universe. The silence does not translate into a *visible* materiality that makes possible the subject's expressive articulation through essence/appearance, authenticity/disalienation, to find its signification in the stabilization of the sign, which would enable the fate of walkperson to become generalizable and would reach out toward a human "geography." The silent, introjected sounds of the Walkman hit up against the shrill, sheer reflective surfaces of postmodern simulacra and are caught "in play," in a double act of historical contingency, somewhere between the space of personhood and the space of the *socius*. Here, there is no assumption that the "subject is a monad-like container, within which things are felt which are then expressed by *projection outwards*" (ibid., 1080; my emphasis).

In the absence of this dialectic of inside/outside, and its metaphysics of depth, postmodernism announces the death of the subject. But in another defining moment in the postmodern debate, Hal Foster's essay "Postmodernism in Parallax," there is a revision of this Jamesonisan obituary. Foster's starting point is closer to my own: it rests on the assumption that the defining "difference" of postmodernity lies at the level of its disjunctive temporal structure. Forster acknowledges the "never complete transition to the postmodern" (1993b,6), which then demands a detour through the Freudian theory of "deferred action" in order to arrive at the history of the present as a "non-synchronous mix of different times" (ibid., 5). This instance of historical *intermediacy,* with its "continual process of anticipation and

reconstruction" (ibid.), opens up a theoretical stretch beyond the death of the subject:

> In a sense the death of the subject is now dead in its turn: the subject has returned—but in the guise of a politics of new, ignored, and different subjectivities, sexualities, and ethnicities. Meanwhile, at a time when First, Second and Third Worlds are no longer distinct (if they ever were), anthropology is newly critical of its own proto-cols, and postcolonial imbrications have complicated anti-colonial confrontations. Finally even as our society remains one of spectacu-lar images *à la* Debord, it is also one of electronic discipline . . . , of the new possibilities that await us in cyberspace. . . . Thus the deferred action, the double movement, of modern and postmodern times. (Ibid., 7)

Foster finds himself doubly inscribed in these postmodern times: wired up like my walkperson, yet seeking, like Munch's homunculus, a medium of expression, projection, and social exchange. He has the desire for the dimension of depth from which the scream emanates, but wants to utter it from within the disjunctive conditions, which I elaborated earlier, of history's moment of intermediacy, and the future as open question. In the sepulchral moment between the death of the subject and its return or revision, Foster experiences a profound disconnection of subjectivity in the postmodern mediatic world, which he can only anecdotally explore. He recalls the Tiananmen Square massacre, the Gulf War, the coup in the Soviet Union and concludes that "[t]his electrochemical wiring connects and disconnects us simultaneously: we are both *psychotechnologically immediate to events and geopolitically remote from them.* Such disconnection is not new . . . but it has reached a new level of pleasure/pain" (ibid., 19). And then, with the rest of us in tow, Foster asks a representative question: "How are these worldly shifts registered, reconstructed, and/or antici-pated, in recent theory?" (ibid., 15).

II

Let us explore this central postmodern question, in the company of Adrienne Rich:

> I'm a canal in Europe where bodies are flung
> I'm a mass grave a life that returns
> I'm a table set with room for the Stranger
> I'm a field with corners left for the landless
> I'm a man-child praising God he's a man,
> I'm a woman who sells for a boat ticket
> • • •
> I'm an immigrant tailor who says *A coat*
> is not a piece of cloth only

...

I have dreamed of Zion I've dreamed of world revolution
I'm a corpse dredged from a canal in Berlin
A river in Mississippi. I am a woman standing
I am standing here in your poem. Unsatisfied.

Adrienne Rich, "Eastern Wartime," in Rich 1991, 44

It would be a minimal reading of Rich's rendition of transnational events, individuals, and communities, rendered through the poetic medium of memory, to reduce the address of her verse to some identitarian sense of a "common humanity", or some Whitmanesque celebration of manifold, naturalistic destiny. For that would erase the tropic force of the verses themselves. The insistent, iterative "I'm a . . . I'm a . . . I am . . . ," as in some bleak counting song of a monstrous child or our times, finds its spatial extension in an object, an attribute, or an event of world-historical significance—slavery, war, holocaust, migration, diaspora, peasant rebellions, revolution. The "I am" is not the instantiation of the universal witness of history and culture. Its iterative field of address—"I'm a table . . . a field . . . a man-child . . . a woman . . . an immigrant—*attenuates* the sovereignty of a "representative" human or world subject authorized in its mastery of events. This does not mean that we are being offered some postmodern *souffle* of identity, renowned for its lightness of its being. Repetition emphasises starting again, re-visioning, so that the process of being subjected to, or the subject of, a particular historicity or system of cultural difference and discrimination has to be, as they say, "recounted" or reconstituted as a historical sign "in a continua of transformation, not abstract ideas of identity and similarity," to echo Walter Benjamin on the temporality of translation. (Benjamin 1979, 107–23).

Within the iterative poetic line lies the articulation of a problem in the representation or signification of the historical "time" of the global or the transnational as it is experienced today. According to the Cambridge sociologist Anthony Giddens, the essence of global cosmopolitanism consists in a "transformation of space and time . . . , *action at a distance*" (Giddens 1994, 4). An unassimilated agent that wants to claim its legacies, exert its human ethical will and recount its spectral memories can no longer survive within what ethical philosophers of "public life"—John Rawls, Henry Shue, Martha Nussbaum— call the "concentric-circle picture" (Shue 1988, 693). The causality that subtends "action at a distance" is wired through a structure of contingency that theorists of the circuitry of the techno-tele-media forms of global culture have described as manufactured uncertainty. Rich's attempt to maintain the *singularity* of each event and person she inscribes—world war, starvation, Indian landless peasants, migrant labor, religious custom, Vietnamese boatpeople, feminist solidarity—is made possible by her attention to the varying, differential density of the media and image structure that signify these subjects; there can be no

easy egalitarianism in the modern memory of trauma and victimage. What makes them representative of the global contingency, or the transnational uncertainty, is that, *in the iterative flow of the verse,* each "installation of the image," each institution of subjecthood or citizenship, become *contiguously and contingently related.* They are not correlated because they share the same historical cause or are mediated by the same sign. Their relation is performative, a relation to the event that changes through the exercise of its enunciation and interpretation—"intrusive, inappropriate, bitter flashing."

The position Rich stakes out is an intervention into the flow of "History that stops for no one" (to use one of her essay titles), and the iterative "I" articulates an *accelerated* motion of what it means to be "torn between ways." It is here that Rich's ethics and aesthetics are located in the place where the woman stands in her poem "unsatisfied" (Rich 1994, quoting Gloria Anzaldúa). The affect of unsatisfaction signals the *on-going process* by which the singularity of the *event* as historical—the satisfaction of remembering, the mimesis of memorialization, the restitution of record, date, time, name—gives way to, opens up a passage toward, the accelerative event of memory, its repetition as revenant, its ghostly appearance as the present, testimony caught in the affective anxiety of what it is in memory's presence, to remember, recall, recount: "unsatisfaction" rivals the satisfaction of making the memorial to a transnational historical epic and ethic, and reminds memory of its anxious, global existence. Recall Lacan's seminar on "The Function of the Good": "The function of memory, remembering, is at the very least a rival of the satisfactions it is charged with effecting. . . . In other words, the structure engendered by memory must not in our experience mask the structure of memory itself, in so far as it is made of a signifying articulation" (Lacan 1992, 223). The iteration of Rich's verses "I am a . . ." as signifying articulation functions as a time signature of an atavistic, even archaic, historic event, a pastness whose very condition is unsatisfaction, if its activism, its historical reactivation, is the performative condition of its futurity—which is paradoxically at once restorative of, and rivalrous to, its memory. Rich's rhetorical and affective gesture is similar to Toni Morrison's rememory of the "global" history of slavery at the end of *Beloved.* "This is not a story to *pass on*" (Morrison 1987, 275; my emphasis), she intones as she brands its burn deeper and more densely into the flesh of "that memory that flashes up in a moment of danger."

As the rhetoric of globality becomes more vaunting and all-embracing, there emerges, in counterpoint, an indeterminate, uncertain discourse of community, which provides a more modest moral measure against which transnational *cultural* claims are measured. I find it, for instance, in Anthony Appiah's vision of a certain postcolonial translation of the relation between the patriotic and the cosmopolitan, the home and the world: "It is because humans live best on a smaller scale that we should defend not just the state, but the country, the town, the street, the business, the craft, the profession . . . as circles *among the*

many circles narrower than the human horizon, that are the appropriate spheres of moral concern" (Appiah 1994; my emphasis).

It is this borderline—narrower than the human horizon—that attracts me, a social space that somehow stops short (but does not fall short) of the transcendent human universal, and for that very reason provides an ethical entitlement to, and enactment of, a sense of community as both an ethical practice and an aesthetic idea. It is art's capacity to reveal the almost impossible, attenuated limit where aura and agora overlap, art's ability to find a language for the high horizons of humanity itself—its finest selves, its inspired othernesses, its visionary styles, its vocabularies of vicissitude—which then reveal its own fabulation, its fragility, *at the moment of its articulation.*

III

It could be argued, however, that the project of postmodern aesthetics is principally concerned with what *constitutes* the moment of art's articulation. Is postmodernity, as Lyotard suggests, the moment *within* modernity from which the "unrepresentable in presentation" emerges, thus pushing modernity to its representational limit, its signifying margins? If, then, we brought this thought to bear on Peter Blake's *The Meeting* as a postmodern picture, would it be appropriate to suggest that its moment of articulation consists in the palimpsest of displaced layers of referentiality and meaning that inform Blake's "presentation"? The fierce intentionality of Courbet's realism, its aggressive antiacademicism, is now ironically recalled in the context of a congregation of camp and even kitsch artists, Hockney and Blake, whose work plays particularly with surfaces, superficies, and beatific ephemera. The figures retain the precise posture and position of Courbet's subjects—even the dog is there!—but the mise en scène has changed to California, where the culture of "nature" is represented as being a kind of antirealist, nonnaturalist performance that strives for the endless sculpting of the "body" and landscape in pursuit of the ultimate *artifice* of natural perfectibility—itself a double irony. In this witty twist between Courbet's figure and Blake's ground, we discover once more the absence of "depth perspective," which Jameson considers to be the defining quality of the postmodern moment of articulation. The celebration of surface, the collapse of epistemological and perspectival distance, the foreshortening of historical depth in a collage of contingencies—these characteristics of postmodern culture, in Jameson's view, locate the moment of articulation in the "death of the subject." But what of that "moment of articulation" that embodies the experience of the spectator confronted with postmodern art as collection or display? If the absence of the dialectic of depth—inside/outside—is now replaced by a lateral "side-by-sideness" (collage, bricolage) of the postmodern as palimpsest, how does it change our practice as viewers and *voyeurs*?

The moment of spectatorship that I want to focus on is not so much art's sublime address to an individual spectator as connoisseur as it is the more

collective and institutionalized conventions of curatorship—the museum and the exhibition. Museums, as cultural institutions, and exhibits, as displays of the diversity of cultural production, have been central to the debates around the conditions and crises of the postmodern. The museum as a form of built public space has become the iconic site for postmodern architectural experimentation—Richard Roger's Centre Pompidou in Paris, 1971–77; James Stirling's Neue Staatsgalerie in Stuttgart, 1977–84; Robert Venturi and Denise Scott Brown's National Gallery Extension in London. If the museum has become representative of postmodern space, then postmodern cultural temporality—the "non-synchronous mix of different times" that I have earlier described as historical *intermediacy*—has had a major impact on the discourse surrounding the fin-de-siècle fascination with the "global show." Perhaps the most famous such exhibit in recent years was "Les Magiciens de la Terre," at the Centre Pompidou in 1989. To celebrate the bicentennial of the French Revolution, the director of the center, Jean-Hubert Martin, announced that "the multiplication of images of the terrestial globe is one of the symptoms of the tightening of communications and links, mediatic and personal, between the people on the planet." This mediatic message from the French bicentennial was carried forth to the Americas with "Circa 1492: Art in the Age of Exploration," held at the National Gallery in Washington in 1992 to celebrate the five-hundredth anniversary of Columbus's voyage. The show insistently placed "1492" within the context of the global art of that period.

Exchanging my roller blades and Sony Discman for an "Acoustiguide," I became the *flâneur* of another age as I followed the voice of the master, J. Carter Brown himself, the director of the National Gallery, leading me through the show. If earlier I likened the popular apprehension of the postmodern experience to a *tableau vivant,* here I was confronted with history of half-a-thousand years as *still life!* Would this postmodern phantasmagoria ever stop—this shuttling between centuries, scenarios, genres, texts, continually confronting the unpresentable in the presentable? Would I, like Dorothy in *The Wizard of Oz,* ever be safely delivered to hearth and home in Kansas, or Chicago, or Bombay, or London? And in this puzzling plethora of locations I realized (or so they tell me) that in the postmodern condition, somewhere over the rainbow lies another rainbow, and then another and another, in a dizzying array of duplications called the simulacral. So you might just as well go to the museum and see the show! As they used to say, in simpler times, the show must go on.

You might think that there has already been a profuse display of "shows" in this essay itself. First I created a hyperreal tableau to illustrate the everyday life of postmodern popular *hype;* then I engineered an encounter with an acknowledged postmodern painting, *The Meeting:* In both instances there is a marked emphasis on the "staging" of social or mimetic reality as an assemblage of sites, memories, phantasy and reality, intention and instantiation. The meaning of

art or experience lies in the circulation and intersection of images and signs that are ironically and differentially disposed to each other—without the inherence of "deep structure" that holds them together—and that therefore need to be performatively and strategically enunciated. It is with this process of representation in mind that I turn to my final display, which is the exhibition or art show itself as the object of a postmodern or poststructuralist critical scrutiny.

As you enter the first gallery of "Circa 1492," your Acoustiguide leads you to a cabinet of late-medieval treasures: an ostrich egg, brought to Europe from North Africa in classical antiquity and turned into a gold jug sometime in the fourteenth century; a rock crystal elephant, carved in India in the fifteenth century, caparisoned with gold and enamel mounts somewhere in Europe during the sixteenth century, and made up as a salt cellar. In these exotic transformations, wide geographical distances conjure cunningly with historical circumstance. The creation of a global culture circa 1492, as it emerges in the "sciences" of mapping and measurement and in the fantasy of cultural expansion, is a major narrative of this exhibit.

Immediately after these gilded Oriental treasures, your Acoustiguide draws you to the dark testimony of Hieronymus Bosch's *Temptation of St. Anthony,* 1500–1505. Bosch's "absurdist" images play out the drama of evil, which they set in a theater of the dream symbol. In testing the limits of the sense of community and its pictorial conventions, they explore the problematic projection of the "human" as it struggles, at the very threshold of early modernity, to become the representative figure in the arts. This is the other central focus of the show.

"Circa 1492" is an exhibit with a double vision: the eye expanding to hold the world in one space; the eye averted, awry, attenuated, trying to see the uniqueness of each specific cultural tradition and production. The show is crafted from a creative tension deep within the early modern moment. On the one hand, art is Map, striving to calculate the world picture on one continuous surface in two dimensions. On the other, Man conjures restlessly to break up that surface, to deepen it with dark dimensions, to personify it with perspective. The exhibition's unique message in "this year of Discovery-Pride," as Daniel J. Boorstin writes in the catalogue's framing essay, "is to become aware of the limits of the kinds of fulfillment that dominate our consciousness in an age of science."

This dynamic of Discovery and Creation certainly goes a way toward questioning the idea of progress as a universal ethic of cultural development. There is an attempt here to revise the linear perspective upon which the West makes its claims to cultural supremacy, claims that its roots lie in a narrative that establishes Renaissance perspective as the natural one for the arts. The structuring principle of "Circa 1492," as curator Jay A. Levenson informs us, is the "horizontal survey." Yet the show aims at a unified effect: from the effort "to

present each civilization on its own terms, not as it might have appeared to visiting Europeans of the period," a marvelous parallelism is to emerge.

This is certainly controversial. Is it possible to "present each civilization on its own terms" once the avowed purpose is to produce a global show of marvelous parallels in postmodern times? This parallelism itself, as an exhibition strategy, must be a critical interpretation of the skeined, cross-cultural history of the infiltration and conquest that followed from exploration, *and that interpretation must come from somewhere*. Why does a more pliant and useful critical or curatorial response to cultural difference fail to develop?

The answer lies in the parallelism that "Circa 1492" promotes both as a cultural paradigm and, more significantly, as a form of spectatorship. Despite the show's three sections ("Europe and the Mediterranean World," "Toward Cathay," and "The Americas"), which attempt to provide local cultural contexts, the terms of the show are substantially set toward the end of the first part, in the subsection on the Renaissance titled "The Mean and Measure of All Things." In Europe, this is the moment of the emergence of the human figure as the "universal" measure of culture; it is the moment of perspective; of the birth of the "artist"; of Leonardo and Dürer; above all, for this exhibit, it is the moment that brings forth the show's most celebrated icon, Leonardo's *Portrait of a Lady with an Ermine* (circa 1490), his picture of Cecilia Gallerani, an accomplished and adventurous Milanese.

We arrive in her presence after encountering maps and astrolabes, trophies of Portuguese and Spanish discovery, Islamic treasures, anatomical and architectural drawings, and that arresting queen mother's head from Benin, which exhibits a formal quality "without any uncertainty, to whose perfection any indication of humanity has yielded." With Cecilia Gallerani it is different: it is precisely her uncertainty, her enigmatic look away from the frame, that conveys *il concetto dell' anima* (the intentions of the subject's mind). Cecilia's subtle glance away establishes or is emblematic of a whole tradition of looking at art and culture. And it is, ironically, through her distracted gaze that the spectator of "Circa 1492" is first inscribed and then held to the ideology and iconography of humanness that lies behind the attempt to present cultural difference in marvelous parallels.

For Cecilia's distraction displays that very quality of creative heterogeneity that Boorstin recommends as the unique vision of "Circa 1492." It is a concept of heterogeneity precisely restricted to the "atomic individual"—the authentic artist and the unique artwork. This is a concept that cannot be generalized into forms of cultural difference generated in and through the interaction and articulation of cultural systems. At the individual level, heterogeneity can only be expressive of preexisting "differences." But a theory of cultural difference must be able to explain those transformations in aesthetic value and cultural practice that are produced through histories and broader patterns of cultural conflict, appropriation, and resistance to domination. The predominant per-

spective of "Circa 1492" is to allow cultural heterogeneity at the individual
level so long as the homogeneity of the (Western) notion of the human is left
relatively uncomplicated within a universal aesthetic realm. The parallel begins
to look distinctly circular.

Let us imagine that as Cecilia looks away, her distracted gaze falls upon
Dürer's portraits of a black man (circa 1505–6) and of the enslaved woman
Katherina (1521), to be found a few feet from the Leonardo. Suddenly I am
caught between the master and the enslaved. The Acoustiguide tells me of
Dürer's interest in the diversity of nature—"in exotica imported from around
the world." Then I turn to the portraits, trying to decipher the "intentions
of the subject's mind": the black man dressed in what looks like a Venetian
cape, the black woman who has had her hair "confined within a European
headdress." In its spirit of parallelism, the catalog suggests that Dürer goes
beyond artistic and cultural stereotypes and shows himself "sensitive to the
personality as well as the exotic potential of his sitter." Can the two be compati-
ble when exoticism erases rather than enhances personality? Since that is the
case, can these portraits of Dürer's be more than naturalist studies? Can the
"mean and measure of all things" frame this radical heterogeneity of the human
condition when the catalog entry states that circa 1492 there were between
140,000 and 170,000 African slaves in Europe?

Where Cecilia's gaze and Katherina's downcast look cross, there is no paral-
lelism, no equidistance. We are at the critical point of contesting histories and
incommensurable subjects of humanity. Histories of the master come to be
reinscribed in terms of, or in contention with, the enslaved or the colonized.
By the mid-1990s, this will be the spectatorial position of the non-Europeans,
the half-Europeans, the African-Americans, the Chicanas and Chicanos, the
Asian-Americans, the Latin Americans—to name only some of the hyphenated
and hybridized peoples among other visiting Americans and Europeans—who
now may visit the National Gallery and who are now a significant part of the
"national" scene. These are, after all, the very peoples whose histories were
most graphically and tragically made and unmade in the wake of the Age of
Exploration, circa 1492. It is clearly in their direction that the organizers aim
their laudable attempt to staunch the "nationalist" sentiment of "Discovery-
Pride" and to complicate the Eurocentric celebration of Columbus. But the
show is complicated by another kind of historical parallelism that is somewhat
less marvelous, and much more melancholic.

This is not principally an academic or art-historical issue. By the mid 1990s,
the international or global art show has become the prodigious exhibitionary
mode of Western "national" museums. Exhibiting art from the colonized or
postcolonial world, displaying the work of the marginalized or the minority,
disinterring forgotten, forlorn "pasts"—such curatorial projects end up sup-
porting the centrality of the Western museum. Parallelism suggests that there
is an equidistant moment between cultures, and where better to stage it—who

could better afford to stage it?—than the great metropolitan centers of the West. The promise of coevality with regard to space and presentation may well be kept; the choice of works of art from "other" cultures may well be catholic and noncanonical. All this may make "global" art more readily available to the embrace of multicultural aesthetics or a meticulous archival study. But the angle of visibility within the museum will not change. What was once exotic or archaic, tribal or folkloristic, inspired by strange gods, is now given a secular national present and an international future. Sites of cultural difference too easily become part of the globalizing West's thirst for its own ethnicity, for citation and simulacral echoes from Elsewhere.

The global perspective in 1492, as in the 1990s, is the purview of power. The globe shrinks for those who own it; for the displaced or the dispossessed, the migrant or refugee, no distance is more awesome than the few feet across borders or frontiers. The parallelism of the modern museum, in its internationalist mode, turns on an aesthetic axis of "equal distance/equal difference," but the history of culture has been neither so equitable nor so ecumenical. The postcolonial perspective suggests rather that in the presentation of cultures, Western and non-Western, we adopt the perspective of the "parallax" (a word that enters the language circa 1594): the "apparent displacement, or difference in the apparent position, of an object, caused by actual change (or difference) of position of the point of observation" (*Oxford English Dictionary*). As the globe revolves, its other side uncannily discloses a skull.

As we enter the final phase of the exhibition, "The Americas," the tragic history of "colonialist" globality around 1492 becomes more apparent and the need for the parallax more pertinent. The great remains of the Inca or Aztec world are the debris of the Culture of Discovery. Their presence in the museum should reflect the devastation that has turned them from being signs in a powerful cultural system to becoming the symbols of a destroyed culture. There is no simple parallelism or equidistance between different historical pasts. A distinction must be maintained—in the very conventions of presentation—between works of art whose pasts have known the colonial violence of destruction and domination, and works that have evolved into an antiquity of a more continuous, consensual kind, moving from courts to collectors, from mansions to museums. Without making such a distinction we can only be connoisseurs of the survival of Art, at the cost of becoming conspirators in the death of History.

IV

If I started with Lyotard's founding insight into the dialectic of postmodernism—"the unrepresentable in presentation itself"—then it seems appropriate to end with the urgency of making present in the display of art what is so often rendered unpresentable or left unrepresented—violence, trauma, dispossession—in the making of a global cultural perspective. The emphasis on

tableau, mise-en-scène, or staging in the discourse of the postmodern, is often understood to be an antiessentialist procedure, emphasizing the constructedness of social or artistic reality. Such self-reflexive arguments, claiming that "experience" or identity are not a priori intuitions but are *constituted* as image, ideology, narrative, or discourse, become significant only when we can move beyond ontological or epistemological issues to confront the ethical question: How do we use the rules and ruses of historical contingency and cultural indeterminacy to transform the inequitable and injurious *necessities* of history. It is often hastily suggested that a "decentered" subject (to use a theoretical cliché) is a subject that disavows history, a subject whose loss of sovereignty leads to a dereliction of social and political responsibility. What I hope to have shown is that the forces of contingency—historical and narratorial—that place the human subject *at an angle* to what is seemingly the center of life, or of history, does not drain human action of its social agency. Human inter-est, the politics of community and the possibility of communication that lies between human subjects, Hannah Arendt reminds us in *The Human Condition* (1958), is constituted interrogatively as an act of *interpretation*. The "web of human relationships" emerges in the interstitial, elliptical moment where the narrative of human history reveals an agent, a subject who is the actor and the sufferer, but the agent is not the "author" of the story of life. The enduring political lesson of postmodernism is to urge us to think of social agency without the mastery or sovereignity of an author. And in the indeterminate relationship between actor and author we are served the aesthetic and ethical challenge to live in disjunctive temporal landscapes that lead us to restructure the past, so that the history of the present—of our late modernity and/or postmodernity—can entertain the possibilities of the future as an open question, a negotiation with the passions and the pitfalls of freedom.

SUGGESTED READINGS

Attridge, D., and G. Bennington. 1989. *Post-Structuralism and the Question of History.*

Bhabha, Homi K. 1994. *The Location of Culture.*

Derrida, Jacques. 1981. "The Double Session." In *Dissemination,* translated by Barbara Johnson.

Foster, Hal. 1993. "Postmodernism in Parallax." *October,* no. 63 (Winter).

Harrison, Charles, and Paul Wood, eds. 1992. *Art in Theory 1900–1990: An Anthology of Changing Ideas.*

Jameson, Fredric. 1991. *Postmodernism, or the Cultural Logic of Late Capitalism.*

Jencks, Charles. 1990. *What Is Post-Modernism?*

Mosquera, Gerardo. 1995. *Beyond the Fantastic: Contemporary Art Criticism from Latin America.*

Lyotard, J. F. 1988. *The Differend: Phrases in Dispute.* Translated by Georges Van Den Abbeele.

Rich, Adrienne. 1991. *Atlas of a Difficult World: Poems 1988–1991.*

Figuration

Richard Shiff

As Robert Nelson states in the introduction to this book, our authors were encouraged to explore or "do" theory, as well as to explain or report on it. Most contributors applied theory to a particular image or object, not only to demonstrate its use but also to develop their understanding of the "critical term" by engaging it with and within a context—whether material, social, historical, or discursive. It would be difficult to argue that an idea or concept can exist independent of the character and nature it assumes through its expression and use. Terms come to life when set against the resistance of the objects, conditions, situations, events, societies, histories—as well as the other terms— that they articulate. Everything has its context. Another way of saying this: everything is figured through something else, through something other.

But what does it mean to be figured? *This* concept is of the utmost interest to art history because it oscillates between the visual and the textual and between matter and sign. It facilitates diverse kinds of understanding by playing one type of knowledge against another. A figure can be a drawing or any depiction (visual art), but it can also be a metaphor or any description (literary art). Does this imply that a drawing *is* a metaphor and a metaphor a drawing? Or are such assertions, articulated in words, no more than metaphorical themselves? To contain or control the "figure" is no simple matter. Figuration spreads.

To figure a thing is to form it, either altering the thing itself—as in carving a stone—or modifying and developing the understanding of a second thing which is being represented by the first—as in carving a stone so that it becomes a generic statue of, say, a stone carver. Through such representation of one thing by another, a stone might also become either an indexical reference to the work of stone carving (showing evidence of the action) or an iconic image of aspects of the specific living carver (as if to function as self-portrait). Indeed, representation operates reflexively: the "second thing" figured by a first can be the actual activity, its agent-maker, or both, expressed and understood through a process of figuration. Put a single mark on a blank surface, and figuration has already occurred in its two complex senses—as forming (or transforming) and as representing.

The "figure" refers to the material form or shape of an object, a property we take to be "real," given the means of verification prevailing in our society or

interpretive community under the conditions of the moment—that is, given our precise interpretive context. A suitable example of such a figure (recalling Nelson's remarks on Wallace Stevens) is the round shape of a jar. In order to verify the actuality of this roundness we might touch and trace over the object with our hands; that gesture would supply acceptable evidence of the "real" physical existence of the form. Yet "figure" also refers to something quite immaterial: the forming of an image or theme, such as a figure to be developed in a reading of Stevens's poem "Anecdote of the Jar." There is still more. Between the circumscribed, tactile resistance of a well-rounded jar and the expansive thematics of a well-turned and well-read poem, "figure" refers to imaginaries. These are immaterial forms or constructs that have the force of real matter. We understand them as natural and unchanging, according to the customs of our interpretive community; but whenever we are able to see these constructs from an ideological perspective other than our initial one, they appear as the arbitrary products of a social process and an instance of collective poetic figuration, that is to say, mythology.

When we claim (as is common today) that no statement can be absolute, that all representation must be figured, this is not so much to use "figure" in its sense of a mere forming, depiction, or description, but to stress the fact that any particular representation asserts its difference from others by deploying a specifiable *mode* of figuration, one among many. The representation or characterization of the form of an object (or immaterial entity), in either the same or a different medium, is its figure. Figuration occurs to the extent that a simple act of visual attention—looking at something, becoming aware that it has significance—is interpretive. What the thing viewed means to me is not necessarily what it means to you, no matter how closely related we may be to each other, perhaps sharing many discourses and experiences. If I add to my vision some textual description and a range of associated terms, perhaps I will approach a common social discourse; but I might also compound initial differences between my vision and yours, or another's. Such localized differences have been factored into the accounts of terms offered in this book. Often the individual author reveals this variance through an allied discipline chosen to develop the assigned art-historical terminology. If one writer inclines toward sociology and cultural studies, another tends toward philosophy and another toward anthropology; perhaps there are hints of both psychology and theology in still another. Such differences are at once personal and political.

As differentiated observers and writers, how do we practice art history in a self-consciously postmodern era, as we privilege (and even revel in) multiplicity—the turn, split, and divergence of figurality, as opposed to the straightforwardness and integrity of common belief, objective knowledge, and mythological truth? Robert Nelson suggests that our volume might best be regarded as "an anthology, a collection of essays, and even a book of short stories." This is to recognize diversity, with no apology for the variance of attitudes among the

writers; a book of "short stories" makes no claim to definitiveness or validity beyond its moment and conditions. Stories are made to be retold and modified, refigured. If anything, a book of story-essays encourages critics and scholars to attend to the particularities of the moments, discourses, and objects they engage. It avoids generalization, comprehensiveness, the establishment of universal principles, and, in a word, closure.

What should be left open must still be ended. Let me attempt both tasks by characterizing the range of attitudes writers on the visual arts customarily take. I will step to the side of my cultural mythologies, or at least make a pretense of doing so to the extent that protocols allow, referring to three very broad modes of address and understanding as if they were discrete and distinguishable. The three attitudes correspond to the discursive practices we know as art, criticism, and history.

Perhaps my statement is already too strong, too anonymous in tone, and therefore presumptuous. Let me say instead that I choose to *figure* the practices of art, criticism, and history by associating them with three very familiar psychological attitudes. For the sake of a theory, think of the three correspondences this way: *art* is the mode of belief, commitment, and overt expressiveness; *criticism* (which includes theory) is the mode of doubt and irony; *history* is the mode of observation and dispassionate judgment. Every individual experiences each of these psychological states or mentalities, and perhaps all three operate simultaneously, although in any given situation one will seem to dominate the other two. Like figures, the three modes articulate one another through their respective differences.

This structure of analysis offers an advantage to the historian; for whenever we are able to identify patterns of domination or hierarchy among these three modes (or others) within a culture, it becomes possible to characterize the attitudes of various constitutive social or professional groups, localized attitudes which may or may not correspond to the prevailing cultural norm. It matters not that at a given moment a given mentality may seem unreasonable or even unrealizable: today, for example, we are quite unlikely to regard recorded history as ever having been constructed objectively or dispassionately. That alone should tell us something. It is not an indication of our superiority over predecessors whom we imagine to have conceived their intellectual enterprise otherwise, but merely a sign of the difference and a part of our collective identity. We might also recognize that because the notion of objective history yet remains available to us as subjectivists, we tend to invoke it in a backhanded way, discrediting any analysis that fails to acknowledge its own engagement with political advocacy, personal motivation, or simple human feeling. This is to say that we pay no compliment today in labeling a historical account empiricist, positivistic, or objective (although "definitive" still seems acceptable to many). The reason both historians and theorists might choose to write "short stories" (which do acknowledge their own subjectivity and fictiveness) is that the histori-

cal mode itself—the mode of address *figured* as objective and dispassionate—is out of favor with the local academic culture.

Just as members of the art profession need not always act in the artistic mode, neither are historians compelled to act in the historical mode. Both can act in the critical mode, as they do by entering into projects of demystification or deconstruction. They can choose to examine problems defined in terms of "reinventing nature," "engendering culture," and other notions of this ironic type, conceiving their topics of investigation so as to undermine nature's claims to naturalness and the authorities' claims to authority. Indeed, such formats are now remarkably familiar and virtually the clichés of present scholarship—prime evidence of the disciplinary turn toward critical reflection that Robert Nelson sketches in his opening essay. Those who associate recent postmodernism with the predominance of retrospective and parodic works of art, as well as with acceptance of multiple voices and conflicted patterns of authority within the academic community, are testifying to the fact that contemporary practice has become more "critical" than either "artistic" or "historical," more a matter of unstable irony than of enduring belief or regulated observation. With the dominance of the critical mode, for better or worse, comes the importance of "theory" and the usefulness of reflective writings on "critical terms."

In order to satisfy a critical mind, the practice of history might be regarded as a collecting and organizing of data, with the details understood as having been figured through desires, languages of representation, and social ideologies. Under what conditions can such history be distinguished from criticism itself? I have no "definitive" answer to this question, but it is nevertheless worth pondering for the speculative pathways it clears. The matter is complicated because any history already has a dual nature: it is simultaneously an account written in a certain literary manner and the "reality" that the very same account describes or configures (a history becomes accepted as reality when its topics and facts assume some conventional or commonplace form). This inherent reflexiveness would seem to make history writing a "critical" practice by definition, the subjective expression of a point of view to be identified not only with the writer but also with the chosen literary mode. A history can yet reclaim objective validity to the extent that its mode of figuration (its manner of writing and argumentation) signifies in itself a certain objectivity. An irony or paradox becomes evident: historians need to code their writing *as* objective observation and judgment before a reader can determine that the writing *is* objective.

We might consider the self-reflexive writing of history as perspectivist or anamorphic since the position of the (short) story teller is necessarily figured into the account. This history requires a flexible sense of time because it represents one perspective through another, the past through the present. Although all histories enact this kind of temporal stretch and compression (anamorphosis in the dimension of time), recent art histories have displayed a relatively exaggerated form of the practice, privileging the position of the writer, manifesting the writer's own needs and desires.

A self-reflexive art history cannot be founded on fixed canonical entities such as masters and masterworks. Its terms become a fluid network of relations which leave the evaluative principles—the means of establishing a canon, should one want one—open to reassessment and further historical investigation. The writer questions the values associated with the objects of study as well as his or her own values. From this perspective, relational constructs (which include the remarkably broad range of traditional dichotomies such as idealism and naturalism, male and female, line and color, hierarchy and equality, and even art and criticism) do not follow the pure logic of a developmental pattern, but appear and reappear in response to emergent sensitivities and needs within a culture or society. When, for instance, revolutionary classes of the nineteenth century opposed an inherited aristocratic order (a hierarchy), the artists among them sought a field of representation on which the source of social authority could be contested (in principle, for the sake of equality). Developing idiosyncratic visual styles, such artists appropriated the performance of originality and expressiveness as their own, stressing the significance of personal experience (available to all) as opposed to acquired academic training (granted as a privilege). It required no philosophical genius for nineteenth-century critics to understand that the naturalness associated with a revolutionary "personal" experience could be imitated, and that forms of naive expression might derive from the collective, studied cultivation of a skill. Art has a rhetoric; it is figured. It can represent its makers, its objects, and its topics as other than they otherwise appear.

Situations and conditions change not only across history but also as one negotiates various social or discursive positions. Locate yourself as a bourgeois romantic or realist artist of the nineteenth century. To promote one factor over its alternative in the relevant critical debate—generative, expressive spontaneity on the one hand, representational artifice on the other—would constitute an ideological assertion, not a logical deduction. The choice would depend in part on how strongly you were to believe in artistic expression as a valid path to self-discovery and social advantage. Believing in such a process, you become— you act as, you figure yourself as—an artist (in the sense that I have been distinguishing artists from critics and historians). What follows now are brief sketches of three self-constituting characters: those who practice art, those who practice criticism, those who practice history.

To act as an *artist* is to have faith in the integrity of personal identity, considering oneself autonomous and capable of self-expressive acts of representation. "Artists"—I use the quotes because not every artist is an "artist"—are therefore great fabricators and storytellers. Historians act as artists when they regard their particular style of writing and argumentation as a valid form of expression in itself, which (they believe) has no deleterious influence on the "real" facts and values associated with their account. If by saying one thing, the historian-as-artist excludes another, such result is considered just and beneficial.

To act as a *critic* is to doubt the stability of one's identity and to assume

an ironic stance toward objects of study, questioning one's assumptions and conclusions. "Critics" are insecure and ever wary of the reflexive effects of their own actions. They focus on the play of artistic means, attending especially to rhetoric and figuration. They are the creators of metadiscourses, commentaries on modes of commentary. When they criticize others yet exempt their own reasoning, they become too convinced of the truth of their own expression to be "critics"; they become, to a certain extent, "artists."

To act as a *historian* is to become—that is, to play at being—a detached and distanced observer. Easier said than done. On the one hand, the historian's perspective shades into the artist's whenever the historian believes in the genuine efficacy or "truth" of art, perhaps to lend the social practice of art ancillary support through the construction of chronologies, classifications, stylistic evolutions, and biographies. On the other hand, the historian's attitude converges with the critic's to the extent that the ultimate authority and perhaps the autonomy of artistic practice is doubted; often the historian reveals motivations and influences that the artist might have wished to deny or never actually recognized. Although the historian's view is likely to be contaminated by either art or criticism, it has its own place and significance: by its independent existence (if only in principle), it demonstrates the degree—perhaps minimal in our own time—to which a culture tolerates claims to objectivity. Such claims, "theory" cannot support.

When I think as a "critic" or "theorist," I doubt (as critics forever do) that any of the three perspectives or attitudes has been or ever will be experienced in a pure state. A mobile historian who shifts at will from one perspective to another becomes more "critical" than the historian as static observer. To assume the position of the willful maker of history—whether you work as artist, critic, or historian—is to acknowledge that you form objects of attention whenever focusing on or describing them. More than that, your actions reconfigure the context as much as they figure the objects addressed. By this embodied process, the writer-maker transforms the medium itself, through its use. Since the effects are real (more than just "real"), writers should be responsible to (not for) what and how they say.

References

Adler, Kathleen, and Marcia Pointon, eds. 1993. *The Body Imaged: The Human Form and Visual Culture since the Renaissance*. Cambridge: Cambridge University Press.

Adorno, Theodor. [1936] 1977. "Letter to Walter Benjamin." In Bloch et al. 1977.

———. 1962. "Commitment." In Arato and Gebhardt 1993.

———. [1972] 1984. *Aesthetic Theory*, translated by C. Lenhardt and edited by Gretel Adorno and Rolf Tiedeman. London and Boston: Routledge and Kegan Paul.

Alpers, Svetlana. 1983. *The Art of Describing: Dutch Art in the Seventeenth Century*. Chicago: University of Chicago Press.

Alpers, Svetlana, and Paul Alpers. 1972. "Ut Pictura Noesis? Criticism in Literary Studies and Art History." *New Literary History* 3.

Althusser, Louis. 1971. "Ideology and Ideological State Apparatuses." In *Lenin and Philosophy and Other Essays*, translated by Ben Brewster. London: New Left Books.

———. 1994. *The Future Lasts a Long Time*, translated by Richard Veasey. London: Vintage.

Andrews, Keith. 1977. *Adam Elsheimer: Paintings, Drawings, Prints*. New York: Rizzoli.

Appadurai, Arjun, ed. 1986. *The Social Life of Things: Commodities in Cultural Perspective*. Cambridge: Cambridge University Press.

Appiah, Anthony. 1994. "Loyalty to Humanity." *Boston Review* 19, no. 5.

Apter, Emily. 1991. *Feminizing the Fetish: Psychoanalysis and Narrative Obsession in Turn-of-the-Century France*. Ithaca: Cornell University Press.

Apter, Emily, and William Pietz, eds. 1993. *Fetishism as Cultural Discourse*. Ithaca: Cornell University Press.

Aragon, Louis. 1971. *Paris Peasant*, translated with an introduction by Simon Watson Taylor. London: Cape.

Arato, Andrew, and Eike Gebhardt, eds. 1993. *The Essential Frankfurt School Reader*. New York: Continuum.

Arendt, Hannah. 1958. *The Human Condition*. Chicago: University of Chicago Press.

Aristotle. 1978. *Poetics* XIV, translated by W. Hamilton Fyfe. Cambridge: Harvard University Press.

Arts Council of Great Britain. 1978. *Gustave Courbet 1819–1877*. London: Royal Academy of Arts.

Attridge, D., and G. Bennington. 1989. *Post-Structuralism and the Question of History*. Cambridge: Cambridge University Press.

Bal, Mieke. 1985. *Narratology: Introduction to the Theory of Narrative*. Toronto: University of Toronto Press.

———. 1991. *Reading "Rembrandt": Beyond the Word-Image Opposition*. Cambridge: Cambridge University Press.

Bal, Mieke, and Norman Bryson. 1991. "Semiotics and Art History." *Art Bulletin* 73.

Bann, Stephen. 1984. *The Clothing of Clio: A Study of the Representation of History in Nineteenth-Century Britain and France*. Cambridge: Cambridge University Press.

————. 1989. *The True Vine: On Visual Representation and the Western Tradition*. New York: Cambridge University Press.

Barolsky, Paul. 1987. *Walter Pater's Renaissance*. University Park: Pennsylvania State University Press.

Baron, Dennis. 1986. *Grammar and Gender*. New Haven: Yale University Press.

Barr, Alfred H., Jr. 1936. *Cubism and Modern Art*. New York: Museum of Modern Art.

Barrell, John. 1980. *The Dark Side of the Landscape: The Rural Poor in English Painting 1730–1840*. Cambridge: Cambridge University Press.

Barthes, Roland. 1961. "The Photographic Message." In Barthes 1977.

————. 1964. "The Rhetoric of the Image." In Barthes 1977.

————. 1972. *Mythologies*. New York: Hill & Wang.

————. 1977. *Image, Music, Text*, translated by Stephen Heath. New York: Hill & Wang.

————. 1981. *Camera Lucida: Reflections on Photography*. New York: Hill & Wang.

————. 1983. *The Fashion System*. New York: Hill & Wang.

Bartman, William S., ed. 1992. *Vija Celmins*. Los Angeles: A.R.T. Press.

Bassett, Sarah Guberti. 1991. "The Antiquities in the Hippodrome of Constantinople." In *Dumbarton Oaks Papers* 45.

Bataille, Georges. 1991. *The Accursed Share: An Essay on General Economy*, translated by Robert Hurley. 2 volumes. New York: Zone Books.

Bates, Robert H., Valentin Mudimbe, and Jean O'Barr, eds. 1993. *Africa and the Disciplines*. Chicago: University of Chicago Press.

Bateson, Gregory. 1958. *Naven*. 2d ed. Stanford: Stanford University Press.

Bathrick, David, and Andreas Huyssen. 1989. "Modernism and the Experience of Modernity." In *Modernity and the Text: Revisions of German Modernism*, edited by David Bathrick and Andreas Huyssen. New York: Columbia University Press.

Bätschmann, Oskar. 1984. *Einführung in der kunstgeschichtlichen Hermeneutik*. Darmstadt: Wissenschaftliche Buchgesellschaft.

Battock, Gregory, ed. 1968. *Minimal Art: A Critical Anthology*. New York: Dutton.

Baudelaire, Charles. [1863]. 1964. *The Painter of Modern Life and Other Essays*, translated and edited by Jonathan Mayne. Oxford: Phaidon.

————. [1846] 1965. *Art in Paris, 1845–1862*, translated and edited by Jonathan Mayne. Oxford: Phaidon.

Baudrillard, Jean. 1975. *The Mirror of Production*, translated by Mark Poster. St. Louis: Telos.

————. 1981. *For a Critique of the Political Economy of the Sign*, translated by Charles Levin. St. Louis: Telos.

————. 1984. "The Precession of Simulacra." In Wallis 1984.

————. 1990. *Revenge of the Crystal: Selected Writings on the Modern Object and Its Destiny, 1968–1983*, translated by Paul Foss and Julian Pefanis. Leichhardt: Pluto Press.

————. 1992. "The Hyper-realism of Simulation." In Harrison and Wood 1992.

————. 1994. *Simulacra and Simulation*, translated by Sheila Faria Glaser. Ann Arbor: University of Michigan Press.

Baxandall, Michael. 1972. *Painting and Experience in Fifteenth-Century Italy*. Oxford: Oxford University Press.

————. 1979. "The Language of Art History." *New Literary History* 10.

————. 1985a. "Language and Explanation." In Baxandall 1985b.

———. 1985b. *Patterns of Intention: On the Historical Explanation of Pictures*. New Haven: Yale University Press.

———. 1985c. "Art, Society, and the Bouguer Principle." *Representations* 12.

Bell, Catherine. 1992. *Ritual Theory; Ritual Practice*. New York: Oxford University Press.

Bell, Clive. [1914] 1987. *Art*. Oxford: Oxford University Press.

Belting, Hans. 1986. "Das Werk im Kontext." In Belting et al. 1986.

———. 1987. *The End of the History of Art?* Chicago: University of Chicago Press.

———. 1994. *Likeness and Presence: A History of the Image before the Era of Art*, translated by Edmund Jephcott. Chicago: University of Chicago Press.

Belting, Hans, et al. 1986. *Kunstgeschichte: Eine Einführung*. Berlin: D. Reimer.

Benhabib, Seyla. 1992. *Situating the Self: Gender, Community and Postmodernism in Contemporary Ethics*. New York: Routledge.

Benjamin, Walter. 1934. "The Author as Producer." In Benjamin 1978.

———. "On the Mimetic Faculty." In Benjamin 1978.

———. 1968a. *Illuminations,* edited by Hannah Arendt, translated by Harry Zohn. New York: Harcourt, Brace & World.

———. 1968b. "Theses on the Philosophy of History." In Benjamin 1968a.

———. 1968c. "The Work of Art in the Age of Mechanical Reproduction." In Benjamin 1968a.

———. 1970. *Charles Baudelaire: A Lyric Poet in the Era of High Capitalism*. London.

———. 1978. *Reflections*. New York: Harcourt Brace Jovanovich.

———. 1979. "On Language as Such and the Language of Man." In *One-Way Street and Other Writings,* translated by Edmund Jephcott and Kingsley Shorter. London: New Left Books.

———. 1982. *Das Passagen-Werk,* edited by Rolf Tiedemann. Frankfurt am Main: Suhrkamp.

Berkeley, George. [1709] 1965. *An Essay towards a New Theory of Vision*. In *Berkeley's Philosophical Writings,* edited by David M. Armstrong. New York: Macmillan.

Bermingham, Ann. 1986. *Landscape and Ideology: The English Rustic Tradition 1740–1860*. Berkeley: University of California Press.

Bhabha, Homi K. 1984. "Of Mimicry and Man: The Ambivalence of Colonial Discourse." *October* 28.

———. 1994a. *The Location of Culture*. New York: Routledge.

———. 1994b. "The Postcolonial and the Postmodern: The Question of Agency." In Bhabha 1994a.

Blier, Suzanne Preston. 1987. *The Anatomy of Architecture: Ontology and Metaphor in Batammaliba Architectural Expression*. New York: Cambridge University Press.

———. 1993. "Truth and Falsehood: Fetish, Magic, and Custom in European and African Art." In Bates, Mudimbe, and O'Barr 1993.

———. 1995. *African Vodun: Art, Psychology, and Power*. Chicago: University of Chicago Press.

Bloch, Ernst, Georg Lukács, Bertolt Brecht, Walter Benjamin, and Theodor Adorno. 1977. *Aesthetics and Politics,* with an Afterword by Fredric Jameson. London: NLB.

Bloch, Maurice, ed. 1975. *Political Language and Oratory in Traditional Society*. New York: Academic Press.

Bloom, Harold. 1973. *The Anxiety of Influence: A Theory of Poetry*. London: Oxford University Press.

———. 1975. *A Map of Misreading*. New York: Oxford University Press.

Board, Marilyn Lincoln. 1989. "Constructing Myths and Ideologies in Matisse's Odalisques." *Genders* 5.

Bourdieu, Pierre. 1977. *Outline of a Theory of Practice*, translated by Richard Nice. Cambridge: Cambridge University Press.

———. 1984. *Distinction: A Social Critique of the Judgement of Taste*, translated by Richard Nice. Cambridge: Harvard University Press.

———. 1993. *The Field of Cultural Production*, edited by Randall Johnson. New York: Columbia University Press.

Bowness, Alan. 1978. "Introduction." In Arts Council of Great Britain 1978.

Boyer d'Agen, ed. 1909. *Ingres d'après une correspondance inédite*. Paris: Daragon.

Brecht, Bertolt. 1938. "Popularity and Realism." In Bloch et al. 1977.

Brilliant, Richard. 1984. *Visual Narratives: Storytelling in Etruscan and Roman Art*.

Broude, Norma, and Mary D. Garrard, eds. 1982. *Feminism and Art History: Questioning the Litany*. New York: Harper and Row.

———, eds. 1992. *The Expanding Discourse: Feminism and Art History*. New York: Harper and Row.

Brown, Karen McCarthy. 1991. *Mama Lola: A Vodoun Priestess in Brooklyn*. Berkeley: University of California Press.

Bryson, Norman. 1981. *Word and Image: French Painting of the Ancien Regime*. New York: Cambridge University Press.

———. 1983. *Vision and Painting: The Logic of the Gaze*. New Haven: Yale University Press.

———. 1984. *Tradition and Desire: From David to Delacroix*. New York: Cambridge University Press.

———. 1988. "The Gaze in the Expanded Field." In Foster 1988.

———. 1990. *Looking at the Overlooked: Four Essays on Still Life Painting*. Cambridge: Harvard University Press.

———, ed. 1988. *Calligram: Essays in the New Art History from France*. Cambridge: Cambridge University Press.

Bryson, Norman, Michael Ann Holly, and Keith Moxey, eds. 1991. *Visual Theory: Painting and Interpretation*. New York: HarperCollins.

———, eds. 1994. *Visual Culture: Images and Interpretations*. Hanover, NH: Wesleyan University Press.

Buchloh, Benjamin H. D. 1982. "Allegorical Procedures: Appropriation and Montage in Contemporary Art." *Artforum* 21.

———. 1984. "Theorizing the Avant-Garde." *Art in America* 72.

Buck-Morss, Susan. 1989. *The Dialectics of Seeing: Walter Benjamin and the Arcades Project*. Cambridge: MIT Press.

Bürger, Peter. 1984. *Theory of the Avant Garde*, translated by Michael Shaw. Minneapolis: University of Minnesota Press.

Burgin, Victor. 1987. "Tea with Madeleine." In Wallis 1987.

Burton, Richard D. E. 1991. *Baudelaire and the Second Republic: Writing and Revolution*. Oxford: Oxford University Press.

Butler, Judith. 1990. *Gender Trouble: Feminism and the Subversion of Identity*. London: Routledge.

————. 1993. *Bodies that Matter: On the Discursive Limits of "Sex."* New York: Routledge.

Bynum, Caroline. 1987. *Holy Feast and Holy Fast: The Religious Significance of Food to Medieval Women.* Berkeley: University of California Press.

Calinescu, Matei. 1987. *Five Faces of Modernity: Modernism, Avant-Garde, Decadence, Kitsch, Postmodernism.* Durham, N.C.: Duke University Press.

Cachin, Françoise, Charles S. Moffett, and Juliet Wilson Bareau. 1983. *Manet 1832–1883.* New York: Metropolitan Museum of Art.

Cannadine, David, and Simon Price. 1987. *Rituals of Royalty: Power and Ceremonial in Traditional Societies.* Cambridge: Cambridge University Press.

Carrier, David. 1991. *Principles of Art History Writing.* University Park: Pennsylvania State University Press.

Carruthers, Mary. 1990. *The Book of Memory: A Study of Memory in Medieval Culture.* Cambridge: Cambridge University Press.

Carter, Michael. 1990. "The Work of Art as Commodity." In Carter, *Framing Art: Introducing Theory and the Visual Image.* Sydney: Transvisual Studies.

Castor, Grahame. 1964. *Pléiade Poetics: A Study in Sixteenth-Century Thought and Terminology.* Cambridge: Cambridge University Press.

Chambers, Ross. 1984. *Story and Situation: Narrative Seduction and the Power of Fiction.* Minneapolis: University of Minnesota Press.

Chesneau, Ernest. 1862. *Les chefs d'école.* Paris: Didier.

Clark, T. J. 1973a. *The Absolute Bourgeois.* London: Thames & Hudson.

————. 1973b. *Image of the People: Gustave Courbet and the 1848 Revolution.* London: Thames & Hudson.

————. 1974. "The Conditions of Artistic Creation." *Times Literary Supplement,* 24 May.

————. 1984. *The Painting of Modern Life: Paris in the Art of Manet and His Followers.* Princeton: Princeton University Press.

————. 1990. "Jackson Pollock's Abstraction." In *Reconstructing Modernism: Art in New York, Paris, and Montreal 1945–1964,* edited by Serge Guilbaut. Cambridge: MIT Press.

Clifford, James. 1988. *The Predicament of Culture: Twentieth-Century Ethnography, Literature, and Art.* Cambridge: Harvard University Press.

Collingwood, R. G. 1938. *The Principles of Art.* London: Oxford University Press.

Connelly, Frances. 1995. *The Sleep of Reason: Primitivism in Modern European Art and Aesthetics, 1725–1907.* University Park: Pennsylvania State University Press.

Corboz, André. 1982. "Walks around the Horses." *Oppositions* 25.

Crary, Jonathan. 1990. *Techniques of the Observer: On Vision and Modernity in the Nineteenth Century.* Cambridge: MIT Press.

Crimp, Douglas. 1980. "The Photographic Activity of Postmodernism." *October* 15.

————. 1993. *On the Museum's Ruins,* with photographs by Louise Lawler. Cambridge: MIT Press.

Crow, Thomas. 1985a. *Painters and Public Life in Eighteenth-Century Paris.* Oxford: Oxford University Press.

————. 1985b. "Codes of Silence: Historical Interpretation and the Art of Watteau." *Representations* 12.

————. 1994. "Yo Morris." *Artforum,* summer.

Dahlhaus, Carl. 1983. *Foundations of Music History,* translated by J. B. Robinson. Cambridge: Cambridge University Press.

Damisch, Hubert. 1975. "Semiotics and Iconography." In *The Tell-Tale Sign: A Survey of Semiotics,* edited by Thomas A. Sebeok. Lisse, Netherlands: Peter De Ridder Press.

Danto, Arthur C. 1964. "The Artworld." *Journal of Philosophy* 61.

———. 1968. *Analytical Philosophy of History.* Cambridge: Cambridge University Press.

———. 1986. *The Philosophical Disenfranchisement of Art.* New York: Columbia University Press.

Davis, Whitney. 1992. "Homovision: A Reading of Freud's 'Fetishism.'" *Genders* 15.

———, ed. 1994. *Journal of Homosexuality* 27, nos. 1 and 2. *Gay and Lesbian Studies in Art History.*

Debord, Guy. 1983. *The Society of the Spectacle.* Detroit: Black and Red.

De Certeau, Michel. 1986. *Heterologies,* translated by Brian Massumi. Minneapolis: University of Minnesota Press.

de Lauretis. *See* Lauretis, Teresa de.

Deleuze, Gilles. 1988. "The Visible and the Articulable." In *Foucault.* Minneapolis: University of Minnesota Press.

———. 1990. "Plato and the Simulacrum." In *The Logic of Sense,* edited by Constance V. Boundas. New York: Columbia University Press.

Deleuze, Gilles, and Félix Guattari. 1977. *Anti-Oedipus: Capitalism and Schizophrenia.* New York: Viking.

———. 1994. *What Is Philosophy?* New York: Columbia University Press.

de Man, Paul. 1979. *Allegories of Reading: Figural Language in Rousseau, Nietzsche, Rilke, and Proust.* New Haven: Yale University Press.

Déotte, Jean-Louis. 1993. *Le musée: l'origine de l'esthétique.* Paris: Editions l'Harmattan.

Derrida, Jacques. 1976. *Of Grammatology,* translated by Gayatri Chakravorty Spivak. Baltimore: Johns Hopkins University Press.

———. 1977. "Signature Event Context." *Glyph* 1.

———. 1978. *Writing and Difference,* translated by Alan Bass. Chicago: University of Chicago Press.

———. 1981. "The Double Session." In *Dissemination,* translated by Barbara Johnson. Chicago: University of Chicago Press.

———. 1987. *The Truth in Painting,* translated by G. Bennington and I. McLeod. Chicago: University of Chicago Press.

———. 1993. *Memoirs of the Blind: The Self-Portrait and Other Ruins,* translated by Pascale-Anne Brault and Michael Naas. Chicago: University of Chicago Press.

———. 1994. *Specters of Marx: The State of the Debt, the Work of Mourning, and the New International.* London: Routledge.

Desai, Vishakha N. 1993. "Beyond the Temple Walls: The Scholarly Fate of North Indian Sculpture, A.D. 700–1200." In *Gods, Guardians, and Lovers: Temple Sculptures from North India A.D. 700–1200,* edited by Vishakha N. Desai and Danielle Mason. New York: Asia Society Galleries.

Dick, Phillip K. 1987. "Pay for the Printer." In *The Complete Stories of Phillip K. Dick,* volume 3, *The Father Thing.* London: Underwood-Miller.

Diderot, Denis. 1957–67. *Salons,* edited by Jean Seznec and Jean Adhémar. 4 vols. London: Oxford University Press.

Dilly, Heinrich. 1979. *Kunstgeschichte als Institution: Studien zur Geschichte einer Disziplin.* Frankfurt: Suhrkamp.

————. 1988. *Deutsche Kunsthistoriker 1933–1945*. Munich: Deutscher Kunstverlag.

Doty, William G. 1986. *Mythography: The Study of Myth and Rituals*. Tuscaloosa: University of Alabama Press.

Douglas, Mary. 1960. *Purity and Danger*. New York: Praeger.

————. 1973. *Natural Symbols*. New York: Random House.

Drewal, Margaret Thompson. 1992. *Yoruba Ritual: Performers, Play, Agency*. Bloomington: Indiana University Press.

Dumas, Alexandre. 1867. "L'Ecole des beaux-arts." In *Paris Guide*, 2 vols. Brussels: Librairie internationale.

Duncan, Carol. 1982. "Virility and Domination in Early Twentieth-Century Vanguard Painting." In *Feminism and Art History: Questioning the Litany*, edited by Norma Broude and Mary Garrard. New York: Harper and Row.

Durham, Scott. 1993. "The Simulacrum: Between Painting and Narrative." *October* 1993.

Durkheim, Emile. 1965. *The Elementary Forms of the Religious Life*, translated by Joseph Ward Awain. New York: The Free Press.

Durkheim, Emile, and Marcel Mauss. 1963. *Primitive Classification*, translated by Rodney Needham. Chicago: University of Chicago Press.

Eco, Umberto. 1976. *A Theory of Semiotics*. Bloomington: Indiana University Press.

Eliade, Mircea. 1959. *The Sacred and the Profane*. New York: Harper and Row.

Eliot, T. S. 1976. *The Sacred Wood*. London: Methuen.

Fabian, Johannes. 1983. *Time and the Other: How Anthropology Makes Its Object*. New York: Columbia University Press.

Faunce, Sarah, and Linda Nochlin, eds. 1988. *Courbet Reconsidered*. New Haven: Yale University Press.

Fermor, Sharon. 1993. *Piero di Cosimo: Fiction, Invention, and Fantasia*. London: Reaktion.

Ferry, Luc. 1993. *Homo Aestheticus: The Invention of Taste in the Democratic Age*, translated by Robert de Loaiza. Chicago: University of Chicago Press.

Finn, David. 1985. *How to Visit a Museum*. New York: Abrams.

Fló, Juan. 1992. "Torres-García in (and from) Montevideo." In *El Taller Torres-García: The School of the South and Its Legacy*, edited by Mari Carmen Ramírez. Austin: University of Texas Press.

Forster, Kurt A. 1972. "Critical History of Art, or Transfiguration of Values." *New Literary History* 3.

Foster, Hal. 1983. "Postmodernism: A Preface." In Foster, ed., 1983.

————. 1985a. "The 'Primitive' Unconscious of Modern Art, or White Skin Black Masks." *October* 34.

————. 1985b. *Recodings, Art, Spectacle, Cultural Politics*. Seattle: Bay Press.

————. 1993. *Compulsive Beauty*, Cambridge, Mass.: MIT Press.

————, ed. 1983. *The Anti-Aesthetic: Essays in Postmodern Cultures*. Port Townsend, Wash.: Bay Press.

————, ed. 1988. *Vision and Visuality*. Dia Art Foundation Discussions in Contemporary Culture, no. 2. Seattle: Bay Press.

Foster, Hal, Benjamin Buchloh, Rosalind Krauss, Yves-Alain Bois, Denis Hollier, and Helen Molesworth. 1994. "The Politics of the Signifier II: A Conversation on the *Informe* and the Abject." *October* 67.

Foster, Hal, Rosalind Krauss, Sylvia Kolbowski, Miwon Kwon, and Benjamin Buchloh. 1993a. "The Politics of the Signifier: A Conversation on the Whitney Bicentennial." *October* 66.

———— 1993b. "Postmodernism in Parallax. *October,* no. 63 (Winter).

Foucault, Michel. 1972. *The Archaeology of Knowledge and the Discourse of Language.* New York: Pantheon.

————. 1977. "Theatrum Philosophicum." In *Language, Counter-memory, Practice: Selected Essays and Interviews.* Ithaca: Cornell University Press.

————. 1977. "Panopticism." In *Discipline and Punish: The Birth of the Prison,* translated by Alan Sheridan. New York: Pantheon.

————. 1982. *This Is Not a Pipe,* translated by James Harkness. Berkeley: University of California Press.

————. 1986. *Death and the Labyrinth: The World of Raymond Roussel.* Garden City, N.Y.: Doubleday.

Frampton, Kenneth. 1971. "Notes on a Lost Avant-Garde." In *Art in Revolution.* London: Hayward Gallery.

Freedberg, David. 1989. *The Power of Images: Studies in the History and Theory of Response.* Chicago: University of Chicago Press.

Freud, Sigmund. 1962. *Three Essays on the Theory of Sexuality,* translated and revised by James Strachey. New York: Basic.

————. 1963. "Fetishism," translated by Joan Riviere. In *Sexuality and the Psychology of Love,* edited by Philip Rieff. New York.

Fried, Michael. 1965. *Three American Painters: Kenneth Noland, Jules Olitski, Frank Stella.* In Harrison and Wood 1992.

————. 1967. "Art and Objecthood." In Battcock 1968.

————. 1980. *Absorption and Theatricality: Painting and Beholder in the Age of Diderot.* Berkeley: University of California Press.

————. 1987. *Realism, Writing, Disfiguration: On Thomas Eakins and Stephen Crane.* Chicago: University of Chicago Press.

————. 1990. *Courbet's Realism.* Chicago: University of Chicago Press.

Friedlander, Max J. 1941. "Artistic Quality: Original and Copy." *Burlington Magazine* 78.

Fry, Roger. [1920] 1981. *Vision and Design.* Oxford: Oxford University Press.

Frye, Northrup. 1983. *The Great Code: The Bible and Literature.* San Diego: Harcourt Brace Jovanovich, Inc.

Fukuyama, Francis. 1992. *The End of History and the Last Man.* New York: Free Press.

Fuss, Diana, ed. 1991. *Inside/Out: Lesbian Theories, Gay Theories.* New York: Routledge.

Fustel de Coulanges, Numa Denis. 1956. *The Ancient City: A Classic Study of the Religious and Civil Institutions of Ancient Greece and Rome.* Garden City, N.Y.: Doubleday.

Gage, John. 1972. *Turner: Rain, Steam, and Speed.* New York: Viking.

Galey, Jean-Claude, ed. 1984. *Différences, valeurs, hiérarchie: Textes offerts à Louis Dumont.* Paris: Ecole des Hautes Etudes en Sciences Sociales.

Gasquet, Joachim. 1926. *Cézanne.* Paris: Bernheim-Jeune.

Gates, Henry Louis, Jr., ed. 1986. *"Race," Writing, and Difference.* Chicago: University of Chicago Press.

Geertz, Clifford. 1973. *The Interpretation of Cultures.* New York: Basic.

————. 1985. "Centers, Kings, and Charisma: Reflections on the Symbolics of Power." In Wilentz 1985.

Genette, Gérard. 1980. *Narrative Discourse,* translated by Jane E. Lewin. Ithaca: Cornell University Press.

Gibert, Pierre. 1986. *Bible, mythes et récits de commencement.* Paris.

Giddons, Anthony. 1994. *Beyond Left and Right: The Future of Radical Politics.* Stanford: Stanford University Press.

Gilman, Sander L. 1985. *Difference and Pathology: Stereotypes of Sexuality, Race, and Madness.* Ithaca: Cornell University Press.

———. 1991. *The Jew's Body.* New York: Routledge.

Gluckman, Max. 1965. *Politics, Law and Ritual in Tribal Society.* Chicago: Aldine.

Godfrey, Sima, ed. 1984. *The Anxiety of Anticipation.* Yale French Studies, no. 6. New Haven: Yale University Press.

Goffman, Erving. 1967. *Interaction Ritual.* Garden City, N.Y.: Doubleday.

Gombrich, Ernst H. 1948. "Icones Symbolicae: The Visual Image in Neo-Platonic Thought." *Journal of the Warburg and Courtauld Institute* II. (Revised version in Gombrich 1972.)

———. 1963. *Meditations on a Hobby Horse and Other Essays on the Theory of Art.* London: Phaidon.

———. 1966. "Norm and Form: The Stylistic Categories of Art History and Their Origins in Renaissance Ideals." In *Norm and Form: Studies in the Art of the Renaissance.* London: Phaidon.

———. 1969. *Art and Illusion: A Study in the Psychology of Pictorial Representation.* Princeton: Princeton University Press.

———. 1972. *Symbolic Images.* London: Phaidon.

Goodman, Nelson. 1976. *The Languages of Art: An Approach to a Theory of Symbols.* Indianapolis: Hackett.

Gouma-Peterson, Thalia, and Patricia Mathews. 1987. "The Feminist Critique of Art History." *Art Bulletin* 69.

Grabar, Oleg. 1973. *The Formation of Islamic Art.* New Haven: Yale University Press.

Gramsci, Antonio. 1973. *Selections from the Prison Notebooks,* edited and translated by Quinton Hoare and Geoffrey Nowell Smith. London: Lawrence & Wishart.

Green, Christopher. 1987. *Cubism and Its Enemies: Modern Movements and Reaction in French Art, 1916–1928.* New Haven: Yale University Press.

Greenberg, Clement. 1939. "Avant Garde and Kitsch." In Greenberg 1986–93, vol. 1.

———. 1940. "Towards a Newer Laocoon." *Partisan Review* 7.

———. 1960. "Modernist Painting." In Greenberg 1986–93, vol. 4.

———. 1967. "Complaints of an Art Critic." In Greenberg 1986–93, vol. 4.

———. 1986–93. *The Collected Essays and Criticisms,* edited by John O'Brian. 4 vols. Chicago: University of Chicago Press.

Greenblatt, Stephen. 1991. *Marvelous Possessions: The Wonder of the New World.* Chicago: University of Chicago Press.

Greene, Thomas M. 1982. *The Light in Troy: Imitation and Discovery in Renaissance Poetry.* New Haven: Yale University Press.

Gregory, C. A. 1982. *Gifts and Commodities.* London: Academic Press.

Greimas, Algirdas Julien, and Joseph Courtés. 1983. *Semiotics and Language: An Analytical Dictionary.* Bloomington: Indiana University Press.

Grudin, Eva Ungar. 1990. "Essay." In *Stitching Memories: African-American Story Quilts.* Williamstown, Mass.: Williams College Museum of Art.

Habermas, Jürgen. 1981. "Modernity: An Incomplete Project." In Foster 1983.

———. 1987. *The Philosophical Discourse of Modernity*. Translated by Frederick Lawrence. Cambridge: MIT Press, 1987.

Hadjinicolaou, Nicos. 1973. *Art History and Class Struggle*. London: Pluto.

———. 1982. "On the Ideology of Avant-Gardism," translated by Diane Belle James. *Praxis* 6.

Hagstrum, Jean. 1958. *The Sister Arts*. Chicago: University of Chicago Press.

Haraway, Donna J. 1991. "A Cyborg Manifesto." In *Simians, Cyborgs and Women: The Reinvention of Nature*. New York: Routledge.

Harmsen, Ger. 1982. "De Stijl and the Russian Revolution." In *De Stijl: 1917–1931: Visions of Utopia*, edited by Mildred Friedman. Minneapolis: Walker Art Center.

Harris, Michael D. 1993. "Resonance, Transformation, and Rhyme: The Art of Renée Stout." In *Astonishment and Power: Kongo Minkisi and the Art of Renée Stout*, edited by Michael D. Harris and Wyatt MacGaffey. Washington: National Museum of African Art.

Harrison, Charles, and Paul Wood, eds. 1992. *Art in Theory 1900–1990: An Anthology of Changing Ideas*. Oxford: Blackwell.

Harvey, David. 1989. *The Condition of Postmodernity: An Enquiry into the Origins of Cultural Change*. Oxford: Blackwell.

Hauser, Arnold. 1963. *The Philosophy of Art History*. Cleveland: World/Meridian.

Heath, Stephen. 1981. *Questions of Cinema*. London: Macmillan.

Hegel, G. W. F. 1975. *Aesthetics: Lectures on Fine Arts*, translated by T. M. Knox. 2 volumes. Oxford: Clarendon.

Heidegger, Martin. 1959. *An Introduction to Metaphysics*. New Haven: Yale University Press.

———. 1977a. *Basic Writings*, edited by David Farrell Krell. New York: HarperCollins.

———. 1977b. *The Question Concerning Technology and Other Essays*. New York: Harper and Row.

Helsinger, Elizabeth. 1996. *Rural Scenes and the Representation of Britain 1815–1850*. Princeton: Princeton University Press.

[Henkels, Herbert]. 1987. *Mondrian: From Figuration to Abstraction*. Tokyo: Tokyo Shimbun.

Herbert, Robert L. 1972. *David: Brutus*. New York: Viking.

———. 1988. *Impressionism: Art, Leisure, and Parisian Society*. New Haven: Yale University Press.

Hertz, Robert. 1973. "The Pre-eminence of the Right Hand: A Study in Religious Polarity." In *Right and Left: Essays on Dual Symbolic Classification*, edited by Rodney Needham. Chicago: University of Chicago Press.

Herwitz, Daniel. 1993. *Making Theory/Constructing Art: On the Authority of the Avant-Garde*. Chicago: University of Chicago Press.

Hiller, Susan, ed. 1991. *The Myth of Primitivism: Perspectives on Art*. London: Routledge.

Hobsbawm, Eric, and Terence Ranger, eds. 1983. *The Invention of Tradition*. Cambridge: Cambridge University Press.

Hollier, Denis. 1992. "The Use-Value of the Impossible," translated by Liesl Ollman. *October* 60.

Holly, Michael Ann. 1984. *Panofsky and the Foundations of Art History*. Ithaca: Cornell University Press.

Holt, Elizabeth Gilmore. 1966. *From the Classicists to the Impressionists: A Documentary History of Art and Architecture in the 19th Century*. Garden City, N.Y.: Anchor.

Hooper-Greenhill, Eilean. 1992. *Museums and the Shaping of Knowledge*. London: Routledge.

Horace. 1978. *Ars Poetica* 361, translated by H. R. Fairclough. Cambridge: Harvard University Press.

Huyssen, Andreas. 1981. "The Search for Tradition: Avant-Garde and Postmodernism in the 1970s." *New German Critique* 22.

Impey, Oliver, and Arthur MacGregor, eds. 1985. *The Origins of Museums: The Cabinet of Curiosities in Sixteenth- and Seventeenth-Century Europe*. Oxford: Oxford University Press.

Institute of Contemporary Arts. 1986. *Endgame: Reference and Simulation in Recent Painting and Sculpture*. Boston: Institute of Contemporary Arts.

Iversen, Margaret. 1993. *Alois Riegl: Art History and Theory*. Cambridge: MIT Press.

Jacoff, Michael. 1993. *The Horses of San Marco and the Quadriga of the Lord*. Princeton: Princeton University Press.

James, E. O. 1955. *The Nature and Functions of the Priesthood*. London: Thames and Hudson.

Jameson, Fredric. 1981. *The Political Unconscious: Narrative as a Socially Symbolic Act*. Ithaca: Cornell University Press.

———. 1991. *Postmodernism, or the Cultural Logic of Late Capitalism*. Durham: Duke University Press.

——— 1992. "The Deconstruction of Expression." In Harrison and Wood, 1992.

Jay, Martin. 1993. *Downcast Eyes: The Denigration of Vision in Twentieth-Century French Thought*. Berkeley: University of California Press.

Jencks, Charles. 1990. *What Is Post-Modernism?* 3d ed. New York: St. Martin's Press.

Jonson, Ben. 1975. "An Expostulation with Inigo Jones." In *The Complete Poems*, edited by George Parfitt. New Haven: Yale University Press.

Joosten, J. M. 1968. "Documentatie over Mondriaan (1)." *Museumjournaal* 13.

Judd, Donald. 1992. ". . . not about masterpieces but why there are so few of them." In Harrison and Wood 1992.

Kant, Immanuel. 1987. *Critique of Judgment*, translated by Werner S. Pluhar. Indianapolis: Hackett Publishing.

Karpf, Jutta. 1994. *Strukturanalyse der mittelalterlichen Bilderzählung: Ein Beitrag zur kunsthistorischen Erzählforschung*. Marburg.

Kemal, Salim, and Ivan Gaskell, eds. 1991. *The Language of Art History*. Cambridge: Cambridge University Press.

Kemp, Wolfgang. 1983. *Der Anteil des Betrachters: Rezeptionsästhetische Studien zur Malerei des 19. Jahrhunderts*. Munich: Maeander.

———. 1987. *Sermo corporeus: Die Erzählung der mittelalterlichen Glasfenster*. Munich.

———, ed. 1989. *Der Text des Bildes: Möglichkeiten und Mittel eigenständiger Bilderzählung*. Munich.

Kessler, Herbert L., and M. S. Simpson, eds. 1985. *Studies in the History of Art: Pictorial Narrative and the Middle Ages*. Washington, D.C.: National Gallery of Art.

Kilson, M. 1983. "Antelopes and Stools: Ga Ceremonial Kingship." *Anthropos* 78.

Klossowski, Pierre. 1963. "A propos du simulacre dans la communication de Georges Bataille." *Critique* 1963.

Kofman, Sarah. 1989. "Ça cloche," translated by Caren Kaplan. In Silverman 1989.

Kojève, Alexandre. 1947. *Introduction à la lecture de Hegel*. Paris: Gallimard.

Koons, Jeff. 1992. *The Jeff Koons Handbook*. London.

Krauss, Rosalind E. 1977. *Passages in Modern Sculpture*. Cambridge: MIT Press.
———. 1981. "The Originality of the Avant-Garde: A Postmodernist Repetition." *October* 18. Also in Krauss 1985.
———. 1985. *The Originality of the Avant-Garde and Other Modernist Myths*. Cambridge: MIT Press.
Kristeva, Julia. 1980. *Desire in Language*. New York: Columbia University Press.
———. 1982. *The Powers of Horror: An Essay in Abjection*. New York: Columbia University Press.
Kubler, George. 1975. "History—or Anthropology—of Art?" *Critical Inquiry* 4.
Lacan, Jacques. 1977a. *Ecrits: A Selection*, translated by Alan Sheridan. New York: Norton.
———. 1977b. "The Mirror Stage as Formative of the Function of the I." In Lacan 1977a.
———. 1978a. "Of the Gaze as *Objet Petit a*." In Lacan 1978b.
———. 1978b. *The Four Fundamental Concepts of Psycho-Analysis*, edited by Jacques-Alain Miller, translated by Alan Sheridan. New York: W. W. Norton.
———. 1992. "The Function of the Good." In *The Seminar of Jacques Lacan, Book VII: The Ethics of Psychoanalysis*, translated by Dennis Porter, edited by Jacques-Alain Miller. New York: W. W. Norton.
Lacoue-Labarthe, Philippe. 1993. *The Subject of Philosophy*, edited by Thomas Tresize, translated by Gary M. Cole. Minneapolis: University of Minnesota Press.
Laplanche, Jean, and J. B. Pontalis. 1988. *The Language of Psychoanalysis*. London: Karnak.
Lash, Scott, and John Urry. 1994. *Economies of Signs and Space*. London: Sage.
Lauretis, Teresa de. 1987. *Technologies of Gender*. Bloomington: Indiana University Press.
———. 1994. *The Practice of Love: Lesbian Sexuality and Perverse Desire*. Bloomington: Indiana University Press.
Lavin, Marilyn Aronberg. 1981. *Piero della Francesco's Baptism of Christ*. New Haven: Yale University Press.
Lavin, Maud. 1993. *Cut with the Kitchen Knife: The Weimar Photomontages of Hannah Höch*. New Haven: Yale University Press.
Lebensztejn, Jean-Claude. 1974. "Esquisse d'une typologie." *Revue de l'art* 26.
Leighten, Patricia. 1990. "The White Peril and *l'Art Nègre*: Picasso, Primitivism, and Anticolonialism." *Art Bulletin* 4.
Lentricchia, Frank, and Thomas McLaughlin, eds. 1990. *Critical Terms for Literary Study*. Chicago: University of Chicago Press.
Leonardo da Vinci. 1956. "Paragone: Of Poetry and Painting." In *Treatise on Painting*, edited by A. Philip McMahon. Princeton: Princeton University Press.
Lessing, Gotthold Ephraim. [1766] 1965. *Laocoon: An Essay upon the Limits of Painting and Poetry*, translated by Ellen Frothingham. New York: Farrar, Straus, and Giroux.
Levin, David Michael, ed. 1993. *Modernity and the Hegemony of Vision*. Berkeley: University of California Press.
Levinas, Emmanuel. 1969. "Ethics and the Face." In *Totality and Infinity: An Essay on Exteriority*, translated by Alphonso Lingis. Pittsburgh: Duquesne University Press.
Lévi-Strauss, Claude. 1962. *The Savage Mind*. Chicago: University of Chicago Press.
———. 1967. *Tristes Tropiques*, translated by John Weightman and Doreen Weightman. New York: Atheneum.

Lewis, Gilbert. 1980. *Day of Shining Red: An Essay on Understanding Ritual.* Cambridge: Cambridge University Press.

Luhmann, Niklas. 1981. "Handlungstheorie and Systemtheorie." *Soziale Aufklärung* 3.

Luijten, Ger, and Ariane Van Suchtelen, eds. 1993. *Dawn of the Golden Age: Northern Netherlandish Art 1580–1620.* Amsterdam: Rijksmuseum.

Lukács, Georg. 1971. *History and Class Consciousness: Studies in Marxist Dialectics,* translated by Rodney Livingstone. Cambridge: MIT Press.

Lyotard, Jean-François. 1988. *The Differend: Phrases in Dispute.* Translated by Georges Van Den Abbeele. Minneapolis: University of Minnesota Press.

———. 1992. "What Is Postmodernism?" In Harrison and Wood 1992.

MacGaffey, Wyatt. 1990. "The Personhood of Ritual Objects: Kongo *Minkisi.*" *Etnofoor* 3.

Mainardi, Patricia. 1982. "Quilts: The Great American Art." In Broude and Garrard 1982.

Mann, Paul. 1991. *The Theory-Death of the Avant-Garde.* Bloomington: Indiana University Press.

Marcuse, Herbert. 1968. "The Affirmative Character of Culture," translated by Jeremy J. Shapiro. In *Negations: Essays in Critical Theory.* Boston: Beacon Press.

Marin, Louis. 1980. "Towards a Theory of Reading in the Visual Arts: Poussin's *The Arcadian Shepherds.*" In *The Reader in the Text: Essays on Audience and Interpretation,* edited by Susan Suleiman and Inge Crosman. Princeton: Princeton University Press.

Marriott, Cecila. 1975. "Iconography in De Kooning's *Excavation.*" *Bulletin of the Art Institute of Chicago* 69.

Martin, Wallace. 1986. *Recent Theories of Narrative.* Ithaca: Cornell University Press.

Marx, Karl. [1867a] 1954. *Capital,* translated by Samuel Moore and Edward Aveling. 2 volumes. Moscow: Progress.

———. [1867b] 1974. "The Fetishism of Commodities." In *Capital,* vol. 1. London: Dent.

———. [1859] 1970. *A Contribution to the Critique of Political Economy.* In Karl Marx and Friedrich Engels, *Selected Works.* Moscow: Progress.

———. [1857] 1973. *Grundrisse: Foundations of the Critique of Political Economy (Rough Draft),* translated by Martin Nicolaus. London: Penguin.

———. [1844] 1975. "Economic and Philosophical Manuscripts." In *Early Writings,* translated by Rodney Livingstone and Gregory Benton. London: Penguin.

Mathews, Patricia. 1988. "Passionate Discontent: The Creative Process and Gender Difference in the French Symbolist Period." *Allen Memorial Art Museum Bulletin* 1.

Mauss, Marcel. 1966. *The Gift: Forms and Functions of Exchange in Archaic Societies,* translated by Ian Cunnison. London.

———. 1973. "Techniques of the Body." In *Right and Left: Essays on Dual Symbolic Classification.* Chicago: University of Chicago Press.

Mayne, J., ed. 1965. *Art in Paris.* Oxford: Phaidon.

McClellan, Andrew. 1994. *Inventing the Louvre: Art, Politics, and the Origins of the Modern Museum in Eighteenth-Century Paris.* Cambridge: Cambridge University Press.

McClintock, Anne. 1993. "Maid to Order: Commercial Fetishism and Gender Power." *Social Text* 37.

McCulloch, John Ramsey. 1825. *The Principles of Political Economy*. London: Longmans.

McLeod, Glen. 1993. *Wallace Stevens and Modern Art: From the Armory Show to Abstract Expressionism*. New Haven: Yale University Press.

McNelly [Kearns], Cleo. 1975. "Nature, Women, and Claude Lévi-Strauss." *Massachusetts Review* 16.

Meillassoux, Claude. 1991. *The Anthropology of Slavery: The Womb of Iron and Gold,* translated by Alide Dasnois. Chicago: University of Chicago Press.

Menzio, Eva. 1979. "Self-Portrait in the Guise of Painting." In *Mot pour Mot/Word for Word*. No. 2. *Artemisia*. Paris: Yvon Lambert Gallery.

Merleau-Ponty, Maurice. 1969. *Humanism and Terror: An Essay on the Communist Problem,* translated by J. O'Neill. Boston: Beacon.

Metropolitan Museum of Art. 1979. *The Horses of San Marco Venice*. Milan: Olivetti.

Metz, Christian. 1974. *Film Language: A Semiotics of the Cinema,* translated by Michael Taylor. New York: Oxford University Press.

Miller, Christopher L. 1985. *Blank Darkness: Africanist Discourse in France*. Chicago: University of Chicago Press.

Millon, Henry A., ed. 1989. "Retaining the Original: Multiple Originals, Copies, and Reproductions." *Studies in the History of Art* 20.

Mitchell, W. J. T. 1986. *Iconology: Image, Text, Ideology*. Chicago: University of Chicago Press.

———. 1994. *Picture Theory: Essays on Verbal and Visual Representation*. Chicago: University of Chicago Press.

———, ed. 1994. *Landscape and Power*. Chicago: University of Chicago Press.

Mitchell, William J. 1992. *The Reconfigured Eye: Visual Truth in the Post-Photographic Era*. Cambridge: MIT Press.

Mondrian, Piet. 1993. *The New Art—The New Life: The Collected Writings of Piet Mondrian,* edited and translated by Harry Holtzman and Martin S. James. New York: Da Capo.

Moore, Sally F., and Barbara G. Myerhoff, eds. 1977. *Secular Ritual*. Amsterdam: Van Gorcum.

Moreau-Nélaton, Etienne. 1926. *Manet raconté par lui-même*. 2 vols. Paris: H. Laurens.

Morphy, Howard. 1993. *Ancestral Connections*. Chicago: University of Chicago Press.

Morrison, Toni. 1987. *Beloved*. London: Picador.

Mosquera, Gerardo. 1995. *Beyond the Fantastic: Contemporary Art Criticism from Latin America*. London: Institute of International Visual Arts.

Moxey, Keith. 1994. *The Practice of Theory: Poststructuralism, Cultural Politics, and Art History*. Ithaca: Cornell University Press.

Mukarovsky, Jan. 1988. "Art as Semiological Fact." In Bryson 1988.

Mulvey, Laura. 1988. "Visual Pleasure and Narrative Cinema." In *Feminism and Film Theory,* edited by Constance Penley. New York: Routledge.

———. 1993. "Some Thoughts on Theories of Fetishism in the Context of Contemporary Culture." *October* 65.

Munn, Nancy. 1973. *Walbiri Iconography*. Ithaca: Cornell University Press.

Murray, Peter, and Linda Murray. 1989. *The Penguin Dictionary of Art and Artists*. 6th ed. London: Penguin.

Myers, Fred R. 1986. *Pintupi Country, Pintupi Self*. Washington: Smithsonian Institution.

Nelson, Robert S. 1989. "The Discourse of Icons, Then and Now." *Art History* 12.

Nochlin, Linda. 1971. *Realism*. Harmondsworth: Penguin.

———. 1988. See Faunce and Nochlin 1988.

Olin, Margaret. 1989. "Forms of Respect: Alois Riegl's Concept of Attentiveness." *Art Bulletin* 71.

———. 1991. "'It Is Not Going to Be Easy to Look into Their Eyes': Privilege of Perception in *Let Us Now Praise Famous Men*." *Art History*, March.

———. 1992. *Forms of Representation in Alois Riegl's Theory of Art*. University Park: Pennsylvania State University Press.

Ortega y Gasset, José. 1968. "The Dehumanization of Art." In *The Dehumanization of Art and Other Essays on Art, Culture and Literature*. Princeton: Princeton University Press.

Ortner, Sherry B. 1974. "Is Female to Male as Nature Is to Culture?" In *Woman, Culture, and Society*, edited by Michelle Z. Rosaldo and Louise Lamphere. Menlo Park: Stanford University Press.

Orton, Fred, and Griselda Pollock. 1980. "*Les Données bretonnantes:* La Prairie de la représentation." *Art History* 3.

Oudart, Jean-Pierre. 1977–78. "Cinema and Suture." *Screen* 18.

Ovid. 1955. *Metamorphoses*, translated by Mary M. Innes. London: Penguin.

Owens, Craig. 1982. "Sherrie Levine at A & M Artworks." *Art in America* 70.

———. 1992a. *Beyond Recognition, Representation, Power, and Culture*. Berkeley: University of California Press.

———. 1992b. "The Allegorical Impulse: Towards a Theory of Postmodernism." In Harrison and Wood 1992.

Panofsky, Erwin. 1955. "Iconography and Iconology." In Panofsky 1970.

———. 1970. *Meaning in the Visual Arts*. Harmondsworth: Penguin.

———. [1939] 1972. "Studies in Iconology, I. Introductory." In *Studies in Iconology: Humanistic Themes in the Art of the Renaissance*. New York: Harper and Row.

———. 1979. "Style and Medium in the Motion Pictures." In *Film Theory and Criticism*, edited by Gerald Mast and Marshall Cohen. New York: Oxford University Press.

Pater, Walter. [1893] 1980. *The Renaissance: Studies in Art and Poetry*, edited by D. L. Hill. Berkeley: University of California Press. (First edition published 1873.)

Patton, Paul. 1992. "Anti-Platonism and Art." In *Gilles Deleuze and the Theater of Philosophy*, edited by Constantin V. Boundas and Dorothea Olowski. New York: Routledge.

Pearce, Susan. 1992. *Museums, Objects, and Collections: A Cultural Study*. Washington: Smithsonian Institution Press.

Peirce, Charles Sanders. 1873. "On the Nature of Signs." In Peirce 1991.

———. 1901[?]. "Sign." In Peirce 1991.

———. 1906. "The Basis of Pragmatism." In Peirce 1991.

———. 1931–58. "The Icon, Index, and Symbol." In *Collected Works*, edited by Charles Hartshorne and Paul Weiss, vol. 2. Cambridge: Harvard University Press.

———. 1991. *Peirce on Signs: Writings on Semiotics by Charles Sanders Peirce*, edited by James Hoopes. Chapel Hill: University of North Carolina Press.

Pellizzi, Francesco. 1992. "*Speculum Animale:* Ray Smith and the Desire of Painting." In *Ray Smith*. Monterrey: Marco.

Perry, Gill. 1993. "Primitivism and the 'Modern.'" In *Primitivism, Cubism, Abstraction: The Early Twentieth Century*, edited by Charles Harrison, Francis Frascina, and Gill Perry. New Haven: Yale University Press.

Pietz, William. 1985, 1987, 1988. "The Problem of the Fetish." *Res: Anthropology and Aesthetics* 9, 13, 16.

Podro, Michael. 1982. *The Critical Historians of Art*. New Haven: Yale University Press.

Poggioli, Renato. 1968. *The Theory of the Avant-Garde,* translated by Gerald Fitzgerald. Cambridge: Harvard University Press.

Pollock, Griselda. 1988. *Vision and Difference: Femininity, Feminism, and the Histories of Art*. London: Routledge.

———. 1989. "Agency and the Avant-Garde." *Block* 15.

———. 1993. *Avant-Garde Gambits, 1888–1893: Gender and the Color of Art History*. London: Thames and Hudson.

Potts, Alex. 1994. *Flesh and the Ideal: Winckelmann and the Origins of Art History*. New Haven: Yale University Press.

Pound, Ezra. 1934. *Make It New*. New Haven: Yale University Press.

Preziosi, Donald. 1989. *Rethinking Art History: Meditations on a Coy Science*. New Haven: Yale University Press.

———. 1992. "The Question of Art History." *Critical Inquiry* 18.

Price, Sally. 1989. *Primitive Art in Civilized Places*. Chicago: University of Chicago Press.

Propp, Vladimir. 1968. *Morphology of the Folktale*. Austin: University of Texas Press.

Quatremère de Quincy, Antoine Chrysostôme. [1824] 1835. *Histoire de la vie et des ouvrages de Raphaël*. Paris: Gosselin.

———. 1837. *Essai sur l'idéal*. Paris: Le Clere.

———. 1989. *Considérations morales sur la destination des ouvrages de l'art* [1815]; *Lettres sur l'enlèvement des ouvrages de l'art antique à Athenes et à Rome* [1836]. Paris: Fayard.

Reed, Christopher. 1994. "Postmodernism and the Art of Identity." In Stangos 1994.

Rees, A. L., and R. Borzello. 1986. *The New Art History*. London: Camden.

Rewald, John. 1986. *Studies in Post-Impressionism*. New York: Thames and Hudson.

Reynolds, Joshua. 1975. *Discourses on Art,* edited by Robert R. Wark. New Haven: Yale University Press.

Rich, Adrienne. 1991. *Atlas of a Difficult World: Poems 1988–1991*. New York: W. W. Norton.

———. 1994. *What Is Found There: Notebooks on Poetry and Politics*. New York: W. W. Norton.

Riegl, Alois. 1902. "Das holländische Gruppenporträt." In *Jahrbuch der Kunstsammlungen des Allerhöchsten Kaiserhauses* 23.

———. 1982. "The Modern Cult of Monuments: Its Character and Origins," translated by Kurt W. Förster and Diane Ghirardo. *Oppositions* 25.

Ringgold, Faith, with Eleanor Flomenhaft. 1990. "Interviewing Faith Ringgold/A Contemporary Heroine." In *Faith Ringgold: A 25 Year Survey*. Hempstead, N.Y.: Fine Arts Museum of Long Island.

Roberts, Tom. 1890. "Letter to the Editor." *The Argus*, 2 July.

Rose, Jacqueline. 1986. *Sexuality in the Field of Vision*. New York: Verson.

Rosen, Stanley. 1983. *Plato's Sophist: The Drama of Original and Image*. New Haven: Yale University Press.

Rosenberg, Harold. 1965. *The Tradition of the New*. New York: McGraw-Hill.

Ross, Andrew. 1989. *No Respect: Intellectuals and Popular Culture*. New York: Routledge.

Roth, Moira. 1992. "Upsetting Apple Carts: The French Collection." In Faith Ringgold, *The French Collection, Part 1*. New York: BMOW Press.

Rubin, William, ed. 1984. *"Primitivism" in 20th Century Art: Affinity of the Tribal and the Modern*. New York: Museum of Modern Art.

Sacks, Oliver. 1993. "To See or Not to See." *New Yorker*, 10 May.

Sahlins, Marshall. 1976. *Culture and Practical Reason*. Chicago: University of Chicago Press.

Said, Edward W. 1978. *Orientalism*. New York: Random House.

———. 1993. *Culture and Imperialism*. New York: Knopf.

Saussure, Ferdinand de. 1966. *Course in General Linguistics,* translated by Wade Baskin. New York: Doubleday.

Schama, Simon. 1987. *The Embarrassment of Riches: An Interpretation of Dutch Culture in the Golden Age*. New York: Knopf.

Schapiro, Meyer. 1957. "The Liberating Quality of Avant-Garde Art." *Art News* 56.

Schechner, Richard. 1985. *Between Theater and Anthropology*. Philadelphia: University of Pennsylvania Press.

Sello, Gottfried. 1988. *Adam Elsheimer*. Munich: C. H. Beck.

Sherman, Cindy. 1990. *Untitled Film Stills: With an Essay by Arthur C. Danto*. New York: Rizzoli.

Shiff, Richard. 1983. "Mastercopy." *Iris* 1.

———. 1983–84. "Representation, Copying, and the Technique of Originality." *New Literary History* 15.

———. 1984. *Cézanne and the End of Impressionism: A Study of the Theory, Technique, and Critical Evaluation of Modern Art*. Chicago: University of Chicago Press.

———. 1989. "On Criticism Handling History." *History of the Human Sciences* 2.

Shklovsky, Victor. 1965. "Art as Technique." In *Russian Formalist Criticism,* edited by Lee Lemon and Marion Reis. Lincoln: University of Nebraska Press.

Shue, Henry. 1988. "Mediating Duties." *Ethics* 98, no. 4.

Siegel, Jeanne. 1985. "After Sherrie Levine." *Arts* 59.

Silverman, Hugh, ed. 1989. *Derrida and Deconstruction*. New York: Routledge.

Silverman, Kaja. 1983. "Suture." In Silverman, *The Subject of Semiotics*. New York: Oxford University Press.

———. 1992. *Male Subjectivity at the Margins*. New York: Routledge.

Simmel, Georg. 1902–03. "The Metropolis and Modern Life." In Harrison and Wood 1992.

———. 1990. *The Philosophy of Money,* translated by Tom Bottomore, David Frisby, and Kaethe Mangelberg. 2d ed. London: Routledge.

Smith, David. 1973. *David Smith,* edited by Garnet McCoy. London: Allen Lane.

Smith, Terry. 1975. "Doing Art History." *The Fox* 2.

———. 1980. "The Divided Meaning of *Shearing the Rams:* Artists and Nationalism 1888–1890." In Anthony Bradley and Terry Smith, eds., *Australian Art and Architecture*. Melbourne: Oxford University Press.

———. 1993. *Making the Modern: Industry, Art, and Design in America*. Chicago: University of Chicago Press.

———. 1996. "Modernism"; "Modernity." In *The Dictionary of Art,* edited by Jane Shoaf Turner. London: Macmillan.

Solomon-Godeau, Abigail. 1989. "Going Native: Paul Gauguin and the Invention of Primitivist Modernism." *Art in America* 77.

Sombart, Werner. 1967. *Luxury and Capitalism*. Ann Arbor: University of Michigan Press.

Spivak, Gayatri. 1981. "French Feminism in an International Frame." *Yale French Studies* 62.

Stallybrass, Peter, and Allon White. 1986. *The Politics and Poetics of Transgression*. Ithaca: Cornell University Press.

Stangos, Richard, ed. 1994. *Concepts of Modern Art*. 3d ed. London: Thames and Hudson.

Steiner, Wendy. 1982. *The Colors of Rhetoric: Problems in the Relation between Modern Literature and Painting*. Chicago: University of Chicago Press.

———. 1988. *Pictures of Romance: Form against Context in Painting and Literature*. Chicago: University of Chicago Press.

Stephanson, Anders. 1987. "Barbara Kruger." *Flash Art* 136.

Stocking, George W. 1982. *Race, Culture, and Evolution: Essays in the History of Anthropology*. Chicago: University of Chicago Press.

Stokes, Adrian. 1978. *The Critical Writings of Adrian Stokes*, edited by L. Gowing. 3 vols. London: Thames and Hudson.

Suleiman, Susan Rubin. 1990. *Subversive Intent, Gender, Politics, and the Avant-Garde*. Cambridge: Harvard University Press.

Summers, David. 1981. "Conventions in the History of Art." *New Literary History* 13.

———. 1986. "Intentions in the History of Art." *New Literary History* 17.

Sutton, Peter, ed. 1988. *Dreamings: The Art of Aboriginal Australia*. New York: Viking.

Tagg, John. 1992. *Grounds of Dispute: Art History, Cultural Politics and the Discursive Field*. London: Macmillan.

Tambiah, Stanley J. 1979. "A Performative Approach to Ritual." *Proceedings of the British Academy* 65.

Tannenbaum, Judith. 1992. *Vija Celmins*. Philadelphia: Institute of Contemporary Art.

Taussig, Michael. 1993. *Mimesis and Alterity: A Particular History of the Senses*. New York: Routledge.

Thomas, Nicholas. 1991. *Entangled Objects: Exchange, Material Culture, and Colonialism in the Pacific*. Cambridge: Harvard University Press.

Thoré, Théophile. 1893. *Les Salons*. 3 vols. Brussels: Lamertin.

Tickner, Lisa. 1988. "Feminism, Art History, and Sexual Difference." *Genders* 3.

Tiffany, Daniel. 1989. "Cryptesthesia: Visions of the Other." *American Journal of Semiotics* 6:2/3.

Todorov, Tzvetan. 1982. *Theories of the Symbol*. Oxford: Blackwell.

Torgovnick, Marianna. 1990. *Gone Primitive: Savage Intellects, Modern Lives*. Chicago: University of Chicago Press.

Toussaint, Hélène. 1978. "The Dossier on 'The Studio' by Courbet." In Arts Council of Great Britain 1978.

Trilling, Lionel. 1971, 1972. *Sincerity and Authenticity*. Cambridge: Harvard University Press.

Troy, Nancy J., ed. 1994. "A Range of Critical Perspectives: The Object of Art History"; "The Subject of Art History." *Art Bulletin* 76.

Turner, Victor. 1967. *Forest of Symbols: Aspects of Ndembu Ritual*. Ithaca: Cornell University Press.

———. 1982. *From Ritual to Theater: The Human Seriousness of Play*. New York: Performing Arts Journal Publications.

Valeri, Valerio. 1985. *Kingship and Sacrifice: Ritual and Society in Ancient Hawaii*. Chicago: University of Chicago Press.

Van Gennep, Arnold. 1960. *The Rites of Passage,* translated by M. B. Vizedom and G. L. Caffee. Chicago: University of Chicago Press.

Venturi, Robert. 1966. *Complexity and Contradiction in Architecture.* New York: Museum of Modern Art.

Veyne, Paul. 1984. *Writing History,* translated by M. Moore-Rinvolucri. Middletown, Conn.: Wesleyan University Press.

Vitet, Ludovic. 1841. "Eustache Lesueur." *Revue des deux mondes,* 1 July.

Vitz, Evelyn Birge. 1989. *Medieval Narratives and Modern Narratology.* New York: NYU Press.

Wallace, Michele. 1990. "Modernism, Postmodernism and the Problem of the Visual in Afro-American Culture." In *Out There: Marginalization and Contemporary Cultures.* New York: New Museum of Contemporary Art.

Wallis, Brian, ed. 1984. *Art after Modernism: Essays on Rethinking Representation.* New York: New Museum of Contemporary Art.

———, ed. 1987. *Blasted Allegories: An Anthropology of Writings by Contemporary Artists.* Cambridge: MIT Press.

Walsh, Kevin. 1992. *The Representation of the Past: Museums and Heritage in the Post-Modern World.* London: Routledge.

Welsh, Robert P., and J. M. Joosten. 1969. *Two Mondrian Sketchbooks 1912–1914.* Amsterdam: Meulenhoff.

Wickhoff, Franz. 1912. "Die Wiener Genesis." In *Schriften,* vol. 3. Berlin.

Wilenski, R. H. 1927. *The Modern Movement in Art.* London: Faber.

Wilentz, Sean, ed. 1985. *Rites of Power: Symbolism, Ritual, and Politics since the Middle Ages.* Philadelphia: University of Pennsylvania Press.

Williams, Gwyn. 1976. *Francisco Goya and the Impossible Revolution.* London: Allen Lane.

Williams, Linda. 1989. "Fetishism and Hard Core: Marx, Freud, and the 'Money Shot.'" In *For Adult Users Only: The Dilemma of Violent Pornography,* edited by Susan Grubar and Joan Huff. Bloomington: Indiana University Press.

Williams, Raymond. 1977. "Base and Superstructure in Marxist Cultural Theory." In *Marxism and Literature.* Oxford: Oxford University Press.

Wittgenstein, Ludwig. 1953. *Philosophical Investigations,* translated by G. E. M. Anscombe. New York: Macmillan.

Wölfflin, Heinrich. [1899] 1968. *Classic Art: An Introduction to the Italian Renaissance,* translated by P. and L. Murray. London: Phaidon.

———. 1950. *Principles of Art History: The Problem of the Development of Style in Later Art,* translated by M. D. Hottinger. New York: Dover.

Wollen, Peter. 1982. "The Two Avant-Gardes." In *Readings and Writings: Semiotic Counter-Strategies.* London: Verso.

Wollheim, Richard. 1973. "Minimal Art." In *On Art and the Mind.* London: Allen Lane.

———. 1987. *Painting as an Art.* Princeton: Princeton University Press.

Yates, Frances. 1966. *The Art of Memory.* Children: University of Chicago Press.

Zerner, Henri, ed. 1982. "The Crisis in the Discipline." *Art Journal* 42.

Zimmerli, Werner. 1956. *Das Alte Testament als Anrede.* Munich.

Žižek, Slavoj. 1991. *Looking Awry: An Introduction to Jacques Lacan through Popular Culture.* Cambridge: MIT Press.

Contributors

MARK ANTLIFF is assistant professor of art history at Queen's University, Canada. He is the author of *Inventing Bergson: Cultural Politics and the Parisian Avant-Garde* and co-editor, with Matthew Affron, of the forthcoming *Fascism, Art, and Ideology in France and Italy*. He received a Guggenheim Fellowship in 1995–96 for work on his current book project, *The Advent of Fascism: Georges Sorel and the European Avant-Garde*.

STEPHEN BANN is professor of modern cultural studies at the University of Kent, Canterbury, England. He is the author of *The Clothing of Clio: A Study of the Representation of History in Nineteenth-Century Britain and France; The True Vine: On Visual Representation and the Western Tradition; The Inventions of History; Under the Sign: John Bargrave as Collector, Traveler, and Witness;* and *Romanticism and the Rise of History*. He is currently working on a study of the French painter Paul Delaroche.

HOMI K. BHABHA is professor of English literature and art at the University of Chicago. He is the author, most recently, of *The Location of Culture* and is a regular contributor to and columnist of *Art Forum*.

SUZANNE PRESTON BLIER is professor of fine arts at Harvard University. She is the author most recently of *African Vodun: Art, Psychology, and Power* and the *Anatomy of Architecture: Ontology and Metaphor in Batammaliba Architectural Expression*.

MICHAEL CAMILLE is professor of medieval art at the University of Chicago and author of *The Gothic Idol, Ideology and Image-Making in Medieval Art; Image on the Edge: The Margins of Medieval Art;* and *The Master of Death: The Lifeless Art of Pierre Remiet, Illuminator* (forthcoming).

DAVID CARRIER, an art critic, teaches philosophy at Carnegie Mellon University. His books include *Artwriting; Principles of Art History Writing; Poussin's Paintings: A Study in Art Historical Methodology; The Aesthete in the City: The Philosophy and Practice of American Abstract Painting in the 1980s;* and *High Art: Charles Baudelaire and the Origins of Modernism*.

WHITNEY DAVIS is professor of art history at Northwestern University and current Arthur Andersen Professor of Teaching in Research in the College of Arts and Sciences. He is also the director of the Alice Berline Kaplan Center for the Humanities at Northwestern. He is the author of *The Canonical Tradition in Ancient Egyptian Art; Masking the Blow: The Scene of Representation in Late Prehistoric Egyptian Art; Drawing the Dream of the Wolves: Homosexuality and Interpretation in Freud's "Wolf Man" Case;* and *Replications: Archaeology, Art History, Psychoanalysis,* and editor of *Gay and Lesbian Studies in Art History*. He is completing a book on homoeroticism in the visual field from 1750 to 1920.

ANN GIBSON is associate professor of art history and associate director of the Humanities Institute at the State University of New York at Stony Brook. She is the author of *Issues in Abstract Expressionism: The Artist-Run Periodicals* and is completing a study on race and gender in abstract expressionism for Yale University Press.

CHARLES HARRISON is professor of the history and theory of art at the Open University in England. He is editor of *Art-Language,* author of *English Art and Modernism 1900–1939* and *Essays on Art and Language,* and co-editor, with Fred Orton, of *Modernism, Criticism, Realism* and, with Paul Wood, of *Art in Theory 1900–1990.* He is currently preparing a book of essays entitled *On Conceptual Art and Painting* and is working with Paul Wood on two further volumes of *Art in Theory,* to cover the periods 1650–1820 and 1820–1900.

WOLFGANG KEMP is professor of art history at the University of Hamburg. His books include *The Desire of My Eyes: The Life and Work of John Ruskin; Der Anteil des Betrachters: Rezeptionsästhetische Studien zur Malerei des 19. Jahrhunderts; Sermo corporeus: Die Erzählung der mittelalterlichen Glasfenster;* and *Christliche Kunst: Ihre Anfänge, ihre Strukturen.*

JOSEPH LEO KOERNER is professor of fine arts at Harvard University and author, most recently, of *Caspar David Friedrich and the Subject of Landscape* and *The Moment of Self-Portraiture in German Renaissance Art.* He is currently working on the history of the altarpiece and on Hieronymous Bosch.

LISBET KOERNER is assistant professor of history of science at Harvard University. Her forthcoming biography of Linnaeus will be published by Harvard University Press. She is currently working on cross-cultural encounters in early modern voyages of discovery.

PATRICIA LEIGHTEN is associate professor of art history at Queen's University, Canada. A former Guggenheim Fellow (1990–91), she is the editor of *Art Journal*'s special issue, "Revising Cubism," and author of *Re-Ordering the Universe: Picasso and Anarchism, 1897–1914* and the forthcoming *A Politics of Form: Primitivism, Art, and Ideology.* A Fellow at the National Humanities Center in 1995–96, she is currently working on *The Esthetics of Radicalism: Anarchism and Cultural Criticism in Avant-Guerre France.*

PAUL MATTICK, JR. teaches philosophy at Adelphi University. The author of *Social Knowledge* and the editor of *Eighteenth-Century Aesthetics and the Reconstruction of Art,* he has written criticism for *Arts* and *Art in America.*

W. J. T. MITCHELL is the Gaylord Donnelley Distinguished Service Professor in the Department of English Language and Literature and the Department of Art at the University of Chicago. He is editor of the journal *Critical Inquiry* and the author, most recently, of *Picture Theory: Essays in Verbal and Visual Representation.*

ROBERT S. NELSON is professor of art history and chair of the Committee on the History of Culture at the University of Chicago. The author of books and articles about the art of the medieval Mediterranean world, he currently edits the College Art Association Monographs. He is working on two projects involving the recep-

tion of Byzantine art in the Renaissance and in the nineteenth and twentieth centuries.

MARGARET OLIN is associate professor of art history and criticism at the School of the Art Institute of Chicago. She is the author of *Forms of Representation in Alois Riegl's Theory of Art* and is currently working on *The Absence of the Jews in Art History: The Place of Ethnicity in the Structure of a Discipline*.

WILLIAM PIETZ has taught at Pitzer College, the University of California at Santa Cruz, and Georgetown University. He is co-editor, with Emily Apter, of *Fetishism as Cultural Discourse*.

ALEX POTTS is senior lecturer in the history of art at Goldsmith's College, London University. He is an editor of *History Workshop Journal* and author of *Flesh and the Ideal: Winckelmann and the Origins of Art History*. He is currently completing a book on modern sculptural aesthetics.

DONALD PREZIOSI is professor of art history at the University of California, Los Angeles. Among his books are *Architecture, Language, and Meaning: The Semiotics of the Built Environment; Minoan Architectural Design;* and *Rethinking Art History: Meditations on a Coy Science*. He is currently working on a book about museums and a volume on the art and architecture of the Aegean.

RICHARD SHIFF is professor of art and architecture and director of the Center for the Study of Modernism at the University of Texas at Austin. He is the author of *Cézanne and the End of Impressionism: A Study of the Theory, Technique, and Critical Evaluation of Modern Art*.

TERRY SMITH is director of the Power Institute of Fine Arts at the University of Sydney. He is the author of *Making the Modern: Industry, Art, and Design in America*.

DAVID SUMMERS is the William R. Kenan Jr. Professor of the History of Art at the University of Virginia. He is the author of *Michelangelo and the Language of Art* and *The Judgment of Sense: Renaissance Naturalism and the Rise of Aesthetics*. He is completing a book on principles of a world art history.

PAUL WOOD is a lecturer in the Department of Art History at the Open University, England. He is a contributing author to *Realism, Rationalism, Surrealism: Art between the Wars* and *Modernism in Dispute: Art since the Forties*. He is the co-editor, with Charles Harrison, of *Art in Theory 1900–1990*.

Index